The EY Exhibition

Late Turner
PAINTING SET FREE

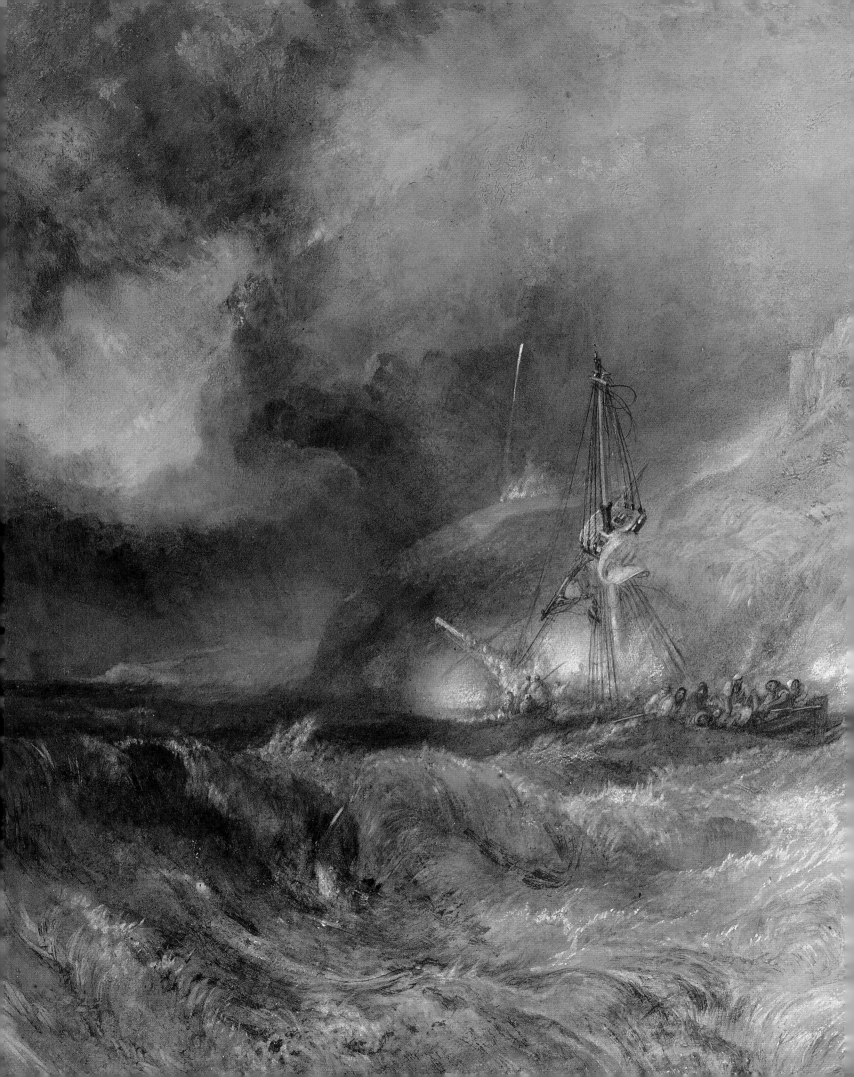

The EY Exhibition

Late Turner
PAINTING SET FREE

EDITED BY DAVID BLAYNEY BROWN, AMY CONCANNON AND SAM SMILES

WITH CONTRIBUTIONS FROM REBECCA HELLEN, MATTHEW IMMS, BRIAN LIVESLEY, NICOLA MOORBY AND JOYCE H. TOWNSEND

TATE PUBLISHING

First published in 2014 by order of
the Tate Trustees by Tate Publishing,
a division of Tate Enterprises Ltd,
Millbank, SW1P 4RG
www.tate.org.uk/publishing

© Tate 2014

On the occasion of *The EY Exhibition:*
Late Turner – Painting Set Free
Tate Britain, London: 10 Sept 2014 – 25 Jan 2015
J. Paul Getty Museum, Los Angeles: 24 Feb – 24 May 2015
de Young, Fine Arts Museums of San Francisco: 20 June –
20 Sept 2015

EY
Building a better
working world

The exhibition at Tate Britain is
part of the EY Tate Partnership

A catalogue record for this book is available
from the British Library

ISBN 978 1 84976 145 1 (hardback)
ISBN 978 1 84976 250 2 (paperback)

Library of Congress Control Number applied for

Designed by Nigel Soper
Colour reprographics by Altaimage, London
Printed and bound in Italy by Elcograf

Front cover: *Light and Colour (Goethe's Theory) – the Morning*
after the Deluge, exh. 1843 (detail, cat.118, p.187)
Frontispiece: *Bamborough Castle* c.1837 (detail, cat.123, p.198)
pp.57–8: *Lake Lucerne: The Bay of Uri from above Brunnen*
c.1844 (detail, cat.166, p.236)

EDITORIAL NOTES:
Measurements of artworks are given in centimetres,
height before width.

TB numbers refer to the Turner Bequest, as catalogued in
A.J. Finberg, *A Complete Inventory of the Turner Bequest*,
2 vols., 1909. Unless otherwise stated all Tate works by
Turner were accepted by the nation as part of the Turner
Bequest, 1856.

D/N/T/A numbers are Tate's accession numbers, which
can be found alongside images of all Turner's paintings,
watercolours and sketches from the Tate collection, along
with many others in museums around the world, on the
'Turner' pages of the Tate website (see www.tate.org.uk)

Contents

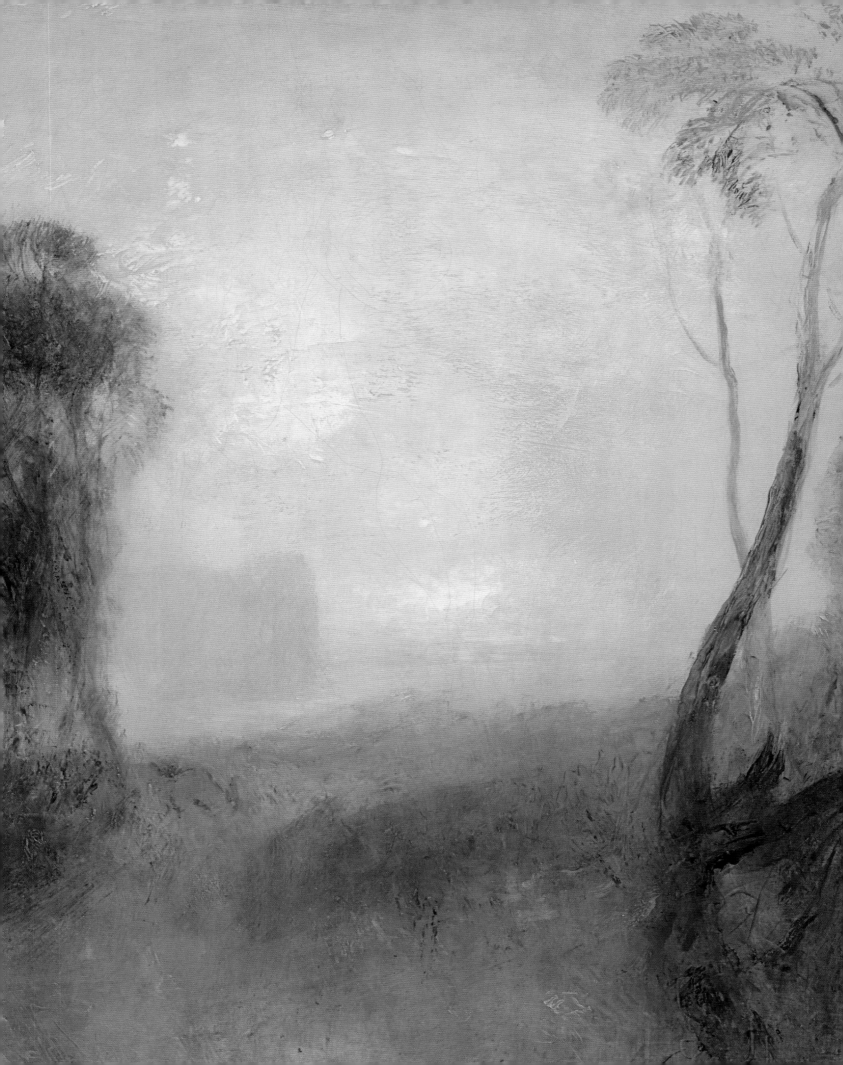

EY's Foreword

EY IS DELIGHTED TO WELCOME you to *The EY Exhibition: Late Turner – Painting Set Free*, the second 'EY Exhibition' as part of our three-year partnership with Tate. In over twenty years of commitment to the arts, EY has supported two exhibitions exploring the works of J.M.W. Turner. So we are especially pleased to be partnering with Tate Britain for this exhibition.

Turner was a complex artist whose later works were considered controversial and radical for his time. We are excited that this exhibition will challenge assumptions around the idea of the 'elderly' artist, and instead demonstrate Turner's exceptional energy and vigour during his final years.

EY is proud to be working with Tate as it continues to build public knowledge, understanding and enjoyment of both British and international art through its galleries across the UK. Our partnership with Tate is an example of how EY uses its investment and expertise to team with other organisations that share our purpose and commitment to building a better working world.

MARTIN COOK
Managing Partner – Commercial, EY

FIG.1
Sunrise, a Castle on a Bay:
'Solitude' ?c.1845
(detail, cat.146, p.220)

Foreword

TATE HAS MADE MANY EXHIBITIONS devoted to aspects of Turner's career, as have other museums and galleries, but there has never been a major exhibition focusing on the late work. This is all the more surprising, given that it is Turner's late work above all that has given rise to the anachronistic positioning of Turner as a proto-modernist in so many recent exhibitions.

The exhibition has two principal aims, and they are held in delicate balance. One is to argue against the idea that Turner was the first modern artist, and the other is to argue that he was a very modern artist. This seeming contradiction is resolved within the larger framework of Turner's artistic self-image: the artist turned sixty in 1835, and the last fifteen years of his career show a new and vigorous focus on his own position within both a contemporary and a posthumous context.

We are indebted to Sam Smiles for accepting the invitation to steer this exhibition; it is an important project and one which a number of Turner scholars, including notably Andrew Wilton and Ian Warrell, hold dear. This is not just because the works of the late years are so extraordinary, but also because it is time for something of a corrective. Sam Smiles has been working on the concept of late style in relation to a number of artists, including Turner, and is especially well placed to elucidate this repositioning.

It was Sam Smiles who alighted upon an unpublished lecture written by the artist and art historian Lawrence Gowing and entitled 'Painting Set Free'; he has used this term as a provocation to our rethinking of the artist's project and ambition. Forty-eight years have elapsed since Gowing made his exhibition *Turner: Imagination and Reality* at the Museum of Modern Art in New York; a whole generation of scholarship allows us to reconsider our reading of Turner in the context of his time.

In 1851 Turner rewrote his will and had already started to buy back some of his own earlier paintings. He had begun to think about his legacy. At the same time, however, he not only defied old age by travelling across Europe to capture its ancient sites and natural topographies, but, more importantly, addressed themes relating to contemporary England as it embraced Victorian innovation. By placing him more securely within his own times the exhibition seeks to identify where and how he was properly modern, rather than casting him as a forerunner of something still to come. In this way, we hope to reveal Turner's innovation on its own terms, rather than ours.

A project such as this relies on support from many quarters, and we wish to acknowledge the manner in which Amy Concannon, as assistant curator, has succeeded in marshalling that complex network both conceptually and practically. Her competence and commitment have been crucial. She and Sam Smiles have been guided by the immense knowledge and experience of David Blayney Brown, and the three have worked as a team. In London the project has also benefited greatly from the experience of Carolyn Kerr, Gillian Buttimer and Sionaigh Durrant. Tate Britain would like to thank HM Government for the provision of Government Indemnity and the Department of Culture, Media and Sport and Arts Council England for arranging the indemnity. We would also like to extend our thanks to EY. Their generosity through the EY Tate Arts Partnership has made it possible to stage shows such as *The EY Exhibition: Late Turner – Painting Set Free* and we are extremely grateful for their ongoing commitment to Tate.

We were delighted that this exhibition is also appearing at the J. Paul Getty Museum, in Los Angeles, and the Fine Arts Museums of San Francisco. At the Getty, we would like to acknowledge the contributions of Julian Brooks, Peter Kerber, and Quincy Houghton, as well as former Getty colleagues David Bomford and Scott Schaefer. At the Fine Arts Museums, we would like to thank Julian Cox, Melissa Buron, and Krista Brugnara for their input and support. The work of Turner has been rather little seen on the West Coast of the United States, and we are very pleased that this important exhibition should address that lacuna.

While the Turner Bequest is housed at Tate Britain, and the exhibition has been able to draw, in particular, on the richness of its holdings of works on paper, more than half the works in this selection come from other collections. On occasion, it is important for Tate Britain to be able to show the Bequest within a much broader context, for otherwise its quite specific character can skew our view of Turner's production. We have asked many museums to entrust this project with their works, and we are deeply conscious that, for many, this means giving up works which constitute a much larger proportion of their holdings than for us. Likewise, we are very grateful to those private collectors who have so generously agreed to share their important works with us. We earnestly hope, as a consequence, that this exhibition will help to reveal, for all of us, a much more rounded picture of the artist, and that we can start to readdress his achievement from a basis of a proper understanding of his ambition.

PENELOPE CURTIS
Tate Britain,
London

TIMOTHY POTTS
J. Paul Getty Museum,
Los Angeles

COLIN B. BAILEY
Fine Arts Museums of
San Francisco

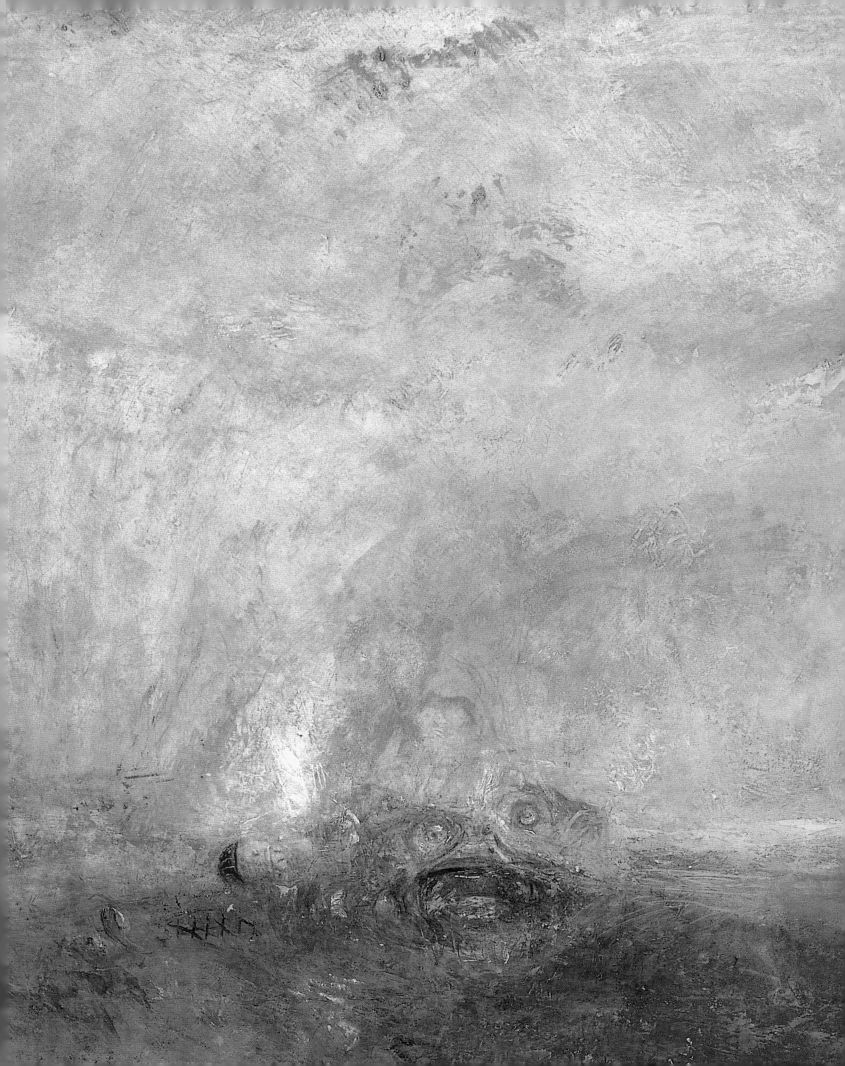

Acknowledgements

MANY SCHOLARS, CURATORS and members of the art trade have helped shape the thinking of the curators through their research, publications, advice and conversation over many years. In particular we would like to thank Nicholas Alfrey, Peter and Sally Bower, Richard Feigen, the late John Gage, Colin Harrison, Luke Herrmann, Robert Hewison, David Hill, Lowell Libson, James Miller, Kathleen Nicholson, Cecilia Powell, Nick Savage, Stephen Wildman and Barry Venning. Special thanks are due to Turner's recent biographers Anthony Bailey and James Hamilton, and to their current successor Eric Shanes. Among former Tate colleagues, Andrew Wilton and Ian Warrell have done much to enlarge knowledge of Turner, not least in his late period; Julia Beaumont-Jones was ever-welcoming in the Clore Prints and Drawings Room, as are Christine Kurpiel and her team. Piers Townshend, and Joyce H. Townsend and Rebecca Hellen who we welcome to this publication, have transformed understanding of media, materials, technique and condition. Lead Curator of Nineteenth-Century Art Alison Smith, Tate Research under Nigel Llewellyn and Jennifer Mundy and the Turner Cataloguing team at Tate Britain have provided encouragement, support and a continuing stream of new discoveries, represented here by Matthew Imms who has identified the true subject of a group of fiery watercolours, and Nicola Moorby who writes on Turner's later travels.

Gerry Alabone, Adrian Moore and Ivan Houghton have conducted major research on picture frames, enabling in particular Turner's series of square canvases to be shown in restored or improved frames more nearly as the artist intended them to be seen. Tate Publishing and editors Miranda Harrison, Rebecca Fortey, Johanna Stephenson, picture researcher Emma O'Neill and production controller Roanne Marner have seen the publication through the press with their usual professionalism. Nigel Soper created its elegant design. Elizabeth Jacklin, Anna Jones, Melanie Greenwood and Lorna Robertson have contributed to the delivery of this exhibition project, while Jennifer Batchelor has steered exhibition interpretation. Our sincere thanks to them all.

SAM SMILES
DAVID BLAYNEY BROWN
AMY CONCANNON

FIG.2
Sunrise with Sea Monsters
c.1845
(detail, cat.142, p.213)

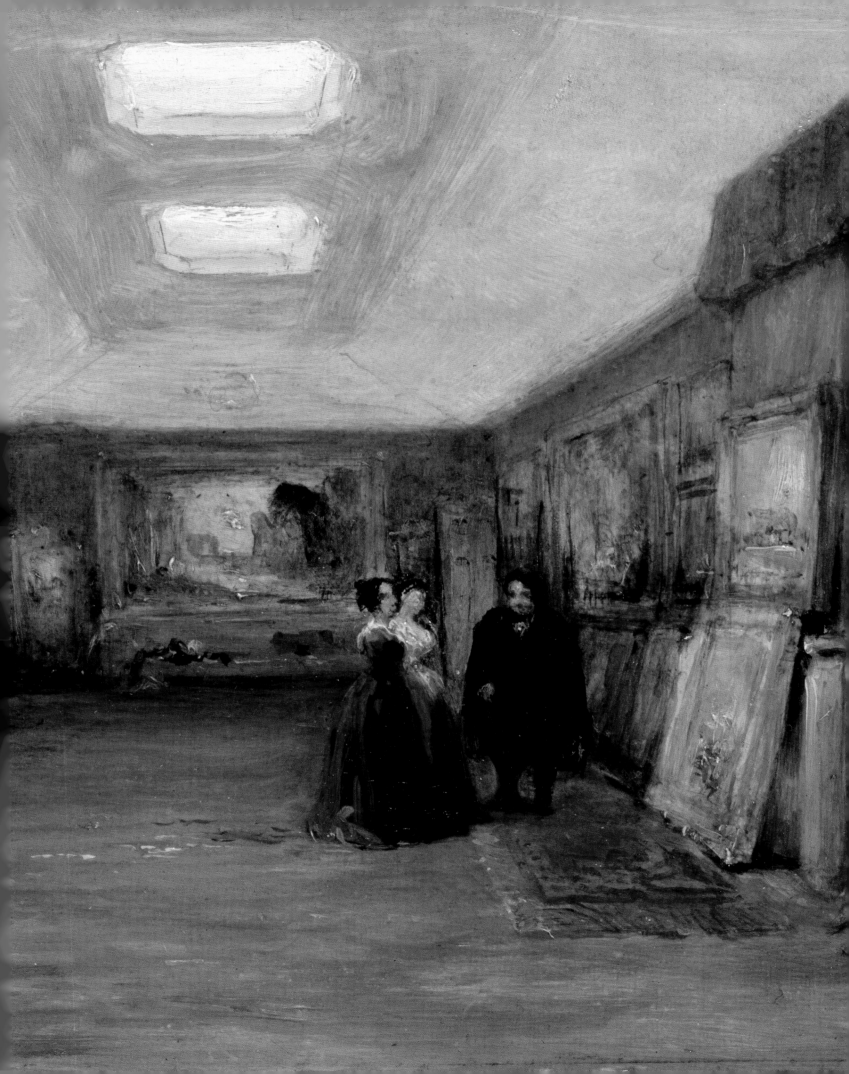

Turner In and Out of Time

Sam Smiles

TURNER TURNED SIXTY in 1835 and the works he produced over the remainder of his life – or at least until he last exhibited in 1850 – are the focus of this exhibition. For many commentators today this final phase of his career saw the emergence of his supreme achievement, the pictures in oils and in watercolour on which his artistic significance ultimately rests. The notion has also grown up that Turner was an increasingly isolated figure in these years, at odds with the culture of his time, deliberately evasive about the meaning of the work he exhibited and a fierce guardian of his privacy. Turner would appear to have existed in an oblique relationship to the early Victorian art world, producing paintings in a pictorial language unique to him and quite beyond the comprehension of his detractors, who assaulted his paintings without mercy in their reviews. For this reason the modern era's positive response to Turner's last period of production has been seen as righting a great wrong. The clichéd understanding of 'late work' reinforces this approach; it presumes that in his final years the artist is working principally for his own satisfaction, heedless of the demands of patrons or the reactions of critics. In self-willed isolation, aware that his time is limited, the master of his craft creates valedictory works that are far beyond his contemporaries' understanding but look forward to posthumous vindication in a world finally ready to accept them.

Turner's last works have been all too frequently described in just this way, as anticipating later developments in the history of art, notably Impressionism and even abstraction. The artist is presented as a visionary, aware as no other before him of what landscape painting might be, who produced a magnificent gallery of finished and unfinished works that baffled his contemporaries and were only properly understood once the tide of modern art had flooded in.[1] Turner, on this analysis, is an exceptional artist not merely because of his high ability and the production of so many outstanding paintings throughout his professional career, but because those pictures he painted in the later 1830s and 1840s break the bonds of time and history to which lesser artists submit. Such an approach implicitly suggests that Turner's last paintings transcended the era in which they were created and are best understood as untimely, in the sense of anticipating what is to come. This assessment has had the consequence that any serious concern with the subjects and meanings of Turner's pictures has been set aside to concentrate instead on those aspects of form and composition that seem to presage modern painting.

Yet if we are to do justice to the works Turner produced in his old age, we cannot overlook

the fact that they were made in the early years of Victoria's reign and were addressed to a contemporary audience. For all their formal and technical brilliance, we should try to make sense of them with that horizon of possibilities in mind. Once we adopt this viewpoint, another artist emerges from behind the cliché of the misunderstood genius, an artist fully engaged with the events and opportunities of Victorian England and determined to communicate to his contemporaries important truths about the world in which they lived. Turner did not turn inwards to paint for himself alone, resigning from his longstanding dedication to showing his work in public arenas. Neither did he retreat from commercial considerations, the sale of his paintings and the search for new commissions. Nor was his subject matter selected merely as a pretext for formal experimentation as if aware of painting's ineluctable Modernist destiny in abstraction. On the contrary, he continued to explore visual perception, natural phenomena, modern life, the course of history and the social and ethical contexts that determine the endeavours of mankind. And in concert with these concerns went a commitment to the activity of painting as an art, drawing on the resources accumulated across a lifetime's practice to present these truths in a highly sophisticated way, handling oil paint and watercolour freely and using the resources of light and colour to choreograph the pictorial structure of his work.

When these contexts are restored to him, the pictures Turner exhibited in his 'late' period are revealed as very much attuned to the world of the mid-nineteenth century, to its economic and technological development, to its concerns with the lessons of history and the nation's future prospects, to debates about the contribution of art to civil society and to reflections on the nature of painting. Turner's commitment to a public art had sustained him throughout his career; he was not going to abandon it now.

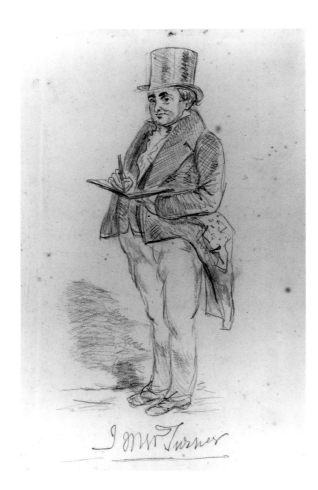

FIG.4
CHARLES MARTIN
Joseph Mallord William Turner 1844
Pencil on paper 37.1 × 26
National Portrait Gallery, London

SENILITY AND SENIORITY

In the sixteen years between 1835 and his death, aged seventy-six, in December 1851, Turner's physical health deteriorated. This is not to say that he became immediately infirm, for he remained very active up until the mid-1840s, but he suffered some acute illnesses and was also beset by more chronic problems typical of a man of his age. The clinical judgement of David Price, Turner's physician when he died, is that he suffered from heart disease.[2] Other observations on his health are not extensive and are derived from the casual observations of friends and acquaintances, none of whom had medical training. This paucity of evidence and its unreliability in terms of clinical precision means that we can but speculate about Turner's health and constitution in his final years, but it is certainly reasonable to conclude that he found it increasingly difficult to maintain his output as his health worsened. And he was all too aware of what his advancing years had in store for him. A year before he died Turner spoke of the physical deterioration associated with ageing: 'I always dreaded it with horror.'[3] Yet for all his anxiety about decrepitude, and even if we had

a store of reliable doctors' notes, it would be a mistake to review Turner's final creative activity as though his age and infirmity give the key to its interpretation.

Turner's letters show that he suffered a serious bout of influenza in March 1837 and from a bad fever in the winter of 1837–8.[4] He endured ill health in the winters of 1844, 1846, 1848, 1849 and 1850. He broke his kneecap in the summer of 1848 and found walking difficult in December 1850 and again in the summer of 1851. At some point in 1850–1 he may have contracted cholera or something like it. He lost his teeth and was reduced to an essentially liquid diet. He needed glasses for close working (cat.6), although numerous witnesses record that otherwise his eyes did not seem to have suffered any deterioration and were as clear and brilliant as a child's. This is not an especially morbid record, but contemporary attitudes to ageing are also significant. Turner's doctor until the end of the 1830s was Sir Anthony Carlisle, one of the pioneers of gerontology, who declared: 'The age of Sixty may, in general, be fixed upon as the commencement of Senility.'[5] As Carlisle prepared a new edition of his *Essay on the Disorders of Old Age and on the Means for Prolonging Human Life* towards the end of 1837, he was also treating Turner (cat.5).[6] Perhaps the artist and his physician, respectively sixty-two and seventy years old, discussed old age and the remedies that might mitigate its impact.

When he was not beset by illness Turner was a regular guest at a multitude of lunches, dinners, excursions and other social occasions until very nearly the end of his life, whether with fellow artists at the Royal Academy, with friends or with patrons. And despite the decay of his house and studio in Queen Anne Street, a number of visitors were permitted access to the premises to view the work on display in his purpose-built gallery (see cats.14, 15). What we know of Turner's social life in this period

comes mainly from letters and reminiscences, but the lithograph by Count D'Orsay (cat.1) provides a visual record of the elderly artist at a *conversazione* held by his patron Elhanan Bicknell in his house at Herne Hill. The rather cruel subtitle, 'The Fallacy of Hope', refers to Turner's regular citation of his own verse composition 'Fallacies of Hope' to accompany some of his pictures, but twists it as a comment on his physical decline.

His advancing years also saw Turner becoming something of a father figure at the Royal Academy. On a number of occasions he helped younger painters improve the effect of their works, adding touches to their canvases on Varnishing Days to resolve difficulties; in 1847, for example, he adjusted the chiaroscuro and the rainbow in Daniel Maclise's *Noah's Sacrifice* (cat.9), added Galileo's concentric system of planets to the background of Solomon Hart's *Milton Visiting Galileo when a Prisoner of the Inquisition* (Wellcome Library, London) and advised John Rogers Herbert on his painting *Our Saviour Subject to his Parents at Nazareth* (replica in Guildhall Art Gallery, London). Turner had long worked in various capacities at the Royal Academy and was still active as Visitor in the Life Academy up to 1837 and in the Painting School until the early 1840s. In February 1845 he was appointed the acting President of the Royal Academy when Sir Martin Archer Shee was too ill to undertake his duties, and he remained Deputy President until December 1846.

Turner's work on his own pictures on Varnishing Days in the 1830s and 1840s occasioned much comment, and a number of anecdotes have come down to us from those who witnessed him preparing his paintings for exhibition (see cat.8). There are good reasons to suppose that some of what was reported, for example that the pictures were worked up from mere lay-ins, was embellished and exaggerated. Yet what all of them reveal is Turner's continued

demonstration of his commitment to painting as an activity and his intense belief in the social importance of the Royal Academy as the place where artists could meet together in one community. One of his last contributions to the Academy was a speech he gave to the students at a dinner in 1847, reminding them of their need to avoid factionalism: '... never mind what anybody else calls you. When you become members of this institution you must fight in a phalanx – no splits – no quarrelling – one mind – one object – the good of the arts and the Royal Academy.'[7]

PATRONS AND COLLECTORS

For all Turner's adherence to the beliefs that had guided him for some fifty years, the art world in which he was working at the end of his life had altered considerably since the 1790s, when he had first exhibited his work. At the outset of his professional career he had succeeded, especially in his most ambitious paintings, in attracting the attention of the aristocracy and landed gentry. Their patronage was not only munificent, raising Turner's standing via the prestige of high prices, but also demonstrated their validation of the artist's contribution to a particular understanding of culture, its principles and values, shared by the educated classes of the day. Forty years later middle-class taste had become the dominant force, the art market had developed and merchants, entrepreneurs and industrialists were active purchasers of his work. For all their wealth, these patrons' position in society was very different from the representatives of the landed interest to whom he had sold earlier in his career. Similarly, when compared to the picture galleries of the grandees who had bought Turner's paintings in the early 1800s, the private collections of these new patrons were much less likely to be dominated by the Old Masters. Whatever Turner may have intended in those of his own paintings that still emulated his artistic predecessors, thereby invoking art's history and

traditions, increasingly his work was displayed in collections committed to the acquisition of contemporary art.

Turner's dominant reputation attracted the interest of these new patrons and encouraged them to acquiesce in his vision without placing inappropriate new demands on him; but equally, faced with an increasingly diversified clientele, he needed to adapt his art to the interests and concerns of those who were shaping modern conditions in Britain. His recognition of these changing circumstances in the operation of the art market saw Turner, from at least the year 1840, put his faith in the art dealer Thomas Griffith to act for him to attract clients and secure sales. It also saw him begin to produce more pictures that were very obviously focused on contemporary enterprises and technologies. This was subject matter that had either not existed or was not deemed to be appropriate for exhibition when he had begun his career.

Beyond any assessment of the changes Turner had witnessed in his lifetime lay a wider issue concerning the direction of British art at mid century. The National Gallery, established in 1824, had initially very few paintings by British artists on display, primarily because its founding collections were those of connoisseurs who had not been energetic patrons of contemporary art.[8] This poor showing was improved in 1847 when part of Robert Vernon's collection was given to the nation. Vernon, whose father was a successful London hackney man, had made his fortune supplying horses to the army during the Napoleonic Wars. The father had collected Old Masters, but the son's collection concentrated principally on modern British art. His house in Pall Mall was opened to the public from 1843 and functioned as an unofficial 'national gallery' of the British School of artists, including four paintings by Turner.[9] Shortage of space meant that the bequest could not be shown in its entirety for many years, but to announce the success of

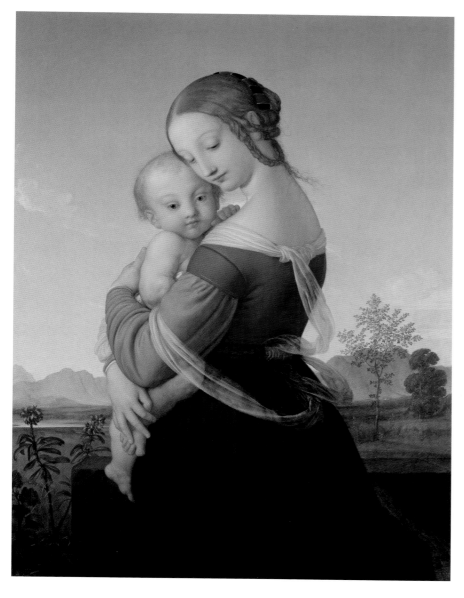

FIG.5
WILLIAM DYCE
Madonna and Child
c.1827–30
Oil paint on canvas
102.9 × 80.6
Tate. Bequeathed by
Colonel Ernest Carrick
Freeman, 1963

the negotiations one work from Vernon's gift was selected by the Trustees of the National Gallery for immediate exhibition: Turner's *The Dogano, San Giorgio, Citella, from the Steps of the Europa* dating from 1842 (cat.63), which was placed on public display on 27 December 1847. This was the kind of painting that even Turner's most vicious critics could not ridicule and its selection as the solitary representative of Vernon's bequest acknowledged the importance of Turner's contribution to British art.

The exhibition of Turner's painting as the *chef-d'oeuvre* of Vernon's collection might suggest that his historical significance was now assured, but that triumph took place at a time when the question of the future development of British art was very much in the air. The influence of the Nazarenes, a brotherhood of German artists active in Rome c.1810–30 who aimed to recover

the spiritual message of Christian art and looked to the early Renaissance for inspiration, was evident in the frescoes painted at Westminster in the 1840s by William Dyce, who had already come under their influence on his visits to Rome in the 1820s (fig.5). While some patriotic voices were raised in opposition to an overly enthusiastic promotion of Germanic aesthetic principles in the context of the decoration of the national seat of government, it was nonetheless true that the qualities of draughtsmanship, rational ordering of space and chaste colouring of modern German art found ready acceptance in England.[10] John Rogers Herbert and Daniel Maclise, for example, both produced work allied to this new sensibility. It is surely noteworthy, then, that when John James Ruskin approached the publisher John Murray in 1842 to discuss the possibility of taking on *Modern Painters*, his son John Ruskin's impassioned defence of Turner's genius, Murray did not think its commercial prospects were good. 'He said the public cared little about Turner and strongly urged my son's writing on the German school, which the public were calling for works on.'[11] A new aesthetic was gaining ground in the 1840s, seemingly at odds with the approach to painting associated with Turner's generation. The emergence of the Pre-Raphaelite Brotherhood in 1848 demonstrated that new priorities in painting had presented themselves.

TURNER THE OLD MASTER?

This sense of an altered world was surely reinforced by the deaths of Turner's fellow painters. From the 1830s and into the 1840s a whole generation of artists was passing: Thomas Lawrence in 1830, Thomas Stothard in 1834, John Constable in 1837, David Wilkie in 1841, John Sell Cotman and John Varley in 1842, Augustus Callcott in 1844, Thomas Phillips in 1845, William Collins in 1847, William Etty in 1849. Including some of Turner's ablest

FIG.6
Calais Pier 1827
Mezzotint on paper
62.3 × 83.7
British Museum

contemporaries in landscape painting as well as close friends, the growing roll-call of the deceased may have prompted thoughts that he was the last representative of an approach to painting whose time was nearly up. In addition, of course, there was a growing sense that he himself was becoming something of an Old Master, at least in respect of his earlier works, some of which had been painted before many of his current critics had been born. Occasional examples from his early career surfaced in the auction rooms or in exhibitions and tended to draw the attention of art critics when they did, not least because these earlier works were increasingly regarded as Turner's most accomplished paintings, a standing rebuke to the works he was now exhibiting as far as his more hostile critics were concerned.

Turner's earlier work was not for him a rebuke, nor a closed book, but instead functioned as a spur to further effort; it was another resource for imaginative transformation. One memorable instance occurred in 1835, when Thomas Lupton took on the task of making a mezzotint of *Calais Pier* (1803; fig.6), a painting that was still in the artist's possession and would become part of his intended bequest to the nation. Lupton reported Turner admiring

the delicacy of hue in the fish in the painting's foreground, whose finesse refuted those who attacked his use of colour.[12] His delight in his own talent was not, however, as complacent as this anecdote suggests. After many weeks' work Lupton's print had to be abandoned because Turner attempted to have the composition radically altered. His reported reply, when Lupton assured him that the print was scrupulously faithful to the proportions of the original painting, is interesting:

> Well, if it is so, it won't do. These are perfect doll's boats! Therefore the boats, &c. &c., must all be considerably increased in size, or there must be a large piece cut off all round the plate to give the boats or objects in the picture more importance; at present it is all *sea* and *sky*, and it won't do.[13]

Turner interfered with the plate, progressively increasing the size of the boats' sails, adding a topsail to one of them, and enlarging their hulls in keeping with the extra weight of canvas they now carried. For all Lupton's evident frustration, Turner's intervention shows that he was effectively reworking his original design for its new iteration, bringing to bear his current

views of painting to make *Calais Pier* a work of the 1830s.

Turner's engagement with his own past was stimulated again in 1837, when a loan exhibition of Old Masters at the British Institution included his 1801 seascape, *Dutch Boats in a Gale: Fishermen Endeavouring to Put their Fish on Board* (the *Bridgewater Seapiece*; on loan to the National Gallery, London, see fig.7 for engraving), which was shown together with *A Rising Gale*, the painting by Willem Van de Velde it had been originally designed to complement. The comparison provoked much critical interest and Turner, too, was clearly intrigued to see the pictures together again after such a long interval. The following year he showed a new work at the British Institution, *Fishing Boats with Hucksters Bargaining for Fish* (fig.8), as a response to his own painting from thirty-seven years earlier. In a letter to Thomas Griffith in 1844 Turner linked the two pictures, declaring that his 1838 *Fishing Boats* 'has to work up against the reputation of Lord E[gerton's] Pictures and I wish they could be seen together or belong to the same family'.[14] Lord Francis Egerton's *Bridgewater Seapiece* certainly did have a reputation, for it was one of the pictures that had brought Turner to public notice at the outset of his career and had been

sold to an aristocrat for the very handsome price of 250 guineas. The new picture was not a commission and it was fanciful for Turner to hope that a sale on the open market might see it join its predecessor. Nevertheless, his wish to have them seen together is worth noting. As is well known, Turner had frequently set himself the challenge of competing with the past masters of landscape; now he could compete with himself. The arrangements Turner made in his will reinforced this principle of bringing his earlier and later work together. His bequest to the nation, 100 finished paintings from all stages of his career, stipulated that the works would be seen together, demonstrating that he saw significant continuities in his oeuvre. Whether he felt that his most recent work trumped what he had produced in his youth and early maturity cannot be ascertained, but clearly he estimated his earlier paintings highly.

The idea that Turner was in a position to reflect on his own development is significant. In 1847 and again in 1849 he exhibited paintings at the Royal Academy, where rather than sending in fresh canvases he worked over pictures that he had originally painted at the beginning of the century, thus effecting a dialogue on the same canvas between the artist he had once been and

the artist he had become. The fact that portions of the first campaign of work were left visible is worth remarking, for it suggests that he did not want to disavow his earlier practice. But nor, conversely, is the evident difference of treatment left in view merely to draw attention to the distance Turner had travelled in his conception of painting. As he did in his work as a whole, he detected important connections between his past and present approaches.

This dynamic exploration of his own history perhaps explains what on the face of it may seem a curious refusal. In 1849 the Society of Arts intended to honour Turner with a career retrospective, a successor to the inaugural exhibition of this sort it had devoted to William Mulready's work in 1848. Excusing himself on account of 'a peculiar inconvenience this year', Turner declined the invitation and his place was taken by William Etty instead.[15] Retrospectives were principally associated with the summer exhibition programme of the British Institution, which had mounted regular posthumous tributes of this sort to the leading lights of the British school between 1813 (Reynolds) and 1845 (Callcott).[16] With respect to landscape

painters, this memorialisation of native artists had also developed with the publication of the biographies of Richard Wilson (1824) and John Constable (1843).[17] These exhibitions and biographies were, however, commemorations of deceased artists. The Society of Arts' initiative, the inspiration of Henry Cole, was to offer visitors the opportunity of making sense of a living artist's achievement. Necessarily, such an accolade was only appropriate to an artist with a long career, and inevitably therefore best fitted someone approaching the end of a lifetime's work. Flattering as the Society's offer may have seemed, one wonders if Turner felt uneasy that such an exhibition would present him as an artist already slipping into the past, rather than the vital presence in the contemporary art world he wished to remain.

CRITICAL RECEPTION
Turner had been running the critical gauntlet for years. His detractors, and there were many, attacked him for obscurity of subject, non-naturalistic colour, indistinct forms and obtrusive handling. For his admirers, however, Turner's mature vision represented a possibility for

painting which only a corrupted culture could so wilfully misunderstand. As one of them wrote,

> in one of his rooms he has more truly brilliant poetic scenes rolled up and laid aside than any collection in the country contains: on some future day, when facsimile-painters swarm in the land, and the world grows weary of common and every-day things, there will be an unrolling of these splendid pictures, and a general turning up of eyes, and shrugging of shoulders at the lack of taste of this our living generation of connoisseurs and patrons.[18]

As he moved into the 1840s Turner showed no sign of making any sort of accommodation with those reviewers who wished to denigrate his work. Even his great champion, Ruskin, proposed a more conciliatory tactic, but was rebuffed, noting with displeasure that Turner 'rudely stopped me when I wanted to speak to him about painting an agreeable picture for the Academy'.[19] A correspondent to an arts magazine in 1843 bewailed the fact that the critics could be so divided, some promoting the early paintings, some the most recent as the true mark of Turner's genius and the works by which he would be remembered.[20] As suggested above, where his reviewers saw divisions Turner saw connections within his oeuvre, but with respect to his reputation this critical polarity had the curious effect of pitting Turner's past against his present, the young artist against the old, as though he were not one painter but two: the accomplished developer of the European landscape tradition and the restless innovator.

From Turner's point of view the significance of his achievement remained what it always had been: elaborating a convincing way of representing natural phenomena in all their complexity. What his critics now attacked

as incomprehensible or fantastic should be properly understood as a further development of a credo he had adopted throughout his career when attempting to engage with the diversity of material substance and visual perception. Turner's pictures are multifaceted and their meanings hard to decipher primarily because he did not use painting to illustrate a subject (as was true of so many of his contemporaries), but instead made the best use of what painting can do as a means of distilling experience and conveying ideas. The titles of his pictures and the quotations included in the Royal Academy's catalogues provide a framework or an orientation for that understanding to begin to take hold as one contemplates the image. Some of its iconographic elements may confirm a reading; others may prompt chains of thoughts and associations. But titles and iconography do not exhaust a picture's meaning: it is in the texture of the painting, the disposition of forms, the articulation of space, the orchestration of colour and the structures of the painted surface that the meaning is embodied and from which it will emerge when the viewer is fully engaged with the work. This is not some uniquely distinctive feature of Turner's so-called 'late style'; it is as true of the work made in the early years of his development as it is in his years of maturity.

PAINTING SET FREE

The subtitle of the present volume (and the exhibition it accompanies) speaks of painting being set free, deliberately borrowing a phrase applied to Turner's last works in the 1960s at the height of that enthusiasm for his modernity that has so warped our understanding of him.[21] The implication then was that Turner's late style saw him free painting from a nineteenth-century context to anticipate twentieth-century concerns. Seen from Turner's viewpoint, however, the setting free of painting can be understood quite differently: as the continued development of

ideas about painting that he had refined over the course of his career. Turner's interest in light and atmosphere allowed him to broach thoughts about perception and its limitations, whether confused by the absence of light or by its radiance in different conditions of beholding. He had also demonstrated how light and colour may be used by painters to set the emotional key of a work, to allude to ethical concerns and to orchestrate the spectator's response. All of these interests tended towards an insistence on colour in painting as more than a descriptive device. It is evident from the sketchbooks that Turner used as far back as the turn of the century that he had begun to explore the possibility of heightened or non-naturalistic colour from very early in his career. His paint handling, too, in both his oil and his watercolour sketches had already been marked by an increasingly free application of pigment and a relatively spare descriptive content. Over the course of five decades the gap between sketch and exhibited picture had narrowed to the point that the works he showed at the Royal Academy's annual exhibitions provoked unease in those whose view of painting had no place for his qualities of handling and his understanding of colour.

What Turner achieved, then, followed to its conclusion the logic of what he had first understood in the early 1800s. Painting would be set free from artificial limitations and an imperfect understanding of the history of art, which overlooked his predecessors' investigations of painting as a communicative medium. And if we, likewise, are to free Turner from the distortion of Modernist interpretations, it is important to recognise that painting was not in these final works free to be autonomous, such that subject matter was merely the excuse for a dazzling display of painterly invention. Far from it – it was precisely Turner's understanding of what an untrammelled practice would permit that gave him the scope to tackle subjects whose

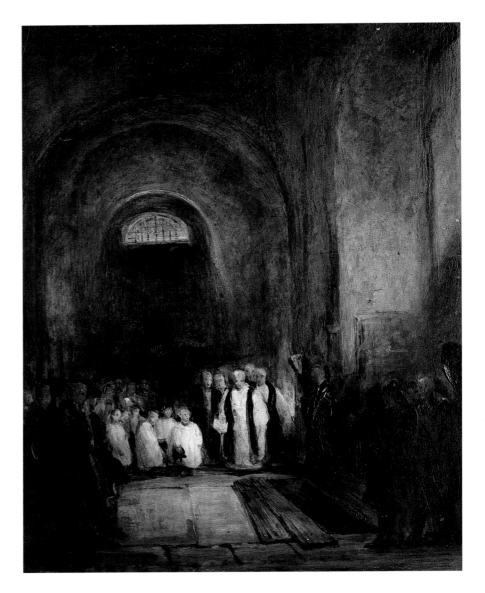

complexity could not have been revealed in any other medium.

The world Turner shows is above all dynamic, not simply in the obvious sense of picturing storm, fire and flood as they transform the natural environment, nor in recording the simple fact of movement, with or without the aid of modern technology, but in the sense of presenting the world as mutable, ever-changing, where solid forms become tremulous in light, water turns into vapour, diurnal and seasonal rhythms of light transmogrify the landscape they illuminate. This ever-shifting world is the stage on which humanity plays out its destiny. More than this, however, we might observe that Turner's commitment to a world understood as in a state of flux chimed with a particularly turbulent period in history. The stable and ordered world of eighteenth-century society, at least as its moneyed beneficiaries had presumed

FIG.9
GEORGE JONES
Turner's Burial in the Crypt of St Paul's
after 1851
Oil paint on millboard
23 × 18
The Ashmolean Museum, University of Oxford. Presented by Mrs George Jones, the artist's widow, 1873

it to be, had been blown apart by unparalleled industrial advances, urbanisation, social unrest and agitation for political change. Technology, in addition to its transformation of the economy, had reordered perceptions of space and time as communications improved. This is not, emphatically, to suggest that Turner's images should be understood as ciphers for the sort of perceptions associated with social commentators of the time, 'reflecting' the radical uncertainty of the age. But it is, perhaps, to propose that a painter with his wits about him would have realised that the period in which he was working was extraordinarily volatile, that the old order was breaking up and new possibilities were emerging in many different fields of human activity. Traditional methods, devised for another era, lacked the capacity to take all this on; Turner's alternative was an art where the relationship of the image to the contemporary world made a virtue of its complexity.

Turner's omnivorous intellectual appetite developed connections between ideas, natural phenomena and historical events that resist interpretation to this day and in many cases the motive and meaning of a particular painting, to paraphrase one of his observations, will remain elusive, at least in its ultimate recess.[22] What is apparent, however, in all his works is the sense of a highly creative mind grappling with the problem of finding a more adequate way of representing what he knew, drawing on all his technical resources to develop an image rich enough to accommodate what he had discerned. The construction of a Modernist lineage for Turner, based on his last works, is therefore unwise and unhelpful. A better reason to explain why his stature is undiminished is precisely because different generations of artists and art lovers recognise in his painting a commitment to the image as an important contributor to the development of knowledge, articulating truths that were inexpressible in any other way. It is the high seriousness of his practice that makes Turner's investigations of form, colour and technique more than empty displays of virtuosity.

NOTES

1 See Smiles 2007.

2 See Guiterman 1989, p.6.

3 Letter to F.H. Fawkes, 27 December 1850, in Gage 1980, p.224.

4 Gage 1980, pp.164–5 no.207, 168 no.214.

5 Carlisle 1817, p.13.

6 See Turner's letter of 7 December 1837 to J.H. Maw; Gage 1980, p.168.

7 Frith 1888, pp.98–9.

8 The thirty-eight paintings selected from John Julius Angerstein's collection included one by Joshua Reynolds, nine by William Hogarth and one by David Wilkie, the only living British artist represented; Sir George Beaumont's gift (accepted 1826) included one painting by Reynolds, two by Richard Wilson, one by Benjamin West and one by Wilkie.

9 He sold a fifth painting by Turner, *Neapolitan Fishing-Girls Surprised Bathing by Moonlight* (cat.86), in 1842, while ordering his collection in readiness for its exposure to the public the following year.

10 See Winter 2004, pp.291–329.

11 Letter from J.J. Ruskin to W.H. Harrison, 31 March 1847; Cook and Wedderburn, III, p.xxxii. The publishers Smith, Elder & Co. took on the book, publishing the first volume (anonymously) in 1843.

12 Cook and Wedderburn, XII, p.378.

13 Thornbury 1877, pp.196–8.

14 Turner to Thomas Griffith, 1 February 1844; Gage 1980, p.195.

15 Hudson and Luckhurst 1954, pp.51–2.

16 The artists commemorated by the British Institution were Joshua Reynolds, Benjamin West, William Hogarth, Thomas Gainsborough, Richard Wilson, Johann Zoffany, Thomas Lawrence, William Hilton, Thomas Stothard, David Wilkie and Augustus Callcott. See Smith 1860, pp.139–213.

17 Shorter accounts of landscape artists, such as obituaries, articles and brief notes, can of course be found earlier, the most significant being Cunningham 1829, which includes brief biographies of Gainsborough and Wilson, but the status of a full biographical treatment is new.

18 Cunningham 1833–4, II, pp.11–12.

19 Diary, 26 January 1844, in Evans and Whitehouse 1956–9, I *(1835–1847)*, p.261.

20 Letter from 'Matilda Y', in Rippingille 1843, pp.265–8.

21 Lawrence Gowing, 'Painting Set Free: The Achievement of Turner', undated MS. Tate Gallery Archive, TG 15/8/4, n.p.

22 '[The] imagination of the artist dwells enthroned in his own recess [and] must be incomprehensible as from darkness...', Turner's draft for a lecture on perspective. BL Add. MS 46151 H, f. 41v.

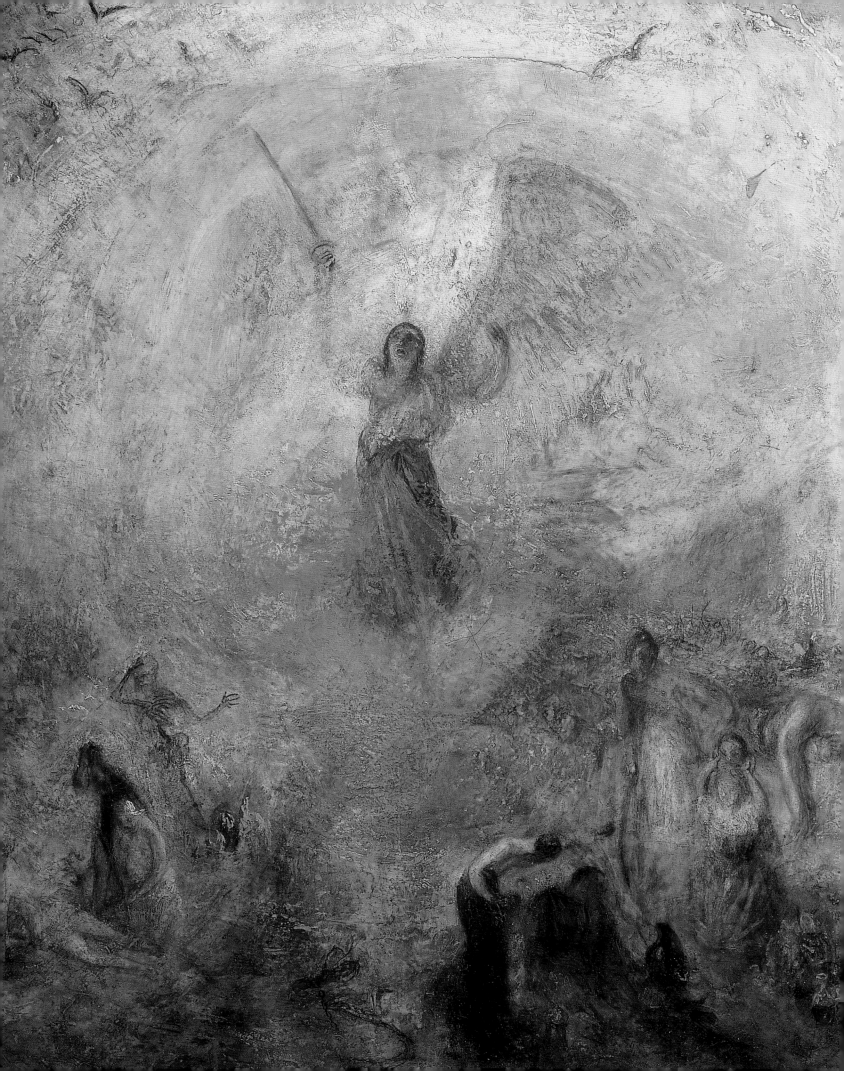

The Later Life of Turner: Body and Mind

Brian Livesley

FROM AS EARLY AS THE 1820s, when he was approaching his fifties, 'Turner's detractors often described his use of colour and handling of paint as the product of a mentally disturbed man and his behaviour in old age as bizarre'. After 1840, 'when in his sixties, he was regarded by many critics as deranged, a somewhat eccentric has-been whose better days were past him'.[1] 'Deranged' was a term that came all too easily to mind since it had been used to describe the much-discussed behaviour of George III when Turner was aged thirteen. Such was the paucity of medical knowledge that diagnosing and recommending treatment for the King's illness[2] was left to the physician Henry Halford, who, in 1813, claimed that ageing was a disease described by the ancient Greeks as 'The Climacteric Disease' and that 'Physicians will not expect me to propose a cure for this malady … [since it is] … a falling away of flesh in the decline of life, without any obvious source of exhaustion…'![3] By contrast, the surgeon Anthony Carlisle, whose anatomy lectures at the Royal Academy were attended by Turner,[4] stated that ageing and disease were *not* synonymous and that specific diagnosis in the elderly could lead to effective treatment. Although Turner gave Carlisle a watercolour to mark his retirement in 1824, and referred generally to him for advice (see cat.5), there appears to be no evidence that

Carlisle diagnosed or treated any of the illnesses proposed for Turner in the present essay. But in 1817 when Turner was aged forty-two and again when he was sixty-three, Sir Anthony had written that 'The age of Sixty [*sic*] may, in general, be fixed upon as the commencement of Senility',[5] thus giving some unintended support to the views of Turner's detractors.

While the limited medical knowledge of the period did not allow resolution of the problem, can we determine from Turner's art whether he had passed into mental aberration, or are there physical factors requiring consideration? Certainly, Turner had no diseases that are immediately recognisable even today. While it is just possible that the problems of his mother, who had been transferred to an asylum, may provide support for Ruskin's contention that by 1846 Turner's paintings were 'indicative of mental disease',[6] there is no evidence that his father had any such illnesses which would affect his son. Anecdotes suggest that he remained robust, assisting his son in the studio and gardening, cooking and housekeeping for the two of them until a ripe old age. Years earlier, Turner's rapid and precocious rise to the top of his profession had certainly aroused jealousy, but the spectre of his disturbed mother (who died in care in 1804) was never invoked to question his sanity even though her condition

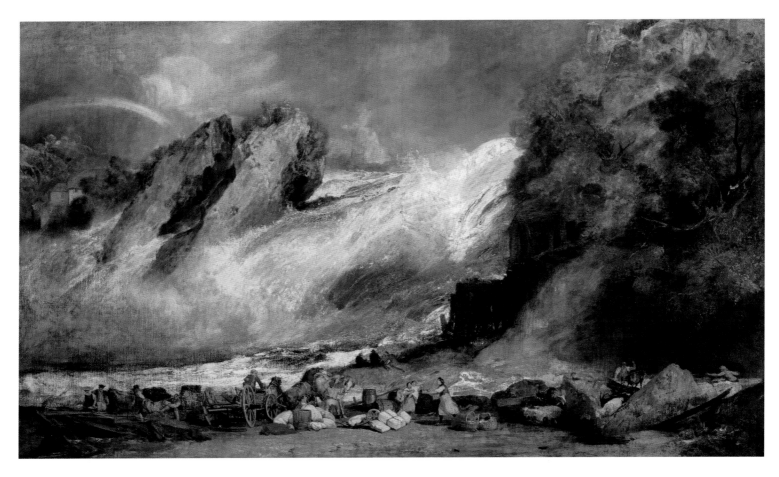

must have been known, not least because the well-connected collector and amateur artist Dr Thomas Monro was involved in her care. Attacks on Turner's work, such as his 1806 *Fall of the Rhine at Schaffhausen* (fig.11), in which he was said to have become 'intoxicated and painted extravagances' or was a 'madman', arose purely as a conservative response to his bold painting style, which already challenged conventional practice while paradoxically attracting other young artists and threatening 'an influenza in art'. Graphic as these metaphors were, and although as we shall see Turner may have been storing up health problems for the future, the record is only of minor physical ailments until, during what has been described as the 'pandemic' of 1836–48,[7] he did contract influenza

and became severely ill. So, apart from his solitary existence for more than twenty years after his father died in 1829 – together with the lack of evidence that he had developed any obviously recognisable medical condition such as a stroke, heart attack, or other acute clinical problem – are there any medical factors that might have affected Turner's later work?

Turner was known for his sun-staring[8] and, as Dinah Birch has pointed out, unlike Claude Lorrain and Aelbert Cuyp who had painted the sun*shine*, Turner alone painted the sun *colour*.[9] While sun-gazing he would have been unaware that this could eventually cause him to develop a glass-blower's cataract[10] and impair his perception for yellow, thus potentially leading to his subsequent excessive use of this colour. By

FIG.11
Fall of the Rhine at Schaffhausen
exhibited 1806
Oil paint on canvas
148.6 × 239.7
Museum of Fine Arts, Boston. Bequest of Alice Marian Curtis, and Special Picture Fund

1826, when Turner was aged fifty-one, among the first to comment upon his unrestricted use of yellow was the *Literary Gazette*, to which other critics added their condemnation. Indeed, he became described as a 'Yellow Dwarf'[11] and was caricatured by Richard Doyle as sloshing yellow onto canvas from a bucket with a mop (fig.12). In 1836, when Turner was aged sixty-one, the admittedly jaundiced critic of *Blackwood's Magazine* recognised a change in his painting style and, reviewing his picture *Snow-Storm, Avalanche and Inundation – A Scene in the Upper Part of the Val d'Aouste, Piedmont* (fig.13), asked: 'Has any accident befallen Mr. Turner's eyes? Have they been put out by the glare of his own colours?'[12] However, it must be said that pictures from the later 1830s, such as *The Fighting Temeraire tugged to her last berth to be broken up* 1838 (fig.17, p.34), show no obvious sign of visual impairment.

Turner was an intelligent, observant and well-read man.[13] He studied the pictures of other artists, visiting the Louvre in 1802 and later, repeatedly, the British Museum. He included scenes from mythology, history and the Bible

among his works, as well as observations and reflections on contemporary events and the increasingly complex world around him. In 1840 his *The Slave Ship* (*Slavers Throwing Overboard the Dead and Dying, Typhoon Coming On*) (fig.14) was the Royal Academy's main exhibit during the first World Anti-slavery Convention held in London from 12 to 23 June that year[14] and his contribution to the abolition movement. A month earlier the British Library had purchased the twelfth-century *Beatus Apocalypse*.[15] This most important and original work of medieval illumination shows an angel standing in the sun. Turner could be expected to have known about this since he exhibited his own picture of this subject with the same theme of retribution taken from the Book of Revelation, at the Royal Academy in 1846.[16] *The Angel Standing in the Sun* (cat.119) was one of three of Turner's pictures which Ruskin condemned as 'indicative of mental disease'.[17] This allegation by Turner's strongest protagonist, when Turner was aged seventy-one, would carry considerable weight with his later critics. Far from being objective and unbiased, however, Ruskin's strong criticism appears to have been affected by some mysterious private business he had with Turner and about which he subsequently stated to Thomas Carlyle, 'I never forgave him, to his death'.[18]

It seems ironic that Ruskin, who knew little of Turner's personal history[19] yet bears a heavy responsibility for implanting the idea of his mental illness, should later show signs of it himself.[20] Even while quite young he had experienced a near-breakdown as a result of his encounter with the full extent of Turner's work and interests, as revealed by the many thousands of private drawings and sketches in the Turner Bequest. His changing reactions to *Slavers* provide a more concentrated example of his unstable judgement. In 1844 he was so enamoured with the picture that, after his father bought it for him and despite its large

FIG.12
RICHARD DOYLE
Turner painting one of his pictures
published in *Almanack of the Month,* June 1846

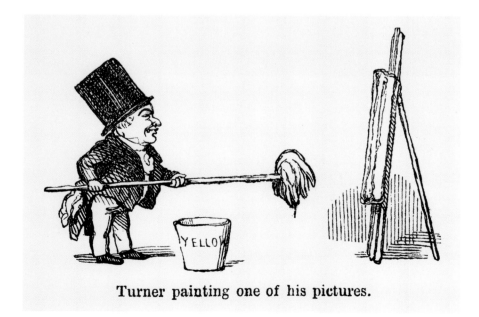

Turner painting one of his pictures.

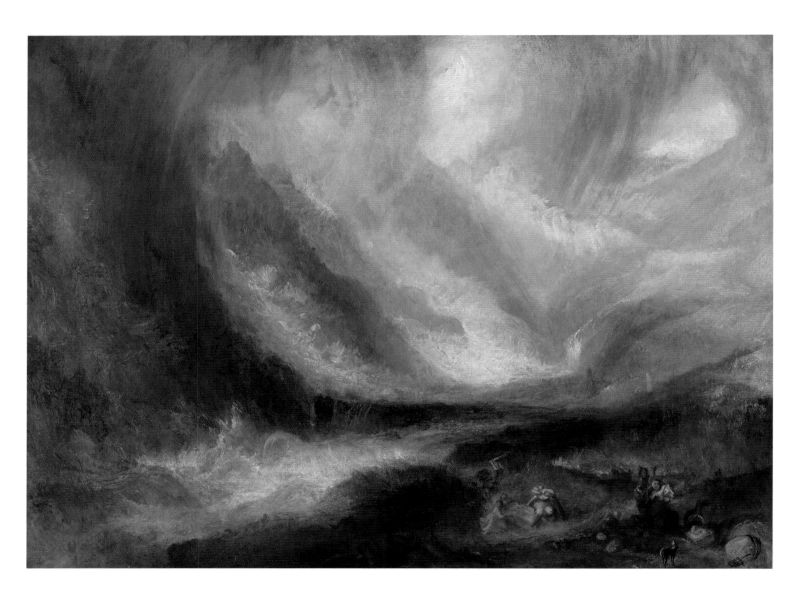

size, he 'placed it at the foot of his bed so that it would be the first thing he would see when he woke up in the morning'.[21] He believed that in viewing paintings the observer should use 'the *innocence of the eye* [*sic*] … as a blind man would see them if suddenly gifted with sight'[22] and, in describing the picture, was effusive about 'the noblest sea that Turner has ever painted and, if so, the noblest certainly ever painted by man', while confining its narrative of slaves being thrown overboard and left to drown (based on a real incident in 1781) to a footnote.[23] On 28

January 1872, however, wanting to be rid of this erstwhile favourite, Ruskin set to work to 'pack the "Slaver" forthwith' for America.[24] In 1900, eight days before the anniversary of sending the picture away, he died. One week later a report, entitled *Mr. Ruskin's Illness described by Himself*, appeared in the *British Medical Journal*.[25] Ruskin had described to a visiting acquaintance his bouts of illness in which, '*while all ugly things assume fearfully and horribly hideous forms*, all beautiful objects appear ten times more lovely [*sic*]'. Had he finally recognised the significance

FIG.13
Snow-Storm, Avalanche and Inundation – a Scene in the Upper Part of the Val d'Aouste, Piedmont
1836
Oil paint on canvas
92.2 × 123
The Art Institute of Chicago. Frederick T. Haskell Collection

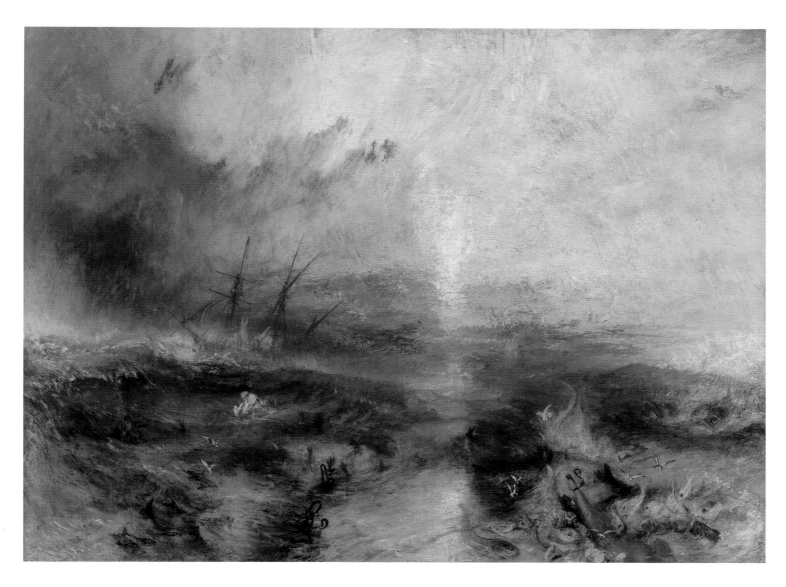

FIG.14

The Slave Ship (Slavers Throwing Overboard the Dead and Dying, Typhoon Coming On)
exhibited 1840
Oil paint on canvas
90.8 × 122.6
Museum of Fine Arts, Boston. Henry Lillie Pierce Fund

of the figure that Turner seems to have placed in the centre of the *Slavers*? Advising a young contemporary, Turner recommended: 'Keep your corners quiet. *Centre your interest*. And always remember that as you can never reach the *brilliancy* of Nature, you need never be afraid to put your brightest light next to your deepest shadow in the centre.'[26] Viewed according to Turner's directions, the *Slavers* follows this model and discloses a centred white form like an angel bursting forth with the right arm raised, as Turner was later to show in his much-criticised *Angel Standing in the Sun*. It appears to descend in judgement from a burst of curving brushstrokes from the top centre, condemning the massacre of the slaves below. Whatever its effect on Ruskin, on Turner's part this would be an entirely rational, if intensely visionary, response to such a monstrous crime.

A reliably empirical clue to explain Turner's own later health is present in the 'rough but extremely characteristic sketch' of Turner by John Gilbert RA (fig.15).[27] Drawn on a Varnishing Day at the Royal Academy in 1841 when Turner

was sixty-six, it shows his well-portrayed corpulence, and it is this condition that has recently paved the way for an evidence-based analysis by the present writer of a cascade of likely later physical problems.[28] These include bilateral posterior cortical cataracts as a result of his direct sun-staring, as stated above, also aggravated later by diabetes, as posited below. In workers staring at industrial fires without eye protection, such cataracts can begin before the age of forty, whereas the centrally placed 'senile cataract' occurs much later. Turner's painting practice and materials may also be taken into account, especially his use of lead-based media. He was said to make up his paints in a 'reckless manner' and it would not be surprising if he developed an essential tremor due to lead toxicity.[29] While a Parkinsonian tremor is reduced by movement, an essential tremor causes noticeable and troublesome shaking of hands during movement. If this seems evident from Turner's written memoranda and shorthand note-taking (though presumably sometimes aggravated by haste or jotting while on the move, as for example in a coach or train), such a tremor would cause great painting difficulties. In 1841, the *Athenaeum* pompously declared that it would not mention the 'other wonderful fruits of a diseased eye and a reckless hand, which he has here exhibited'.[30]

Fortunately (or otherwise in the long term), essential tremor can be relieved for social and other occasions by self-medicating with a glass or two of alcohol. Turner's propensity for sherry became well known. It was reported that 'When people came to see him, he would sometimes come down quite dizzy "with work." But I fear that latterly he drank sherry constantly while he painted.'[31] His drinking would have contributed to his weight-gain, and his subsequent development of diabetes mellitus would become the undoubted cause of his pronounced fatigue.[32] This is one of the commonest symptoms of diabetes and

can completely interfere with daily activities. His ability to paint close to his canvas without his glasses can be explained by index-myopia (diabetic short-sightedness) as a result of the rise in blood-glucose levels causing swelling of the lens in each eye. What is quite certain, and proved by the death mask taken soon after he died (cat.16), is that as his health gradually deteriorated he had lost all his teeth. Unlike many edentulous elderly people today, he could not chew, and because his gums were so tender he could not be fitted with false teeth.[33] He was

FIG.15
W.J. LINTON after John Gilbert
Joseph Mallord William Turner c.1837
Engraving on paper
Private collection

left sucking meat while 'drinking prodigious quantities of rum and milk'.[34] Such pronounced thirst is typical of uncontrolled diabetes mellitus. Turner's teeth loss and severe gum tenderness would have been the result of ulcerative gingivitis caused by vitamin C deficiency,[35] due to the effects of alcoholism and diabetic polyuria. His progressive diabetes and probably also his chronic lead toxicity can explain the weakness in his leg muscles[36] that finally rendered him bed-bound.

Despite his several disabling conditions, and knowing he would not survive, Turner had a completely rational conversation with his doctor,[37] confirming no evidence of 'mental disease'. On 19 December 1851, Dr William Bartlett, the locum doctor who was attending Turner, wrote: 'just before 9 a.m. the sun burst forth and shone directly on him with that brilliancy which he loved to gaze on ... He died [at 10 am] without a groan.'[38]

NOTES

1 Lewison 2012, p.61.

2 Trench 1964.

3 Livesley 1977.

4 Inscription by Turner: 'Notes from an Anatomy Lecture by Sir Anthony Carlisle', c.1809–11 (Tate, D07968; TB CXIV 6).

5 Carlisle 1817, p.13; Carlisle 1838–9, p.1.

6 Cook and Wedderburn, XIII, p.167.

7 Patterson 1985.

8 Thornbury 1862, II, p.276.

9 Birch 1990, p.88.

10 Brock 2007. Such a cataract can also occur in bottle-finishers, chain-makers, iron-smelters and stokers.

11 Bailey 1997, pp.249–51; Grigsby 2002, p.142.

12 *Blackwood's Magazine*, October 1836, pp.50–1.

13 Gage 1969, p.106.

14 On 17 April 1839 the British and Foreign Anti-Slavery Society was formed. It became known as the Anti-Slavery Society, as had its predecessor, and was established to campaign against slavery worldwide (it having been abolished throughout the British Empire by Act of Parliament in 1833).

15 British Library, London, BL 239349.

16 Revelation 19:17–18.

17 Cook and Wedderburn, XIII, p.167.

18 Cate 1982, p.136.

19 Thornbury 1862, I, p.VII.

20 For a recent analysis of Ruskin's mental deterioration, see Kempster and Alty 2008.

21 Leon 1949, p.84.

22 Cook and Wedderburn, XV, p.27.

23 Ruskin 1898, I, pp.404–5.

24 Bradley and Gushy 1987, p.256.

25 'H.', 'The late Mr Ruskin. Mr Ruskin's illness described by himself', *British Medical Journal*, 1900, I, pp.225–6. Ruskin died on 20 January 1900.

26 Lloyd 1880, p.43.

27 Chignell 1902, pp.211–12.

28 Livesley 2013.

29 Louis 2003, pp.1707–11.

30 Finberg 1961, p.383.

31 Thornbury 1862, II, p.151.

32 Gage 1980, p.223.

33 Bishop, Gelbier and King 2004, p.762.

34 Finberg 1961, pp.437–8.

35 Nishda 2000.

36 Garland 1955; B. Livesley and C.E. Sissons, 'Chronic Lead Intoxication mimicking Motor Neurone Disease', *British Medical Journal*, vol.4, 1968, pp.387–8.

37 Livesley 2013.

38 Finberg 1961, p.438.

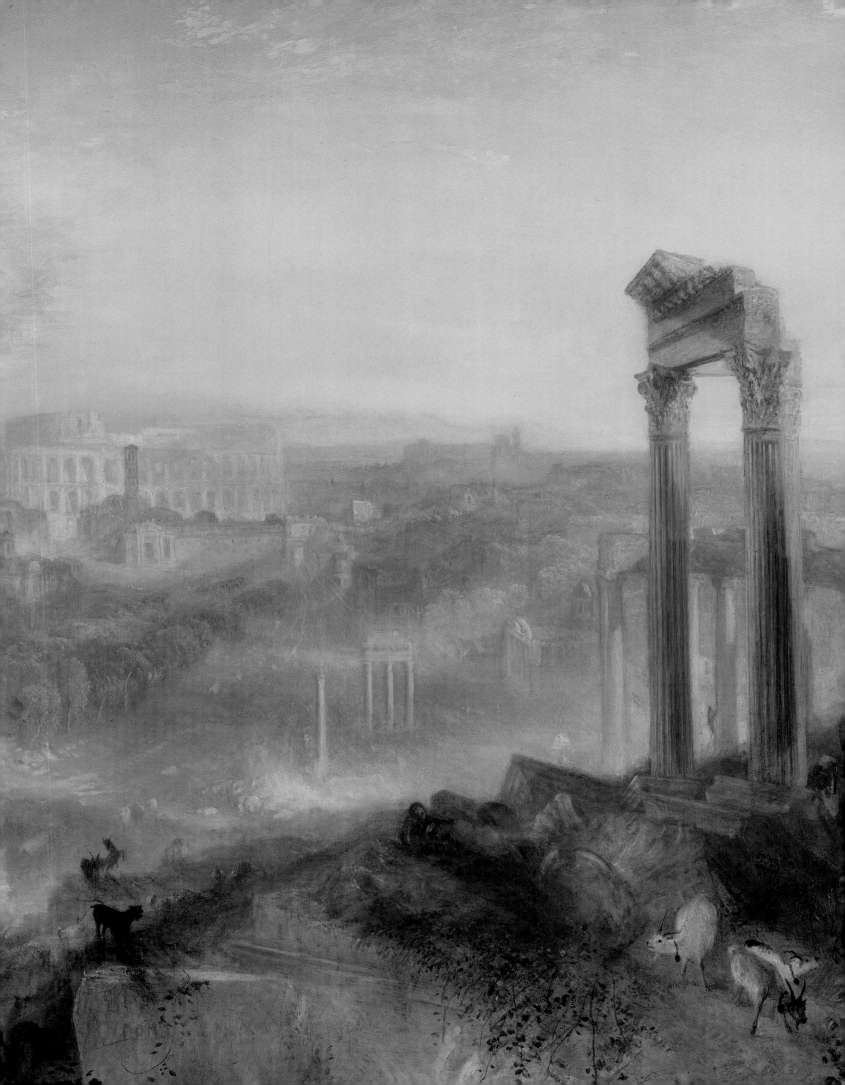

'Born again':
Old and New in Turner's Later Work

David Blayney Brown

IN 1844 WILLIAM BECKFORD died at his house in Bath. Fifteen years older than Turner, he had been the last of the artist's important early patrons to survive into his last decade – long enough to become thoroughly disillusioned with his erstwhile protégé. The journalist Cyrus Redding remembered Beckford complaining that Turner 'paints now as if his brains and imagination were mixed upon his palette with soapsuds and lather; one must be *born again* to understand his pictures'.[1]

Despite his way with words, Beckford made no claim to such a rebirth. Like many longstanding observers, he felt abandoned by an artist who himself seemed born again, his very paint energised by the accelerating tempo of change – political, industrial, social, scientific – that made 1830s Britain a window into the future. Unquestionably, Turner was exceptional for his adventurous colour, unbridled self-expression and embrace of newfangled subjects like railways and steamships. Just as striking, however, is how little he had forgotten his sense of tradition or his own life history, and his reluctance – or perhaps latterly, his inability – to look much further afield than he had previously done. In 1835 he set out on one of his most ambitious European tours. But the adventure was rather put into perspective that summer by his old rival John Glover, who sent back to London a whole exhibition of pictures from Van Diemen's Land (Tasmania) where he had settled in 1830 at the age of sixty-three. Glover had unlearned the academic style that had earned his nickname 'the English Claude' and found a new style to paint the landscapes and people of his adopted home.

Turner's art was reborn from more familiar materials, and sometimes from itself. Rather than exploring new places, he revisited or remembered old favourites – Norham Castle, Venice, the Swiss lakes – refreshed themes, traditions, even pictures from former years, and took on time and change as subjects in themselves. In views of ancient and modern Rome (cats.83, 84) he spanned millennia, while in *The Fighting Temeraire* (fig.17) he portrayed the recent transition from sail to steam. Elsewhere, from *Regulus* (cat.78) to *The Wreck Buoy* (cat.110), he revised earlier subjects, superimposing layers of paint that invite excavation, like an archaeological site, but convey as much the impression of continuity as the shock of a sudden break. Old and new always fascinated Turner, fitting the Romantic habit of thinking across time, but seemed to attract him more as he aged. It came as naturally to paint the River Tyne as a modern version of an ancient seaport by Claude (fig.18) as it did to revive an old subject in a new style; or to compare antiquity in its original state and returning as it

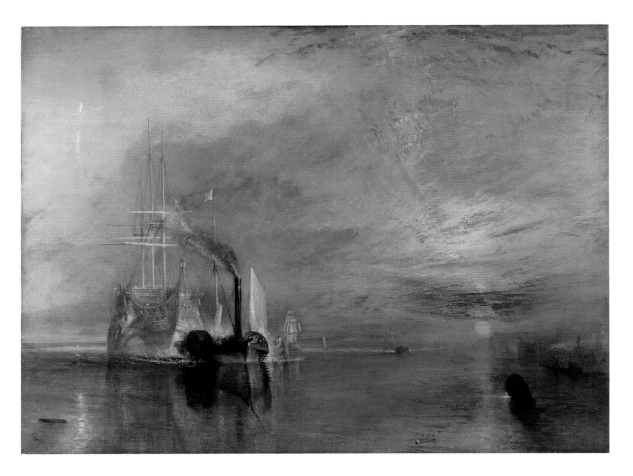

were to nature. What distressed Beckford was as strikingly deployed, and presumably more shockingly so, in historical subjects.

John Ruskin's elevation of Turner as the foremost 'Modern Painter' was always problematic in its selective emphasis on truth to nature. Ruskin refused to engage with works like *Rain, Steam, and Speed* (cat.97), which celebrated the man-made modernity that he personally deplored, and was put out by other pictures whose subjects seemed very old-fashioned by the mid-1830s – or 'nonsense' later on. Certainly Turner's renewed enthusiasm for classical history, literature and myth was brave at a time when their relevance and familiarity were evaporating or being superseded by other narratives, but a series of pictures illustrating Ovid's *Metamorphoses* seem most revealing for representing transformation. If Turner's classicism looked *retardataire*, at the same time the surface appearance of his pictures was unlike anything seen before. It made for a troubling paradox. Yet it would surely be a mistake to disconnect conception from process. The art historian Jeremy Lewison has questioned whether Turner's diffuse treatment of ancient myth was a 'last hurrah, or … recognition of

the difficulty of employing it'.[2] Perhaps instead Turner shows the old melting into light and air to make way for something new; change rather than decay, and not dissolution but the rebirth of these ancient stories, materialising from the natural world they had been imagined to explain.

For Turner, antiquity did not lie lost in time, associated only with downfall and decline. As a student of architecture he recognised its continuing inspiration, and while in Berlin in 1835 he took special interest in recent classical buildings designed by Karl Friedrich Schinkel (figs.19, 20). Dignified, practical and set in beautiful public spaces, these had been planned to rebuild the once makeshift, barrack-like Prussian capital on the model of Periclean Athens. Like Leo von Klenze's additions to Bavaria, they proclaimed the revival of the German states after the Napoleonic Wars. Turner may have seen Schinkel's symbolic pictures of Greek cities approaching their zenith, and architectural reconstructions like that of Sestos in *The Parting of Hero and Leander* (cat.79) evoke the sense of 'common cause' with the ancient world that admirers observed in Schinkel's work.[3] However, Turner did not replicate meticulous German finishing but spun

modern buildings, like ancient myths, from thin air. *The Opening of the Wallhalla, 1842* (cat.96), depicting von Klenze's Doric temple to German culture by the Danube at Regensburg, proved too insubstantial for visitors to the Munich exhibition to which Turner sent it in 1845.

London had been given its own classical make-over by Turner's architect friends John Nash and John Soane, the latter drawing up early ideas for the triumphal arch between Green Park and Buckingham Palace later completed by Decimus Burton. The casting of Matthew Cotes Wyatt's vast equestrian statue of the Duke of Wellington to surmount the arch inspired Turner to update a picture of an iron foundry he had painted many years before. Rechristened *The Hero of a Hundred Fights* (cat.111), the repaint was exhibited in 1847 with a reference to Friedrich Schiller's *Lied von der Glocke* (*Song of the Bell*) in which the life cycle of a bell symbolises that of man and nation; the German poem was a reminder that Prussian troops had shared in Wellington's victory over Napoleon at Waterloo, which the arch and statue were designed to celebrate. Hardly was the statue up before it became a laughing stock and a campaign was mounted to remove it, from

which Turner tactfully stood aside, preferring to preserve it in paint. In 1837 Sir Robert Peel had compared the mistaken choice of a 'bad architect and worse sculptor' to earlier appointments 'of Soane for this folly and Nash for that'.[4] Times were changing and it would not be surprising if Soane's death that year and Nash's in 1835 begged questions about the future of their work, and indeed of classicism, a style synonymous with ruin as much as reconstruction.

As an imperial capital, the 'new Rome', London contained for the Romantic imagination the seeds of its fall, when it would be torn asunder as in John Martin's pictures of historical cataclysms – or fade like Rome or Carthage in Turner's own. In Turner's Italy, change is inexorable but usually benign. The metropolis so lovingly reconstructed in *Ancient Rome; Agrippina Landing with the Ashes of Germanicus* (cat.83) regenerates in *Modern Rome – Campo Vaccino* (cat.84), while in *Modern Italy – the Pifferari* (cat.82) Abruzzi bagpipers wander among the ruins of Tivoli, the music they play to the Virgin like that once offered to the gods. Meanwhile, the natural beauty of the 'garden of the world' lasts for ever, as Byron described in his poem *Childe Harold's Pilgrimage*:

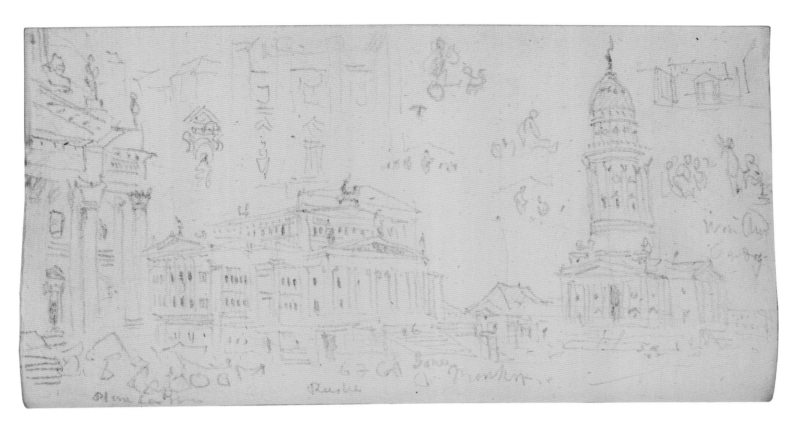

Thy wreck a glory, and thy ruin graced
With an immaculate charm which cannot
be defaced.

As Turner quoted it, this might be a metaphor for history or, more personally, for art as the artist begins to age.

The onset of a Gothic revival in the 1830s, claiming moral superiority over a profane or agnostic classical culture, must have made Turner's Roman subjects more archaic than ever. Despite early interest in medieval architecture and its continuing presence in his topographical work, it made little impact in later paintings unless burned down like the old Palace of Westminster (cat.89) or, as in *Venice, the Bridge of Sighs* (cat.50), where the Gothic Doge's Palace flanks the classical prison. Unlike Ruskin, Turner does not seem to have experienced Venice as a Gothic counterpart to classical Rome, but travelled as a modern tourist running a gamut of hedonistic pleasures – music, fireworks, bars, brothels – beyond antiquarian sightseeing. Venice was one of those places, with the Swiss lakes and the seaside Cockney paradise of Margate, where Turner became young again. While his Venetian pictures were sometimes given epigraphs from *Childe Harold* and flirted with Byron's fatalism as he surveyed the capital of a once-great trading power fallen on hard times – a warning from history to Britain in its pomp – they could not miss the excitement that underscored it, making melancholy seem affected. *Approach to Venice* (cat.66) was exhibited with two quotations: Byron's ambivalent description of dusk when 'The moon is up, and yet it is not night', suggesting the city's fading splendour and its modern pleasures, and unequivocally joyous lines by Samuel Rogers recalling the older poet's passage to Venice 'as in a dream'.

The Sun of Venice Going to Sea (cat.65) reverses Rogers's journey, leaving Venice to fade into memory. Since Turner was a keen angler, the fishing boat with its painted sail has been seen as a self-portrait and the artist wrote its epigraph, from his supposed epic poem 'Fallacies of Hope', describing the boat setting out on a fine morning, heedless of the doom awaiting it at evening. This might be about imperial hubris, hostile critics or the artist's transition from youth to age. If any British picture matches Caspar David Friedrich's allegories of the voyage of life it might be this, but from Ruskin onwards, Turner's pessimism has surely been overdone. To this writer, 'Fallacies of Hope' sounds less a personal credo than the obverse of Thomas Campbell's *Pleasures of Hope* or Rogers's *Pleasures of Memory*, creating a literary space

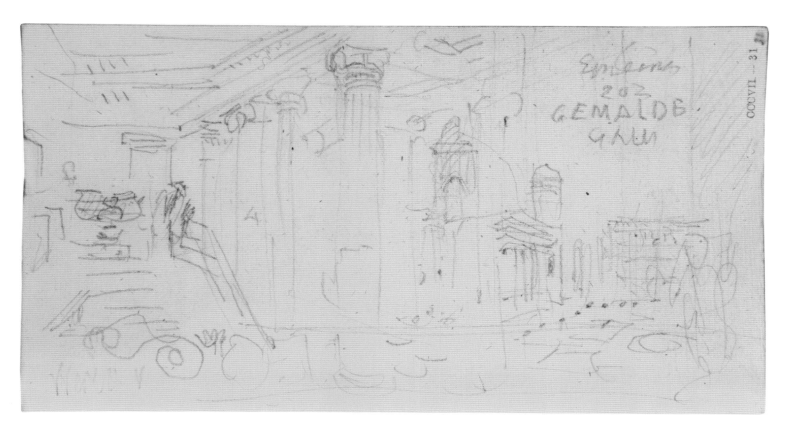

FIG.20

*Berlin: The Upper Vestibule
of the Museum with the
copy of Warwick Vase at
the top of the stairway and
the Domkirche and Schloss
seen on the right through
the Museum Colonade and
across Lustgarten* 1835
Graphite on paper
8.9 × 16.2
Tate D31080; TB CCCVII 31

of Turner's own. As Romantic traits, gloom and foreboding tended to be switched on and off – not least by Rogers, who wondered 'how a man can ever be cheerful, when he knows that he *must die*',[5] but was a sparkling wit and lived to ninety-two despite looking so cadaverous that he was known as 'Mr von Dug Up'.

While death and disaster occur in a number of Turner's late pictures, others are full of energy and life, rapture and transcendence. 'Shade and Darkness' on the eve of the biblical Deluge give way to 'Light and Colour' the next morning, showing the emotional as well as optical extremes associated with the spectrum by the German writer Goethe, whose *Farbenlehre* (*Theory of Colour*) had been translated by Turner's younger artist friend Charles Eastlake (cats.117–18). In Turner's spinning compositions these are interdependent and cyclical, each engendering the other in an unending round.

It seems as facile to ask whether the older Turner was a pessimist or optimist as to position him as old-fashioned or ultra-modern, behind or ahead of his time. To suggest, as many have done, that Turner's later work betrays loss of faith in redemption is to believe that he had it to begin with. A secular view would see him looking for salvation through the constant renewal of his art and a determination that it

should be preserved and remembered. Hence his regularly updated plans for a Turner Gallery, or for prints after pictures that sometimes revised their subjects or titles (cat.2; and see cats.78, 88). While he neglected canvases destined for his Bequest, he resurrected others 'left lumbering about', repainting them or finishing them with new subjects on the Royal Academy Varnishing Days in displays of animating wizardry that dazzled fellow-exhibitors. In painted versions of prints from his former *Liber Studiorum* (cats.143–8) he breathed fresh air and colour into landscapes once seen, literally and metaphorically, in monochrome. While these were private works, left as treats for the future, in a series of exhibited pictures he summed up his achievement as a history painter from biblical to modern times on a new square format (cats.112–20), working sometimes within a sphere, ancient symbol of transformation. His last exhibits, in 1850 (cats.171–3), retold Virgil's story of Dido and Aeneas, one of love and loss but also a foundation myth, in Claudean compositions in his own most iridescent style. If art was born again in these shimmering canvases, for *The Times* the painter appeared to have lived life backwards, having 'possessed in youth all the dignity of age only to exchange it for the effervescence of youth'.[6]

NOTES

1 *New Monthly Magazine*, vol.72, 1844, p.24.

2 Lewison 2012, p.18.

3 Bettina von Arnim, quoted in Blayney Brown 2001.

4 Quoted in Piggott 2012, p.17.

5 Ricks 2011, p.6.

6 *The Times*, 4 May 1850.

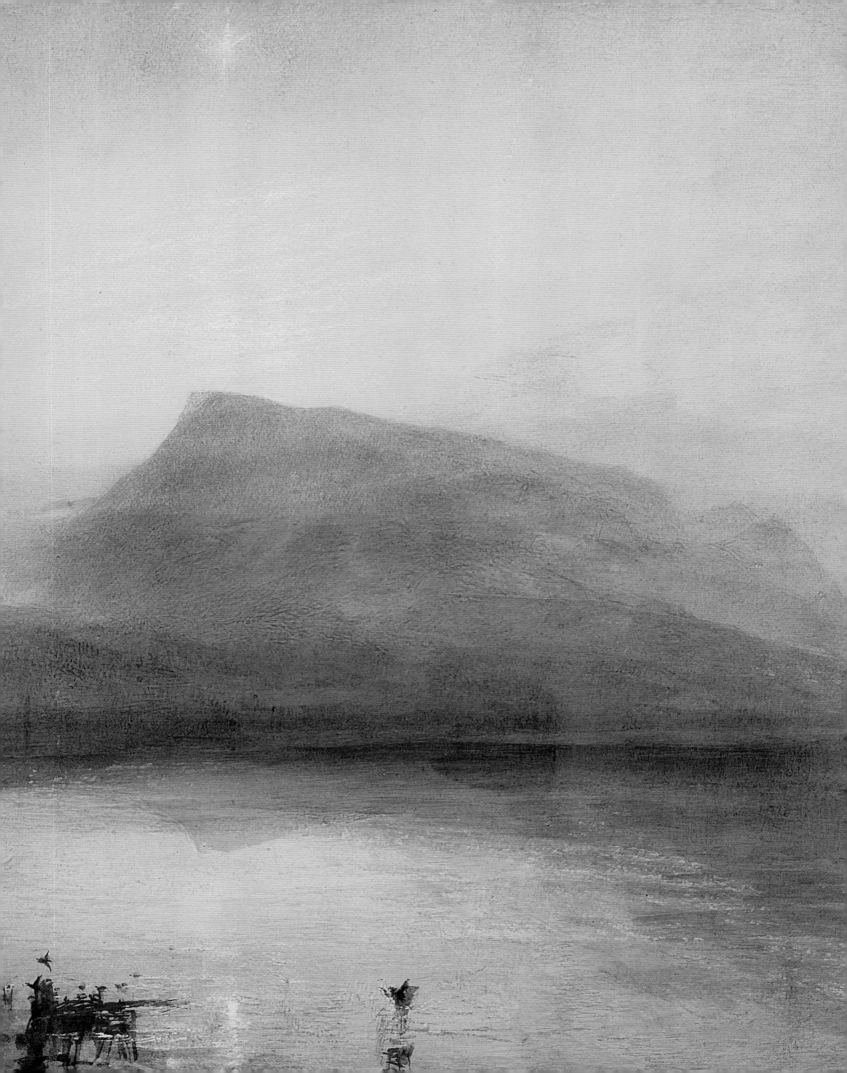

'Ain't they worth more?' Turner's Later Watercolours

Amy Concannon

WITHIN YEARS OF Turner's first exhibit in watercolour he was recognised as a rising star; by the 1820s he was a 'magician', whose watercolours displayed 'a certain magic arrangement, a graphic secret of his own'.[1] Turner embraced and cloaked himself in this enigma, furthering popular perception of him as a lofty, unreachable genius by never disclosing his techniques and, after 1830, ceasing to submit watercolours for exhibition. Shielding his later watercolours from wide public consumption wove an aura around them that would, after Turner's death, be complicated by the subjective and inconsistent commentaries of John Ruskin.[2] Barriers to the understanding and appreciation of Turner's later watercolours were so substantial that, nearly thirty years after his death, *The Spectator* claimed that they were 'still by the great majority of the public *distrusted*, if not absolutely *disliked*'.[3]

These themes – of spectacle and mystique – are woven into the very surface of *The Blue Rigi* (cat.155), a veil of mastery in which Turner deployed, as Martin Hardie termed it, 'every weapon in his armoury'.[4] Turner's use of these 'weapons' in *The Blue Rigi* will form the first focus of this essay, before the context of its creation is considered. Today this painting is taken as a definitive statement of Turner's watercolour supremacy, and even, when grouped together with other later watercolours, as the most important work of his late career.[5] However, it should be remembered that for Turner, *The Blue Rigi* did not represent the ultimate destination, but rather a landmark on a continuing journey in watercolour that, in his later years, took him in multiple directions.

It all began with a piece of paper. The role played by paper in works we routinely call 'watercolours' was not merely a supporting one: lightweight, portable, versatile and inexpensive relative to canvas, its centrality to the swift materialisation of creative impulses is borne out by the tens of thousands of sheets in the Turner Bequest now housed at Tate Britain. Whether for sketching or making finished watercolours, Turner was astute in his choice of paper, and in later life capitalised on advances in paper manufacturing. Able to 'make almost any paper work for him', he embraced an increased diversity of sheets in his maturity.[6] Yet in order to guarantee the success of *The Blue Rigi* he chose a paper that he knew *would* work. This is a 'Whatman' wove writing paper, of the kind he had been using for five decades and which, as its 1827 watermark suggests, had lain in his stock for fifteen years (see fig.28, p.46).[7] Turner's economical treatment of this paper for *The Blue Rigi* signposts his intimate knowledge of its material properties, as analysis by paper

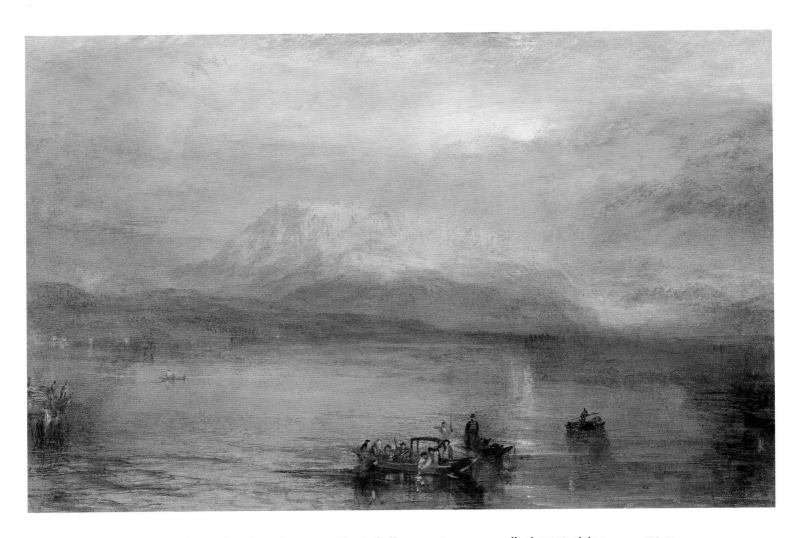

historian Peter Bower has shown. Purchased amongst a batch of pre-folded 'Royal'-sized sheets (around 47.5 × 60 cm), the artist split it in half and exploited the subtle difference in texture of its two sides to different technical ends. A slightly undulating surface will facilitate seamless blending of washes: the colouristic haze of *The Blue Rigi* is therefore painted on the 'wire' side of one half of the sheet; the smoother 'felt' side of the other half bears *The Red Rigi* (fig.22), its more even surface supporting the tighter definition of foreground detail.[8] The size of these sheets correlates to many other finished watercolours from the 1830s onwards, revealing Turner's ease not just with the type of paper, but also with its format. By comparison with a work from Turner's youth, for example *Lake Geneva* (1802–5, Yale Center for British Art, New Haven), measuring 73.3 × 113.3 cm, *The Blue Rigi* – comparatively diminutive – reflects the confidence of Turner's maturity, as an artist no longer needing to outsize competitors.

At the height of his mastery of the medium Turner advised an aspiring watercolourist to 'First of all, respect your paper!', characterising the practice as a battle between artist and material.[9] Inherently delicate, paper demanded careful planning and masterly, controlled execution. In *The Blue Rigi* Turner effected a powerful symbiosis between his materials, with their associations of fragility and temporality, and his subject, dawn's ephemeral light. His initial wash of yellow sunlight, radiating out from behind the mountain, forms the thinnest of films over the luminous white paper; the same technique is used for moonlight in *Fishermen on the Lagoon, Moonlight* (cat.54). From this very first layer of brushwork Turner simultaneously built up and removed pigment. Using a dry brush, sponge, blotting paper or rag he dabbed away to reveal more of the white surface for mist, while white highlights on the lake and Venus in the sky were scraped out – perhaps with his 'eagle-claw' fingernail – in order to fully reclaim raw, reflective paper white, which in other works he might protect with stopping-out fluid.[10] Gelatine sizing offered enhanced durability of paper under such pressure from Turner's hand, allowing him

FIG.22
The Red Rigi 1842
Watercolour, wash and gouache on paper with some scratching out
30.5 × 45.8
National Gallery of Victoria, Melbourne.
Felton Bequest, 1947

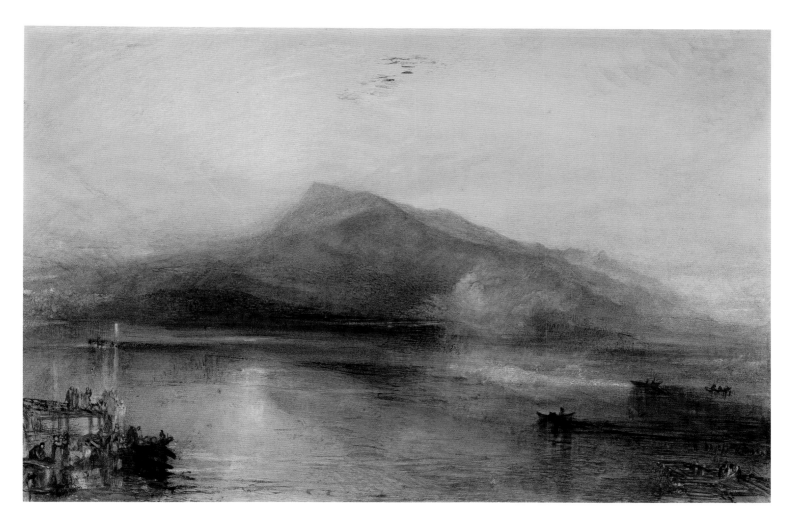

to fully exploit the transparency of watercolour and the white of the paper, without recourse to an opaque white gouache. Turner conceptualised this active role of paper late in life when he wrote of it as 'the acting-ground in Water Colours', as compared to 'White in Oil Colours', against the text of Goethe's *Farbenlehre* (*Theory of Colours*, 1810, translated into English in 1840).[11]

But for Turner the 'acting-ground' of paper did not have to be white. More frequently from the late 1820s, he elected to use buff or blue paper, such as in the Venetian studies of the 1840s (cats.56–60) and the work he produced on a tour of the Meuse and Mosel rivers in the late 1830s (cats.29, 30, for example); he might also tone his paper himself with a wash of grey, as he did on sheets in the *Whalers* sketchbook (cats.102–5). He used coloured grounds as a vehicle for vibrant explorations in opaque bodycolour or gouache, which could be worked from dark to light, symptomatic of the increasing elision between his technique in oil and watercolour.[12] Amongst the most dramatic examples of this is *Venice: Santa Maria della Salute, Night Scene*

with Rockets (cat.57), in which Turner clearly revelled in the layering of the brilliant firework and its glow over a dark, velvety black sky.

In the decade before *The Blue Rigi* was painted, Turner's long-term investigation into colour intensified. This drove his intellectual engagement with the colour theories of Goethe and George Field and his alchemistic zeal for new pigments.[13] From the 1830s he developed a strong relationship with William Winsor, a chemist who, with artist Henry Newton, had set up a business supplying artists' materials in premises not far from Turner's studio and gallery in Queen Anne Street. However, one anecdote recalls that when Winsor commented on Turner's regular purchase of fugitive colours in an age of laboratory-developed, light-fast pigments, the artist replied, 'your business Winsor is to make colours, mine is to use them'.[14]

Turner's use of watercolour had taken a new direction in the 1820s through 'colour beginnings' (see fig.24), an initial stage in his process of composition in which diffusions of colour on saturated paper supplanted linear

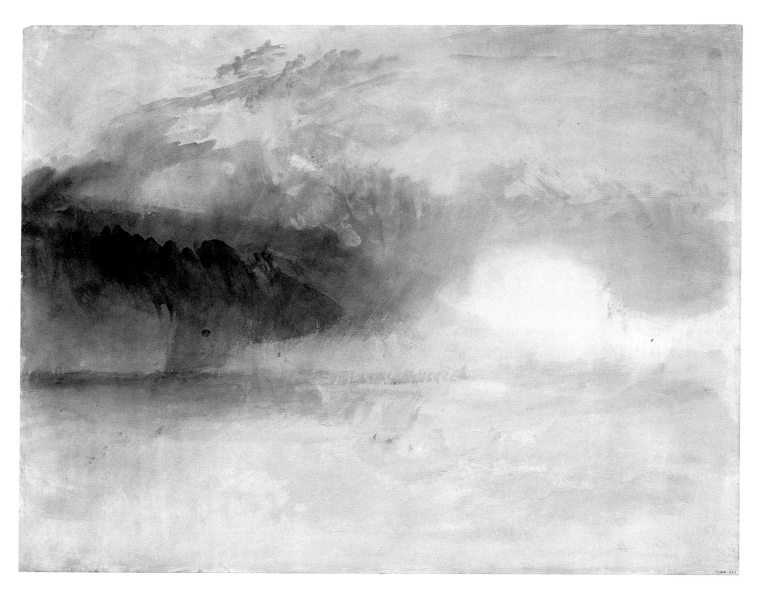

definition of form. These 'beginnings' were studio productions but as Turner matured, watercolour – indeed colour – took on a greater prominence as a tool in outdoor sketching. As a younger man he had remarked on his preference for pencil for sketching quickly; the speed of youth furnished the elder artist with an impressive memory for form and detail so that colour could now come to the fore. This shift in priorities is clear in the *Ideas of Folkestone* sketchbook (cat.128) and in *Eu by Moonlight*'s formation from pools of vivid colour (cat.69).

Although assigned over two decades after Turner's death, the colouristic names of *The Blue Rigi*, *The Red Rigi* and *The Dark Rigi* (fig.23) emphasise the most immediate aspect of their visual force: the colour of light at different times of the day.[15] The powerful hues of Turner's watercolours had long attracted derision as 'glaring tints', but his empirical and technical approach to colour did not go unnoticed, one critic declaring that 'His outlines, his shadows, are colour – as it is in nature'.[16] Though 'a too unbroken blue' might have alarmed an onlooker of *The Blue Rigi* in 1851, scrutiny of its surface reveals balance of force and delicacy from layers of colour laid down using a rich gamut of techniques.[17] In common with the entire series of late Swiss watercolours (see cats.160, 162, for example), thin, transparent layers of colour – the traditional mainstay of watercolour practice – merge almost seamlessly with scumblings of dense, thickened pigment reminiscent of Turner's technique with oil colours. Pools of colour are enlivened by rhythmic patterns, which aid in the three-dimensional modelling of the landscape. These might be created by scratching out thick pigment to uncover light ground beneath, as in *Küssnacht, Lake of Lucerne: Sample Study* (cat.161), or else by

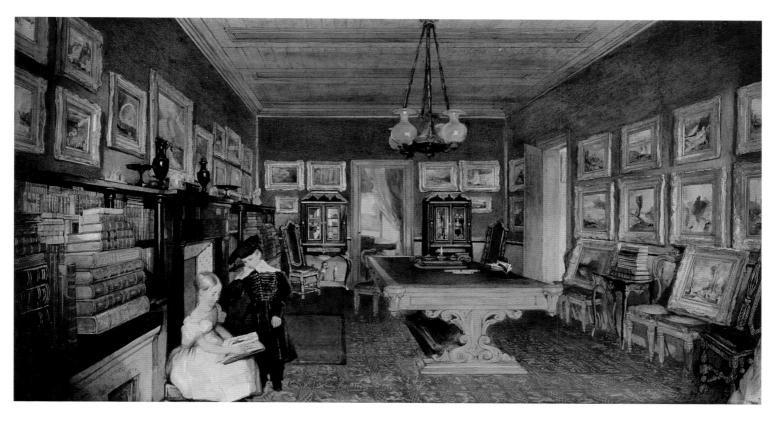

hatching – the laying-on of colour in fine strokes. Turner had long used this technique, borrowed from the miniature portraitist's repertoire, as a way to build up tonal density on a small scale in vignette illustrations intended for engraving; its application in the upper corners of *The Blue Rigi* even evokes the ovoid shape of a vignette. While hatching might be the engraver's route to tonal variation or a way for Turner to evoke the texture of oil paint, used as it is in *The Blue Rigi*, to colour a seemingly cloudless sky, it appears a self-consciously graphic technique. Its pattern draws attention to the physical make-up of the work, to the hand responsible – Turner's, and to his power to condense vast landscapes and capture natural phenomena through marks made in watercolour on a sheet of paper. *The Blue Rigi*'s status as a work of art in itself, and not a springboard to engraving, rests on its inimitable subtleties of interplay between paper and

watercolour, and between colour and texture.

Yet it was through the language of line – in engravings – that Turner's watercolours, and indeed his name, became known to a wide public. Watercolours were regularly displayed by publishers seeking to promote corresponding engravings and, by the 1830s, critics would regularly overlook original works in favour of monochrome reproductions.[18] Resembling in technique and subject the watercolours Turner made for his long-term topographical print project *Picturesque Views in England and Wales*, *Bamborough Castle* (cat.123) stimulated great interest when circulated at a meeting of the Graphic Society – comprising artists, engravers, patrons and scientists – in 1837. This large watercolour, seemingly never engraved, was perhaps intended to promote *Picturesque Views*, but only a year later the project failed. Saturation point in the market for prints after Turner's work

had been reached and the failure of *Picturesque Views* was no doubt a factor in his reticence to produce *Heidelberg with a Rainbow* for publisher Thomas Prior in 1840. However, he had received 100 guineas for this work, the highest recorded sum he had thus far been paid for a watercolour. Did this perhaps inspire Turner to change tack and to conceive a trajectory for finished watercolours that bypassed the print market and exhibition galleries altogether?

Although it has been suggested that Turner envisaged the *The Blue Rigi* and other watercolours derived from the 1841 Swiss tour as a way to rejuvenate his income from prints, their making and marketing carved out for

them a new direction and status.[19] By making 'sample studies' and marketing these via an agent, Thomas Griffith, at high prices and as exclusive compositions apparently directly to a body of existing patrons, Turner was returning to an earlier precedent by which oil paintings had been produced for Lord Egremont at Petworth House, West Sussex, via sketches painted to scale.[20] According to Ruskin, Turner's circle perceived a visual shift in them, too, with Griffith remarking that the drawings were 'not in [Turner's] usual style' and B.G. Windus, who had purchased a work only two years earlier, declining to purchase *The Blue Rigi*, amongst others, on account of their 'new' aesthetic.

FIG.26
Storm in the St Gotthard Pass. The First Bridge above Altdorf: Sample Study (detail) c.1844–5
Graphite, watercolour and pen on paper 23.9 × 29.7
Tate D36135; TB CCCLXIII 283

FIG.27
SAMUEL PALMER
Going to Fold: Study for
Eclogue VI 'Till Vesper
Bade the Swain' 1879
Watercolour on paper
12.5 × 19.2
Victoria and Albert
Museum, London

Despite Turner's initial disappointment with the price of 80 guineas set for these watercolours – 'Ain't they worth more?', he apparently cried – this sales model was repeated year on year. *Lauerzer See, with the Mythens* (cat.170), larger in size, with its remarkably textured pools of pure colour and traces of Turner's thumbprint in its thick, heavy pigment, belongs to the final set that he created for speculation.

Ruskin refered to *The Blue Rigi* and *The Red Rigi* as 'signs' 'for [Turner's] re-opened shop'. This was a completely new 'shop', its wares coming to the attention of a relatively closed circle and attracting an even smaller number of buyers.[21] Perhaps the artist's decision not

to exhibit these new sets of watercolours, exempting them from criticism, shook potential buyers' confidence: it was on exhibited work, after all, that his reputation rested. These, to use Ruskin's phrase, 'quite other conditions'[22] surrounding the production of *The Blue Rigi* were thrown into sharper relief by the emphatic celebration of Turner's earlier work, such as his paintings in Windus's collection in Tottenham, where 'Turner [was] on his throne' and where watercolours hung as he wished – like oils, close-framed in gilt surrounds (fig.25).[23] Visitors to the Leeds Music Hall in 1839 saw more than forty watercolours belonging to the Fawkes family of Farnley Hall, which Turner had painted over

twenty years previously, while in 1850 London's Society of Painters in Water-Colours exhibited three Turners from the 1810s on loan from a private collection.[24] Munro of Novar, meanwhile, welcomed visitors to view his portfolios containing upwards of a hundred Turner watercolours, which did include a small number of works from the 1840s.[25]

The relative scarcity of access to watercolours from the final decade of Turner's life could only deepen the mystique that surrounded his 'graphic secret'. Yet another dimension of this 'secret' lay behind the closed doors of his studio. Increasingly unburdened by commissions for highly finished and tightly wrought watercolours for engraving, here Turner flexed the medium in scores of loose, limpid visions – often stark and turbulent but consistently atmospheric – that would have startled his contemporaries (see cats.69, 132). Though he divulged to patrons glimpses of this free handling,

such as in the wet-in-wet description of rainfall in his sample study for *Storm in the St Gotthard Pass* (fig.26: detail), he was unwilling to relinquish ownership of such developmental works, even when approached by his agent as late as 1851.[26] Intriguingly, however, a draft codicil to his will, written between 1846 and 1849, reveals this very private artist contemplating posthumous displays of unfinished works on paper at his Queen Anne Street gallery.[27] Though this clause did not make the much-contested final will, aspects of Turner's private world on paper went public in 1857 in the first display of his sketches, curated by Ruskin and held in London's Marlborough House.[28] This first show focused entirely on the final decade of Turner's life, reflecting Ruskin's personal bias towards the period in which he knew Turner personally and revealing work of a very different nature from that by which he had come to be understood.

Samuel Palmer, who had encouraged his fellow artist John Linnell to visit Windus's collection of paintings by Turner twenty years previously, was enthralled by these new opportunities to see studio sketches.[29] As Andrew Wilton has stated, Turner's influence pervaded the next generation of watercolourists far more than it did practitioners in oils, but this was not without complication.[30] Although the bold colouring and inventive techniques of Turner's late watercolours were inspiring to artists like Palmer (fig.27), his privileging of atmosphere over legibility was not generally to Victorian taste; indeed, Turner's position as a hero in Richard and Samuel Redgrave's *A Century of British Painters* of 1866 was based on his early work.[31] Efforts made by Ruskin to promote the late watercolours through displays and the distribution of copies to art schools, meanwhile, were undermined by his regular changes of mind and the accumulating contradictions in successive editions of his commentaries on these very works.[32] The opening up of Turner's studio work, his 'graphic secret', seemed only to further his enigma and accentuate his identity as a 'unique and creative genius', whose virtuosity and freedom in handling the medium of watercolour could not, and should not, be imitated.[33]

As much as generations of artists and art historians and modern technical analysis might seek to explain Turner's 'graphic secret', the sheer showmanship of *The Blue Rigi* and the uninhibited splendour of his late sketches continues to beguile. They embody both continuity and change in Turner's journey with watercolour. This was the medium that had launched his career, sustained a steady income from printmaking, and, in later life, offered a portable and swift route to colour, atmosphere and expression, whether in highly finished or experimental work. Whatever mysteries and secrets they withhold, Turner's later watercolours ultimately reveal the joy of a lifetime's investment in creating the richest possible effects from the simplest of means – deployed with the utmost care – of paper, water and pigment.

NOTES

1 *London Magazine*, February 1823, p.219.

2 Cook and Wedderburn, XIII.

3 *Spectator*, 25 January 1879, p.115.

4 Hardie 1967, p.40.

5 Gage 1987, p.62.

6 Bower 1999, pp.13, 36.

7 The sheet, like that for *The Red Rigi*, is watermarked 'J WHATMAN / TURKEY MILL'. For the manufacture of this paper, see Bower 1999, p.36.

8 I am very grateful to Peter Bower for generously sharing his unpublished findings with me.

9 Advice given to Mary Lloyd and recounted by her in 'A Memoir of J.M.W. Turner R.A. by M.L', reproduced in *Turner Studies*, vol.4, no.1, pp.22–3.

10 The description of Turner's fingernail comes from Edith Mary Fawkes, typescript in the Library of the National Gallery, London; see also Robert Yardley, '*First Rate Taking in Stores*', in Joll, Butlin and Herrmann 2001, pp.109–10.

11 See Gage 1984, p.42. For the role of white in Turner's practice, see Townsend 1993, pp.45–6.

12 Townsend 1993, p.47.

13 Field 1835.

14 Typescript by W.E. Killik, 'A Short History of the House of Winsor & Newton Ltd', 1925, quoted in Bower 1989, p.5.

15 *The Blue Rigi* was originally titled 'The Righi' and appeared thus in Bicknell's sale in 1863. Ruskin was the first to use the colour-referencing sobriquets in print in his 1878 account of their genesis. See Cook and Wedderburn, XIII, pp.480, 483.

16 *Spectator*, 17 November 1832, p.1096.

17 Waagen 1854, II, p.352.

18 Ian Warrell, '"The wonder-working artist": Contemporary Responses to Turner's Exhibited and Engraved Watercolours', in Shanes 2000, pp.44–5.

19 Upstone 1993, p.15; I. Warrell, 'Turner's Late Swiss Watercolours – and Oils', in Parris 1999, p.145.

20 Rowell, Warrell and Blayney Brown 2002, pp.30–5, 123.

21 Cook and Wedderburn, XIII, pp.477.

22 Cook and Wedderburn, XIII, pp.475.

23 Obituary of Turner in the *Gentleman's Magazine*, February 1852.

24 Wilton 1987, pp.241–5.

25 *Art Union*, vol.9, 1847, pp.253–5.

26 Wilton 1987, p.245.

27 PRO Prob. 37–1547–3–Y. Cited in Whittingham 1993, p.48; Smiles 2007, p.56.

28 For this display, see Warrell 1995.

29 21 February 1838, in Lister 1974, I, p.115.

30 A. Wilton, 'The Legacy of Turner's Watercolours', in Shanes 2000, p.47.

31 Redgrave 1866, I, pp.402–7.

32 See 'Modern Painters' and 'Elements of Drawing' in Cook and Wedderburn, XIII.

33 *Spectator*, 24 April 1858, p.447.

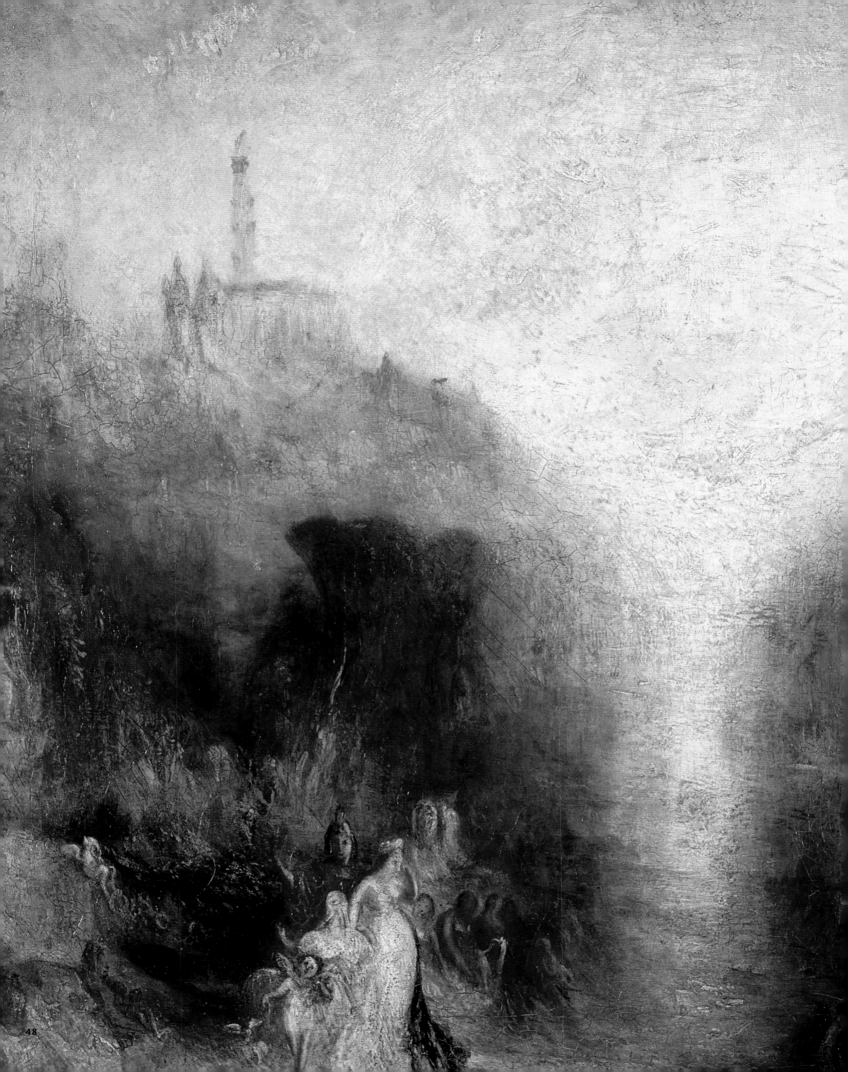

Materials, Technique and Condition in Turner's Later Paintings

Rebecca Hellen and Joyce H. Townsend

JOHN CONSTABLE described Turner's pictures as 'painted with tinted steam',[1] evoking fleeting and perhaps mysterious methods. What were these, and how had they developed by the mid-1850s? Recent examination and materials analysis of his paint have provided much insight into Turner's techniques, revealing the surfaces of his later pictures as more complex than his earlier ones. Greater numbers of localised brushstrokes and an increased versatility and experimentation in handling were the result of many years' experience and supreme confidence in the use of his chosen materials, which by 1830 were composed of an established range of supports and paints.

Five paintings from the Turner Bequest are examined here, on both panels and canvases, taking account of their documented conservation histories and variations in current appearance, partly a result of their different supports. The panel paintings *Story of Apollo and Daphne* (cat.80) exhibited in 1837 and *The Opening of the Wallhalla, 1842* (cat.96) exhibited in 1843 have supports of identically sized large pieces of hardwood, the exact type of wood remaining unidentified. The canvases, smaller but uniformly sized, are *Mercury Sent to Admonish Aeneas* (cat.171), *The Visit to the Tomb* (cat.172) and *The Departure of the Fleet* (cat.173). Turner's final exhibits of 1850, the year before his death,

the canvases are part of an original series of four telling the story of Dido and Aeneas at Carthage. The panels provide unique and exemplary analytical evidence of Turner's materials, and retain their original texture. Despite Turner's use of similar paints, the canvases have undergone more changes over time, and comparison helps us to understand how past histories, current condition and Turner's materials and techniques define what we view today. His completion of a painting was only the beginning of its history: its appearance would change, often faster and ultimately more radically than many paintings by his contemporaries. Understanding the present appearance of Turner's later exhibited oil paintings requires knowledge of how paint progressively ages and alters, and when his choice of painting materials accelerated such changes.

After the death of his father, who had acted as studio assistant, in 1829, Turner's panels and canvases were commercially supplied. Whereas formerly they were sometimes made up by his father, white absorbent grounds were now ready prepared and applied by artists' colourmen.[2] Absorbency was useful because it allowed the wet paint to dry rapidly to its final colour, enabling Turner to proceed with the early stages of a composition while in full creative flow. Contemporary accounts suggest that he worked

FIG.29
The Visit to the Tomb
exh.1850
(detail, cat.172, p.241)

FIG.30
Magnified detail of drying
cracks caused by megilp
medium

rapidly and technical examinations confirm that he would develop compositional ideas radically during the process.

Results of analytical studies of the panel paintings *Story of Apollo and Daphne* and *The Opening of the Wallhalla* provide accurate information on Turner's long-held preference for certain paint mediums, as well as on the coloured pigments he regularly used, and gives the opportunity to note their common defects. Some defects or changes in appearance typically occurred quite soon after painting, while others emerged more slowly later on. Turner's palette had already broadly incorporated most new pigments available at the time.[3] Fading of his pigments is often alluded to and has occurred to a degree in some of the works discussed here, but is not their most striking alteration. The two

panels discussed here provide good examples of paint defects that would have appeared early on as well as developing later over time; there is physical and written evidence for both types of change.

The *Wallhalla* was described by Ruskin as having 'cracked before it had been eight days in the Academy rooms'.[4] Analysis shows that Turner used megilp, a commercially available 'medium modifier' made from leaded drying oil and mastic varnish.[5] Megilps caused the defects noted by Ruskin and other contemporaries, which have subsequently worsened. Coloured paint squeezed out from bladders or from a newly invented paint tube (in the case of the chrome yellow)[6] would have been mixed with megilp medium by the brushload. This formed a soft impasto that flowed out a little when painted

thickly (as seen in the figures in the foreground of the *Wallhalla*), and would also make very thin glazes to create areas of increased gloss (such as water) or to intensify existing colours locally (for details of costume). In thicker applications the topmost surface dried quickly and shrank, with the area beneath remaining more liquid, creating the wide, shallow drying cracks Ruskin noted (fig.30). These are distinct from the sharper, deeper ageing cracks that develop over the long term in all old paintings.

Paint based on drying oil and lead white, liberally used by Turner in every painting, grows more transparent with age, making the colour of layers beneath more prominent. Hence Old Master paintings with a mid-toned support or ground appear even warmer and more transparent today, especially when thinly painted. Georgian and early Victorian artists and connoisseurs craved this limpid and translucent beauty, not realising that it was impossible to create with newly applied paint. Turner's later materials and techniques do not indicate attempts to re-create this quality, but rather his enjoyment and skill in combining the effects of colour contrasts and texture. His use of lead driers with lead white meant that his paint changed rapidly compared with older paintings. Examination with a microscope reveals that his lead white-based grounds and lead paints are virtually all affected by this process. In the case of the works examined here it is not as visually disturbing as in other works by Turner: however, it is pervasive.

The best analyses of Turner's medium come from the paintings on panel discussed here; samples from these are not contaminated with materials used in a structural repair process called lining which over the last 150 years has been applied to all canvases in the Turner Bequest and involves heat, pressure and various types of glues and adhesives.[7] In particular, spermaceti wax, which is collected from the sperm whale, was detected in the *Wallhalla* (in the river and the misty middle ground, for example), as well as unbleached beeswax, indicating the high risk of using heat in treating Turner's paintings, since spermaceti wax has a very low melting point. A wax-based mixture could have been added into any colour – just like megilp. The wax mixture makes a perfectly mixed colour go much further, without diluting its intensity, and forms a paint medium capable of holding high impasto as it dries, without slumping like megilp. A visitor to Turner's studio after he died noticed 'pots of blue and red wax' by his easels.[8] Both panels examined here have wax-based paint, the stiffer textures preserved just as they were first applied.

In addition to Turner's choice of media, the *Wallhalla* was affected early in its life by transport across Europe, when Turner sent it to the Congress of European Art in Munich two years after showing it in London. Much to his annoyance, it was returned with an extra bill to pay for its transport and with 'sundry spots upon it'. A visitor to Turner's studio, Elizabeth Rigby (later Lady Eastlake), described his attempts to repair the damage: 'on this Turner laid his misshapen thumb in a pathetic way. Mr Munro [of Novar] suggested they [the spots] would rub out, and I offered my cambric handkerchief; but the old man edged us away, and stood before his picture like a hen in a fury.'[9]

In addition to any such mishaps through travel and handling and attendant variations in the environment, the early onset of paint defects, and adjustments by the artist himself, subsequent repairs are also highly influential in the appearance of Turner's paintings today. Past restorers had a different ethical standpoint from our own, and were obliged to work without microscopes, analytical facilities or a good understanding of Turner's materials. The earliest 'restoration' on *Story of Apollo and Daphne*, documented in 1899, was noted as 'surface

cleaned and varnished'. This can be interpreted as the removal of heavy particulate London soot and grime followed by re-varnishing. Following this in 1934, restorer Herbert Walker was the first to record the panel's cracks, although surely they, like those in the *Wallhalla*, appeared early. Walker stated that the painting was

> very much damaged by cracking of the pigment, mainly in the centre of the work; there is also a very bad place in the lower left hand corner ... Most of these cracks should yield to treatment by heat which would bring them together, and retouching be avoided. The area affected is considerable, for the work is a large one, and would involve a great expenditure of time.

Thankfully the cracks do not appear to have been melted back together[10] and in general the work is well preserved.

What kinds of materials and techniques did Turner use for the Carthaginian paintings – *Mercury Sent to Admonish Aeneas*, *The Visit to the Tomb* and *The Departure of the Fleet* – and how did they fare in comparison to the panels discussed above? Contemporary reviews and knowledge of their production underpin our understanding of Turner's practice here, especially significant as his last exhibited 'finished' works. An early account[11] described the pictures 'set in a row while [Turner] went from one to the other, first painting upon one, touching on the next, and so on, in rotation'. Looking at the paintings together, it seems clear that Turner conceived and executed them as a suite. Despite the subsequent disappearance of a fourth picture, a description[12] and old photograph suggest that all the pictures were painted in a broadly similar way, with similar materials. They are all on plain weave linen canvas, with five layers of absorbent ground made from lead

white and chalk bound in linseed oil applied wet in wet. Each image was started with the highly thinned, sketchy, warm and cool layers visible in many unfinished Turner oils. However, while the series is sometimes considered to depict four times of day,[13] Turner may have begun with effects different from those seen in the pictures today. Recent examination of *Mercury Sent to Admonish Aeneas* (cat.171) shows earlier warm mauve layers, now evident where large losses have occurred in the central areas, which today are covered with lead white and yellows depicting bright, shimmering sunlight. This shift is typical of the changes in mood or internal lighting that Turner often made in his later years, as he finished pictures in their frames during the three Royal Academy Varnishing Days. Officially intended for artists to repair damages sustained in transit and make last-minute adjustments, Turner had turned these occasions into theatre, giving public displays of his virtuoso techniques that passed instantly into legend. The Carthage series, however, will have been completed at home by the ailing painter.

FIG.31
Cross-section from orange-brown area of paint with melted appearance from *Mercury Sent to Admonish Aeneas*, cat.171, p.240, photographed at ×320 in normal light

there are seven further structural treatments recorded prior to recent full treatment[15] enabling its display again.

Wax-based paint medium plays a particular part in changes to works on canvas. The thickest paint layers (up to 5mm thick) in late Turner oils, when analysed, have usually included beeswax combined with linseed oil and sometimes mastic resin. Tiny samples of paint from the Carthage series (such as figs.31, 32) have exactly the appearance expected from such a mixture, although in all of these works it is clear that multiple and merging layers of different medium modifiers are present, applied in every order imaginable, but rarely following precepts that could have minimised later cracking, since such applications would have interfered with Turner's spontaneous and rapid working methods.

The Carthage canvases were lined early, and clearly had numerous applications of wax-based paint, leading to flattened surfaces and in some areas, a melted appearance (fig.33). The mid- to foreground areas of *Mercury Sent to Admonish Aeneas* and *Departure of the Fleet* are good examples of this phenomenon. Other areas, such as the sky, are well preserved where Turner used fewer types of medium modifiers and tended to keep the paint diluted (with turpentine presumably, but it leaves no trace behind) so that the entire sky area remained workable and could be finished last, to create a coherent whole.

As well as affecting texture, heat used in the lining process exacerbates the inevitable darkening of megilp in particular. Once-transparent or golden glazes prevalent in landscapes and shadows have grown brown. Unlike varnishes, these form the very structure of the painting and cannot be returned to their original appearance. The Carthage pictures, like other late Turners, now have an overall warm tonality which is stronger than the artist intended, seen today in *Mercury Admonishing Aeneas* even after recent conservation treatment

In 1850 a critic noted that these pictures are 'full of combinations of forms of richest fancy and of colours of most dazzling hue'.[14] That this is not the impression they give today attests to their complex life histories, ownership, travels, locations of display, and various early conservation treatments. While the *Wallhalla* made its journey to Germany, the Carthage paintings had many later travels, for example to Scotland in the 1900s and to Baltimore, USA, in the 1960s, no doubt without today's high standards of protection for artworks. Canvas supports become taut and then slack in reaction to changes in the environment; when slack, due to damp conditions, any re-tensioning would have encouraged the growth of cracks in the paint and ground. Coupled with Turner's thick and multi-layered paint structures, each painting has suffered flaking as a result and has undergone lining to deal with this. The first recorded treatment of *Mercury Sent to Admonish Aeneas* was a glue-paste lining, noted in 1893. Recent X-radiography clearly indicates that it has suffered great losses of paint and ground;

has reduced the 'golden glow' made by layers of subsequent non-original but old, yellowed varnishes.

Turner's late finished oils have a versatility of paint handling and confidence in the application of materials which differ from his earlier works. Light-over-dark and dark-over-light translucent scumbles and transparent glazes occur throughout the canvases, as do local pairings of contrasting primary colours such as yellow or red against blue. How did he apply such paint? Many layers are highly localised, and must have been applied with a tiny brush or the tip of a brush (fig.34). Turner had always used a variety of tools: small and mid-sized round brushes; palette knives; the brush handle; the brush heel, to jab into the paint; and rags. Depictions of him at work on Royal Academy Varnishing Days show rags in his pockets or close at hand (cat.8). In exhibited works, the effect of using rags can be hard to discern beneath later paint, but in less finished canvases their broad sweep and misty mixing of colours is easier to spot. In the Carthage paintings – and in many others – the occasional fingerprint can be seen, when a stiff area of impasto was perhaps too prominent. A palette knife created shafts of light in the skies of Carthage by sweeping translucent megilp scumbles across the upper paint surfaces. A reviewer stated that these late canvases displayed, along with 'eccentricity of manner', the 'creative quality of Art, the suggestive powers of the artist, in as high a degree as the works of any painter'. He wrote that the paintings should be looked at from a distance for the 'general effect' and 'as great pictorial schemes abounding in rich stores of Nature and deductions from Art'.[16] These comments are a fitting tribute to the striking effects Turner achieved using a variety of tools and modified paint media to vary textures and translucency – effects which remain evident despite their changing appearance over time.

FIG.33
Magnified detail showing Turner's wax-based paint in *Mercury Sent to Admonish Aeneas*, cat.171, p.240

FIG.34
Magnified detail showing fine brushstrokes and multiple layers in *Mercury Sent to Admonish Aeneas*

In these final works on canvas Turner concentrated less on depicting details than he did in the panels. The figures and their costumes are more allusive and the architectural elements indistinct, though softening of wax through lining has certainly exacerbated these effects, bringing to mind Constable's description of Turner's painting with tinted steam. As we have seen, assessment of how Turner intended his late finished oil paintings to appear is hampered by their physical histories, and much is to be gained by comparing the surfaces of the canvases and panels discussed here.

In summary, the panels, whilst sharing certain common deterioration issues with the canvases, at least retain the texture created by Turner's choice of tools, and serve as good exemplars of the paint surfaces seen by his contemporaries.

Viewing the paintings today, the ephemeral nature of his ambitions to create his inspired, shimmering surfaces strikes us painfully, just as it struck Ruskin. The pictures are compromised by so many factors: Turner's materials and techniques; the natural and often visually obvious changes as the paints age; and conservation treatments, sometimes dating from Turner's own lifetime. The Carthage series especially has perhaps been undervalued because of this. Even so, with a more comprehensive understanding of these canvases, their surfaces, palette and compositions still convey, to the mind at least, their 'rich fancy' and 'dazzling hue'. The panels also remain 'magical' and are a wonderful guide to Turner's handling and mastery of textures. All must and can still be cherished and enjoyed for what they have become.

NOTES

1 Charles Robert Leslie, *Memoirs of the Life of John Constable*, London 1845, p.277.

2 Townsend 1994.

3 Townsend 1993b.

4 Ruskin quoted in Butlin and Joll 1984, p.250 under no.401.

5 Townsend et al. 1998; Joyce H. Townsend, 'Turner's Materials and Processes', in Warrell 2013, pp.42–9.

6 Turner's tin paint box (Tate, TGA 7315.6) includes bladders of paint in many colours, and a single tube containing chrome yellow; see Townsend in Warrell 2013, pp.168–9.

7 Weak or torn canvas supports were adhered to a new canvas and then restretched. Some, treated early in their existence because they were already deteriorating, experienced less desirable changes, including flattening of impasto, widening of cracks, permanent darkening of the medium and the pressing of varnish and dirt into heat-softened paint.

8 Trimmer, quoted in Thornbury 1862, p.362.

9 Eastlake Smith 1895, I, p.189.

10 Tate conservation record for N00553.

11 J.W. Archer, '*Reminiscences*', quoted in Butlin and Joll 1984, p.274 under no.429.

12 By D.S. MacColl; quoted in Butlin and Joll 1984, p.275 under no.430.

13 Ziff 1984.

14 Anon., *The Athenaeum*, 18 May 1850 quoted in Butlin and Joll 1984, p.274 under no.429.

15 By Rebecca Hellen.

16 Anon., *The Athenaeum*, 18 May 1850, quoted by Butlin and Joll 1984, p.274 under no.429.

Catalogue

Decline and Fall: Turner's Old Age and his Early Biographers

Sam Smiles

Turner's last years provide a useful example of the ways in which an artist can be mythologised. A factual account of his life between 1835 and 1851 can be outlined straightforwardly and its most significant features are itemised in the Chronology on pp.245–7. But this picture is the product of many years of research that has filled in countless aspects of Turner's professional and personal biography as new sources have come to light. For example, just under half of Turner's surviving correspondence was written after he turned sixty and it has served as a fount of information about his friendships, his production of work for exhibition or sale and his state of health.

It would have been a still richer and more intimate store had Sophia Booth not burnt Turner's letters to her shortly after his death.[1] Turner's relationship with his former Margate landlady was an important feature of the last eighteen years of his life, and from 1846 he lived with her at 6 Davis Place, Chelsea (cat.3). Turner's discretion about this liaison explains his evasiveness when fellow Academicians wished to call on him but it fuelled the idea of him leading a mysterious life in those final years. After he died the relationship became known and some of his contemporaries – notably David Roberts and John Ruskin – fretted at its impropriety.

Personal reminiscences of friends and colleagues, together with other sources of information, were known to Turner's first biographers. Had they had access to all we now know, they might have held back from characterising the elderly artist as an increasingly reclusive and enigmatic figure. Instead, challenged by the distinctiveness of his art, especially the works he produced in his old age, there was a strong temptation to present Turner as similarly idiosyncratic, even maverick.[2] In its obituary the *Athenaeum* described his last works as 'those eccentricities

of a great genius in which he of late years indulged … those were his dotages and lees.'[3] The 'eccentricities' of his painting seemed to be echoed in the anecdotes about Turner's appearance and behaviour that began to proliferate in his last years and especially after his death. His great friend the painter George Jones noted how 'his eccentricities were too delightful to the [Press] to pass without a sarcasm. Even his house in Queen Anne Street was a subject for sarcasm, and of comparison with the resident [*sic*] of the late James Barry in Castle Street' (fig.35).[4] This was a comparison that did Turner no favours, for the last years of the history painter James Barry were grim: he had died in penury and squalor in 1806, a personal situation that seemed to mock the high idealism and dignity of his art.

As Julie Codell has observed, the production of artists' biographies was a relatively new literary industry in the nineteenth century.[5] As it developed into a mature genre in the 1870s, the artist biography tended to celebrate the collegial, sociable and collaborative traits of its subject. If the artist was married, or at least lived a 'regular' life, his professional authority was balanced by domesticity, which in turn placed his activity within the normal definitions of material success that were appropriate for the professional classes. Artists who worked hard, who encouraged others, who supported their professional institutions and who contributed to the national school were fitting subjects for biographical treatment. Given the expectations of the artist biography, much of Turner's career was appropriate for it: his precocious talent, his years of success, the prosperity built on that success, his support for the Royal Academy, his gift of his pictures to the nation. But there were aspects of his life, especially his later years, which disturbed any complacent idea that his biography was exemplary in the way that a Victorian reader might have hoped. His final

a rounded portrait of his subject, including his 'dark' side. This was a matter of sensitivity to Turner's more fastidious acquaintances, who had qualms about certain aspects of his personal life. A decade earlier Ruskin had fleetingly considered writing the biography, but had dropped the idea for that very reason. As he wrote to his father, 'there might be much which would be painful to tell and dishonest to conceal'.[7] Effie Ruskin, on honeymoon with him in Venice, wrote to her mother:

> Some are anxious for him to write Turner's Life but he thinks not, and I dissuade him from it as what is known of Turner would not be profitable to any lady and he has left no rules for painting or any memorial that would be any good but his great gift to the country. The sooner they make a Myth of him the better.[8]

Thornbury's biography is badly flawed, for his approach to evidence was not discriminating, with hearsay regularly presented as fact. Moreover, the book is poorly ordered, with numerous diversions and changes of emphasis, and the image of Turner it constructs is patchy at best. As one would expect from the criticism Turner had encountered in the 1840s, the works of his last years are deemed to represent a steep falling away from his major achievements. Thornbury's judgement on Turner's final paintings is severe:

> Of his later works I am no defender. They are dreams, challenges, theories, experiments, and absurdities. The figures are generally contemptible, and the pyrotechnic colour rises sometimes almost to insanity, and occasionally sinks into imbecility. With the eye dim and the sense of form lost, the outlines are gone, and the sentiment only remains. Certainly they are

years, it seemed, had seen his art degenerate as his strength of body and mind waned, while a regrettable liaison had compromised his material success.

In 1862 Walter Thornbury published the first full-length biography: *The Life and Correspondence of J.M.W. Turner*.[6] Thornbury was a prolific author and journalist, not an art specialist. He had been in his early twenties when Turner died and had never met him. He sought John Ruskin's advice and received his encouragement to proceed, aiming to produce

what no one else could achieve, but then no one wishes to achieve them.[9]

Thornbury buttressed his position by quoting Ruskin's judgement on Turner's final decline: 'In 1845, however, his health gave way, and his mind and sight began to fail; insomuch that the artistic fruits of the last five years of his life … are of wholly inferior value.'[10] Some of Thornbury's remarks about the quality of Turner's last paintings are further coloured by vulgar insinuation: 'In 1842 Turner's power of sight and accuracy was fast declining, and even brown sherry could not brace the once dexterous fingers or clarify the clouding eyes.'[11] Taken to task by reviewers for presenting Turner in such an unflattering light, he used the preface of the second edition to wade into even deeper waters, asking rhetorically, 'Was it some grain of his mother's insanity that tainted this great genius?'[12]

Nevertheless, for all its faults the biography contains some valuable eye-witness recollections, including those of Turner's friend Henry Scott Trimmer who not only supplied helpful anecdotes but also contributed an informative account of Turner's house and studio in Queen Anne Street, including the picture gallery (cat.14) and the painting room, with the pigments and equipment it contained.[13] Other colleagues and acquaintances spoke warmly of Turner's generosity and his support for younger artists (cat.9).[14] And against Ruskin's portrayal of Turner's withdrawal from society, David Roberts is quoted: 'that he was not the recluse Ruskin has pictured him, is *well known to all who knew anything about him*, for he loved the society of his brother painters.'[15]

Those Victorian biographers of Turner who followed Thornbury echoed his judgement on Turner's last works. Philip Gilbert Hamerton's account was published in 1879 and shared with Ruskin a belief that Turner's powers had declined sharply in his closing years. As far as he was concerned, all Turner's work after 1845 was produced in 'a state of senile decrepitude'.[16] Cosmo Monkhouse's account appeared in the same year. Turner is portrayed as a tragic figure, his art becoming a surrogate for the domestic happiness denied him by his lack of social skills. By not marrying, Turner had ruined his life:

He made his home the scene of his irregularities, and, by entering into intimate relations with uneducated women, cut himself off from healthy social influences which would have given daily employment to his naturally warm heart, and prevented him from growing into a selfish, solitary man. Not to be able to enjoy habitually the society of pure educated women, not to be able to welcome your friend to your hearth, could not have been good for a man's character, or his art, or his intellect.[17]

Monkhouse presents Turner as an uneducated and intellectually bereft artist, for whom painting was a refuge from a world in which he could not participate: 'He thus lived in two worlds – one the pictorial sight-world, in which he was a profound scholar and a poet, the other the articulate, moral, social word-world in which he was a dunce and underbred.'[18] He dates Turner's decline to about 1845, as did Ruskin and Hamerton, and uses the analogy of a shipwreck to stand for the tragedy of Turner's final period of production:

a great painter, the very slave of his genius, compelled to paint this and paint that at its bidding without being able to distinguish what was great and what was little, what sublime and what ridiculous … he appears to us in these last days like a great ship, rudderless, but still grand and with all sails set, at the mercy of the wind, which played with it a little while and then cast it on the rocks.[19]

In these accounts of Turner's old age he is presented too often as someone ill at ease in society, prone to abruptness, inarticulate in expression, reclusive, secretive and evasive. Victorian authors were hungry for an answer as to why Turner's final works were so challenging and his personal life, be it his physical, mental or moral condition, seemed to supply the answer.

It is true that Turner took pains to conceal even from his closest friends that he was living with Sophia Booth in Chelsea; it is also true that when he was beset by illness he was unable to participate as fully in society as he once had. Yet what may explain the gap between what his biographers expected and the way he lived his life in these closing years is more fundamental. Turner's credo throughout his career was that of the professional artist. The creative personality whose works were placed before the public was the persona Turner cultivated. The private life of the individual who had produced these paintings was, to that extent, immaterial.[20]

NOTES

1 William Bartlett, the surgeon from the Kensington Dispensary who attended Turner at the very end of his life, informed Ruskin in 1857: 'I was grieved after his death to find Mrs Booth burning a clothes' basket full of letters from him received, many of them poetical effusions.' Bembridge, Ruskin MS. 54/C, quoted in Gage 1980, p.xxvi.

2 For an account of Turner's posthumous critics and biographers, see Smiles 2007.

3 *The Athenaeum*, 27 December 1851, p.1383.

4 George Jones, 'Recollections of J.M.W. Turner', published in Gage 1980, p.6.

5 Codell 2003.

6 Thornbury 1862; a revised edition was published in 1877. The first posthumous biography was a brief, thirty-page account published the year after Turner's death; see Cunningham 1852.

7 Letter dated 1 January 1852, in Bradley 1955, pp.119–20.

8 Letter dated 4 January 1852, in Lutyens 1965, pp.241–2.

9 Thornbury [1862] 1877, p.548.

10 Ibid., p.416.

11 Ibid., p.171. Further remarks about Turner over-indulging in alcohol at home, in public houses, restaurants and at the Athenaeum Club can be found on pp.239, 302 and 352–3.

12 Thornbury [1862] 1877, p.vii.

13 Ibid., pp.362–4.

14 Ibid., pp.229, 272–4.

15 Ibid., p.230.

16 Hamerton [1879] 1895, p.297. The articles on which the book is based were first published in *The Portfolio*, January 1876 to December 1878.

17 Monkhouse 1879, p.77.

18 Ibid., p.4.

19 Ibid., p.131.

20 For a further discussion, see Smiles 2008.

1

CHARLES JOSEPH HULLMANDEL (1789–1850) after Alfred Guillaume Gabriel, Count D'Orsay (1801–52)

Portrait of J.M.W. Turner ('The Fallacy of Hope') 1851

Lithograph on paper 32.8 × 22.5
Published by J. Hogarth, 1851
Tate T05039. Presented by Richard Godfrey in memory of Wilfred Yee Huie 1988
Exhibited London only

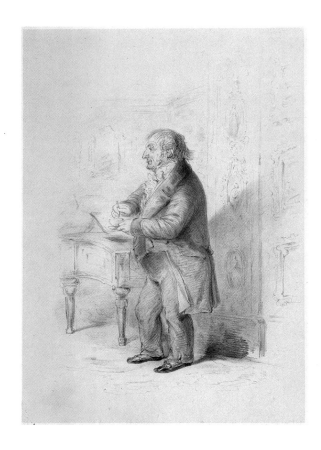

THIS PORTRAIT of Turner at the home of his patron Elhanan Bicknell provides an insight into his gregarious last years. Bicknell regularly hosted gatherings of artists and writers at his home in Herne Hill, south London, usually on Sundays, and Turner's presence is recorded there on a number of occasions from 1841 until at least 1847. He is shown standing in front of the rococo panelling of the old drawing room, in which Bicknell displayed some of his collection of watercolours. Turner's neat attire bears out his friends' observations that he was better turned out at this period of his life, thanks to the ministrations of his mistress, Sophia Booth, with whom he lived in Chelsea.

D'Orsay's portrait was described as a truthful likeness: 'The best sketch of him we know is Count D'Orsay's clever drawing of him at some soireé with a tea-cup in his hand.'[1] (The original chalk drawing is in a private collection.) D'Orsay also etched separately a profile of Turner's head, on a slightly larger scale. Annotations on two impressions of the engraving indicate that D'Orsay's friend Edwin Landseer may have helped him with it. The inscription alludes to an epigraph from 'Fallacies of Hope', an unpublished collection of Turner's own verse, from which he attached extracts to some of his exhibited pictures from 1812 onwards.

Bicknell had made his money in the spermaceti oil business and was a munificent patron of contemporary artists, building up an important collection. The first record of his interest in Turner's works dates from 1835 and his initial purchases, two watercolours, were made in 1838. In 1841 Bicknell bought his first oil painting by Turner, *Venice, the Giudecca*, which was perhaps a commission. The following year he commissioned a second oil, *Campo Santo, Venice*, and selected from Turner's 'sample studies' two finished watercolours of the 1842

Swiss set: *The Blue Rigi* (cat.155) and *Brunnen, Lake Lucerne* (private collection). In 1844 he bought eight oils from Turner's studio, dating from the 1810s to the 1830s. He also purchased six small watercolours of the 1830s and 1840s, probably in the same transaction.[2]

Count D'Orsay was a French dandy and *bon viveur* who lived in London from 1830 to 1849. A talented amateur artist, working successfully in sculpture and painting, he made numerous sketches of contemporary celebrities, especially those attending the salons of his intimate companion Lady Blessington, which were a magnet for the fashionable artistic and literary circles of the day. Over a hundred of these sketches were engraved by Richard James Lane and published by John Mitchell of Bond Street.[3]
SS

1 *Athenaeum*, 17 March 1858, p.344, cited in Wilton 1987, p.217, pl.286.

2 See Bicknell and Guiterman 1987.

3 W. Teignmouth Shore, *D'Orsay, or, The Complete Dandy*, London 1911, p.227.

2

George Hollis (1793–1842) after Turner

St Mark's Place, Venice: Juliet and her Nurse 1842

Line engraving on paper 42.3 × 56.4

Tate T05188. Purchased 1988

Exhibited London only

Turner had always had his detractors but by the mid-1830s he was a truly controversial artist, polarising opinion as never before. The original of this print, *Juliet and her Nurse* (private collection), shown at the Royal Academy in 1836, was among his most contentious pictures of the decade and a milestone in his critical reputation, one may guess to his surprise. In 1833, when he first exhibited pictures of Venice and introduced the view-painter Canaletto, improbably working at his easel outdoors, reviewers made no objection and praised this 'lesson in atmosphere and poetry'. For literal-minded critics in 1836, importing Shakespeare's Juliet to Venice from Verona was a step too far, while the Revd John Eagles, the hyperbolically sour critic of *Blackwood's Magazine*, found that with 'so many absurdities' in the new picture Juliet was the least of its problems.[2] Despite this, the picture was bought by Turner's loyal admirer Munro of Novar and the *Blackwood's* review roused the young Ruskin to draft a defiant response, which he sent to Turner, asserting the artist's exceptionalism. Embarrassed, Turner thanked Ruskin but added: 'I never move in such matters. They are of no import save mischief.'[3] The exchange marked the beginning of Ruskin's lifelong involvement with Turner's work. He published the first volume of *Modern Painters*, anonymously, in 1843.

Ian Warrell has suggested that Turner began the picture as a descriptive view and put Juliet on her roof to solve the problem of an empty foreground between the arcades on either side of the piazza – hardly a ringing endorsement of her centrality to the narrative, even if her pose and lighting on a brilliant night echo Romeo's flattering claim that her radiance matches the moon. As Warrell observes, the revellers in the piazza look more modern and flares, fireworks and a Punch and Judy show evoke carnival.[4] Maybe the girl leaning into the picture to watch

them is not so much Juliet herself as a modern woman who reminds Turner of her, a lover who personifies Venice, most feminine and eroticised of cities. Or perhaps the women are actors themselves, reminders of the love of theatre in a city that is itself a stage; and this is a costume drama, a masquerade moonshine re-creating the bewitched enchantment that Venice produced in Romantic visitors. Warrell notes the similarity of Juliet's pose to that of Martin Archer Shee's earlier portrait of *Maria Ann Pope as Juliet* (Garrick Club, London), which had been re-exhibited in London in 1833.

One of various large-scale plates after Turner pictures issued in the 1840s, the print was published by his agent, Thomas Griffith. This first state named Juliet and her nurse in its title. In the second they were dropped and replaced by 'Moonlight' and – as if to rebuke pedantic critics – Turner's own version of lines from Byron's *Childe Harold's Pilgrimage* (canto IV) describing Venice as 'The pleasant place of all festivity/The revels of the earth, the Masque of Italy'. DBB

1 *Morning Chronicle*, 6 June 1833.

2 *Blackwood's Magazine*, 1836, quoted in Butlin and Joll 1984, pp.215–16.

3 Letter, 6 May 1836, ibid., p.216.

4 Warrell 2003, pp.71, 73.

3

John Wykeham Archer (1808–64)
House of J.M.W. Turner, 6 Davis Place, Chelsea 1852
Watercolour with gouache over graphite on paper 37.5 × 27.3
British Museum, 1874,0314.461
Exhibited London only

Turner lived with Sophia Booth at 6 Davis Place, Chelsea, from October 1846 until his death on 19 December 1851. It was situated in a small terrace, with a boatbuilder living on one side and two beersellers on the other. Across the water, on the south bank of the Thames, an industrial site had grown up, with chemical factories, a flourmill, sawmills and a timberyard.[1]

Archer called at the house in 1852. He had already visited Turner's birthplace in Maiden Lane and had painted one watercolour of the front of the house and another of an interior room entitled 'Attic (said to have been Turner's first studio)' (both British Museum). These were reproduced as woodblock engravings in the account of Turner's character that Archer published in *Once a Week* a decade later.[2] In the second edition of Walter Thornbury's biography of Turner (1877) and in Cosmo Monkhouse's account of the artist (1879), the woodblock of the attic was reproduced again, but now retitled as 'Room in which Turner died, at Chelsea', with some books and a portfolio added to it to suggest what his activities were in his final days.

Archer met Sophia Booth on his visit to Davis Place; she refused to let him see Turner's bedroom but entertained him nevertheless and provided him with information about Turner's life at Chelsea. Her testimony is a valuable complement to the accounts of William Bartlett, who attended Turner there in a medical capacity, and David Roberts, who visited the house after he died. Roberts had better luck than Archer, for he was shown 'the bed room where he usually Sleept & the Room facing the water where he died'.[3] Mrs Booth told Archer that Turner painted his last Carthaginian pictures in the house (cats.1 71–3), 'set in a row, and he went from one to the other, first painting upon one, touching on the next, and so on, in rotation'.

As can be seen in the watercolour, Turner had the original roof of the house altered and a platform constructed with ironwork railings, which allowed him to survey the Thames and the changing light. Mrs Booth told Archer that Turner called the view upriver the 'English view' and downriver the 'Dutch view'. The view of the Thames from inside the house was much more restricted: the ivy or Virginia creeper fanning out from the window box below is supported by trellises either side, which would have framed it closely.

Archer's watercolour, with Turner's pet starling in its cage, discarded ship's tackle on the road and chickens pecking in the dirt, implies that the location was a place of retirement or retreat from the world, but this was not entirely true. Davis Place was in a liminal position, poised between town and countryside, and was close to a major site of public entertainment. To the west of the terrace were the twelve acres of Cremorne Gardens. These had been first developed by Charles Random de Berenger as Cremorne Stadium (1832–43) for sporting activities and occasional galas. The site was taken over by a succession of managers and developed as Cremorne Pleasure Gardens; by 1846 it was offering the public the delights of its ornamental grounds as well as regular concerts, firework displays, balloon ascents and other enticements. It was frequently rowdy and its critics, alarmed at the mixing of social classes and its unabashed hedonism, called it wanton. A threepenny steam ferry plied between Cremorne Pier and the City, until the gardens closed at midnight.[4]

John Wykeham Archer was an engraver and painter in watercolours. He had recently depicted other London houses associated with famous names in his *Vestiges of Old London* (1851).[5] The same impulse explains an undated watercolour of the house, painted by John Brown and entitled 'Cottage in which Turner Died, Chelsea' (Vassar College, Frances Lehman Loeb Art Center, 1864.2.1109). Like Archer, Brown made other studies of famous people's residences, a growing

trend in this period which Brian Lukacher has
aptly described as hagiographic topography.[6] SS

1 For a thorough account of Turner's life in Davis Place and the
 subsequent history of the house, see Piggott 2011.

2 Archer 1862.

3 See Guiterman 1989, p.7.

4 Wroth 1907, pp.1–24.

5 'The House of John Dryden, Fetter Lane'; and 'House of Milton, and
 Tree Planted by Him', in Archer 1851. A watercolour of 1850 by Archer
 (private collection) is inscribed 'House of Sir Isaac Newton at 35 St
 Martin's Street, Leicester Square'.

6 See Lukacher 1999, p.24. Brown's watercolours in the collection of
 Vassar College include 'Sir Isaac Newton's Observatory' (n.d.) and
 'The Room in which George Stephenson, the Engineer was born at
 Willington [sic], Northumberland' (1857).

4
Letter from J.M.W. Turner to J.H. Maw,
7 December 1837

The British Library. BL ADD. MS. 50119, fol. 35
Exhibited London only

SIR ANTHONY CARLISLE (1768–1842)

Practical Observations on the Preservation of Health, and the Prevention of Diseases; comprising the author's experience on the disorders of childhood and old age, etc. London: John Churchill, 1838

The British Library. Shelfmark: 1039.i.32
Exhibited London only

I N HIS LETTER Turner writes about a bad cold he is suffering (as he did most winters as he grew older), and the instructions he has received from his doctor, Sir Anthony Carlisle:

> I am now more than an invalid and Sufferer … from having taken cold … I hope the *worst is now past*, but Sir Anthony Carlisle, who I consult in misfortune says I must not stir out of doors until it is dry weather (frost) I hope he includes, or I may become a prisoner all of the Winter.

Carlisle was seven years Turner's senior and advised him as a physician up until his death in 1840. He had been Surgeon Extraordinary to the Prince Regent (1820), was Surgeon to the Westminster Hospital (1793–1840), and was elected President of the Royal College of Surgeons (1828 and 1837). He had also served as Professor of Anatomy at the Royal Academy (1808–24), where presumably he first met Turner. His interests extended beyond the practice of medicine: he was a member of the Geological Society from 1809 and an expert on molluscs and crustacea. Turner had attended Carlisle's lectures at the Royal Academy and on his retirement from his post there presented him with a watercolour, *Fish-Market, Hastings* (Hastings Museum and Art Gallery).

A pioneer of gerontology in England, Carlisle's *Essay on the Disorders of Old Age and on the means for prolonging human life* (1817) was cited by subsequent authorities. He insisted that the ordinary causes of death in old persons were diseases and not, as many still assumed in the early 1800s, the mere exhaustion of age. He saw senility as a condition susceptible to amelioration by diet, exercise and moderate living, all of which promoted not only bodily health but also a good psychological balance.[1] The book was deliberately designed for the common reader, 'principally … persons already

advanced in years', and he brought out a new edition in 1838. It is certainly possible that during a routine consultation the artist and his doctor, respectively sixty-two and seventy years old in 1837, talked more generally about the *Essay*, about old age and its effects on bodily and mental functions.[2] SS

1 Carlisle 1817.
2 See Carlisle 1838.

6

Turner's Palette Case and Spectacles

Wood, glass, paint and metal
Case 29.5 × 35.5
The Ashmolean Museum, University of Oxford
Exhibited London only

THESE SPECTACLES were taken from Turner's studio after his death and presented to the University Galleries, Oxford, by John Ruskin in 1861. The power of their lenses (+3 and +4) suggests that they were designed for close work, probably in the preparation of finished watercolours in the later 1820s and 1830s when Turner reached his fifties and, like most adults of that age, was subject to presbyopia (age-related long-sightedness). The extraordinary amount of detail included in Turner's topographical series and vignettes, especially in the staffage that populates so many of these scenes, would have required the ability to work with accuracy at very close range. In addition, the finesse of his watercolour technique, with careful, fine stipplings and minute touches of colour as he brought an image to completion, would have been impossible without the ability to focus on the paper.

Turner's eyesight continues to be the subject of much speculation. Conjectures about his acuity of vision have hovered about his art for a considerable time, both during his life and after it. Some of his critical enemies dressed up their discomfort with Turner's style by recourse to insinuations that his vision was defective. As early as 1815, Sir George Beaumont described *Crossing the Brook* (Tate) as '*weak* and like the work of an Old man, one who had no longer saw or felt colour properly; it was all of peagreen insipidity'. In 1837, as noted by Brian Livesley above (p.27), the critic for *Blackwood's Magazine* made sarcastic speculations about damage to Turner's eyes from 'the glare of his own colours'. Beyond this kind of knocking copy, ophthalmologists and other medical investigators have used his later paintings as evidence of progressive degeneration of his eyesight. These enquiries began with Richard Liebreich, an ophthalmic surgeon at St Thomas Hospital, who in 1872 presented an academic paper to the Royal Institution in which he concluded

that Turner must have suffered from cataracts.[1] Livesley's essay in the present volume (p.25–31) proposes some possible confirmation of this, and identifies further potential problems, from a modern clinical perspective.

Reliable contemporary evidence of the health of Turner's eyes is elusive, however. The photographer J.J.E. Mayall, who photographed Turner in the mid-1840s, told the artist's biographer Walter Thornbury that Turner sat for him 'in the act of reading; a position favourable for him on account of his weak eyes and their being rather bloodshot'.[2] On the other hand, all other accounts of Turner's eyes in his later life concur that they were clear, brilliant and showed no evidence of disease. None of these contemporary witnesses had medical training, however, so their testimony is not conclusive either way. SS

1 Liebreich 1872.
2 Thornbury 1877, p.349.

7
Turner's 'Chelsea' Palette
Wooden palette with paint on its
surface 33.6 × 43
Labelled 'Used at Chelsea'
Tate Gallery Archive, TGA 871/15
Exhibited London only

THIS PALETTE WAS used by Turner at the end of his life, when he lived with Sophia Booth in Davis Place, Chelsea. It has been analysed by Joyce H. Townsend, whose research shows that it contains a wide selection of pigments, including zinc white mixed with lead white, and a scarlet lead chromate, which were only available in the 1840s. The paint on the palette seems to have been mixed by Turner, combining a variety of pigments. Although its overall appearance is dominated by pinkish browns and greens, colours unlike those associated with Turner's paintings of this period, its range of pigments is comparable to those found in his studio after his death and includes cochineal lake, Mars red, chrome scarlet, scarlet madder, vermilion, Mars orange, chrome orange, smalt, Prussian blue, ultramarine, viridian, emerald green, chrome yellow, pale lemon, yellow ochre, brown ochre, lead white, lamp black and bone black.

Turner used a wide variety of pigments over the course of his career and took advantage of new additions developed by colour merchants, such as the firm of Winsor & Newton. For example, the green pigment viridian, which had been developed in the 1830s, was first used by Turner in a painting of 1842; orange vermilion was available from the mid-1830s and first used by him in a picture exhibited in 1843; barium chromate, used in lemon yellow, was patented in the early 1840s and first used by Turner in 1843; while chrome scarlet is listed in a Winsor & Newton catalogue of the early 1840s.[1] SS

1 See Townsend 1993.

8

W<small>ILLIAM</small> P<small>ARROTT</small> (1813–69)
Turner on Varnishing Day ?c.1840
Oil paint on panel 25 × 24.2
Collection of the Guild of St George, Museums Sheffield
Exhibited London only

'V<small>ARNISHING</small> D<small>AYS</small>' were the short period set aside for members and Associates of the Royal Academy to varnish and put the final touches to their paintings before the annual exhibitions opened to the public. The same privilege was available to exhibitors at the British Institution. Turner was a keen supporter of the practice. When it was proposed to curtail it, he is reported to have said: 'Then you will do away with the only social meetings we have, the only occasions on which we all come together in any easy unrestrained manner. When we have no varnishing days we shall not know one another.'[1]

Accounts of Turner's activities on these occasions include his work on *The Burning of the Houses of Lords and Commons* (cat.89) and *Regulus* (cat.78) at the British Institution and *The Fighting Temeraire* (fig.17, p.34), *Rain, Steam, and Speed* (cat.97) and *Undine Giving the Ring to Massaniello* (cat.120) at the Royal Academy. It has also been surmised that *The Hero of a Hundred Fights* exhibited at the Academy in 1847 (cat.111) was reworked during the Varnishing Days. In the later 1830s and 1840s especially, Turner's practice on these occasions was characterised as bringing to completion canvases that had been little more than lay-ins when submitted to the exhibition. However, recent technical analysis has thrown some doubt on just how unfinished the pictures Turner sent in actually were. His fellow artists may have regarded them as insubstantial, but theirs was a relative judgement based on their own standards of finish. Yet, irrespective of how much work was required to complete his pictures, there is no doubt that Turner's procedures on these occasions were distinctive. His single-minded and seemingly magical transformation of the canvas into a completed picture amounted to a virtuoso demonstration of the art of painting – the equivalent of the bravura performances of musical prodigies such as the violinist Niccolò

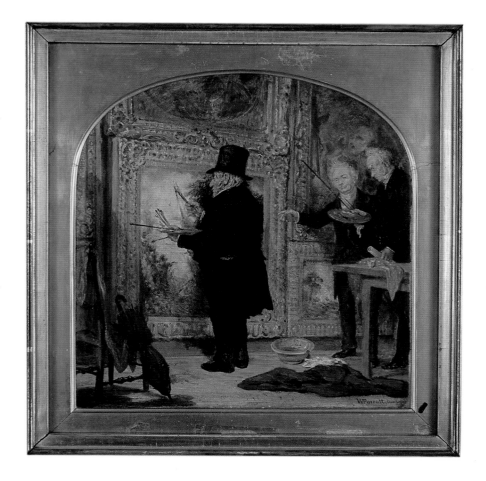

Paganini that were so much admired at the time.

Parrott shows Turner modifying a large, upright canvas, rather unlike the formats he used most frequently at this stage in his career unless it is *Mercury and Argus* (cat.77) being readied for its second exhibition at the British Institution in 1840. It may be, however, that we should better understand Parrott's painting as a generalised homage to Turner, rather than an eyewitness document. Its presentation recalls Charles West Cope's oil sketch of c.1828 (National Portrait Gallery, London), which shows Turner painting, standing on a bench, apparently in the Royal Academy Schools, with the porters looking on. SS

1 Taylor 1860, p.135.

9

DANIEL MACLISE (1806–70)

Noah's Sacrifice exhibited 1847

Oil paint on canvas 206 × 254
Leeds Museums and Galleries (Leeds Art Gallery)
Exhibited London only

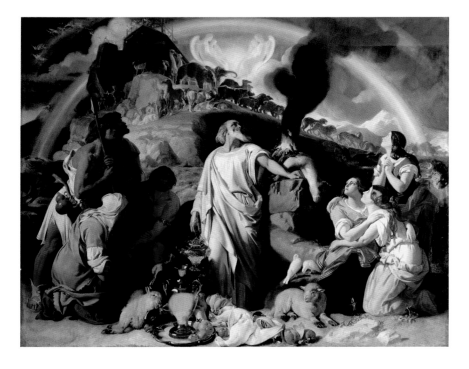

MACLISE WAS A generation younger than Turner. He first exhibited at the Royal Academy in 1829 and was elected ARA in 1835 and RA in 1840. His work throughout the 1840s was concerned principally with historical subjects, interspersed with portraits. In the exhibition of 1847 this painting was hung alongside Turner's *Hero of a Hundred Fights* (cat.111). In his memoir of Turner, George Jones recounts in amusing detail how Turner helped Maclise improve his picture.

Turner: 'I wish Maclise that you would alter that lamb in the foreground, but you won't.'

Maclise: 'Well, what shall I do?'

Turner: 'Make it darker behind to bring the lamb out, but you won't.'

Maclise: 'Yes I will.'

Turner: 'No you won't.'

Maclise: 'But I will.'

Turner: 'No you won't.'

Maclise did as Turner proposed and asked his neighbour if that would do.

Turner (stepping back to look at it): 'It is better, but not right.'

He then went up to the picture, took Maclise's brush, accomplished his wish and improved the effect. He also introduced a portion of the rainbow, or reflected rainbow, much to the satisfaction of Maclise, and his work remained untouched.[1]

Jones wrote his account of Turner's assistance to Maclise expressly to refute those who claimed his friend was unwilling to provide advice. It is also a counterweight to those better-known anecdotes of Turner using Varnishing Days competitively or to eclipse his rivals. Indeed, Turner seems to have been especially attentive to his younger colleagues during the 1847 Varnishing Days. He enhanced Solomon Hart's *Milton Visiting Galileo when a Prisoner of the Inquisition* (Wellcome Institute, London) by adding Galileo's concentric system of planets to the wall behind the astronomer, and also advised John Rogers Herbert on his painting *Our Saviour Subject to his Parents at Nazareth* (replica in Guildhall Art Gallery, London).

Turner's very different approach to the story of Noah, *Light and Colour (Goethe's Theory) – the Morning after the Deluge* (cat.118) had been exhibited at the Academy four years earlier. It had not depicted the rainbow as such, but as prismatic bubbles. His longstanding fascination with rainbows culminated in his reworked picture *The Wreck Buoy* shown at the Royal Academy in 1849 (cat.110). SS

1 George Jones, 'Recollections of J.M.W. Turner' in Gage 1980, p.8.

The Angel Troubling the Pool c.1845

Graphite and watercolour on paper 22 × 29

Tate D36120; TB CCCLXIV 273

THE SUBJECT of this watercolour comes from St John's Gospel in the New Testament (John 5:2–4):

Now there is at Jerusalem by the sheep market a pool, which is called in the Hebrew tongue Bethesda, having five porches. In these lay a great multitude of impotent folk, of blind, halt, withered; waiting for the moving of the water. For an angel went down at a certain season into the pool, and troubled the water; whosoever then first after the troubling of the water stepped in was made whole of whatsoever disease he had.

This description is the prelude to the miracle of Jesus curing a man who had been ill for thirty-eight years, but was unable to make use of this traditional place of healing because he was too infirm to push his way through the crowd into the pool. Seen thus, the angel's action and the sick waiting to take advantage of the waters is a more ambiguous image than it might appear.

Turner relocates the scene to an Alpine landscape, for reasons that are unclear. It is just possible that he was musing on the religiously inflamed situation in Switzerland in 1844 and 1845, especially the Freischarenzüge, when armed secularist radicals invaded the canton of Lucerne to expel the Jesuits by force. But it is more likely that the image has a personal meaning, triggered by an experience in Switzerland that had reminded him of the decline of his health as he approached seventy. Or, perhaps, the image alludes to someone close to him, such as Hannah Danby, who had looked after his house and studio in Queen Anne Street since 1809. From reports of those who visited the premises towards the end of Turner's life, Hannah was suffering from a severe facial disfigurement, which required her to swathe her head in flannel.

Turner had first painted biblical subjects when he was in his twenties, exhibiting five ambitious historical pictures from the Old Testament between 1800 and 1805. He also seems to have considered working up a picture on the subject of the life of Jacob, c.1805, judging from the titles he jotted down in his *Studies for Pictures: Isleworth* sketchbook.[1] A further three pictures with biblical subject matter were painted in the early 1830s and he produced five vignette illustrations with biblical content for John Macrone's edition of Milton's *Poetical Works* (1835). In the 1840s he exhibited four pictures, all of them included in this exhibition (cats.113, 117, 118, 119), that are best interpreted as meditations on the Bible story and its spiritual implications.

Although Turner's religious beliefs are not known, it is recorded that in the later 1830s he attended St Mark's Chapel to hear the Revd Edward Daniell preach. Daniell was also a talented artist and he and Turner had become exceptionally close friends after Daniell moved to London in 1835. He resigned his curacy in 1840 to travel in the Middle East and died of malaria in 1843, much to Turner's grief. SS

1 Tate D05580 (TB XC 56a).

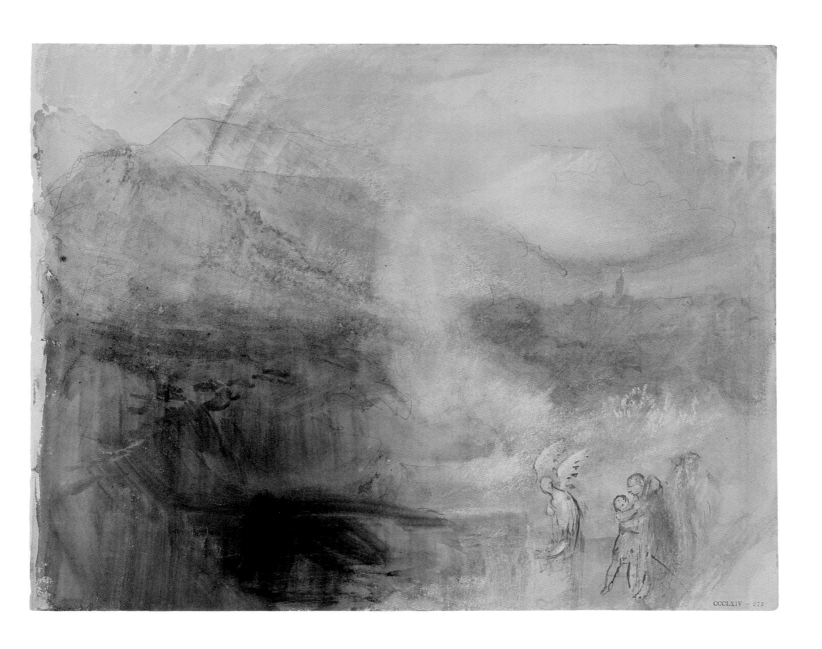

CCCLXIV — 273

11

Brighton Beach, with the Chain Pier in the Distance, from the West c.1827, reworked after 1843

Oil paint on canvas 91.3 × 121.9
Tate N01986
Exhibited London only

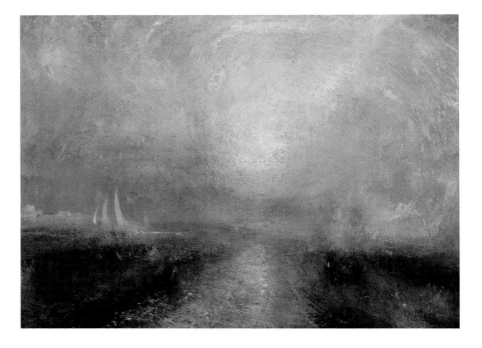

FIG.36
Yacht Approaching the Coast c.1840–5
Oil paint on canvas
102.2 × 142.2
Tate N04662

TURNER MADE repeat visits to the fashionable resort of Brighton throughout the 1820s after the completion of its 1,100-ft Chain Pier in 1823. He placed this feat of engineering at the centre of a painting he made around 1827 for the decorative scheme at Petworth House, the Sussex seat of the Third Earl of Egremont, a major patron and friend of Turner's who died in 1837. Also thought to originate from 1827, *Brighton Beach, with the Chain Pier in the Distance* offers only a slight intimation of the pier's elegant structure; indeed, the haze through which we read the townscape of Brighton most likely contributed to the initial identification of this subject as Hastings upon its discovery in a storeroom of the National Gallery in 1906.

Ian Warrell has suggested that the present painting – like so many of Turner's works – emerged from the artist's compulsive competitiveness, in this case with John Constable's *Chain Pier, Brighton*, exhibited in 1827;[1] there is indeed a distinct compositional parity between the two. Turner injects drama by sweeping the viewer into the sea, placing us at a distance from the stability of the land, heralding the direction in which his seascapes of the 1840s would head: away from the shore and out to sea (see pp.192–5).

Like *The Wreck Buoy* and *Hero of a Hundred Fights* (cats.110, 111), *Brighton Beach* was subject to later reworking; unlike them, however, it was never finished nor exhibited. So why might Turner return to this painting fifteen years or more after having started it? Scientific analysis has revealed damage to the original sky, possibly caused by rain from the leaking roof in Turner's Queen Anne Street gallery, which was notoriously dilapidated by the late 1830s.[2] Turner's revisitation of this painting may therefore have arisen from the simple need to repair it. The retouchings are datable by his use of yellow barium chromate, a pigment not available before 1843, but also by the chaotic charge of this reworked sky. Clouds descend in curves to create wispy vortexes of the kind seen in works of around the same date such as *Snow Storm – Steam-Boat off a Harbour's Mouth* (cat.95) and *Yacht Approaching the Coast* (fig.36).

Turner may have also been inspired to revisit this canvas by enhanced connections with Brighton: the town was home after 1840 to his solicitor George Cobb, and after 1841 was accessible by rail from London, much to the artist's excitement.[3] Possible evidence for Turner's regular presence in Brighton in this decade comes in the form of a letter from an unnamed female correspondent quoted in the first biography of the artist by Walter Thornbury: 'October 6, 1843. Brighton – J.M.W.T did not go with us or join us this year.'[4] Though this evidence is slight, it contributes to a broader profile of Turner as someone who was continually drawn to the coast not just for its skies and atmospheric horizons but also for the social scene to be found there. Still, *Brighton Beach, with the Chain Pier in the Distance* was left unfinished, a status likely never to be explained. AC

1 Ian Warrell, 'J.M.W. Turner in Brighton' in Beevers 1995, p.37. See also Solkin 2009.

2 Joyce H. Townsend, Tate Conservation Department Analysis Report, 1991.

3 Letter from Turner to George Cobb, 7 October 1840, quoted in Gage 1972, p.43.

4 Thornbury 1862, II, p.97.

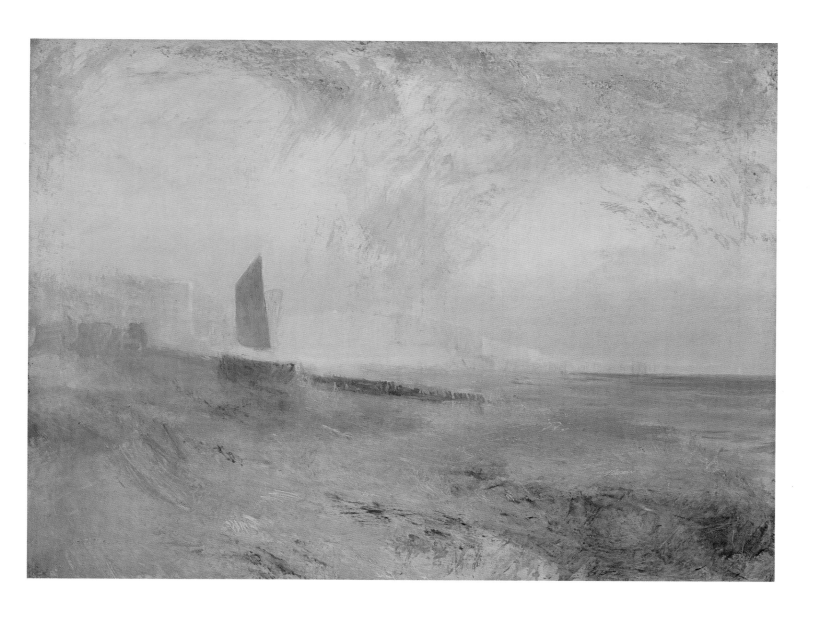

12

Sun Setting over a Lake c.1840–5

Oil paint on canvas 91.1 × 122.6

Tate N04665

Exhibited London only

IN LATER LIFE, especially in the 1840s, Turner reaped the benefit of decades of experimentation with new pigments and materials, working with a brighter palette in more expressive, tactile ways. He painted a number of bold sketches and studies in oil depicting effects like this fiery sunset over water, which, like many comparable watercolours, seem to have been made entirely for his own pleasure or instruction and were certainly not exhibited or sold. They have often been called abstract, because their 'subjects' seem indistinct or ambiguous, veiled in mist or dissolved through light. More probably, such natural or optical processes *were* the subject, and seem to be acknowledged by the artist's comments (to Ruskin in 1844) that 'atmosphere is my style' or (to a likely patron) 'indistinctness of my fault' (or

'forte', depending how his words were heard). If modern aesthetic terms can be applied at all to these elemental images, they might be better described as expressionist, both in their execution and powers of emotional suggestion; and when they appeared in finished pictures like *War. The Exile and the Rock Limpet* (cat.116), writers like Ruskin imputed all sorts of doleful meanings to Turner's bloodshot skies.

While critics have been unable to agree whether works like *Sun Setting* are finished or were abandoned in progress, the paint surface is often densely layered and worked. Here, its structure hints at solid forms such as mountains on the right, and its tones at a shape like a low building or a boat reflected on the water below. DBB

13 Reassembled sheet of four works.

Clockwise, from top left:

Fiery Sunset off the Coast c.1841–5
Watercolour on paper 18.5 × 23
Tate D27596; TB CCLXXX 79

Bridge with Sunlight, possibly Coblenz
c.1841–5
Graphite and watercolour on paper 18.3 × 22.9
Tate D27602; TB CCLXXX 85

River or Coastal Subject: ?Light Towers
c.1841–5
Graphite and watercolour on paper 18.5 × 23
Tate D27600; TB CCLXXX 83

*A Figure Study, possibly for 'The Angel
Standing in the Sun'* c.1841–5
Watercolour on paper 18.6 × 23
Tate D27595; TB CCLXXX 78

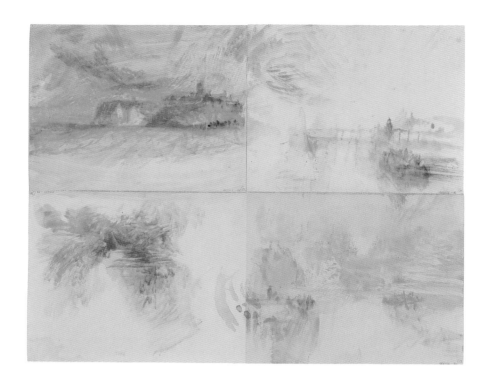

THE WAY IN WHICH Turner's works on paper are presented to us today – largely uniform in size and bearing one image per sheet – is not necessarily reflective of the process by which those images were made, or the state in which they may have been found upon his death. Turner would purchase his paper in large sheets and, though he might cut them down into smaller sheets before drawing, it was not uncommon for him to work up a number of images on one sheet. The point at which the four images here were divided is not known but their reassembly provides much insight into Turner's working methods.

Turner's energetic scrubbing on and driving of paint about the sheet's surface renders his construction of these images more immediately obvious than their subject matter. Though they are predominantly coastal subjects, definition of form was seemingly not Turner's objective. Instead his focus appears to be the behaviour of his materials, be it a new brush, or type of paper. As Peter Bower has observed, although Turner purchased his favourite papers in bulk, an increasing diversity of paper is to be found in his later work.[1] This sheet is representative of the new breeds of paper manufactured from the early 1800s to meet a growing demand for specialist watercolour materials. It is embossed 'Extra Superfine Drawing Board' and composed of three layers of paper, watermarked 1841, plied together to form the board and glazed to give a smooth surface.[2]

On to this smooth surface Turner has cast his images in a limited but bold palette of red, blue and yellow, most likely working quickly across them one colour at a time. At the top left is *Fiery Sunset off the Coast*, which overlaps the image on its right, thought to depict the bridge at Constance or Coblenz. This then ebbs into the sun-flooded bay below it, featuring a cliff at the left with boats floating in the foreground. Compositionally, these works echo many of Turner's previous productions, leading Bower to describe them as 'remembrances'.[3] This also explains the sheer speed with which they have been laid down, so entrenched was coastal imagery in Turner's imagination in the early 1840s.

If these three sketches are evocations from memory, the potential anomaly here is the inverted image at the bottom left, thought to be a sketch for *The Angel Standing in the Sun*, a painting not exhibited until 1846 (see cat.119). Yet, whether remembering, recasting or inventing anew, this sheet opens a window on Turner's studio and his cerebral process of experimentation. Be it with a new motif or new materials, they evince the speed and ease with which his mind conjured images both observed and imagined. AC

1 Bower 1999, p.13.
2 Ibid., p.115.
3 Ibid., p.118.

14

GEORGE JONES (1786–1869)
*Interior of Turner's Gallery;
The Artist Showing his Works* after 1851
Oil paint on millboard 14 × 23
The Ashmolean Museum, University of Oxford.
Presented by Mrs George Jones, the artist's widow, 1881
Exhibited London only

15

*Turner's Body Lying in State,
29 December 1851* after 1851
Oil paint on millboard 14 × 23
The Ashmolean Museum, University of Oxford.
Presented by Mrs Jones, the artist's widow, 1873
Exhibited London only

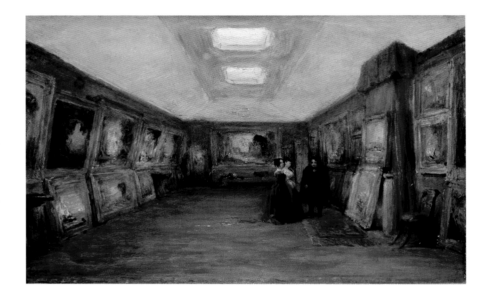

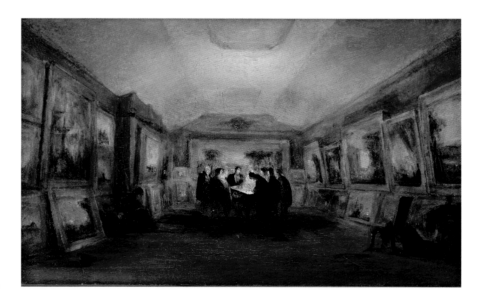

TURNER DIED at his cottage in Davis Place (now part of Cheyne Walk), Chelsea, on 19 December 1851 and his body was transferred to his former house in Queen Anne Street soon afterwards, where it was placed in the centre of the gallery there. The funeral took place on 30 December. Jones recorded Turner's interment in another painting: *Turner's Burial in the Crypt of St Paul's* (fig.9, p.22).

These two pictures of the gallery are of exceptional interest as records of its appearance. Turner had designed it himself, hanging his pictures against a red wall covering and making use of top-lighting diffused through tissue paper spread on netting. The two paintings show the room from different ends, allowing Jones to include all the works hanging there. Research on his presentation has allowed the pictures on display to be identified, most obviously perhaps *Dido Building Carthage* (National Gallery, London) seen on the end wall in *The Artist Showing his Works* and *The Battle of Trafalgar, as Seen from the Mizen Starboard Shrouds of the Victory* (1806–8, Tate) on the left wall in *Turner's Body Lying in State.*[1]

By all accounts, the gallery was in considerable disrepair in Turner's final years, unheated, the roof leaking and the pictures deteriorating, but Jones shows it unimpaired as a tribute to Turner's achievement. There is an element of symbolism here, too, with the daylight of *The Artist Showing his Works* replaced by candle light in *Turner's Body Lying in State*. Moreover, the source of illumination in the latter picture is so close to the coffin as to suggest that Turner's legacy will remain as radiant as his works.

George Jones specialised in battle scenes and historical subjects. He was ten years younger than Turner and probably got to know him in the 1820s. He became one of his closest friends, sharing his passion for angling as well as his devotion to the Royal Academy. In his will of

1831 Turner named him as one of the trustees of his proposed charitable institution for decayed artists and as one of his executors. Jones was also instrumental in encouraging Robert Vernon to buy Turner's work. After the painter's death he helped to arrange and catalogue the Turner Bequest. SS

1 For a detailed online presentation,
 see http://www2.tate.org.uk/turner/gallery3d.htm.

16

Attributed to THOMAS WOOLNER (1825–92)

Death mask of Turner 1851

Plaster 25.4 × 17.8 × 20.6
National Portrait Gallery, London. NPG 1664
Exhibited London only

A FTER TURNER DIED on 19 December 1851 a death mask was made. This is traditionally attributed to the sculptor Thomas Woolner, a member of the Pre-Raphaelite Brotherhood then at the outset of his career. In the previous two years, unable to secure good commissions, Woolner had been making portrait medallions, including those of Alfred Tennyson, Thomas Carlyle and William Wordsworth. It is presumed that he made this death mask with a view to producing a medallion or a commemorative bust of Turner, but his emigration to Australia in 1852 perhaps caused him to abandon the plan.

Woolner was a deep admirer of Turner, writing in 1859 that 'there is a charm in his things that attracts me more than the paintings of almost any other artist'.[1] In the 1870s he was elected to the Royal Academy and as his fortunes improved he bought pictures by Turner. He owned a version of the oil painting *Neapolitan Fisher Girls Surprised Bathing by Moonlight* (?1840; private collection) and, briefly, *Whalers* (1845; Metropolitan Museum of Art, New York), and he also acquired three Turner watercolours of the 1790s, as well as one from Turner's Rhine series of 1817.

Woolner's daughter Amy recalled seeing two casts in her father's studio, this copy being whiter than the other.[2] Another copy was later acquired by Dr Crawford J. Pocock of Brighton and Hove, who was a friend of George Cruikshank and of John Ruskin. Pocock's art collection contained drawings by Ruskin, William Blake's *Death on a Pale Horse* (c.1800; Fitzwilliam Museum, Cambridge), D.G. Rossetti's red chalk portrait of Ruskin (1861; Ashmolean Museum, Oxford) and a large number of engravings after Turner, including a very fine set of the *Liber Studiorum*. Most of the collection was auctioned in 1891 and the death mask was subsequently purchased by the artist and drawing master William Ward.[3] Ward had been Ruskin's most trusted copyist

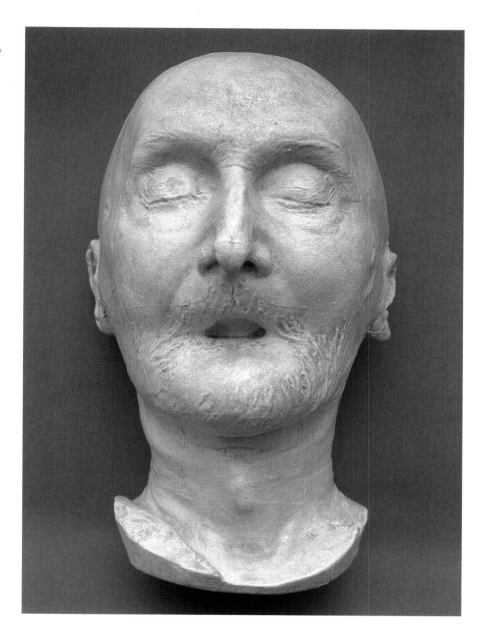

of Turner watercolours from 1858, but he abandoned such work in about 1890 as the strain on his eyes began to tell. In compensation, from the mid-1880s he had turned increasingly to art dealing.[4] SS

1 Woolner 1917, p.169.

2 National Portrait Gallery Archive.

3 Hutton 1894, p.142.

4 Ward 1922, p.42.

Turner Elsewhere: Travel and Tours 1835–45

Nicola Moorby

IT WOULD BE DIFFICULT to overemphasise the importance of travel in Turner's life and its role in stimulating his artistic development. Unlike his contemporary John Constable, who focused on familiar places and who never crossed the Channel, Turner's approach to landscape was characterised by a restless wanderlust that time and again drew him away from home in search of inspirational scenery. Describing the process as being 'on the wing', Turner cherished the special insights that visiting somewhere lent to the act of depicting it and he became acutely attuned to the physical, cultural and emotional nuances of place.[1] These potent responses were channelled directly into his paintings, informing not only their subjects but also their style, substance, and even at times their technique. Throughout his life the lure of 'elsewhere' constituted a creative imperative that led him all over Britain and Europe, and the frequency and variety of his travels ensured that his landscape vision was always fresh, vital, and above all, unique.

Turner first caught the travel bug as a young boy of sixteen when a trip to the West Country of England provided the impetus for several finished watercolours. From this moment on travelling became a critical part of his *modus operandi* and he placed particular value on gathering first-hand knowledge of the world as an artist-tourist. Sketching campaigns became a regular fixture in his calendar and it was an unusual year in which he did not leave London at least once. These expeditions usually took place during the summer and early autumn but far from being holidays, they were planned and pursued with professional rigour and purpose that paid rich dividends. Armed with the paraphernalia of the travelling artist (guidebooks, maps, sketchbooks, pencils and portable paints; fig.37), Turner would set off shortly after the closure of the Royal Academy exhibition in July and return weeks or months

later, with countless drawings documenting in minute detail the many miles he had covered and the sights he had seen.

Turner's heavy reliance on sketchbooks meant that he accumulated tens of thousands of sketches which function as the pictorial equivalent of a 'stream of consciousness' or a shorthand written account of his travels. This ceaseless activity was borne out by the artist and photographer William Lake Price who, encountering Turner on a steamer on Lake Constance during the 1840s, described how he 'held in his hand a tiny book, some two or three inches square, in which he continuously and rapidly noted down one after another of the changing combinations of mountain, water, trees, &c., which appeared on the passage, until some *twenty* or more had been stored away in an hour-and-a-half's passage'.[2] Such books filled with on-the-spot memoranda were arguably the most precious tools of Turner's trade, their spines and covers carefully labelled so that, on his studio shelves, he could quickly reference locations and itineraries such as *Copenhagen to Dresden* and *Rotterdam to Venice* (cats.17–19).

Travel was central to Turner's creative routine and the pattern of his touring habits remained virtually unchanged over the years. However, his choice of destinations did not. During his youth, the outbreak of war between Britain and France had effectively closed down travel to the Continent and the first half of Turner's career was, of necessity, characterised by journeys in and around the British Isles. Only after 1815, when the Battle of Waterloo brought a decisive end to the Napoleonic Wars, was travelling abroad once again a viable option and Turner was finally able to go overseas. By this time the artist had reached middle age. He was successful, well regarded and financially secure, and already widely recognised as one of the pre-eminent British painters of the day. Yet despite his considerable achievements, he must have

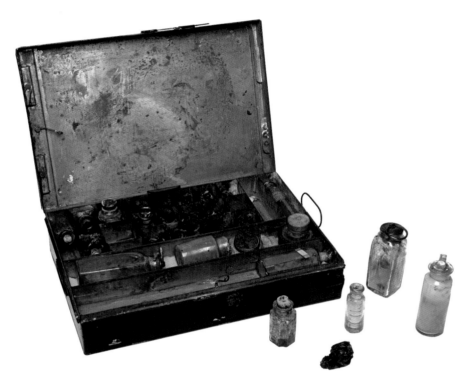

ambitious of all his journeys, travelling as far as Denmark and Bohemia. Ten years later, failing health could not prevent him making two trips to France, although he had in truth hoped to return to Switzerland and even to climb the Rigi.

What did this renewed access to Europe mean for Turner in the mature phase of his career? What did he find abroad that he had not uncovered in the Britain of his younger years? And how did his later travels come to define the appearance and content of his later work? Certainly the discovery of new lands and landscapes injected vibrant new flavours into his art. For example, there is the heightened colour palette already evident from the 1820s onwards and at least partly inspired by his experience of Mediterranean sunshine. Similarly, the speed and smokiness of modern modes of transport such as steamboats might be argued to have contributed to the increasing lack of finish characterising his later pictures. At the same time, new histories and mythologies presented themselves as grist for his fertile imagination, leading to paintings on themes as varied as the parallels between ancient and modern Italy (cats.81, 82), the faded glories of Venice's illustrious past (cat.50) or contemporary German culture (*Opening of the Wallhalla*, cat.96). Aside from such instances where travel had a direct impact on Turner's work, his later tours refreshed his creative output more generally, reinvigorating his joy in landscape and firing his imagination to new flights of fancy. As long as he could, he continued to be a stalwart traveller, undaunted by the rigours and challenges of nineteenth-century tourism, the limitations of language or even by various health concerns from stomach upsets to rabies. This steadfast streak reflects more widely the tireless, indefatigable nature of his evolving creativity.

One area of productivity which got a new lease of life was the artist's illustrative work for topographical engravings. These published

harboured a sense of regret and frustration, arising not only from an unfulfilled yearning for foreign climes but also a nagging feeling that his artistic education was still incomplete, lacking as it did the requisite finish of a European 'Grand Tour' and, above all, a sojourn in Italy, the birthplace of classical civilisation and the foundation for British taste and learning at this time. Following the return of peace, Turner eagerly took advantage of the new freedoms open to British tourists and the second half of his career saw a sustained exploration of many parts of Europe. The Continent became his oyster and between 1817 and the mid-1840s he undertook no fewer than twenty European tours, particularly focusing on the Netherlands, France, Italy, Germany and Switzerland. He was a plucky and energetic traveller. In 1835, for example, as if to defy any idea that a 60-year-old might begin to take it easy, he made one of the most

FIG.38
The Temple of Poseidon at Sunium (Cape Colonna)
c.1834
Graphite, watercolour and gouache on paper
38.2 × 58.8
Tate T07561. Accepted by HM Government in lieu of tax and allocated to the Tate Gallery 1999

images were very much in vogue in the early and mid-nineteenth century and formed the greater part of Turner's financial bread-and-butter. They also dictated the focus of much of his later travels. His earlier exploration of British countryside, rivers and coastline gave way to a new interest in continental scenery, particularly the major rivers of western and central Europe such as the Rhine, Meuse and Mosel. In addition to the obvious aesthetic appeal of river scenery and the fact that waterways often served as the most effective route between destinations, rivers dominated Turner's understanding of place, providing a natural focal point for all manner of ways of approaching landscape. They often appear in his late work as the setting for broader reflections on history, culture or the condition of contemporary life (cats.29–33).

At the same time, as an artist-tourist Turner was able to share and anticipate the experiences and interests of a wider travelling public caught up in the growing boom for middle-class tourism and eager for pictures, prints and guidebooks. He joined them in the new hotels springing up around the Swiss lakes or in Venice.

His sparkling visualisations of that city were predominantly the product of his later years and among the most potent works of his entire career, creating such a beguiling iconography that generations of artists including James Abbot McNeill Whistler and Claude Monet were subsequently shaped by it.

Yet it is worth remembering that although Turner was irrefutably one of the greatest and most energetic artist-travellers of the nineteenth century, his view was a selective one. He chose to limit his experiences to certain parts of Europe, bypassing, for example, Ireland, Spain, Sicily and the further reaches of the eastern Mediterranean, places that were entering the repertoire of colleagues like David Wilkie, whose death on the way back to Britain from the Middle East Turner poignantly memorialised in *Peace – Burial at Sea* (cat.115). Years earlier, there had been a missed opportunity to visit Greece, which for an artist of his classical mien might have been considered a natural complement to Italy as a must-see destination. This was perhaps Turner's strangest omission, as he had since shown obvious sympathy for

Greek independence from Ottoman Turkey and for the poet Byron's commitment to the cause – and thus had been moved to depict Greece at second hand or from imagination (fig.38). Equally, Turner never seems to have been tempted to attempt longer pilgrimages to some of the other destinations becoming popular with British artists such as Egypt and the Middle East (despite producing biblical-themed illustrations of the Holy Land during the 1830s), or India and the exotic Far East (although he provided topographical views for White's *Views of India*, published 1836–7 (fig.39).

The chosen geographic focus of his tours suggests that he was not merely driven by the desire for novelty, adventure and an appetite for pastures new. Rather, his travels suggest a lifelong quest for something more elusive, a transcendental spirit of place that nourished his instinctive inclination for mood and atmosphere. Both at home and abroad, the most resonant and cherished locations were those where natural wonders coexisted with local aesthetic beauty. Places such as Venice and Lake Lucerne – even Margate – became settings to which he formed strong emotional attachments and returned again and again, both in actuality and through the agency of his art. Not only did they represent the perfect backdrop against which to express universal themes such as the action of natural phenomena and light, the passing of time and the frailties of the human condition. These special, beloved corners of the world also seem to have engendered a deep-seated personal contentment within Turner, perhaps satisfying something he had never been able to realise in his domestic life in London, and providing for a short time a soothing berth for this restless, wandering soul.

1 Letter to Henry Pickersgill, August 1839; Gage 1980, pp.174, 275.
2 Quoted in Wilton 1987, pp.226–7.

17

Studies of Paintings in the Dresden Picture Gallery: Correggio, 'Madonna with St Sebastian' and Watteau, 'Conversation in a Park'; Studies of Paintings by Correggio in the Dresden Picture Gallery ('Madonna with St George'), and the Kreuzkirche, Dresden ('Madonna with St Francis') from the *Copenhagen to Dresden* sketchbook 1835

Graphite on paper; each page 16.2 × 8.9
Tate D31031 and D31032; TB CCCVII 6a, 7
Exhibited London only

18

Coburg: Schloss Rosenau from the Itz Valley from the *Venice: Passau to Wurtzburg* sketchbook 1840

Graphite on paper 12.6 × 19.8
Tate D31318; TB CCCX 22
Exhibited London only

WHEREVER HE WENT, Turner carried pencils and notebooks with him and his sketchbooks cast an illuminating spotlight on his experiences and itineraries.[1] Whether travelling by carriage, boat or on foot, he was constantly sketching and between major destinations he used his sketchbooks sequentially so that turning the pages mirrors the passing of the miles. His travel sketchbooks reveal his wide range of interests when away from home. If the majority of pages are devoted to landscape scenery, other concerns are also very apparent and however crude or schematic the image, every line, dot and dash of pencil echoes the memory of something seen and hoarded for future reference. Decoding these sometimes near-indecipherable memoranda is crucial to appreciating the significance of Turner's European experiences. At first sight sketches from the *Copenhagen to Dresden* sketchbook (cat.17) resemble crude doodles. But when it becomes clear that these are diagrammatic copies of paintings by the Italian artist Correggio in the Dresden Picture Gallery,[2] they become part of Turner's long dialogue with the Old Masters and, more importantly, evidence of one of the main purposes of his 1835 tour of northern and central Europe: visiting the new art galleries and famous picture collections in Germany.[3] Since Turner was not a German-speaker, the same sketchbook also contains several pages which have been given over to useful phrases such as 'Which is the way | Was is die weg', or 'Wie weit ist es | How far is it' in German and English, handy questions that any tourist today might be glad to have at their disposal.[4]

Further sketchbook pages respectively chronicle portions of a later tour: the outward

19

Botzen; Figures on a Hillside
from the *Rotterdam to Venice*
sketchbook 1840

Graphite on paper; each page 8.9 × 14.9
Tate D32318 and D32319; TB CCCXX 29a, 30
Exhibited London only

20

Fribourg: The Convent Vale
c.1841

Graphite and watercolour on paper
23.5 × 33.5
Tate D33553; TB CCCXXXV 13
Exhibited London only

(cat.18) and return (cat.19, Tate D32319) legs of a journey in 1840 through the Netherlands and Germany to Venice. The latter shows Turner's interest in the people he encountered, this time in a town or village near the Austro-Italian border in South Tyrol. He has caught them in quick thumbnail sketches, slight but full of life, and written notes reveal his fascination with their colourful regional costumes, including a hat adorned with 'Red and Green Bells'. Local details like these might later appear in a painting, perhaps to inject human interest into the foreground of a sweeping panorama.

On other occasions there is an explicit link between an on-the-spot sketch and the genesis of a finished picture. A drawing made on the return journey from Venice, for example, depicts Schloss Rosenau, the birthplace of Prince Albert of Saxe-Coburg-Gotha near Coburg in Bavaria (cat.18). Written annotations here remind the artist that the trees lining the banks of the River Itz in the foreground are 'alder' trees and that the tri-band flag flying from the castellated round tower in the upper right-hand corner displays the ducal colours of red and white (labelled as 'R[ed] W[hite] R[ed]').[5] Turner had an obvious interest in the ancestral home of the new husband of Queen Victoria and, probably in a bid to gain royal favour, later developed his pencil composition into a grand oil painting, *Schloss Rosenau, Seat of HRH Prince Albert of Coburg, near Coburg, Germany*, exhibited 1841 (Walker Art Gallery, Liverpool).

Turner's ceaseless sketching habit and interest in topical or significant places did not preclude more reflective exercises in which objective pencil lines were embellished with expressive, even fanciful touches of colour. Cat.20, a single sheet removed from a once-bound sketchbook, is one of several views of the Swiss town of Fribourg employing incipient suggestions of watercolour and red ink over the first pencil outlines. NM

1 For a more extensive discussion of some of Turner's travel sketchbooks, see Nicola Moorby 'An Italian Treasury: Turner's Sketchbooks', in Hamilton 2009, pp.111–17.

2 'Madonna with St George' (top) and 'Madonna with St Francis' (bottom), as identified by Powell 1995, p.234.

3 Ibid., p.46; Ian Warrell, '"Stolen hints from celebrated Pictures": Turner as Copyist, Collector and Consumer of Old Master Paintings', in Solkin 2009, p.54.

4 Tate D31023, TB CCCVII 2 v.; see Powell 1995, p.235.

5 See Powell 1995, under no.107.

21

Mont-Blanc and Le Chetif Looking over Pré-Saint Didier in the Val d'Aosta 1836

Watercolour on paper 25.5 × 27.9

Tate D35964; TB CCCLXIV 121

Exhibited London only

22

Mont Blanc and the Glacier des Bossons from above Chamonix; Evening 1836

Graphite and watercolour on paper 25.6 × 28

Tate D35996; TB CCCLXIV 152

Exhibited London only

TURNER HAD ALWAYS recognised that the most compelling way to gain an understanding of the physical geography of the land was to venture into it on foot. Nowhere was that experience more intense than in the extreme environment of the Alps, the focus of several important tours during the artist's lifetime. Alpine tourism at this time required stamina and courage but for a dauntless traveller like Turner the rewards were enormous. His sketches and paintings of the majestic mountains are some of his most powerful and dramatic statements, inspiring new ideas about the Sublime and its expression within the landscape genre.

Turner's first Alpine tour was in 1802 when he was a young man of twenty-seven. Since then he had crossed the mountains to other European destinations, never tiring of their spectacular beauty, but it was not until 1836 that he undertook another specific expedition, in part retracing his steps from over thirty years earlier through the Swiss Alps to the Aosta Valley in Italy. As in 1802, but unusually nevertheless, he was not alone, accompanied for most of this trip by one of his most enthusiastic patrons, the Scottish landowner H.A.J. Munro of Novar. The two men sketched side by side and from Munro we have valuable anecdotal evidence about Turner's working habits. Apparently he had a preference for lofty 'bird's-eye' viewpoints which lent distance and height to his sketches. He worked quickly and silently, pouring his enthusiasm for the scenery into his drawings rather than rhapsodising about it in words.[1] He sketched in pencil on the spot and only brought his paints out later at overnight stops at inns,

his memory as well as his paints colouring his daytime efforts. As he did so, he insisted on using a sponge to create misty, aerial effects.

Munro's recollections help us to appreciate the apparent naturalism and immediacy of Turner's 1836 colour studies of Mont Blanc and the Aosta Valley (cats.21, 22). According to David Hill, these works were not intended as preliminary stages for later paintings but were meant to capture as nearly as possible the shifting dynamism of the meteorological conditions and the sharp clarity of the mountain environment. They helped the artist 'to focus and structure the process of observation, and thereby intensify the quality of the experience itself' and, as such, are 'sufficient and entire unto themselves'.[2] Of particular delight is the way Turner has used delicate touches of pink and lilac to gild the pristine snow-capped peaks with hints of rosy evening light in *Mont Blanc and the Glacier des Bossons from above Chamonix; Evening*. NM

1 Munro's account informed Walter Thornbury's *Life of Turner*, published in 1862, the relevant section of which is reproduced in Hill 2000, p.263.

2 Hill 2000, p.261.

23

Inscription by Turner: recollection of verse composed for the painting *Snow-Storm: Hannibal and his Army Crossing the Alps*, and *Looking up the Val d'Aosta from below Verres to Issogne Castle* from the *Fort Bard* sketchbook 1836

Graphite on paper; each page 10.4 × 14.8
Tate D29325, D29326; TB CCXCIV 60a, 61
Exhibited London only

24

***From Sarre looking towards Aymavilles, Val d'Aosta* 1836**

Watercolour and gouache with scratching out on paper
23.7 × 29.8
The Syndics of the Fitzwilliam Museum (Given by the Friends of the Fitzwilliam Museum, 1932)
Exhibited London only

Yet the chief advanced, looked on the Sun/Weak wan and broad skirting [deleted] with hope/When the fierce archer of the downward year/Stained [original word altered] Italy Blanched with storms/ In vain the fierce Salassis barrd his way/Or rolling rocks the advancing foe oerwhelmed [inserted: fell trechery found]/Which the loud winds sobs Capua joys beware

Hannibal crossing the Alps

ROAMING AMIDST THE Alpine peaks and valleys in 1836, Turner was able to explore a host of mountain settlements with their remote churches, castles and impressively situated bridges. Tireless in his search for the best viewpoints, he used hard leather-bound sketchbooks to make rapid pencil sketches on the spot. One of these books he named Fort Bard after a fortress at the entrance to the Aosta Valley that had been a strategically significant site during the Napoleonic Wars. A double-page spread from this sketchbook reveals his profound sensitivity to the historical background and ambience of a place. One side contains a rough but recognisable sketch looking south-east along the lower Aosta Valley towards the castle of Issogne near Verres. Opposite it, Turner has scribbled lines of verse as he tries to remember a poem he had written to accompany an 1812 painting of Hannibal crossing the Alps.[1] The familiar experience of struggling through difficult terrain and coping with harsh weather, coupled with his proximity to places only recently conquered by Napoleon, brought his former thoughts on the Carthaginian general to mind. Even though his memory of the words was imperfect, the spirit of his musings on Hannibal's battles with local Salassian tribesmen and hostile elements was still keenly felt.

Turner's reconnection with the Alpine landscape led to renewed engagement with the Sublime, a major aesthetic concept which had formerly preoccupied the artist during his twenties and thirties. In addition to informal, naturalistic coloured impressions like cats. 21 and 22, the 1836 trip gave rise to more developed, highly worked watercolour studies. The compositional structure of *From Sarre looking towards Aymavilles*, for example, shows greater attention to the recessional space and depth within the profiles of the landscape and, rather than consisting of simple washes of colour over rough pencil jottings, the textural appearance of the watercolour reveals that Turner has rubbed, scratched and manipulated the painted surface, and added gouache in places to add a degree of opacity. These exercises provided the starting point for a sensationally atmospheric oil painting, *Snow-Storm, Avalanche and Inundation – A Scene in the Upper Part of the Val d'Aouste, Piedmont* (Art Institute of Chicago) which the artist exhibited at the Royal Academy in 1837 (fig.13, p.28).[2] NM

1 *Snow Storm: Hannibal and his Army Crossing the Alps* (Tate N00490); see Hill 2000, p.290; Butlin and Joll 1984, no.126; Warrell 2007, p.52.

2 Butlin and Joll 1984, no.371. See also Warrell 2007, no.108, reproduced p.154.

25

The Confluence at Namur: Moonlight c.1839

Gouache, watercolour and ink on blue paper 14.2 × 19.1

Tate D24716; TB CCLIX 151

Exhibited London only

26

*Mézières, with the Pont de Pierre and
Church of Notre-Dame* c.1839

Gouache and watercolour on blue paper 13.9 × 19.3

Tate D24731; TB CCLIX 166

Exhibited London only

27

Brussels: The Diligence c.1839

Gouache, watercolour and ink on paper 14 × 19.5

Tate D24784; TB CCLIX 219

Exhibited London only

28

*The 'Promenade de Sept-Heures'
at Spa* c.1839

Gouache, watercolour and ink on blue paper 14 × 18.9

Tate D24753; TB CCLIX 188

Exhibited London only

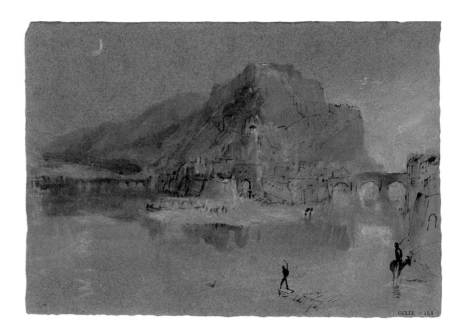

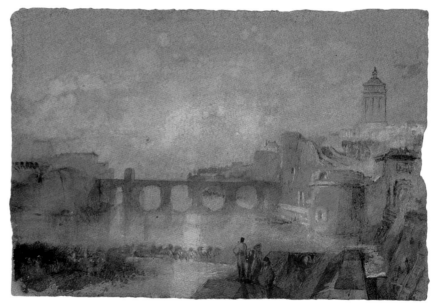

Turner's later travels often focused on the great rivers of Europe as he assembled the groundwork for series of picturesque illustrations, aimed at the buoyant market for engraved topography. During the mid-1820s and early 1830s he toured in France, absorbed by the beauties of the Loire and Seine. This led to publications featuring views of both French rivers, seemingly intended as the first instalments of a larger, annual issue of works dedicated to European river scenery. Probably with this aim in mind, he set off again in 1839, crossing the North Sea to Ostend in Belgium and trekking east towards Liège, whence his itinerary took him on an international loop encompassing sections of three major rivers, the Rhine, Meuse and Mosel (a tributary of the Rhine, known in French as Moselle).[1]

This second Meuse-Mosel tour was, in part, a repeat of a similar expedition undertaken fifteen years earlier in 1824. Turner did, however, also include some non-river vistas from his journey through Belgium and detour to Spa, a town famous for its mineral springs (after which all such watering places are named. See cats.27 and 28). He also made a unique set of twenty views

in the small Duchy of Luxembourg. In its entirety the series shares many stylistic similarities with Turner's earlier illustrations of the Loire and Seine. Yet there was nothing blasé about his work in 1839. The tour resulted in a spectacular series of over a hundred coloured studies, notable for their extraordinary and unrestrained chromatic brilliance. Like the French river watercolours, the Meuse-Mosel images were painted on small rectangles of blue paper, mostly torn from sheets manufactured by one of his favourite papermakers, George Steart of Bally, Ellen & Steart at the De Montalt Mill, Bath.[2] This choice of paper was key to the distinctive appearance of the series as its natural blue shade lent depth and intensity to the local colour laid on it or served as a colour in its own right.

As was Turner's customary practice, the Meuse-Mosel paintings were based on a vast body of on-the-spot pencil sketches accumulated in the sketchbooks he carried with him throughout his tour. Leafing through their pages reveals how valuable the drawings were for developing later compositions. Turner obviously relied on them for selecting his motifs and mapping out the topography of each location with an accuracy which memory alone could not have supported. The view of Mézières on the Meuse in France for example (cat.26) is derived from an outline study of the relative positions of the river, the bridge (Pont d'Espérance) and the adjacent church of Notre-Dame d'Espérance, but the detailed re-creation of the classical church tower is based on several other precise sketches found within the same book.[3] What the sketchbooks do not supply, however, is the intense and exotic colouring which floods the scene, recasting it as a triumphant evocation of sunset. This was the product of Turner's memory or, perhaps more truthfully, his imagination. A red sky at night has always been very much an artist's delight but no other painter had ever dared to depict it quite as flagrantly as Turner. NM

1 For the itinerary and dating of the tour, see Powell 1991, pp.45–54.

2 See Bower 1999, pp.89–90.

3 See Powell 1991, no.103, p.164. Also the forthcoming catalogue entry for TB CCLXXXVIII by Alice Rylance-Watson in David Blayney Brown (ed.), *J.M.W. Turner: Sketchbooks, Drawings and Watercolours*, http://www.tate.org.uk/art/research-publications/jmw-turner.

29

St Martin's Church, Cochem c.1839
Gouache and watercolour on blue paper 19 × 13.9
Tate D20253; TB CCXXI T
Exhibited London only

30

The Leyen Burg at Gondorf c.1839
Gouache and watercolour on blue paper 13.8 × 18.8
Tate D24588; TB CCLIX 23
Exhibited London only

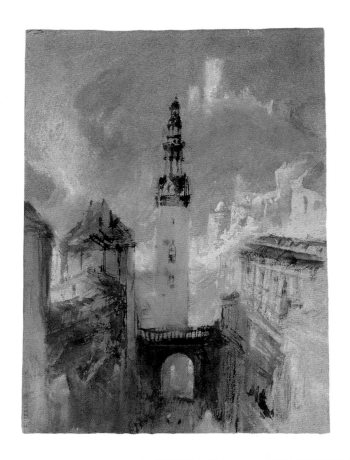

THESE FOUR COLOUR STUDIES depict scenes from the Mosel stage of Turner's 1839 tour. As so often with the views he drew and painted that year, the prospects are determined by the scenic spectacle of a ruined *burg* (castle) or tower perched on a rocky eminence at the bend of the river, such as the 'yellow' castle of Metternich at Beilstein on the Mosel (cat.33), or a picturesque framing of a shoreline bridge and town with water winding

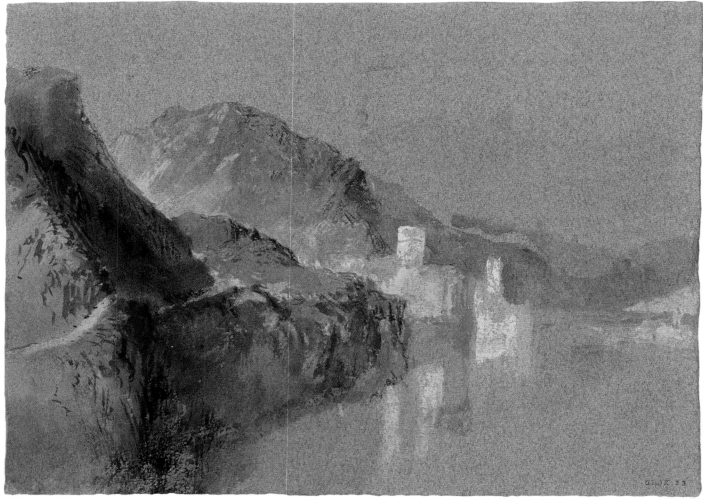

31

The Ruined Monastery at Wolf c.1839

Gouache and watercolour on paper 14.1 × 19

Tate D24717; TB CCLIX 152

Exhibited London only

32

Burg Treis c.1839

Goauche and watercolour on blue paper 14 × 19

Tate D24735; TB CCLIX 170

Exhibited London only

33

*'The Yellow Castle', Beilstein on
the Moselle* c.1839

Watercolour with some scratching out on paper
16 × 23.5

The Syndics of the Fitzwilliam Museum

(Given by The Friends of the Fitzwilliam Museum, 1933)

Exhibited London only

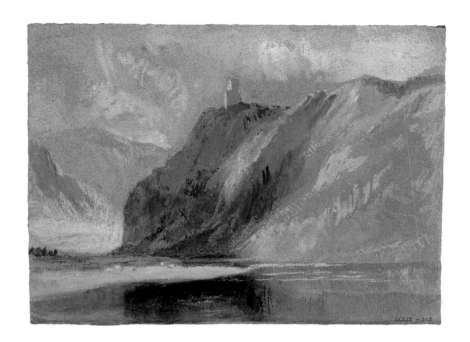

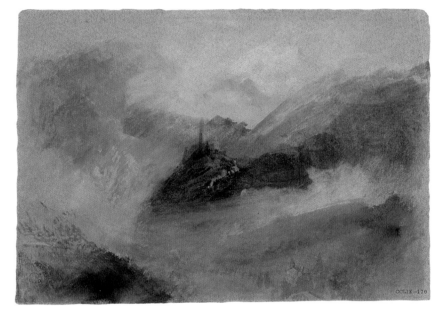

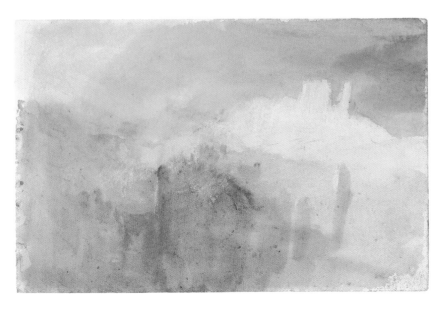

through the centre. Typical is Turner's vivid and emotive use of colour in counterpoint with the blue of the paper support, which has sometimes been left bare in areas of sky or river so that it becomes an integral part of the composition. This is particularly effective for the depiction of reflections such as the ghostly mirror image of the white tower of the Leyen Burg at Gondorf (cat.30), or to suggest ripples interrupting the glass-like surface of the river at Wolf (cat.31).

The toned paper provides a perfect backdrop for Turner's bright pigments, applied both as watercolour and in extensive patches of gouache. Note, for example, the foggy opacity of the cloud wreathing the heights of Burg Treis (cat.32) and the elegant solidity of the architecture at Cochem (cat.29). Occasionally Turner supplemented his use of paintbrushes with fine additions in pen and black ink, which lends yet another dimension to his depiction of place and highlights the contrast between the lightest and darkest polarities of a view. Devices such as these helped with the process of translating his images into black-and-white prints and Turner excelled at assisting his engravers in their quest to match the superlative quality of his use of tone and colour. Unfortunately the Meuse-Mosel studies never reached the stage of being engraved and European rivers publications beyond those covering France remained one of the great, unrealised projects of his career. NM

34

The Fortress and Town of Ehrenbreitstein from Coblenz from the *First Mossel and Oxford* sketchbook 1839

Graphite on paper; each page 14 × 23.5
Tate D28303, D28302; TB CCLXXXIX 7, 6a
Exhibited London only

35

A Steamer and Passengers at a Pier: ?Ehrenbreitstein from Coblenz c.1841

Watercolour, gouache and pen on paper 24.3 × 34.3
Tate D36137; TB CCCLXIV 284
Exhibited London only

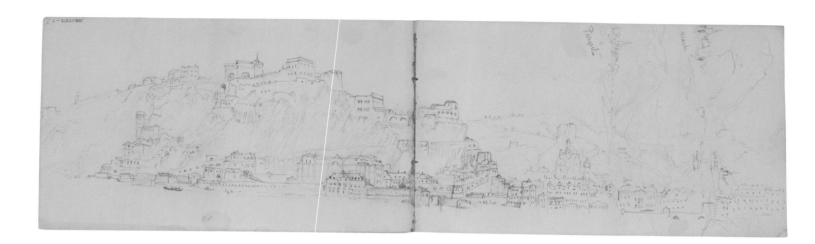

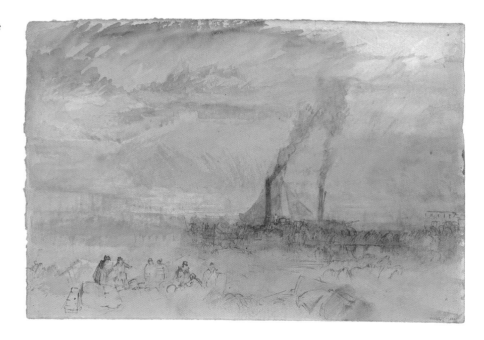

ONE OF THE FEATURES of German landscape that Turner found so appealing was the picturesque profusion of castles lining the banks of the major rivers. Among the most impressive of these was Ehrenbreitstein, an immense fortress facing the town of Coblenz at the confluence of the Rhine and Mosel rivers. One contemporary guidebook aptly described it as 'The Gibraltar of the Rhine'.[1] Turner had first come across the site in 1817 and over the years it became one of his favourite Germanic subjects, appearing in numerous pencil and watercolour sketches. The sketchbook drawing, *The Fortress and Town of Ehrenbreitstein from Coblenz*, dates from his tour of the Meuse-Mosel region in 1839, when the artist returned to the location for the third time. Despite his familiarity with the spot, his professional interest in it remained undiminished. The fortress had undergone extensive reconstruction during the intervening years and this sketch is an extremely accurate and descriptive record of the newly restored building as seen from the opposite side of the river.

Ehrenbreitstein also formed the subject of an 1835 oil painting (cat.88), in the title of which Turner translated the German word as 'bright' rather than 'broad'. However, his error was strangely apposite and he was evidently particularly struck by the way the bulk of

castle and rock take on the fiery colours of the setting sun. In 1841 he painted a sequence of watercolours of Ehrenbreitstein under different lighting conditions and featuring a progression of technicolour effects (cats.36, 37).[2] The finer points of the architecture, so carefully documented in his earlier sketchbook drawing, have now all but disappeared and the castle merges into one with the rock as a broad, contoured mass of colour. This treatment of landscape using a formal arrangement of colour might almost be

36
Ehrenbreitstein 1841
Watercolour and ink on paper 23.7 × 30
Tate D36206; TB CCCLXIV 346

37
Ehrenbreitstein 1841
Watercolour and pen on paper 25 × 31.5
Tate D36138; TB CCCLXIX 285

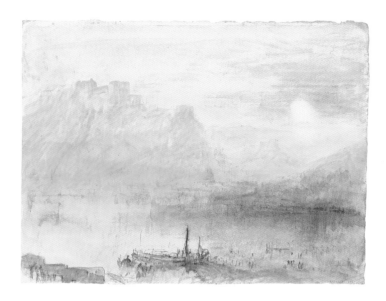

described as abstract, although Turner's handling of the paint varies from very loose washes to minute flickering brushstrokes. He also includes moments of human interest, such as the bridge of boats which connected the two sides of the river and which can be seen as the calligraphic sequence of black strokes stretching across the centre of cat.37. Visible in the foreground of cat.36, meanwhile, is a paddle-steamer, a new form of transport which the artist frequently used in later life. Steamers are a central feature of another study perhaps depicting Ehrenbreitstein from Coblenz (cat.35).[3] They came to be one of the great symbols of modernity in Turner's work (see, for example, cat.95). NM

1 John Murray, *A Handbook for Travellers on the Continent*, London 1840, p.266.

2 See Powell 1995, nos.115–21, pp.188–90.

3 Warrell 1995, p.41, has suggested that the view could as easily be of Dover.

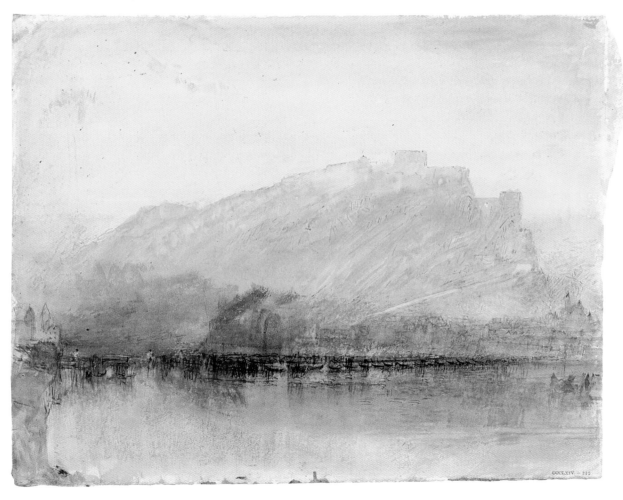

38
Heidelberg: Sunset c.1842

Watercolour, gouache and pencil on paper 38 × 55.2
Manchester City Galleries

Turner's late German subjects deserve to be counted alongside his Venetian and Swiss imagery as amongst his most sophisticated articulations of landscape. *Heidelberg: Sunset* is one of a series of paintings featuring the famous university town and is a magnificent example of a finished watercolour from the last decade of Turner's life.

Turner had first visited Heidelberg in 1833 on his way through Germany and Austria to Venice; he returned seven years later in 1840 and again in 1844. Of obvious picturesque appeal in its own right, the town's situation on the Neckar, a major tributary of the Rhine, brought it into Turner's wider exploration of that great European river and his understanding of German history and culture. This watercolour is one of a pair dating from the early 1840s which both depict the view looking upstream from the right side of the river. Spanning the Neckar in the centre is the elegant old stone bridge that leads towards the Old Town (Aldstadt) on the opposite bank, with the distinctive spire of the Gothic Church of the Holy Spirit (Heiliggeist Kirche) to the right, and the ruined castle lying across the brow of the wooded hill known as the Königstuhl (King's Chair or Throne) beyond. Turner's first version of the prospect, *Heidelberg, with a Rainbow* (c.1841; private collection) depicted the town sparkling in sunshine after a shower of rain.[1] Here, however, he elicits a more romantic ambience with the right-hand side of the composition bathed in evening sunlight and the dusky blue of night encroaching from the left. A pearly white moon peeps out from behind the hills in the east and casts a faint, luminescent glow onto the thready clouds above.

The whole work is a technical tour de force, demonstrating the extraordinary control that Turner had over his medium by this stage of his life and the arsenal of effects he could call upon in his portrayal of atmosphere. A profuse variety of processes, including wet wash, stippling, scratching out and the use of gouache, are brought together in seamless harmony. Perhaps the most satisfying element of the picture, however, is the juxtaposition of the buttery yellows and pinky-oranges with the complementary intensity of ultramarine and cobalt blue.

Turner remained much engaged by Heidelberg during the mid-1840s and made several watercolour sketches and a near-finished oil painting (Tate N00518) which drew upon a pertinent British connection to the town. During the seventeenth century Heidelberg Castle had been the home of Elizabeth, eldest daughter of James I, who in 1613 married Friedrich V, the Elector Palatine. Known as the 'Winter Queen' because of her short-lived reign, she was nevertheless grandmother to a later British monarch, the Hanoverian King George I. The Heidelberg oil was perhaps intended to form a pendant with another work featuring modern German references, *The Opening of the Wallhalla, 1842*, exhibited in 1843 (cat.96). NM

1 Reproduced in Shanes 2000, no.102, p.224. See also Powell 1995, no.127, pp.197–8.

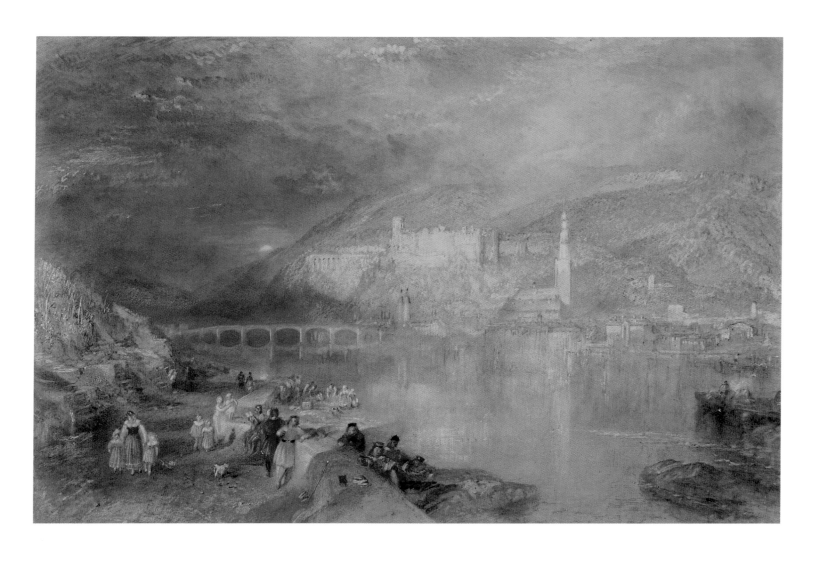

39

Lausanne from the South-West from the
Rhine, Flushing and Lausanne sketchbook
c.1841–2

Graphite on paper; each page 10.7 × 17.5
Tate D33254 and D33253; TB CCCXXX 11, 10a
Exhibited London only

TURNER VISITED SWITZERLAND for several
weeks each year from 1841 to 1844. The
first visit was his most wide-ranging tour
of the country, when he travelled all the way
from Lake Constance in the German north-east
to Lake Geneva in the French-speaking south-
west.[1] A significant stop during the later stages of
his itinerary was Lausanne, the hilly city situated
on the shores of Lake Geneva (known in French
as Lac Léman). Having already tarried there
once, as part of his 1836 journey towards the
Swiss Alps (cats.21, 22), he was familiar with the
layout of the old town with its prominent citadel.[2]
This did not stop him venturing out again and
making further sketches of some of the more
striking landmarks, particularly the cathedral of
Notre-Dame, seen here in a pencil sketchbook
drawing from the south-west (cat.40). An even
greater pull, however, was exerted by distant
views of Lausanne from the valley to the west
and also from above the city looking south-east
across the lake towards the mountain known
as the Dent d'Oche. Using these prospects as a
starting point Turner initiated a significant group
of watercolours notable for their dream-like use
of colour. The two examples shown here adopt
a near-identical compositional format, with
the picture plane equally divided between sky
and land (or lake) and the horizon punctuated
by the profile of the Dent d'Oche. Turner
explored a very similar motif in his sequence of
watercolours featuring the silhouette of the Rigi
mountain on Lake Lucerne (cats.152–6).

Both images illustrate lighting effects
arising late in the day. Cat.40 depicts sunset
with the landscape saturated in orange, pink
and yellow and the cypress trees casting long
shadows upon the hill in the foreground.
The soft twilight of cat.39 engenders a more
melancholic, contemplative mood, which serves
as an appropriate backdrop for the human

narrative played out in the foreground. A solemn
procession of figures can be seen progressing up
the hill from left to right, the line culminating
in a rectangular form that appears to be a coffin
on a bier. The watercolour has hence long been
known as *Funeral at Lausanne*, although this was
not a title that originated from the artist.

In 1857, six years after Turner's death,
Ruskin published the first catalogue featuring
some hundred previously unknown preparatory
and unfinished watercolours from the Turner
Bequest. Ruskin selected examples of Turner's
late watercolour studies and presented them in
the guise of an imaginary European tour from
northern France, up the Rhine into Switzerland,
down through Italy to Venice and back again.[3]
Each picture was elucidated by written
information which incorporated perceptive
commentary about Turner's technical effects but
could occasionally be unfashionably opinionated
or downright negative. He described this last
watercolour as 'Out and out the worst sketch
in the whole series; disgracefully careless and
clumsy, but too beautiful in subject to be left
out'.[4] NM

1 See Warrell 1995, p.11. Also Ian Warrell, 'Turner in Switzerland',
 in Gabathuler, Howard and Warrell 2013, p.17.

2 See Hill 2000, pp.268–9.

3 See Warrell 1995.

4 Quoted in Warrell 1995, p.142.

40

Funeral at Lausanne 1841
Graphite and watercolour on paper 23.5 × 33.7
Tate D33526; TB CCCXXXIV 2

41

*Lake Geneva, with the Dent d'Oche,
from above Lausanne* 1841
Graphite and watercolour on paper 23.5 × 33.8
Tate D33534; TB CCCXXXIV 10

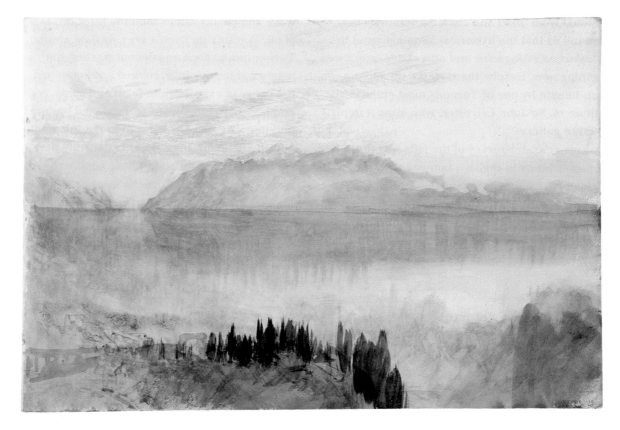

Venice: The Rio di San Luca, with the Palazzo Grimani and the Church of San Luca ?1840

Gouache and watercolour on paper 19.4 × 28.2

Tate D32216; TB CCCXVII 31

Exhibited London only

The Porta della Carta, Doge's Palace c.1840

Gouache, graphite and watercolour on paper 30.5 × 23.4

Tate D32247; TB CCCXVIII 28

Exhibited London only

TURNER HAD FIRST seen the city of canals and water in 1819, aged forty-four, and again in 1833 when he was in his late fifties, but the most important visit was his last when, in August 1840, *en route* to Germany, he spent a fortnight at the Hotel Europa on the Grand Canal (see cat.61). Judging by the amount of visual material he managed to accumulate during this time, not a moment of the two weeks can have been wasted. As was his custom on tour, and as he had done on his previous visits, he ranged all around the streets, piazzas and quays with pencil and sketchbook in hand, amassing in the process around two hundred topographical drawings. More unusually, he also embarked on an energetic and sustained flurry of painting and, courtesy of his travelling watercolour palette, produced an extraordinary series of over a hundred coloured Venetian studies. These views are beautifully expressive and quite unlike his depiction of any other city to date. Yet even the most finely resolved examples must be considered unfinished. It is possible therefore that Turner intended to use them as preliminary samples designed to obtain commissions, rather like his later 'sample studies' of Swiss scenery (see pp.222–35). Rather than being entered in his customary leatherbound or board-covered books, they were painted on loose sheets of paper or within a couple of larger 'roll' sketchbooks, so-called because their soft paper covers enabled them to be rolled up for ease of portability. They range from dazzling loose evocations on white paper (cat.53) to more sombre cityscapes on grey, blue or buff sheets (cats.51, 52), and finally to a sequence of mysterious nocturnal views utilising opaque gouache on a darker grey-brown

CCCXVIII – 2 8

paper (cats.56–8). Together they represent an enchanting and lyrical ode to Venice, revealing not only how Turner saw the city but also how he felt about it.

Turner's survey of Venice took in many of its most celebrated landmarks like the Porta della Carta, the magnificent and ornate ceremonial entrance to one of the city's most famous buildings, the Doge's Palace in the Piazza San Marco (cat.52). He also sought out unfamiliar corners and vistas, such as an unusual view from the Rio San Luca, one of the narrow channels leading off the Grand Canal. The study looks north-west from the church of San Luca (far right-hand side) towards the back elevation of the Palazzo Grimani (centre), a sixteenth-century palace more often pictured looking directly across the Grand Canal towards its Renaissance façade. Turner recorded both motifs in pencil before repeating the subjects using a combination of watercolour and gouache to portray the interplay of light and shadow across the architectural surfaces. NM

53

Venice: The Zitelle, Santa Maria della Salute, the Campanile and San Giorgio Maggiore from the Canale della Grazia 1840

Graphite, watercolour and pen on paper 24.3 × 30.5

Tate D32156; TB CCCXVI 19

Exhibited London only

54

Fishermen on the Lagoon, Moonlight 1840

Watercolour on paper 19.2 × 28

Tate D36192; TB CCCLXIV 334

PROBABLY THE MOST powerful factor in Turner's later appreciation of Venice was his absolute mastery of watercolour, and his ability to exploit its characteristic material properties using the most melting and luminous effects. The Lagoon, the canals and the way the grand Venetian architecture was softened within myriad reflections all seemed to him perfect themes for the use of wet-in-wet, the application of liquid washes of colour on wet or damp paper so that the paint diffuses and outlines appear indistinct and blurred. His instinct for depicting Venice in this way had been evident in a small group of watercolours dating from 1819, which, at the time, represent the most exceptionally expressive and limpid use of wash to date.[1] By 1840 Turner had a further twenty years of watercolour practice behind him, including decades honing the wet-in-wet technique in his private and experimental landscape studies

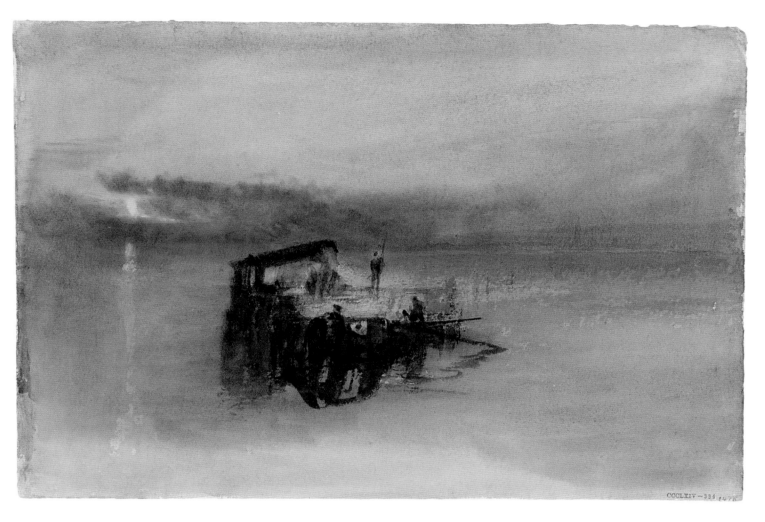

known as 'colour beginnings'. In Venice he was able to bring that experience to bear and, coupled with his very personal and subjective response to the city, he achieved the perfect union of style and subject, producing some of the most breathtaking and lyrical wet watercolour studies ever created.

Many of the most atmospheric examples feature the wide expanse of the Lagoon with Venice itself a mere silhouette on the horizon. The majority of these scenes were painted on white paper, the most effective support for showcasing the purity of transparent colours. Cat.53, for example, depicts a view looking towards the heart of the city with the western tip of the Giudecca island on the left and San Giorgio Maggiore on the right. The whole is suffused by the blush tints of dawn, the shifting strength of the light effected by a compositional arrangement based on three primary colours, with the chromatic shift between red, yellow and blue effortlessly achieved by merging the respective washes. By contrast, the pictorial structure of cat.54 is defined by successive

horizontal bands of blues, greens and greys which provide a subtle sense of depth and distance in this delicate moonlit study. The haziness of the background is offset by the stark black solidity of the structure in the central foreground, a wooden platform that provided a useful temporary mooring place for fishermen and other boats on the Lagoon.[2]

As Ian Warrell has noted, the vaporous effects evident here were not exclusive to Turner's depiction of Venice;[3] the artist employed similar tricks and techniques for other subjects both before and after. However, it is the happy marriage of motif and medium which make the 1840 watercolours so special. Venice's unique blend of water and architecture suited Turner's aptitude for images based upon wet-in-wet washes, creating a perception of the city as a place of intangible and dreamy beauty. NM

1 See the watercolours from the *Como and Venice* sketchbook (Tate, TB CLXXXI, D15254, D15255, D15256, D15258).

2 Warrell 2003, p.236.

3 Ibid., p.25.

55
Venice: An Imaginary View of the Arsenale c.1840

Watercolour and gouache on paper 24.3 × 30.8
Tate D32164; TB CCCXVI 27

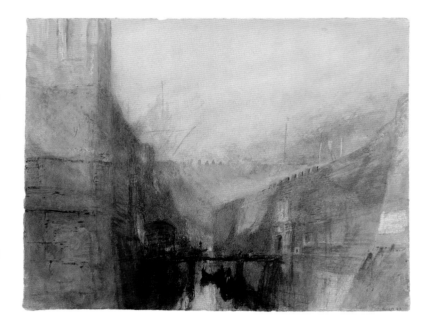

PRIOR TO 1840 Turner had approached his Italian sites influenced by the mighty weight of art historical precedent. His mid-career sketches and paintings of Rome reveal his knowledge of traditional Italian *vedute*, made famous through the prints of Giovanni Battista Piranesi, whilst early Venetian views are essays in the style of another eighteenth-century viewmaker, Antonio Canaletto.[1] He made frequent reference to the classical past and to Renaissance masters such as Raphael, and his whole understanding of Italianate landscape was indebted to Claude Lorrain, the seventeenth-century Frenchman whose paintings represented the epitome of idealised light-filled countryside. These great forebears represented both a paradigm and a challenge to Turner, and his Italian-inspired works reveal how powerfully they overshadowed his outlook, compelling him to build upon their legacy rather than create an entirely new model. All this changed in Venice, however. His experiences during his last visit altered the way he thought about Italy and in his hands the city became as much imagined as real. The need to acknowledge the past gave way to an entirely new way of seeing that was original, personal and predicated on the notion that light was more palpable and present than the physical fabric of the buildings around him.

Although Turner took careful and accurate sketches recording the topography of Venice, he freely altered details, condensed viewpoints and moved landmarks to suit his aesthetic vision. One of his most extraordinary creations is this almost fantastical view of the Arsenale, an important compound of shipyards and armouries situated at the eastern end of the city. Formerly one of the largest and most effective industrial complexes in Europe, its operations had been suspended by Napoleon and by the mid-nineteenth century it was much reduced. On-the-spot sketchbook studies show that Turner was very familiar with the Arsenale's distinctive canal entrance flanked by twin bell and clock towers, and the adjacent land entrance, the Porta Magna, a classical stone gateway surmounted by the city's symbolic winged lion and further sculptures of lions in front. His watercolour, however, recalls little of the actual appearance of the site. The white portal to the right bears some resemblance to the Porta Magna and the tall masts of ships rising at the back indicate the naval presence within. However, the high walls and narrow bridge appear to be figments of the artist's imagination.[2] The source of light is also implausible, so that instead of the view being enveloped in sunshine, a lambent glow seems to emanate from the very bricks themselves. The intense, heightened palette lends a hallucinatory feel to the composition and rather than an exercise in historical topography the image is more in the nature of a rhapsody on the tonal contrast between warm and cool colours, reminiscent of Turner's earlier pictures of the *Burning of the Houses of Parliament* (cat.89). NM

1 For example, *Bridge of Sighs, Ducal Palace and Custom-House, Venice: Canaletti Painting*, 1833 (Tate N00370).

2 See Warrell 2003, pp.126–7.

56
Venice: The Bridge of Sighs, Night 1840
Watercolour and gouache on buff paper 22.7 × 15.4
Tate D32253; TB CCCXIX 5
Exhibited London only

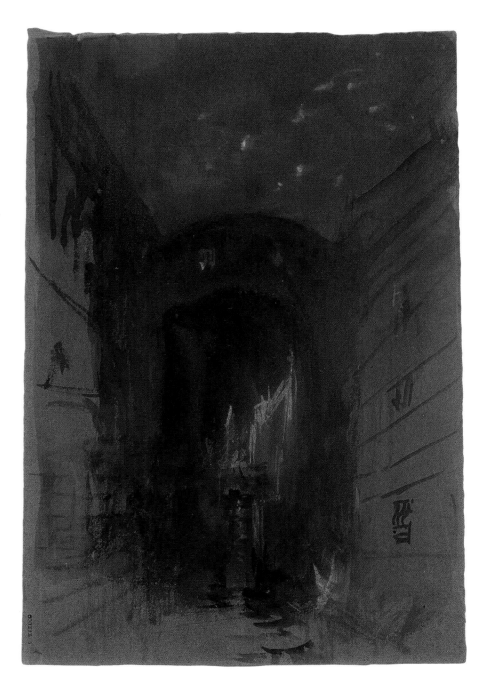

Turner's watercolours reveal that his enchantment with Venice lasted from morning until night. In addition to painting a variety of weather conditions, he depicted the city at different times of day: drenched in the colours of dawn, the midday sun, sunset and twilight, and finally after dark, when airy light gave way to heavy shadows. This depiction of nocturnal Venice was a relatively recent way of viewing the city and can be seen as part of a wider Romantic interest in moonlight and the transformative effects of night. The vogue was taken up within various aspects of nineteenth-century culture, including music (Beethoven's 'Moonlight Sonata' of 1801) and poetry (Turner was familiar with descriptions by Lord Byron and Samuel Rogers), and later reached its apotheosis in the piano 'Nocturnes' of Frédéric Chopin and the paintings of James Abbott McNeill Whistler.

In contrast to the delicate lucidity of the daytime scenes, Turner's night views of Venice are characterised by dusky, velvety skies and dense, murky forms achieved through the use of gouache on dark brown-grey paper. The change from transparent washes on white paper to opaque colours on a tonal ground lent a new dimension to his sensuous exploration of the city. By night Venice is not so much ethereal as obfuscated by layers of darkness that cloak it in sombre mystery. Domes and campaniles picked out in white gouache take on an eerie, spectral quality and the waterways are glassy expanses of impenetrable inky hue. Often Turner chooses to illuminate a scene using a theatrical injection of light such as the dramatic flare of a firework arcing away from the church of Santa Maria della Salute (cat.57) or the brilliant stars piercing the gloom above the Bridge of Sighs (cat.56). In general the delineation of shape and outline is even more cursory than in the loose washes of the sunlit scenes, throwing the chiaroscuro contrast between light and dark into stark relief.

Also related to Turner's nocturnal views is a further sequence of images on brown paper showing unusual glimpses of Venetian interiors (cats.59 and 60). Here the handling of paint is remarkably free and modern in its appearance and more closely resembles the painterly oil

57
Venice: Santa Maria della Salute, Night Scene with Rockets
1840
Watercolour and gouache on buff paper 24 × 31.5
Tate D32248; TB CCCXVIII 29

58
Venice: The Piazzetta, with San Marco and its Campanile; Night
c.1840
Watercolour and gouache on buff paper 15 × 22.8
Tate D32220; TB CCCXVIII 1
Exhibited London only

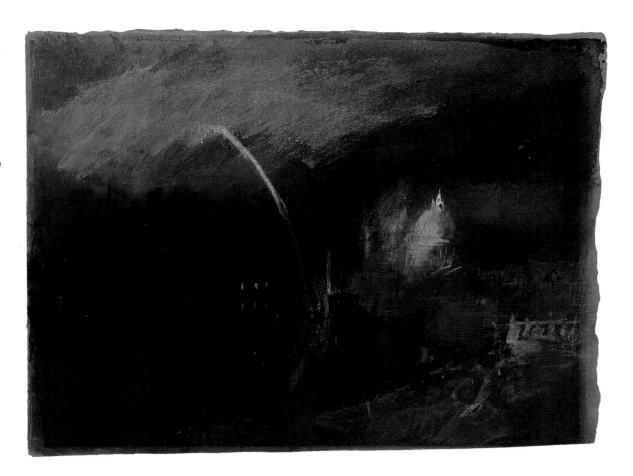

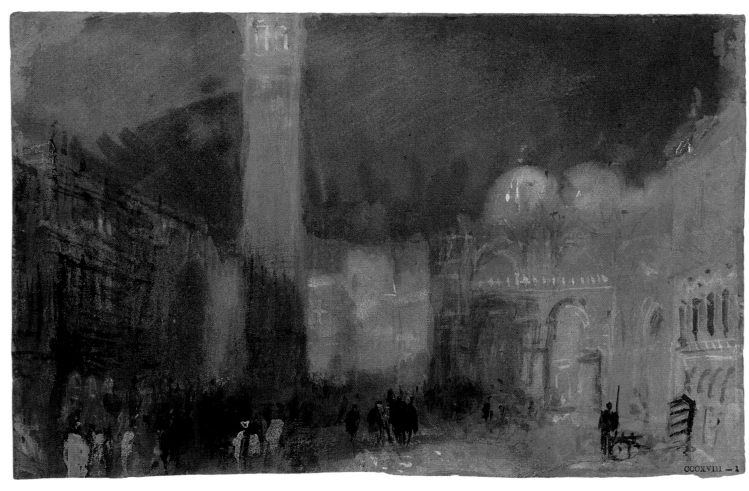

59

Venice: ?The Interior of a Wineshop 1840
Watercolour and gouache on buff paper 23.5 × 31
Tate D32240; TB CCCXVIII 21
Exhibited London only

60

Venice: The Interior of San Marco: the Atrium Looking North 1840
Chalk, goauche and watercolour on buff paper 24.3 × 30.4
Tate D32241; TB CCCXVIII 22
Exhibited London only

surfaces of later artists such as Walter Richard Sickert.[1] Certainly never intended for anything other than private reference, these rapid and instinctive studies seem to throw a sudden and intense spotlight into dark, crepuscular spaces so that they become momentarily alive with accents of white, yellow and red. These range from the vast basilica of San Marco encrusted with mosaics (cat.60) to an unidentified vaulted cellar (cat.59), traditionally understood to be the interior of a wine shop with shelves lined with bottles and flasks, and circular barrels arranged in the foreground. NM

1 See, for example, Robert Upstone, '*Interior of St Mark's, Venice* 1895–6 by Walter Richard Sickert', catalogue entry, May 2009, in Helena Bonett, Ysanne Holt, Jennifer Mundy (eds.), *The Camden Town Group in Context*, May 2012, http://www.tate.org.uk/art/research-publications/camden-town-group/walter-richard-sickert-interior-of-st-marks-venice-r1138998, accessed 2 November 2013.

61

Turner's Bedroom in the Palazzo Giustinian
(the Hotel Europa), Venice c.1840

Watercolour and gouache on paper 23 × 30.2
Tate D32219; TB CCCXVII 34

IT IS NOT CLEAR how much watercolour work Turner actually completed in front of his subject matter. As a rule he preferred sketching on the spot in pencil and only using his paints back in the comfort of his studio, lodgings or hotel room. However, the freshness and vibrancy of the 1840 studies have led to speculation that at least some coloured work during his late Venetian sojourn must have been done out of doors. One group certainly has been identified as deriving directly from the motif and that is a series of views painted from the Hotel Europa, a fifteenth-century palace where Turner stayed during his fortnight's residence in Venice.[1] Conveniently situated at the head of the Grand Canal opposite the Punta della Dogana and within view of the churches of Santa Maria della Salute, San Giorgio Maggiore and San Marco, the hotel, also known as the Palazzo Giustinian, had previously hosted the artist during his earlier visit in 1833. It was obviously an establishment where he felt comfortable and enough at ease to turn his bedroom into a makeshift studio. An unusual snapshot of this space can be seen in an intimate and schematic watercolour study (cat.61). Using his brush as a pencil, Turner has blocked in the main features of his bedroom using broad masses of colour. Despite the lack of detail, we can see that the ceiling was decorated with painted stucco, that the head of the bed was covered by a canopy of yellow curtains and that Turner had at least two east-facing windows opening out onto the stunning panorama towards San Marco.

62

Venice at Sunrise from the Hotel Europa,
with the Campanile of San Marco c.1840

Watercolour on paper 19.8 × 28

Tate D35949; TB CCCLXIV 106

On more than one occasion Turner painted views looking directly out of these windows, as confirmed by an inscription on the verso of one sheet which reads 'From my Bed Room, Venice'.[2] Other studies, meanwhile, reveal that another favoured vantage point was the hotel roof. From here he painted cat.62, recording the prospect looking east over roof terraces and chimney pots towards the glorious spectacle of the sun emerging between the campanile of San Marco and the dome of San Giorgio. Here he worked swiftly, dropping brushloads of liquid orange and red into the surrounding wet yellow wash (a technique known as charging) to describe the effect of daybreak colours staining the sky. Further images can be pinpointed to different times of day, hinting at the artist's compulsion to document the changing Venetian light.

Another guest staying at the Hotel Europa during August 1840 was fellow painter William Callow. He later recalled enjoying an evening cigar in a gondola, catching sight of Turner sketching the sunset from another and feeling 'quite ashamed of myself idling away the time whilst he [Turner] was hard at work so late'.[3] Even when the light failed him, Turner was hardly inactive but was preoccupied with observing, if not actually painting in situ, the mysterious impressions of nocturnal Venice (see cats.56–8). NM

1 See Warrell 2003, p.24.
2 Tate D32140, TB CCCXVI 3.
3 Autobiography, 1908; cited in Hamilton 1997, p.287.

63

The Dogano, San Giorgio, Citella,
from the Steps of the Europa
exhibited 1842

Oil paint on canvas 61.6 × 92.7

Tate N00372. Presented by Robert Vernon 1847

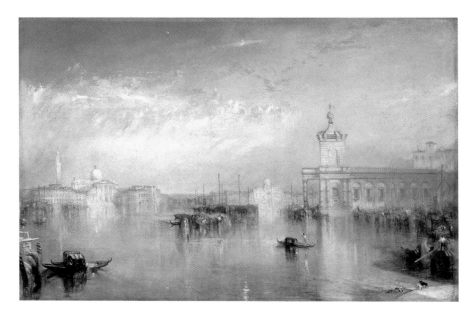

TURNER'S VENETIAN STAY in 1840 resulted
in a series of paintings for exhibition
and sale (cats.63–8). Ever an astute
businessman, he was surely sensitive to the
growing commercial popularity of Venetian
subjects since the 1830s.[1] Between 1840 and 1846
he sold nine such pictures (out of a possible
seventeen), a high success rate at a time when
he was finding it increasingly difficult to find
buyers.

This picture, looking from Turner's hotel, the
Europa, could almost be guaranteed a success.
Situated near the mouth of the Grand Canal, the
Europa provided a good location for sketching
the city's rooftops by day and night as well as
views like this looking across to the Dogana,
and beyond it to the islands of San Giorgio
Maggiore and the Giudecca, where the churches
of Santa Maria della Salute and Santa Maria della
Presentazione, known as the 'Zitelle' (or Citella),
are located. At the Royal Academy in 1842 this
picture was accompanied by another Venetian
subject, *Campo Santo, Venice* (Toledo Museum of
Art, Ohio), showing the cemetery of the Campo
Santo on the island of San Michele. *Campo Santo*
was purchased – and probably commissioned
– by Elhanan Bicknell as a companion work to
another painting by Turner in his collection,
Giudecca, La Donna della Salute and San Giorgio
(private collection), which he had bought in
1841. In 1863, both pictures were said to have
been 'painted expressly for Mr. Bicknell'.[2]
Nevertheless, it is possible that the exhibition
in 1842 of *Campo Santo* with *The Dogano, San
Giorgio, Citella, from the Steps of the Europa* was
intended to invite comparisons between these
two paintings. Together they seem to allude to
the rise and fall of the city, with the Dogana (or
Customs House) symbolising the mercantile
power of Venice in its prime and the Campo
Santo alluding to its subsequent decline. The
point is underlined by the contrast between the
pots shown in the foreground here, on the steps
on the right, which probably represent imported
luxury goods, and the rubbish floating on the sea
in the foreground of *Campo Santo*.[3]

The critics were broadly positive in their
reactions, praising Turner's command of light
and colour and his successful evocation of the
ethereal atmosphere of the city. The *Art Union*
did, however, demur at Turner's reflections
being too strongly painted.[4] His addition of the
black and white dogs, next to the pots in the
foreground, is a characteristic device where the
range of colour and the depth of tone to be found
across the whole painting are compressed into
one small area.[5]

The Dogano was purchased by Robert Vernon
from the Royal Academy exhibition and given to
the National Gallery five years later, as part of
his major bequest of paintings by artists of the
English school. Exhibited there in December
1847, as the token representative of the whole
gift, it was the first painting by Turner to enter
the national collection. SS

1 Warrell 2003, p.24.

2 *The Times*, 27 April 1863, p.12.

3 See Mullen 1979, no.260; Gage
 1983, no.67.

4 *Art Union*, 1 June 1842, p.120.

5 Gage 1983, no.67.

64

St Benedetto, Looking towards Fusina
exhibited 1843

Oil paint on canvas 62.2 × 92.7

Tate N00534

Exhibited London only

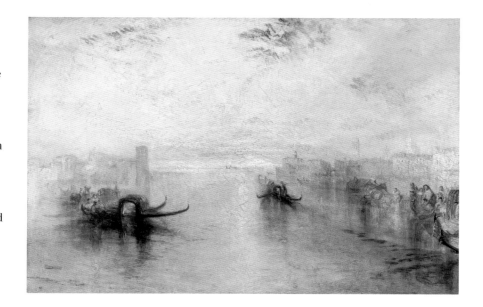

THIS PAINTING was exhibited at the Royal Academy in 1843. Despite remaining unsold (and therefore never leaving the artist's hands), it was described by Ruskin as 'the best Venetian picture of Turner's which he has left to us'.[1]

Like his imaginary view of the Arsenale (cat.55), the painting is a specious representation of the city. Turner would have us believe we are looking along the Giudecca canal towards the port of Fusina on the mainland to the west. Boats and barges drift within the foreground, and one centrally placed gondola points the way to the setting sun at the centre of the composition. However, despite the fact that the view is based on an earlier watercolour study from the *Grand Canal and Giudecca* sketchbook,[2] the artist appears to have invented the details of the buildings lining the waterside and the precise location resists identification. Also puzzling is the titular reference to St Benedetto, as no church of this name is to be found in this district. Yet as a depiction of Venetian landscape the vista is entirely convincing, capturing the spirit and essence of people's idea of the place. As Ruskin eloquently explained, 'without one single accurate detail' it is 'the likest thing to what it is meant for ... of all that I have even seen'.[3]

As ever, the power and impact of Turner's Venice is derived from the stylistic dramatisation of light. At the heart of the design is one of the artist's favourite pictorial devices, an intense concentration of white and yellow pigment which is intended to replicate the dazzling effect of staring directly at the sun. This motif is one which Turner borrowed from Claude Lorrain and which he most famously used in *Regulus*, a painting about a Roman general who was blinded by sunlight (see cat.78). It has been suggested therefore that the reference in the title here is to St Benedict of Nursia (St Benedetto di Norcia), a first-century monk who experienced God's glory as a spectacular vision of light, during which he saw 'the whole world gathered together as it were under one beam of the sun'.[4] NM

1 Quoted in Butlin and Joll 1984, under no.406.

2 Tate D32129; TB CCCXV 13.

3 Butlin and Joll 1984, under no.406.

4 See Warrell 2003, p.194. The life of St Benedict is told in *The Dialogues of Pope St Gregory the Great.*

65

The Sun of Venice Going to Sea exh.1843

Oil paint on canvas 61.6 × 92.1

Tate N00535

SHOWING A VENETIAN fishing boat setting out at dawn, this picture was exhibited with lines from Turner's 'Fallacies of Hope', based on Thomas Gray's *The Bard* and perhaps on Shelley's *Lines Written among the Euganean Hills*. They sound a fatalistic note, warning of a 'demon in grim repose' who 'expects his evening prey'. With its sail painted with boats in brilliant sunshine – a picture within the picture – the boat has been seen as a self-portrait, an autobiographical statement by the ageing artist as well as a metaphor for the rise and fall of the Venetian empire, with implications for the British as their own approached its zenith. Yet unless it is to be found in the putrid water of the Venetian Lagoon, which Turner has painted green (a colour he had previously associated with servitude), there seems little overt pessimism in the picture itself. At least one critic missed it completely, writing that the boat was 'like a thing of life … so gay – so buoyant – so swift'.[1]

As the boat leaves Venice behind, the eastern fringes of the city dissolve in luminous mist. Ethereal, insubstantial, the picture charts a course for Turner's later Venetian oils, seeing the city from ever further away, dematerialising as it slips into memory. Later, Turner's gradual eclipse of Venice began to grate on Ruskin as he discovered his own distinctive mission, to study the city's fabric in detail on the spot. But

in 1843, the year he began publishing *Modern Painters*, he fell in love with this picture, even being thrown out of the Royal Academy for trying to copy it. Next year, seeing it again in Turner's Gallery, he told the artist it was his favourite: 'I said the worst of his pictures was one could never see enough of them. "That's part of their quality", said Turner.'[2] In Venice in September 1845, Ruskin was granted a reincarnation of the picture when, at six one morning, 'out came a fishing boat with its painted sail full to the wind, the most gorgeous orange and red … the very counterpart of the Sol di Venezia'.[3]

Working over a priming of lead white and chalk, Turner built his picture out of a tissue of delicate touches and layers of many colours: Mars brown and orange, carbon and bone blacks, red lake, vermilion, chrome orange, yellow, emerald green, ultramarine and cobalt blue. By 1856 Ruskin noted that the water had lost 'transparency in the green ripples' and the sky, originally white, had darkened, but there was still 'marvellous brilliancy in the arrangement of colour' that made it one of Turner's foremost works in oil.[4] DBB

1 *Illustrated London News*, 27 May 1843.

2 Diary, 29 April 1844, quoted in Butlin and Joll 1984, p.251.

3 Letter to John James Ruskin, 14 September 1845, quoted ibid., p.251.

4 Cook and Wedderburn, XIII, p.164.

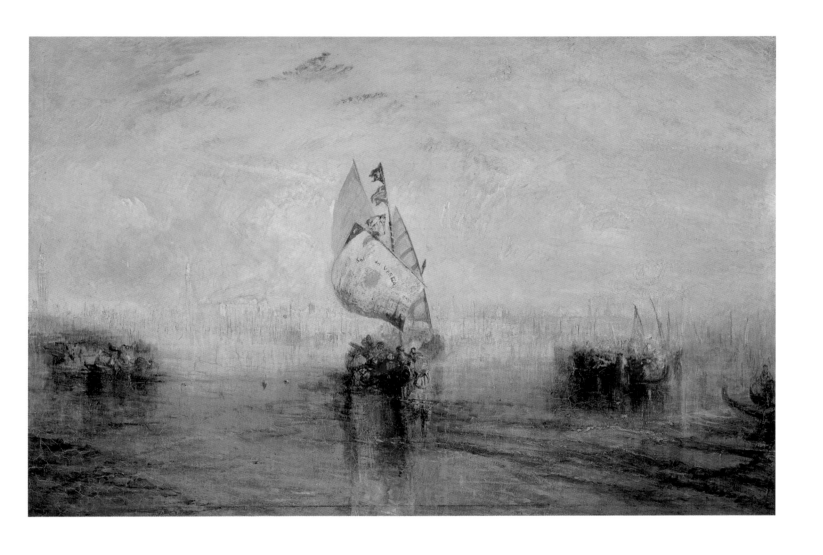

66

Approach to Venice exhibited 1844

Oil paint on canvas 62 × 94
National Gallery of Art, Washington, Andrew W. Mellon
Collection, 1937.1.110

TURNER OFTEN CHOSE passages of verse to accompany his lyrical visions of his beloved Venice. *Approach to Venice*, a picture which depicts vessels laden with figures heading across the Lagoon towards the distant city, was exhibited with the following lines:

> The path lies o'er the sea invisible.
> And from the land we went
> As to a floating city, steering in,
> And gliding up her streets as in a dream,
> So smoothly, silently
>
> The moon is up, and yet it is not night
> The sun as yet disputes the day with her.

The first is taken from *Italy* by Samuel Rogers, a popular travel narrative for which Turner had produced exquisite vignette illustrations during 1826–7. The second is a couplet adapted from Byron's epic, *Childe Harold's Pilgrimage* (see cat.88). Both texts engender a sense of intangible change, drawing attention to the ambiguous nature of Turner's Venice, poised as it is in this painting between day and night, land and sea, reality and reverie. Like *St Benedetto* (cat.64), the basic compositional prototype is derived from an earlier watercolour study and, indeed, the fluidity and haziness of the finished oil picture owes a great deal to Turner's way of working in watercolour.[1] The artist often tried to emulate the characteristics of one medium in the appearance of another and here, using oil paints, he has successfully replicated the liquid transparency of watercolour wash. Such technical trickery furthered his mythical portrayal of Venice as an insubstantial mirage, dissolving into the light.

With the passing of the years a further but unforeseen parallel emerged between the 'Sinking City' and Turner's interpretation of it in oil. Following its exposure at the Royal Academy many contemporary critics commented on the ravishing colouring of *Approach to Venice*, most notably Ruskin, who described it as 'the most perfectly *beautiful* piece of colour of all that I have seen produced by human hands, by any means, or at any period'.[2] However, by 1856 the appearance of the picture had changed and Ruskin lamented that it was now a 'wreck of dead colours'.[3] The deterioration was perhaps a direct result of Turner's use of megilp, which tends to darken and yellow over time and hence obscure the brilliance of the original palette.[4] According to Ruskin, the particular casualties in this work were the rich greens which apparently had once been prominent in the foreground.[5] Like Venice itself, Turner's later paintings turned out to be fragile things, susceptible to the ravages of time and in some cases existing now only as a shadow of their former glory. NM

1 Tate D32153, TB CCCXVI 16. Reproduced in Warrell 2003, fig.262, p.240.
2 Cook and Wedderburn, III, p.250, quoted in Warrell 2003, p.238.
3 Cook and Wedderburn, XIII, p.166; Warrell 2003, loc.cit.
4 For megilp see p.50 in the present volume.
5 See Butlin and Joll 1984, no.413, p.235.

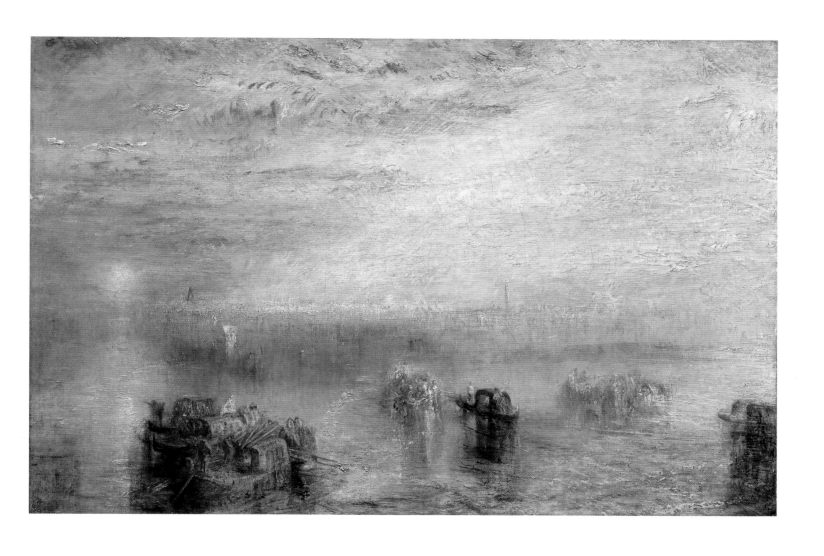

67

Going to the Ball (San Martino)
exhibited 1846

Oil paint on canvas 61.6 × 92.4

Tate N00544

Exhibited London only

THE LAST PICTURES Turner painted of Venice revisited the theme of *Approach to Venice* (cat.66). In 1845 and 1846 he produced two successive pairs of pictures, each focusing on groups of revellers crossing the Lagoon by boat with the city a remote outline on the horizon. This so-called late Venetian 'Ball' grouping evolved in response to requests from potential patrons, William Wethered and Francis McCracken. Both men were members of the *nouveau riche*, having made their money in trade or manufacturing, and typified the new breed of collector driving the British art market by the mid-nineteenth century. Following the rage for Venetian subjects, the two men sought to purchase examples by the great Mr Turner. However, their ambivalent response and

ultimate rejection of his work is typical of the fate of many of Turner's late oils.

Turner's first attempts to satisfy the requirements of Messrs Wethered and McCracken were a pair of paintings exhibited at the Royal Academy in 1845. Entitled *Venice, Evening Going to the Ball*[1] and *Morning, Returning from the Ball, St Martino*,[2] these companion pieces featured very similar views at twilight and dawn. They were hauntingly beautiful but, in common with much of Turner's late work, their intense colouring and perceived lack of finish attracted derision in the press and after reading the negative reviews the two potential owners got cold feet and withdrew their orders. The following year Turner tried

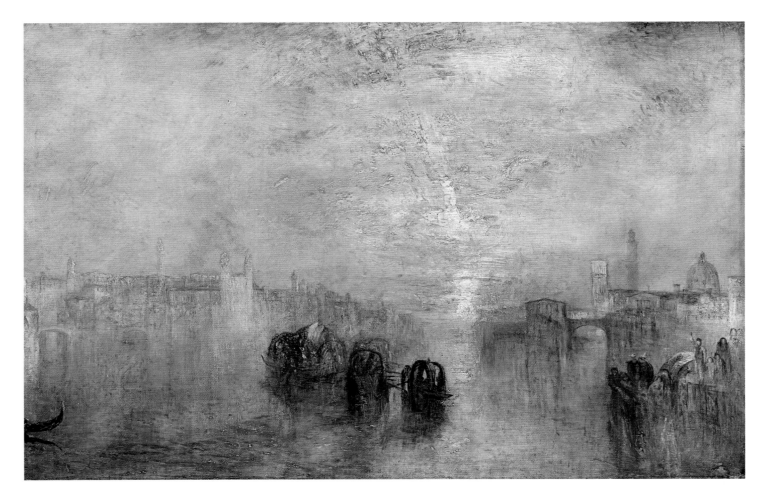

68

*Returning from the Ball
(St Martha)* exhibited 1846

Oil paint on canvas 61.6 × 92.4

Tate N00543

Exhibited London only

again with a second set of pictures (cats.67, 68) which, somewhat optimistically and perhaps ill-advisedly, were essentially variants of the first: Lagoon scenes at different times of day. These were submitted to the Academy in an unfinished state and were only completed on Varnishing Day, when already on the wall. However, despite containing greater clarity of form than his first offerings, the second pairing too came under attack in the newspapers, this time for their chromatic idiosyncrasies and particularly the prevalence of Turner's beloved chrome yellow (fig.12, p.27). Wethered and McCracken again reneged on their commissions and these latest Venetian subjects stayed in Turner's ownership, unsold and unwanted, in his studio until his death.

Nowadays it is hard to appreciate the shock value that led to their rejection. Pictures such as these have come to represent the epitome of the artist's achievements during the later part of his career. Even during his lifetime, the *Art Union* exclaimed that Venice might have been built to be painted by Turner. Put another way today, the artist might be said to be most 'himself' when painting the city. Along with the late Swiss views it is these vaporous, glowing Venetian visions which, for many people, represent Turner at his most characteristically 'Turnerian'. NM

1 Butlin and Joll 1984, no.416/421, reproduced by Warrell 2003, fig.264, p.242. For the confusion between the two pairs of pictures see Warrell 2003, pp.239–48.

2 Butlin and Joll 1984, no.417/422, reproduced by Warrell 2003, fig.265, p.244.

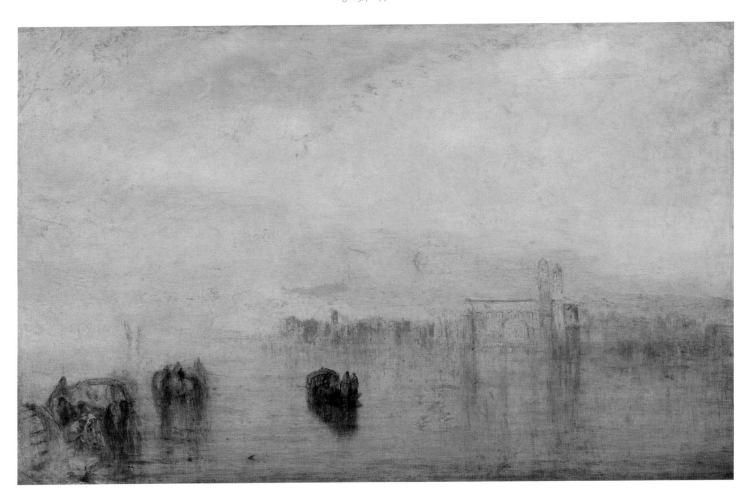

69
Eu by Moonlight 1845
Watercolour on paper 22.8 × 33.3
Tate D35436; TB CCCLIX 1
Exhibited London only

70
The Town and Château of Eu 1845
Graphite and watercolour on paper 23.1 × 32.5
Tate D35441; TB CCCLIX 6
Exhibited London only

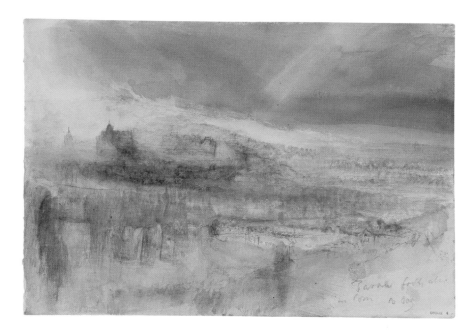

IN SEPTEMBER 1845 Turner made his last expedition abroad, crossing the Channel to Dieppe in France and travelling north-east along the coast of Picardy as far as Eu and Le Tréport. As intrepid as ever, the septuagenarian artist travelled light and, reportedly in search of 'storms and shipwrecks', only carried with him some sketchbooks and a change of linen.[1] This paucity of clothing proved to be something of an embarrassment when he received an unexpected invitation to dine with Louis-Philippe, the current French monarch (1830–48), who happened to be staying at Eu. The two men had first met thirty years earlier, when they were neighbours in Twickenham during Louis-Philippe's period of exile in England, and they had maintained a warm, if sporadic, friendship ever since. Adequate evening dress was apparently cobbled together for Turner and he spent a pleasant evening as the guest of the so-called 'Citizen King' at his summer residence, a sixteenth-century chateau, situated at the heart of the town.[2] Turner went on to make several loose studies in which the chateau appears (see cats.70 and 72), usually pictured from a distance, in juxtaposition with the nearby thirteenth-century cathedral of St Laurent. These views, produced in a roll-sketchbook, were first rapidly sketched in pencil before brief indications of local colour and tone were added in watercolour. Other images from the same book include a schematic rendering of the cathedral's Gothic interior (cat.71) and an atmospheric composition featuring the landscape of the Bresle river flooded by moonlight (cat.69).

Turner was not the only British representative at the French court in the autumn of 1845. For a couple of days in September, Queen Victoria and Prince Albert also stayed at Château d'Eu. It is not known whether their visit overlapped with Turner's but several pages of the *Dieppe* sketchbook appear to depict a grand, ornate interior with people seated at a long table set with candelabra (cat.73), possibly during an official banquet held for the royal couple. The subject perhaps indicates Turner's intention to paint a picture commemorating the strengthening diplomatic bonds in Anglo-French relations. The previous year, 1844, he had similarly recorded the French king's state visit to England in a pair

71

Inside the Church of Notre-Dame and St-Laurent at Eu 1845

Graphite and watercolour on paper 36.2 × 23.2

Tate D35445; TB CCCLIX 10

Exhibited London only

72

Eu: The Church of Notre-Dame and St-Laurent, with the Château of Louis-Philippe Beyond 1845

Graphite and watercolour on paper 23.2 × 32.8

Tate D35451; TB CCCLIX 16

Exhibited London only

73

An Interior, with Figures from the *Dieppe* sketchbook 1845

Graphite, gouache and watercolour on paper 23.2 × 33.2

Tate D35480; TB CCCLX 21

Exhibited London only

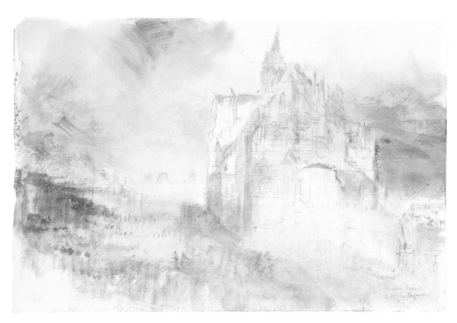

of oil paintings (see cat.101), although for a long time the misty effects of these led to them being misidentified as Venetian subjects.[3]

Louis-Philippe was ousted by revolution in 1848 and once again fled to England, where he lived out his remaining years, estranged from his native France. He died in 1850, a year before Turner. A charming memento of their mutual regard is a gold snuffbox with the royal monogram picked out in diamonds, presented by Louis-Philippe to Turner probably in 1838, in exchange for a set of prints, thought to be examples of his earlier series *Rivers of France*. NM

1 Quoted in Redgrave 1866, II, p.86.

2 Ibid. See also Wilton 1987, p.229; Upstone 1993, pp.19, 56–7; Bailey 1997, pp.366–7.

3 See Warrell 2003, pp.255–7. Also Warrell 2013b.

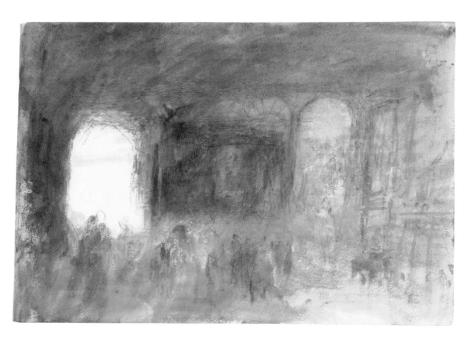

lectures Turner would have heard – over the 'ravages of all-devouring time'.[6]

In 1852, not long after Turner died, Gandy's ruined Bank was misremembered as a work by Turner himself. Instead, Turner's memorials to Soane had been *Ancient Rome; Agrippina Landing with the Ashes of Germanicus* (cat.83) and *Modern Rome – Campo Vaccino* (cat.84) exhibited in 1839. As background the first picture contains a palace and 'triumphal bridge' like one imagined by the young Soane and also refashioned by Gandy (fig.43), rather as the architecture in West's earlier version of the subject had been based on Diocletian's palace at Spalatro.[7] *Modern Rome* echoed, in Turner's latest, atmospherically charged style, a larger *Forum Romanum* (Tate) previously painted for Soane but not bought by him. In the same 1839 exhibition Turner showed *Cicero at his Villa* (cat.85), in which the great Roman orator points out the beauties of his country estate, perhaps at the moment he was forced to leave it. Turner would have remembered Cicero's downfall and execution, the revival of his writings during the Renaissance, and Richard Wilson, a previous painter of this subject whose reputation had collapsed and had yet to rebound. As with Ovid, Turner may have had in mind his own

professional ups and downs. *Cicero* was one of Ruskin's 'nonsense pictures' but seems perfectly understandable within a horizon of reference that Turner's young admirer may not have appreciated.

Turner continued to paint subjects from Ovid's *Metamorphoses* into the mid-1840s, culminating in *Europa and the Bull* (cat.143), partly based on the frontispiece of his earlier *Liber Studiorum* (fig.57, p.215). In *Bacchus and Ariadne* (cat.112), exhibited in 1840, he introduced a square format which, like *Glaucus and Scylla* (cat.114), he finished as a tondo as the logical conclusion of its compositional embrace. The latter was offset, in the same exhibition, by a coolly toned *Dawn of Christianity* (cat.113), also painted as a roundel, representing the biblical flight into Egypt. A far cry from an earlier canvas in which Turner introduced Tobias and the Angel to a conventionally Claudean Tivoli (cat.75), *Dawn* inaugurated a more radical and challenging phase in Turner's later history painting, envisioning a primordial world still in creative flux as the waters of the Flood recede. Natural forces played out again in *Shade and Darkness – The Evening of the Deluge* (cat.117) and *Light and Colour – The Morning after the Deluge* (cat.118) exhibited

FIG.42
JOSEPH MICHAEL GANDY
Aerial Cutaway View of the Bank of England from the South East 1830
Pen and watercolour on paper 84.5 × 140
Sir John Soane's Museum, London

FIG.43

JOSEPH MICHAEL GANDY
*Architectural Visions of
Early Fancy in the Gay
Morning of Youth, and
Dreams in the Evening
of Life* 1820
Pencil, ink, watercolour
and gouache on paper
73.5 × 130.5
Sir John Soane's Museum,
London

in 1843. Painted in oppositional palettes, they proclaimed both historical fatalism and faith in (if not religion) the mysteries and materials of art. By contrast, sexual love and its consequences seem among the themes of *The Angel Standing in the Sun* (cat.119) and *Undine Giving the Ring to Massaniello, Fisherman of Naples* (cat.120) exhibited in 1846 – pictures whose protagonists burst from aureoles of light with almost orgasmic force. Hieroglyphs rather than linear narratives, these works explored states of consciousness, optics and the power of paint, shocking and mystifying Turner's audience who thought them senile ramblings or simply mad. Certainly they abandoned the expository moral clarity expected from academic history painting. But Turner's last act, or rather contribution, as a biblical painter was both rational and well-meant – improving the rainbow in the background of his young friend Daniel Maclise's *Noah's Sacrifice* (cat.9) as it hung beside his own repainted *Hero of a Hundred Fights* (cat.111) in the Academy in 1847.

Turner had last appeared there in strength in 1844, with seven pictures including *Rain, Steam, and Speed* (cat.97). Its juxtaposition of running hare and trundling train, nature and artifice in a damp Thames Valley seems a modern metamorphosis, an echo of Ovid for the

machine age. The same year Turner showed historic or art-historically inspired marines of Admiral Van Tromp and 'Port Ruysdael', named after the painter of that name and evoking the Golden Age of seventeenth-century Holland (cats.98, 99). A final quartet exhibited in 1850 returned to Carthage, Virgil and Claude in blazing colours and tremulous brushwork (cats.171–5). How extraordinary these pictures must have looked two years after the formation of the Pre-Raphaelite Brotherhood with its high finish, modern moral subjects and literal truth to nature. Rather than targeting those young painters, however, perhaps at last Turner had roused himself to defy Ruskin, whose contempt for Claude and selective praise for the foremost 'Modern Painter' (all intended to improve 'the class of people who admire Maclise'[8]) had denied him so much of his history.

1 *Spectator*, 28 May 1836.

2 For Ruskin's response see Cook and Wedderburn, III, pp.635–40.

3 Cook and Wedderburn, XIII, p.130.

4 *Spectator*, 11 February 1837.

5 See Brian Livesley's essay in the present volume, pp.26, 30.

6 Watkin 1996, pp.496, 593; also Lukacher 2006, pp.163–6.

7 Adam and Walker 1764, pl.47; von Erffa and Staley 1986, p.47 repr.

8 Ruskin to Samuel Prout, 7 December 1843; Cook and Wedderburn, XXXVIII, p.336.

74

The Arch of Constantine, Rome c.1835

Oil paint on canvas 91.4 × 121.9
Tate N02066
Exhibited London only

75

Tivoli: Tobias and the Angel c.1835

Oil paint on canvas 90.5 × 121
Tate N02067
Exhibited London only

BASED ON TURNER'S DRAWINGS and memories of Italy and the Claudean tradition of classical landscape, these two landscapes with figures are painted on canvases of a size that Turner regularly used for exhibition. They have been abandoned half-way short of completion; *Tivoli* is the more finished of the two. They may have been designed as a pair, as their compositions and colouring are complementary. In *The Arch of Constantine* Turner has used large amounts of chrome yellow in the sky as a foil to the silhouette of emerald green trees. Since he usually finished yellow skies last this indicates how far he had progressed, and moreover he has added striations of pink cloud. He has given figures to both compositions, the main ones in the white impasto he typically used, but only in *Tivoli* are these convincingly identifiable, as Tobias and the Angel. The figures are more numerous in the Roman subject and include darker groups in shadow; the main figure, in white near the centre foreground, is undefined.

Still works in progress, these canvases retain

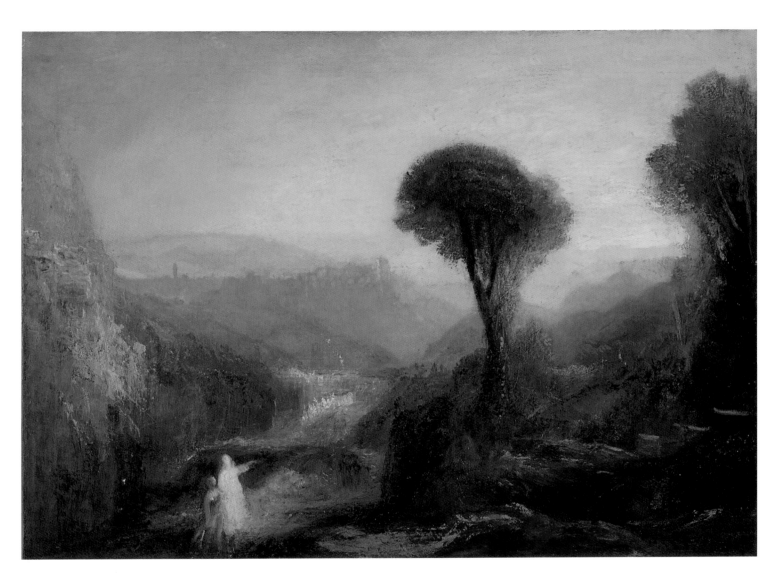

the tactile physicality of Turner's handling. In *The Arch of Constantine* he has used his thumbnail as well as the side of a wide brush to apply paint. Over what might be an egg-based primer he has used scumbles, perhaps mostly oil-based, and glazes; yellow has been laid over localised white underpaint. These unfinished works were presumably part of his stock of unfinished pictures set aside for possible exhibition and completion on Varnishing Days. In some sense, they may be related to pairs of pictures depicting ancient and modern Italy or Rome that Turner finished and exhibited in 1838 and 1839 (cats.81–4). DBB

The Death of Actaeon, with a Distant View of Montjovet, Val d'Aosta c.1837

Oil paint on canvas 149.2 × 111.1
Tate A00909
Exhibited London only

Ovid's stories of magical transformation, the *Metamorphoses*, gave Turner a number of subjects in his later years even though, in contemporary culture, they were being overtaken by German nature mythology and pantheism (which interested him as well; see cat.120). In 1838 he painted the poet's banishment from Rome (cat.81). These two pictures, only one of which was exhibited at the Royal Academy in 1836, were the first of the late Ovid subjects. For both Turner used upright canvases.

Mercury and Argus tells the story of the love of Zeus for Io, a priestess of his wife Hera. When Hera became jealous, Zeus turned Io into a white heifer and himself into a cloud. Not taken in by these disguises, Hera demanded the heifer as a gift and tethered her to a tree guarded by hundred-eyed Argus, but – as Turner shows – Zeus sent Mercury to lull Argus to sleep with his flute before killing him, leaving his charge untended. Turner showed the picture again in 1840, at the British Institution, after repainting its background. According to Munro of Novar, who would have bought it in 1836 with Turner's other two exhibits (see cat.2) had he not felt 'ashamed of taking so large a haul',[1] it was originally based on the harbour at Cromarty near his Scottish home, where Turner stayed in 1831. There seems no trace of this in the picture today; the setting is Claudean and most un-Scottish in its warm and sultry colouring, which critics described as 'blood and chalk',[2] 'sulphureo-ochreous' or 'mulligatawny'.[3] Ruskin, however, praised the picture for truth to nature.

Turner took the background for *Death of Actaeon* from his tour of the Val d'Aosta with Munro in 1836. It shows the valley with the castle of Montjovet. The picture is unfinished, with free, fluid brushwork reminiscent of Rubens, whose work Munro admired and owned. A change in the position of the left-hand tree can still be seen. The figures are mere suggestions but appear to include Actaeon, turned into a stag by Diana and torn apart by his hounds. The subject may have been commissioned by Joseph Gillott, one of Turner's new mercantile patrons, as a companion to *Mercury and Argus*, which he owned by 1845, as it is nearly the same size and the composition is complementary. On the other hand, the background suggests that Turner was mindful of Munro's interest. Titian's *Death of Actaeon* (National Gallery, London), which Turner's picture recalls, had been lent to the British Institution by Abraham Hume in 1819. DBB

1 Munro quoted in Butlin and Joll 1984, p.218.

2 *Blackwood's Magazine*, vol.40, 1836, pp.550–1.

3 *The Times*, 11 May 1836.

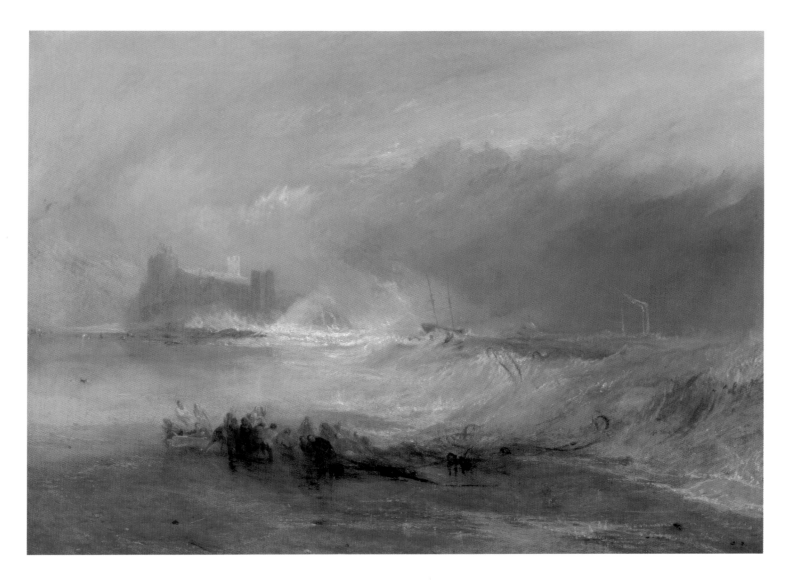

FIG.45
Wreckers – Coast of Northumberland, with a Steam-Boat Assisting a Ship off Shore
1833–4
Oil paint on canvas
90.5 × 120.8
Yale Center for British Art, Paul Mellon Collection

depictions of *Ancient* and *Modern Italy* (cats.81, 82) and *Ancient* and *Modern Rome* (cats.83, 84) demonstrate his continuing readiness to make comparisons across history. Turner used time creatively to enrich the meanings of what his subjects depicted and this dialogue across the ages was something he had explored from quite early in his career. Contemporary landscapes at home could be enlivened with references to Britain's historical legacy, for example, while paintings of Rome's conflict with Carthage might suggest a modern parallel in the wars between England and France. As with the titles for his pictures and the poetic quotations he sometimes attached to their catalogue entries, Turner seems to have presumed that an attentive spectator would be responsive to this more capacious frame of reference.

The same habit of mind is evident in *The Burning of the Houses of Lords and Commons, 16th October, 1834* (cat.89). In the foreground of the painting an incongruous cluster of participants can be discerned. A group of women seem to be importuning a man in late-medieval dress; to their right other characters appear, also apparently from another era, insofar as their costume can be made out. The entire ensemble is self-contained, framed by a wrought-iron balcony and separated from the crowd of onlookers. The women have their backs turned to the blaze across the river and in engaging with this anachronistic figure have presumably elected to look to the past as a means of making sense of this catastrophe. This deliberate collision of the historical and the contemporary points to an important aspect of Turner's approach to representing the modern age: rather than simply documenting its appearance he was also concerned to register its connotations.

With the fire in Whitehall there was a rich associative tradition to exploit, but with other contemporary subjects Turner engaged with

sights and incidents that had no historical precursors. In choosing to make significant paintings from this material his art took a decisive turn away from history painting, whose artistic importance was sanctioned by tradition and whose subjects were self-evidently of note, and also from the traditional stock-in-trade of landscape and marine painting. His mature style gave him a painterly language of sufficient flexibility to accommodate modern experience or, rather, those aspects of it that interested him. By the same token, this approach militated against banal, genre-like images or that kind of straightforward reportage that would reduce painting to illustration. He treated the new culture of the age such that its concerns were raised to the dignity of art; even the most commonplace theme could be elevated, once subjected to his bravura technique.

Nevertheless, it would be quite wrong to think that Turner's subjects were chosen relatively indiscriminately, merely as an excuse to dazzle. Looking over the works produced in the later 1830s and 1840s, one is struck by the frequency with which Turner's selection of contemporary subjects can be aligned with recent news items and topics of debate. These were subjects in the public eye. *Slavers* (fig.14, p.29), for example, was exhibited a year after the British and Foreign Anti-Slavery Society was established in 1839 and when the activities of the African Civilisation Society were receiving considerable coverage. His unfinished *Disaster at Sea* (cat.87) almost certainly depicts the shipwreck of the convict ship *Amphitrite* in 1833; *War. The Exile and the Rock Limpet* (cat.116) seems to have been intended partly as a riposte to the glorification of Napoleon following the removal of his remains from St Helena for state burial in Les Invalides in Paris in December 1840; the *Hero of a Hundred Fights* (cat.111) capitalises on the recent erection in London of Wyatt's colossal

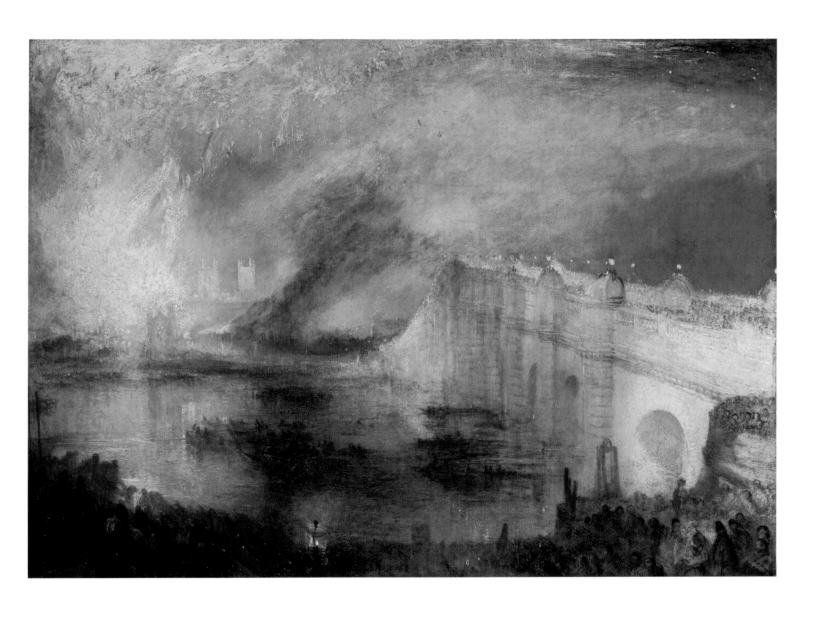

90

*Fire at the Grand Storehouse
of the Tower of London* 1841
Watercolour and gouache on paper 23.5 × 32.5
Tate D27847; TB CCLXXXIII 2

91

*Fire at the Grand Storehouse
of the Tower of London* 1841
Watercolour on paper 23.5 × 32.5
Tate D27848; TB CCLXXXIII 3

L ATE ON SATURDAY 30 October 1841, a major
fire broke out at the Tower of London,
centred on the Grand Storehouse. Just
north of the four-square turreted keep, the White
Tower, this substantial late seventeenth-century
red brick and stone building housed a historical
collection of armaments. Popular prints show the
fierce flames through rows of tall windows and
the roof with its central cupola beyond the dark
outer bastions and perimeter wall of the Tower,
with large crowds watching from across the
broad moat on three sides.

These three watercolour studies, along
with six others, come from a sketchbook that
has been associated for over a century with
the catastrophic burning of the old Houses of
Parliament in October 1834.[1] Turner observed
that event at first hand and exhibited two
spectacular paintings the following year
(Cleveland Museum of Art, Ohio, and cat.89);
he also began a watercolour.[2] All share an
elemental palette founded on red, yellow and
white against shadowy blue and black. However,
the architectural features in the nine smaller
watercolours have long puzzled scholars,
who have tried to infer details of Parliament,
Westminster Hall and the adjacent abbey and
bridge, while sometimes speculating that they
are entirely different buildings on another,
unknown occasion.[3] Close examination of these
structures and their setting, and comparison with
other visual records, now leaves no doubt that
Turner's subject is the later fire at the Tower.

Turner had a longstanding interest in the
pictorial possibilities of fire, beginning with the
aftermath of the conflagration at the Pantheon
in London's Oxford Street in 1792.[4] He had also
made watercolours of the Tower in calmer
circumstances for engravings of 1795, 1831
and 1833, all showing the cupola of the Grand
Storehouse juxtaposed with the White Tower.[5]
In 1841, having returned from Switzerland a few
days before the fire broke out on 30 October,[6]

92

*Fire at the Grand Storehouse
of the Tower of London* 1841
Watercolour on paper 23.5 × 32.5
Tate D27852; TB CCLXXXIII 7

he evidently applied in its aftermath for direct access to the Tower, but was rebuffed by a brusque note from the Duke of Wellington on 3 November, stating that no-one was to be admitted 'except on business'.[7] There are sedate contemporary prints showing well-dressed visitors inside the shell of the Grand Storehouse, but Turner seems to have abandoned the theme.

Whether or not Turner had made his watercolour studies on the spot, while the fire was still raging, remains unresolved. Assuming that he witnessed the event at first hand, given that he is known to have been averse to watercolour sketching directly from the motif even in favourable circumstances, unhindered by smoke and crowds, it seems most likely that he would have worked on them back at his studio. Another moot point is the heavy offsetting

of colour from one sheet to another, either from turning the pages before each had dried, or from subsequent water damage. The red, yellow and blue used here to signify the fire and its setting also sit well with Turner's relatively unmodulated use of these colours in the ethereal watercolour sketches made on his Swiss tours in the early 1840s. MI

1 Finberg 1909, II, p.909, TB CCLXXXIII, as 'Burning of the Houses of Parliament Sketch Book (1)'.

2 Tate D36235; TB CCCLXIV 373.

3 For discussion of the nine watercolours see Solender 1984, pp.43–53; Dorment 1986, pp.398–401; Sarah Taft in Warrell 2007, pp.179, 181.

4 Tate D00121; TB IX A.

5 The watercolours are: Sterling and Francine Clark Art Institute, Williamstown, Massachusetts; private collection; and Tate D27694; CCLXXX 177.

6 Gage 1980, p.184 no.246.

7 Ibid., pp.185–6 no.247.

93
The Thames above Waterloo Bridge, c.1835–40
Oil paint on canvas 90.8 × 121
Tate N01992
Exhibited London only

THIS UNFINISHED painting depicts Waterloo Bridge from upstream, with the shot-tower at Float Mead on the south bank visible at the right and steamboats berthed at Hungerford Pier on the left.

In the mid-1820s Turner painted watercolours of London sites further downriver. He also made a number of pencil studies of this part of the Thames.[1] Returning to the subject a decade later he faced the challenge of a transmogrified landscape. Steamboat services began at the new Hungerford Pier in the summer of 1834, carrying some 100,000 passengers in their first year of operation and over a million by 1840.[2] In the foreground are shown Thames wherries, the traditional means of travelling on the river, whose parent body, The Watermen's Company, was at loggerheads with the new steamboat operators. The problem was investigated by parliamentary select committees on 'Steam Navigation' and the 'Carriage of Passengers for Hire upon the River Thames' in 1831 and 1837–8 respectively.

Initially, perhaps, Turner may have intended a response to John Constable's *Opening of Waterloo Bridge* (Tate), exhibited at the Royal Academy in 1832, but his interest seems to be focused more on the spectacle of atmospheric pollution. Unlike other artists' images of this stretch of the river, which show steamboat traffic under clear skies, Turner's painting revels in the clouds of smoke and vapour obscuring the view.[3]

His approach can be compared with a contemporary account of a steamboat voyage from Old Shades Pier (London Bridge) to Hungerford Market:

What a gorgeous scene is now before us!
… churches, warehouses, steam-chimneys, shot-towers, wharfs, bridges – the noblest and the humblest things – all are picturesque; and the eye, looking upon the mass, sees nothing of that meanness with which our Thames banks have been reproached. In truth, this juxtaposition of the magnificent and the common fills the mind with as much food for thought as if from London Bridge to Westminster there was one splendid quay, containing the sheds, and coal-barges, and time-worn landings which meet us at every glance … the wharfs on the one bank … and the foundries, and glass-houses, and printing-offices, on the other bank, still sending out their dense smoke, – we know that without this never-tiring energy, disagreeable as are some of its outward forms, the splendour which is around us could not have been.[4] SS

1 *Tabley No. 3* sketchbook, c.1825 (Tate, TB CV), *Old London Bridge* sketchbook, c.1823–4 (Tate, TB CCV) and *Colnaghi's Account* sketchbook, c.1829–30 (Tate, TB CCXLII).

2 'Hungerford and Lambeth Suspension Bridge', *The Mirror of Literature, Amusement, and Instruction: Containing Original Papers*, vol.38, no.1067, 10 July 1841, p.10.

3 Compare William Parrott 'Westminster & Hungerford from Waterloo Bridge', lithograph, 1840, in *London from the Thames* (London: Henry Brooks; printed by C. Hullmandel [1841]).

4 'The Silent Highway', in Knight 1841, pp.15–16.

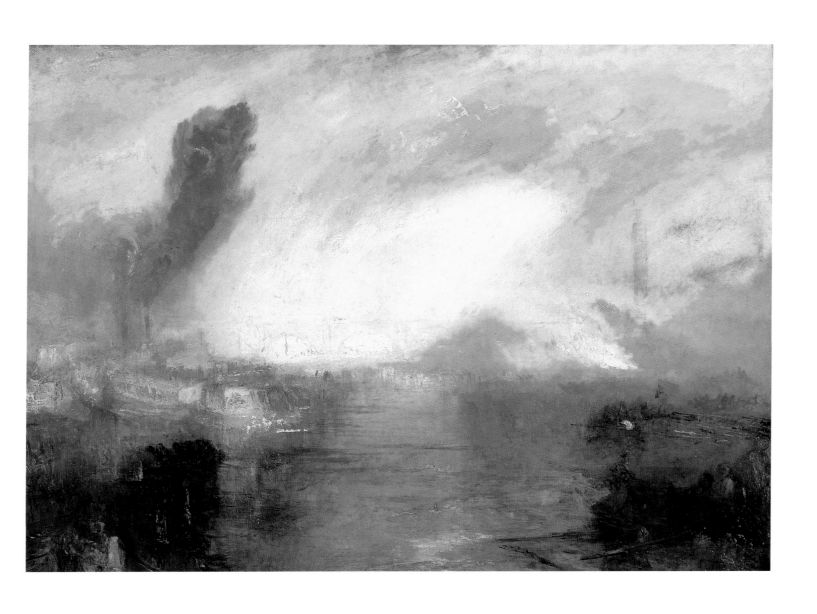

94

Lake Lucerne from Flüelen (the First Steamer on Lake Lucerne) c.1841
Watercolour and scraping out on white paper 23.1 × 28.9
UCL Art Museum, University College London
Exhibited London only

Turner's late Swiss watercolours are justly celebrated for their technical finesse, and control of the medium that allowed him to suggest distance and atmospheric depth with extraordinary subtlety. His control of colour here, ranging from the most delicate of transparent washes to relatively saturated areas of pigment, carries the eye effortlessly over several miles towards the mountains that close the view. Yet the image is not merely a celebration of Swiss light and landscape. Although indicated in the most economical, even cursory fashion, the figures Turner includes locate the scene in a human context, with fishermen hauling in nets, fish being landed and steamboat passengers on the pier.[1]

The boat itself, its funnel a rigid vertical positioned against the diaphanous mist and cloud of the far distance, was indeed a recent arrival on Lake Lucerne. In December 1835, the merchant Casimir Friedrich Knörr announced his attention to found a steamboat company and the paddleboat *Stadt Luzern* made its maiden voyage on 24 September 1837. The local watermen's guilds, fearing loss of trade, were successful in putting pressure on government officials to prevent it operating into the Canton of Uri, and hence to Flüelen, for the first year of its operation. Turner's watercolour was painted shortly after these anxieties had been overcome and he depicted the *Stadt Luzern* in other sketches and drawings of this period.[2]

Turner had been sketching steamboats on rivers and at sea since the 1810s, both in England and abroad, so incorporating a steamboat in a landscape composition was not in itself a novelty for him. However, the paddleboat's arrival on the Lake of Lucerne, irrespective of its economic impact, was a sign of the penetration of modern technology into even the most striking of landscapes. There is also, perhaps, a sense that its presence added an acoustic element – the sound of the engine, the churning of paddles, the ship's whistle – that would have been more noticeable in the natural amphitheatre of this stretch of the lake. SS

1 Turner made another sketch of this scene from a very similar position on a subsequent sketching tour (*The Lake of Lucerne from Fluelen*, c.1843–5; Tate D36240; TB CCCLXIV 344).

2 For example, *Lake Lucerne* (?1841; private collection); *Steamboat in a Storm* (?1841; Yale Center for British Art, New Haven); *Fluelen from the Lake* (?1841; Fitzwilliam Museum, Cambridge); *Brunnen with a Steamer* (c.1841; private collection).

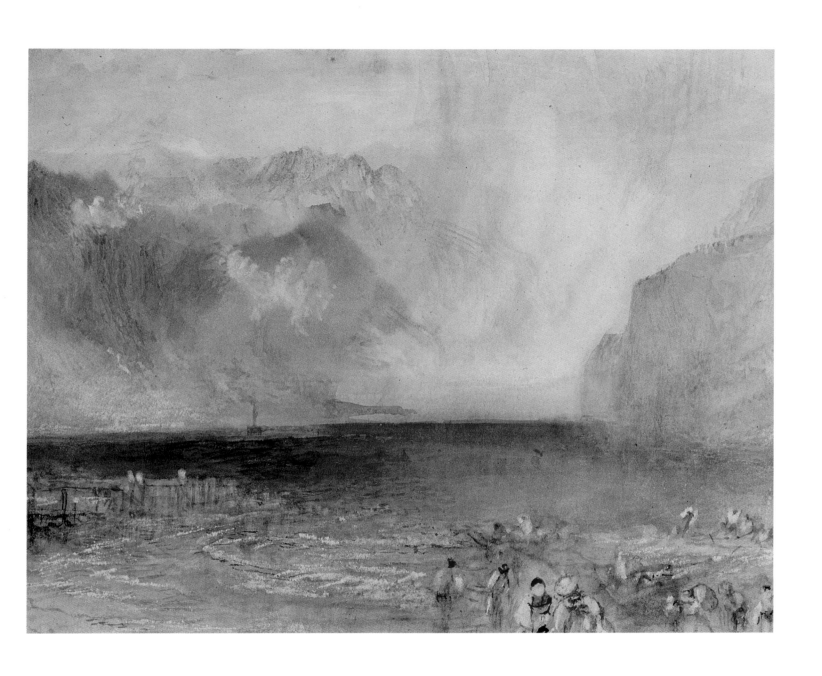

95

Snow Storm – Steam-Boat off a Harbour's Mouth making Signals in Shallow Water, and going by the Lead. The Author was in this Storm on the Night the Ariel left Harwich exhibited 1842

Oil paint on canvas 91.4 × 121.9

Tate N00530

TURNER'S EXTENSIVE title simultaneously helps his viewers understand the subject, using very precise nautical terminology, and asserts the veracity of the picture. Yet the title, seemingly so precise and informative, cannot be corroborated. *Ariel* was a popular name for ships, including the steam packet that bore Prince Albert to England on 6 February 1840 to marry Queen Victoria. However, no vessel called *Ariel* is reported leaving Harwich in a ferocious storm in these years.[1] It is possible instead that Turner was thinking of the brig *Fairy*, which sailed from Harwich on 12 November 1840 and sank with all hands in a violent storm.[2] He is not recorded in Harwich then and may have observed that night's storm elsewhere.

The technological achievement of steam power is pitted against the raw violence of nature. The indefiniteness of the elements, the artificial light of rockets and the thick smoke produce a highly energetic visual field in which forms emerge and disappear in a welter of paint.[3] Traditional perspective is under severe strain here: the steamboat is positioned at the heart of a vortex of energy, with waves rearing up and snow flurries descending, the horizon seemingly tilted at an angle.

Critical reaction was hostile and Turner was subjected to ridicule:

This gentleman has, on former occasions, chosen to paint with cream, or chocolate, yolk of egg, or currant jelly, – here he uses his whole array of kitchen stuff. Where the steam-boat is – where the harbour begins, or where it ends – which are the signals, and which the author in the *Ariel* ... are matters past our finding out.[4]

Visiting Turner's gallery, the Revd William Kingsley was given this account of the painting's origins by the artist:

I did not paint it to be understood, but I wished to show what such a scene was like; I got the sailors to lash me to the mast to observe it; I was lashed for four hours, and I did not expect to escape, but I felt bound to record it if I did. But no one had any business to like the picture.[5]

As has been frequently observed, the story is very close to one told of the marine painter Joseph Vernet, and this has raised suspicions about its truth. Reporting Kingsley's visit, Ruskin also records Turner insisting on his presence in the storm, when reacting to one of his critics' sneering epithets: "'Soapsuds and whitewash! What would they have? I wonder what they think the sea's like? I wish they'd been in it.'"[6] Wariness about this anecdote, too, is perhaps advisable until such time as the original criticism is found. But if these stories are true, they point to Turner confirming the importance of experience to rebut those who would dismiss his pictures as fantasies. SS

1 A brig called *Ariel* was lost with all her crew on 30 November 1839, but this was off the coast at Alnmouth, Northumberland. See 'Loss of the Ariel', *The Northern Liberator*, Saturday, December 21, 1839, p.3.

2 'The Fairy Surveying Vessel', *The Essex Standard, and General Advertiser for the Eastern Counties*, 18 December 1840, p.3.

3 See Lukacher 1990.

4 *Athenaeum*, 14 May 1842, quoted in Butlin and Joll 1984, p.247.

5 John Ruskin, *Notes on the Turner Gallery at Marlborough House 1856*, in Cook and Wedderburn, XIII, p.162.

6 Ibid., p.161.

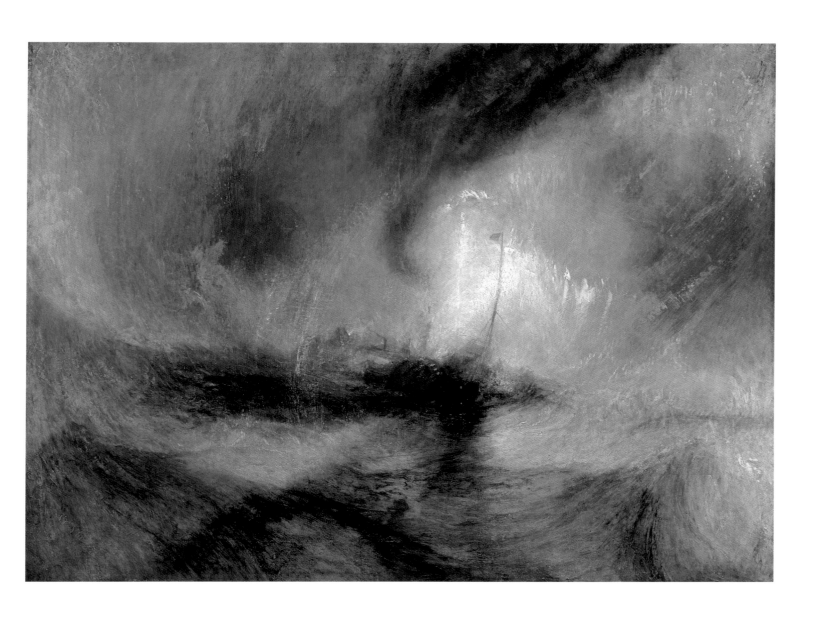

96
The Opening of the Wallhalla, 1842
exhibited 1843

Oil paint on mahogany 112.7 × 200.7
Tate N00533
Exhibited London only

RETURNING FROM VENICE in 1840 Turner travelled along the Danube and drew the nearly completed Walhalla near Regensburg. Designed by the neoclassical architect Leo von Klenze, the Doric temple was built for the King of Bavaria as a shrine to German culture and its revival after the Napoleonic Wars. Turner exhibited this picture of its formal opening at the Royal Academy with lines from his 'Fallacies of Hope' dedicated first in French, *'L'honneur au Roi de Bavare'*, describing Napoleon's invasion and celebrating the return of peace and 'science, and the arts … of German fatherland'.

For the picture, Turner used one of the two large hardwood panels previously primed for him by his colourman (see also cat.80) and worked with a complex range of materials and processes on this firm support. Colours include at least three organic reds, natural ultramarine, Prussian blue, emerald green, viridian, lemon chrome and mid-chrome yellow, chrome orange, Mars red and orange, ochres and bone black. He painted the river with blues, green and chrome yellow mixed in glazes; used linseed oil, heat-treated oil for the sky, bitumen and oil for landscape shadows, resin and oil/resin mixtures in specific areas and layers of almost pure wax medium for water, with size for mixing. He worked up the image in thin glazes, sometimes applied vertically to unite the composition; and used a palette knife, the tip of a brush handle to emphasise architectural detail and his thumbnail to create the texture of vegetation.[1]

The picture was praised as one of Turner's 'most intelligible' for many years.[2] Even *Blackwood's Magazine* admitted that it 'had its beauties', despite the usual absurd figures.[3] *The Illustrated London News* drew attention to Turner's distinctive way of adding successive touches of diluted tints to build up 'atmosphere – the colour – the depth of nature'.[4] More critically, the *Art Union* thought viewers of this 'whirlpool of colours' would find it hard to remember the painter's early naturalism and only time would tell if his latest efforts could redeem his squandered reputation.[5] According to Ruskin, the picture 'cracked before it had been eight days in the Academy rooms'.[6] It did not sell and in 1845 its misty indistinctness became its undoing when Turner sent it to Munich for the opening 'Congress of European Art' at the new 'Temple of Art and Industry'. He hoped to compliment his hosts on their cultural renaissance but, knowing his work through prints whose engravers supplied detail lacking in the originals, they wondered instead if he was making fun of them. The picture was returned with its surface spotted and an extra bill to pay for carriage. Munro of Novar and Lady Eastlake were at Turner's Queen Anne Street studio in 1846, when he fussed over the damage 'like a hen in a fury'.[7] DBB

1 See pp.50–1 in the present volume; also Townsend 1993a, pp.61–2.

2 *Morning Chronicle*, 9 May 1843.

3 *Blackwood's Magazine*, August 1843, quoted in Butlin and Joll 1984, p.250.

4 *Illustrated London News*, 20 May 1843.

5 *Art Union*, June 1843, quoted in Butlin and Joll 1984, p.250.

6 Cook and Wedderburn, III, p.249.

7 Eastlake Smith 1895, I, p.189.

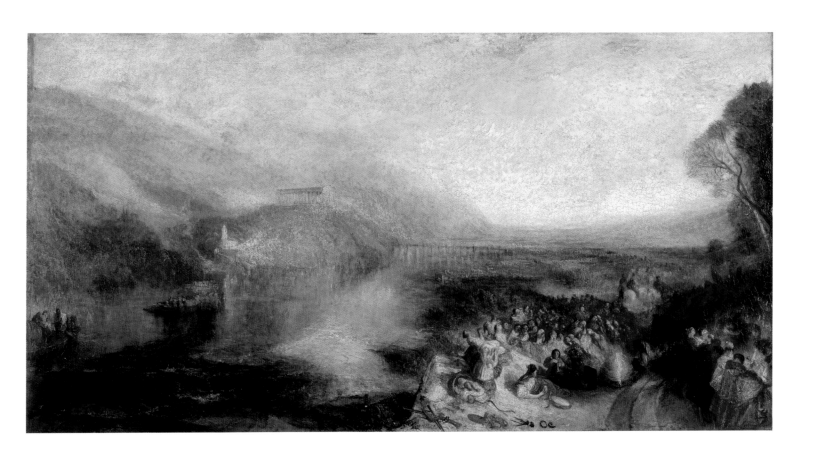

97

Rain, Steam, and Speed –
the Great Western Railway exhibited 1844

Oil paint on canvas 91 × 121.8
The National Gallery, London. Turner Bequest, 1856
Exhibited London only

TURNER HAD PAINTED the upper Thames Valley throughout his career and particularly admired its beauty and serenity. The plunging diagonal that cuts across that familiar location here is an emphatic demonstration of how the new technologies of the age imposed a precise, geometrical order on this pastoral world.

The painting's title is both a simple description of modern travel in rainy weather and a reflection on the achievement of steam technology. Nature's sublimity is controlled and condensed in the new industrial paradigm, when water is transformed by heat to produce motive power. The *Firefly* class of locomotives could haul trains weighing eighty tons at up to sixty miles per hour. At top speed their smokeboxes glowed white hot, as depicted here. One named *Greyhound* entered service on this route in 1841. Turner may have known of it when adding the hare in the foreground during the Royal Academy's Varnishing Days.[1]

The critics had reservations about the painting but were struck by its boldness of execution. The *Morning Chronicle* described it as 'probably the most insane and the most magnificent of all these prodigious compositions'.[2] Thackeray marvelled at how Turner had managed to paint a train at speed:

All these wonders are performed with means not less wonderful than the effects are. The rain … is composed of dabs of dirty putty *slapped* on to the canvass with a trowel; the sunshine scintillates out of very thick, smeary lumps of chrome yellow. The shadows are produced by cool tones of crimson lake, and quiet glazings of vermillion [;] although the fire in the steam-engine looks as if it were red I am not prepared to say that it is not painted with cobalt and pea-green… The world has never seen anything like this picture.[3]

In addition to the general 'railway mania' of the period, there was particular interest in Brunel's Great Western Railway. The track passed close to Windsor and first Prince Albert and then Queen Victoria had made symbolically important journeys on the line in the early 1840s. The bridge at Maidenhead, over which the train is travelling, was acknowledged as a radical feat of engineering, using flat brick arches.

The carriages behind the locomotive are all open to the elements. These were for third-class passengers, who travelled in simple trucks without roofs or seats. On 24 December 1841, eight third-class passengers were killed and seventeen maimed when a train derailed in Sonning Cutting, ten miles from this bridge. The 1844 exhibition coincided with new railway legislation to improve third-class conditions, partly prompted by the Sonning tragedy and promoted by W.E. Gladstone, President of the Board of Trade.[4] For the attentive viewer, Turner's painting was nothing if not topical. SS

1 Leslie 1914, pp.144–5.

2 *The Morning Chronicle*, 8 May 1844, quoted in Butlin and Joll 1984, p.257.

3 *Fraser's Magazine*, June 1844, quoted in Butlin and Joll 1984, p.257.

4 *An Act to attach certain Conditions to the construction of future Railways authorised by any Act of the present or succeeding sessions of Parliament; and for other Purposes in relation to Railways.*

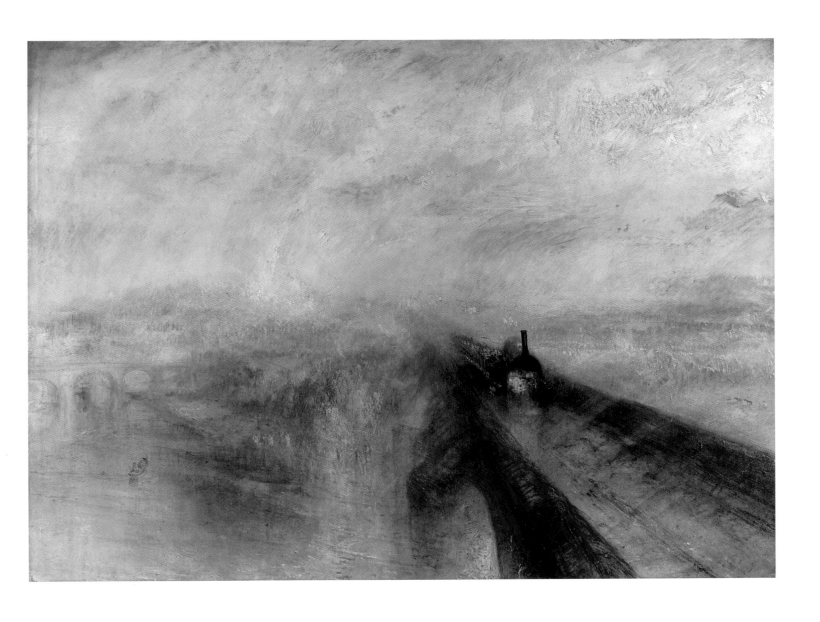

98

*Van Tromp, Going About to Please
His Masters, Ships a Sea, Getting a
Good Wetting* exhibited 1844
Oil paint on canvas 91.4 × 121.9
The J. Paul Getty Museum, Los Angeles
Exhibited Los Angeles only

99

*Fishing Boats Bringing a Disabled Ship
into Port Ruysdael* exhibited 1844
Oil paint on canvas 91.4 × 123.2
Tate N00536

T URNER HELD THE Dutch landscape
tradition in very high regard and had
drawn on it from early in his career. In
1844 he exhibited his three final paintings with
overt Dutch associations, two of which were *Van
Tromp, Going About to Please His Masters* and
*Fishing Boats Bringing a Disabled Ship into Port
Ruysdael.* They brought to a close one of his most
persistent interests.[1]

Turner had painted three marines in the 1830s
with 'Van Tromp' as their subject, *Admiral Van
Tromp's Barge at the Entrance of the Texel 1645*
(1831; Sir John Soane's Museum, London), *Van
Tromp's Shallop, at the Entrance of the Scheldt*
(1832; Wadsworth Athenaeum, Hartford, CT)
and *Van Tromp Returning after the Battle of the
Dogger Bank* (1833; Tate). They referred to the

Dutch admirals Maarten Harpetsz. Tromp and
his son Cornelis Maartensz. Tromp. The final,
1844 painting probably concerns Cornelis Tromp,
who had been relieved of his command in 1666
after disobeying orders at the Battle of the North
Foreland, in the Second Anglo-Dutch War, and
being suspected of plotting to overthrow the
government. He was restored to his command
in 1673 to help defend his country in the Third
Anglo-Dutch War. Turner's painting shows the
Admiral submitting to the authority of the Dutch
republic's government, the States General: he
is tacking ('going about') in a choppy sea, while
his 'masters' observe him from a state barge.
Unperturbed by the spray drenching him, Van
Tromp, dressed in white, waves his hat towards
his superiors. Turner added a note to the Royal

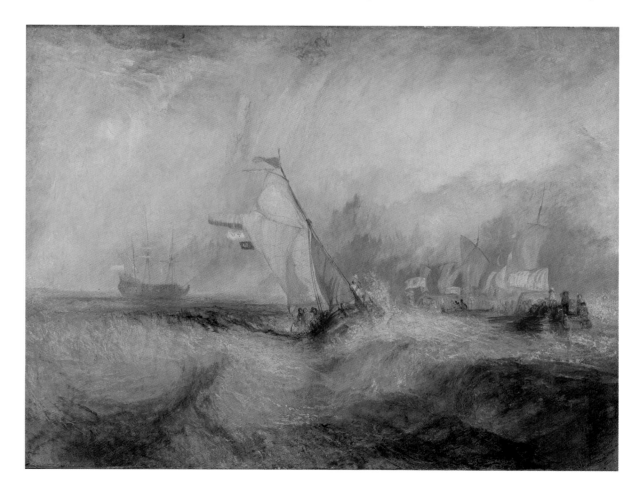

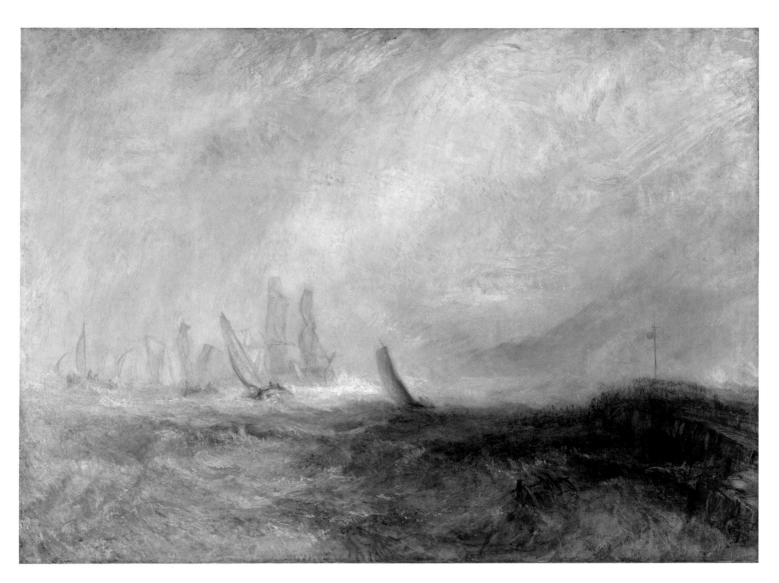

Academy catalogue, 'vide Lives of the Dutch painters', to explain the source of the incident depicted, but no corroborating text has been located.

In *Fishing Boats Bringing a Disabled Ship into Port Ruysdael* the disabled ship has presumably lost its rudder and is drifting to leeward at the mercy of the wind. Port Ruysdael is Turner's invented tribute (using his habitual spelling) to the great Dutch painter Jacob van Ruisdael. He had used the name once before in *Port Ruysdael* (1827; Yale Center for British Art, New Haven).[2] That painting was bought by Turner's patron Elhanan Bicknell in March 1844. In a letter to his dealer, Thomas Griffith, in February Turner talked of 'the new Port Rysdael', referring to the present picture and indicating that he intended to

reprise his earlier work.[3] The two compositions are quite different in many respects, however, most particularly in the much lighter tonality of the later picture and its more restricted palette. Its economy of means is also striking: the superstructure of the pier as it pushes into the sea is depicted with ambiguous calligraphic marks, while the flapping sails and hull of the brig and the more distant fishing boats are indicated by adding thin outlines to passages of off-white pigment. SS

1 *Rain, Steam, and Speed* pays a tribute to Rembrandt's landscapes; see Gage 1972, pp.45–63.

2 Turner may have based the name on his 1802 memorandum 'Sea Port Ruysdael', analysing Jacob van Ruisdael's *Coast Scene* (Louvre, Paris), in the *Studies in the Louvre* sketchbook (Tate D04299; TB LXXII 23).

3 Gage 1980, p.196.

102

A Steamer leaving Harbour c.1845

Chalk and watercolour on paper 22.1 × 33.3

Tate D35244; TB CCCLIII 5

Exhibited London only

103

Sunset amid Dark Clouds
over the Sea c.1845

Watercolour and chalk on paper 22.1 × 33

Tate D35240; TB CCCLIII 1

Exhibited London only

104

Sea Monsters and Vessels
at Sunset c.1845

Watercolour and chalk on paper with traces of
metallic particles 22.1 × 32.5

Tate D35260; TB CCCLIII 21

Exhibited London only

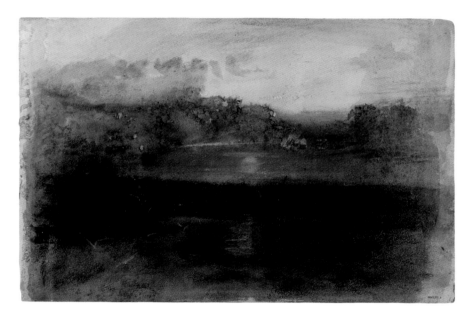

THE ENERGY radiating from these
sketches reflects Turner's evident thrill
in the challenge of imagining whaling
voyages – for he had never been on one – and,
in particular, the emotive charge of the battle
for survival between man and hunted giants of
the deep, informing his paintings of the whaling
industry (cats.107–9). This dark theme finds
physical embodiment in Turner's choice of
media and its handling in cats.103–5, drawn from
the now-disbound *Whalers* sketchbook (Tate,
TB CCCLIII). Deep black chalk predominates,
juxtaposed with a violent orange for sunset
or fire in sketches so vigorously worked as to
suggest more of the subject's turbulence and
violence over and above its specifics. These
characteristics are well represented in *Burning
Blubber*, where the nominally sketched-in figures
play a secondary role to the abstracted study
of the effect of luminous fire on dark sea, an
irresistible visual spectacle for an artist long
fascinated with fire and water (see cats.90–2).

Turner's imaginative projections extrapolate
from a range of sources. His crossings to the
Continent in 1844 and 1845 may have renewed
his connectivity to the sea and its dangers but,
more particularly, the stories of whales that
abounded in maritime folklore were given
a factual counterpart in Thomas Beale's *The*

105
Burning Blubber c.1845
Chalk and watercolour
on paper 22.1 × 33.2
Tate D35246; TB CCCLIII 7
Exhibited London only

106
A Harpooned Whale 1845
Graphite and watercolour
on paper 23.8 × 33.6
Tate D35391; TB CCCLVII 6
Exhibited London only

Natural History of the Sperm Whale … to which is added, a Sketch of a South-Sea Whaling Voyage, re-issued in 1839.[1] Beale's text described in thrilling detail the chase, capture and processing of whale carcasses, a dangerous and dramatic endeavour in which Turner clearly saw great pictorial potential. *A Harpooned Whale*, from the *Ambleteuse and Wimereux* sketchbook (Tate, TB CCCLVII), foregrounds the whale's battle for survival at the point of capture as it raises its tail in an attempt to dive. Energetic flicks and sweeps of watercolour infer a bloody struggle, while the faintly pencilled-in ship on the horizon emphasises the discrepancy of scale between the hunter and hunted; Turner's satisfaction with his vision is evident in the inscription, 'I shall use this'.[2]

Within this context of the sea as a place of perverse mystery and violence, *Sunset amid Dark Clouds over the Sea* and *A Steamer leaving Harbour* are rendered more unsettling than they might perhaps first appear, charged with implications of danger and death. The steamer in particular represents at once the heroic advances made by new technology to ease passage over treacherous waters but, ultimately in its sombre setting, suggests the futility of advances to overcome man's vulnerability against the elements. *Sea Monsters and Vessels at Sunset*, on the other hand, like the painting *Sunrise with Sea Monsters* (cat.142), is perhaps a more light-hearted offering from the depths of Turner's imagination, in which gigantic, fish-like sea creatures emerge as a playful counterpoint to the real-world drama of the whaling industry and the reasoned, scientific study of whales in texts like Beale's. AC

1 Butlin and Joll 1984, p.262 no.415. Several other literary sources have been suggested, for example see Butlin, Wilton and Gage 1974, p.189 under cat.B117; Bicknell 1985; Wallace 1988; Wallace 1989.
2 Related drawings include *The Whaler* (Fitzwilliam Museum, Cambridge) and *The Whale on Shore* (Taft Museum of Art, Cincinnati).

107

Whalers exhibited 1845

Oil paint on canvas 91.1 × 121.9

Tate N00545

108

'Hurrah! for the Whaler Erebus! Another Fish!' exhibited 1846

Oil paint on canvas 90.2 × 120.6

Tate N00546

109

Whalers (Boiling Blubber) Entangled in Flaw Ice, Endeavouring to Extricate Themselves exhibited 1846

Oil paint on canvas 89.9 × 120

Tate N00547

T URNER'S PATRON Elhanan Bicknell was a partner in the firm of Langton and Bicknell, whaling ship owners and candle manufacturers. Among their interests was refining spermaceti oil from the Pacific sperm whale fishery. Bicknell had begun building up his collection of British art in the later 1830s and had become an important client of Turner's, buying two of the finished Swiss subjects from the 1842 watercolour set – *The Blue Rigi* (cat.155) and *Brunnen, Lake Lucerne* (private collection) – and eight oil paintings in 1844.[1] Turner's four paintings exploring the whaling industry, exhibited two at a time in 1845 and 1846, were probably designed to attract his interest.

In the Royal Academy catalogues, both of the 1845 paintings and one of the 1846 pair referred to 'Beale's Voyage', meaning Thomas Beale's *Natural History of the Sperm Whale* (1835; expanded edition 1839). Bicknell subscribed for four copies and may have given or lent one to Turner. In January 1845 Turner invited Bicknell to visit his gallery in Queen Anne Street, 'for I have a whale or two on the canvas'.[2] Bicknell briefly acquired *Whalers* (also known as *The Whale Ship*, 1845; Metropolitan Museum of Art, New York), but fell out with Turner over its finish. As John James Ruskin reported to his son, 'Bicknell is quarrelling with Turner … he found Water Colour in Whalers and rubbed out some with [a] Handky. He went to Turner who looked Daggers and refused to do anything but at last he has taken it back to alter.'[3] The picture was not returned to Bicknell, who may not have appreciated its style.

Bicknell's picture shows a bleeding whale rising out of the sea at the left, while in the centre whaleboats are capsizing as another resists attack. Tate's *Whalers* records a successful hunt. The whale has been harpooned and is bleeding. The three boats in the foreground are poised to strike again, for the harpooneer has his lance ready.

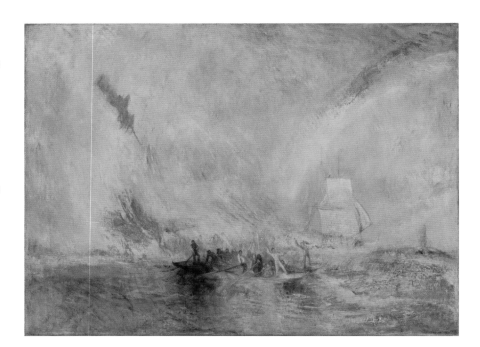

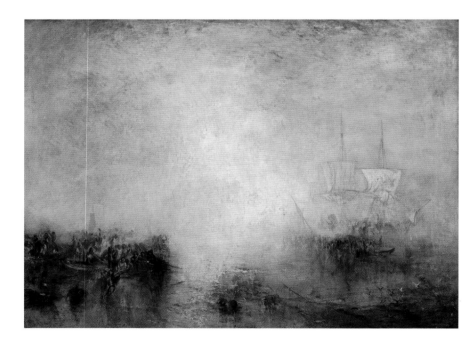

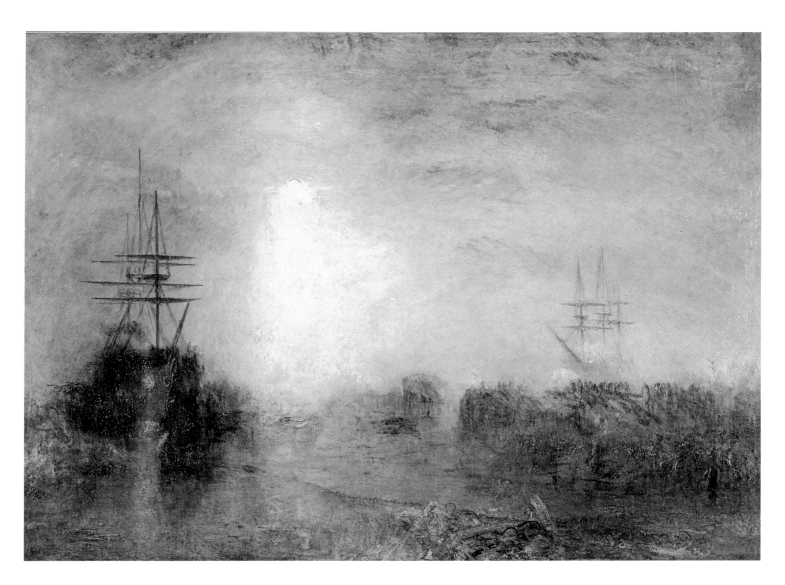

The paintings exhibited in 1846 are less dramatic. *Hurrah! for the Whaler Erebus! Another Fish!* shows a whale being cut up for blubber, its head and jaw visible by the ship's mast. The name 'Erebus' probably derives from HMS *Erebus*, which with the *Terror* had explored Antarctica in 1839–43. In *Whalers (Boiling Blubber)* the warm colours dominant in *Hurrah! for the Whaler Erebus!* have been replaced by a cool palette, the yellow sun transformed into a pallid white disk. The dead whale is laid out on the ice at the right and is being sawn into pieces. The fires of the ovens used to render the blubber into oil are shown on the left. The predicament of the ships, however, suggests that the same sea that supports the pursuit of profit may also threaten those who had ventured to secure it.

Although there were some dissenting voices,

critical reaction to these pictures was mainly positive, praising Turner's aerial effects, his ability to render light and his mastery of colour. *The Times*, for example, reviewing *Whalers* in 1845 drew attention to Turner's 'free, vigorous, fearless embodiment of a moment. To do justice to Turner, it should always be remembered that he is the painter, not of reflections, but of immediate sensations.'[4] Assessing *Erebus*, the paper's critic declared that its qualities 'should check all those who regard the pictures of this great colourist as mere themes for mirth'.[5] SS

1 See Waagen 1854, II, p.359; *Art Journal*, 1862, p.45.

2 Gage 1980, p.205.

3 Shapiro 1972, p.248.

4 *The Times*, 6 May 1845, quoted in Butlin and Joll 1984, p.261.

5 *The Times*, 6 May 1846, quoted ibid., p.268.

The Wreck Buoy c.1807; reworked and exhibited 1849

Oil paint on canvas 92.7 × 123.2
National Museums Liverpool, Walker Art Gallery.
Bequeathed by Emma Holt 1944
Exhibited London only

Towards the end of the 1840s Turner's exhibition record at the Royal Academy began to falter. In 1847 his sole exhibit was *The Hero of a Hundred Fights*, in 1848 he exhibited nothing, and in 1849 he showed only *Venus and Adonis* (private collection) and *The Wreck Buoy*, both of which were in the collection of Munro of Novar. Munro had bought *Venus and Adonis* at auction in 1830 but it is not known when he acquired *The Wreck Buoy*. Turner had first painted these canvases some four decades earlier. *Venus and Adonis* was exhibited unaltered, but both *The Hero of a Hundred Fights* and *The Wreck Buoy* were reworked in Turner's final manner.

The Hero of a Hundred Fights seems originally to have depicted the interior of an iron forge, showing the cogwheels of a tilt hammer. On this composition Turner superimposed an

FIG.48
Study for Unidentified Vignettes: Wreck Buoy, Gurnet, Dogfish, and Plaice
c.1835
Watercolour on paper
20.3 × 15.5
Tate D25465; TB CCLXII 342

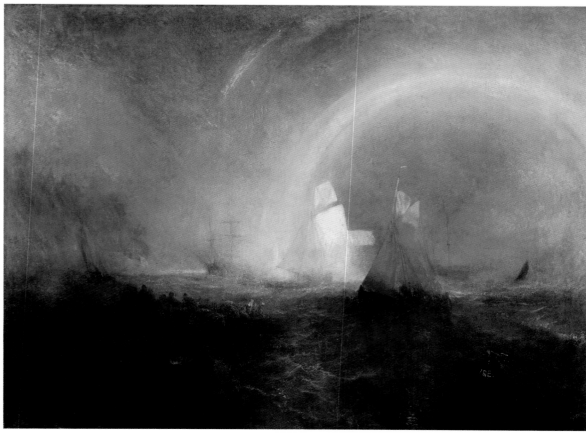

The Hero of a Hundred Fights
c.1800–10, reworked and exhibited 1847
Oil paint on canvas 90.8 × 121.3
Tate N00551

incandescent eruption of orange and yellow. The silhouette of Matthew Wyatt's bronze statue of Wellington, originally made to be installed atop the triumphal arch at Hyde Park Corner in London in 1846, is surrounded by light spiralling towards us in fiery arcs. Foundry workers are seen below Wellington, their appearance warped by the heat.

When the painting was exhibited the catalogue added: 'An idea suggested by the German invocation upon casting the bell: in England called tapping the furnace. MS. Fallacies of Hope.' Turner's reference to 'the German invocation' alludes to Friedrich Schiller's ballad *Das Lied von der Glocke* ('The Song of the Bell'). Edward Bulwer Lytton's translation had been published in 1844. The poem compares the bell's manufacture with the life of a peasant undergoing various trials and, among other things, talks about the need to regulate forces which, left unchecked, unleash destruction (fire or revolution). As the victor of Waterloo in 1815 Wellington was a popular figure, and the honorific 'hero of a hundred fights' was regularly applied to him, but his opposition to extending the franchise in 1832 had infuriated many seeking peaceful political reform at home.

Turner extensively repainted *The Wreck Buoy* in six days, adding details and enhancing the contrast of light against dark.[1] It probably depicts shipping in the Thames estuary, with 'West-East' on the left-hand buoy indicating perhaps the narrow channel between the East and West Barrows. The focus of the picture is the almost spectral transformation of the shipping at the centre of the composition as sunlight penetrates a bank of mist. The double rainbow is extraordinarily pale, but Turner may have known of 'fogbows', either directly or through his acquaintance with the scientist David Brewster, who conducted research on light's modification by atmosphere.

The combination of ships with a rainbow had already been developed in a mezzotint (c.1825)

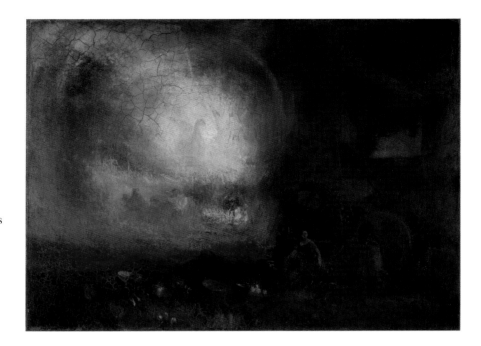

for Turner's *Little Liber* series. A green wreck buoy had also been the subject of a watercolour vignette of c.1835 (fig.48).[2] In bringing rainbow and wreck together Turner plays up the contrast of hope with loss that animated so many of his pictures.

Reactions to both pictures were mixed. Turner found an ally in the *Literary Gazette* critic who described *Hero* as 'a marvellous piece of colouring' and rhapsodised *The Wreck Buoy* as 'a wonderful specimen of his powers in colours. Rainbows, beaconlights of fiery intensity, and the harmonising of tints that seem more to belong to fire-works than oil-painting, are carried to an extent for which the eye hardly dares to vouch.'[3] More hostile criticism is typified by the *Illustrated London News*, saying of *Hero*: 'this kind of painting is not the madness of genius – it is the folly and imbecility of old age', while *The Wreck Buoy* was 'evidently a picture painted twenty years ago, left lumbering about and then cleaned up, or intended to be so, by the insertion of two or three bright new rainbows'.[4] SS

1 Thornbury 1862, I, pp.232–3.

2 Tate D25465; TB CCLXIII 342.

3 *The Literary Gazette*, 8 May 1847 and 26 May 1849, quoted in Butlin and Joll 1984, pp.272, 273.

4 *The Illustrated London News*, 8 May 1847 and 26 May 1849, quoted ibid.

Squaring the Circle: New Formats from 1840

David Blayney Brown

IN HIS LAST DECADES, Turner introduced new sizes and formats for oil paintings, varying his standard range even for frequent subjects like Venice or Switzerland. A particularly notable innovation, in 1840, was a square support, measuring 78.7 × 78.7 cm, for *Bacchus and Ariadne* (cat.112). He used similar sizes for a series of pictures, sometimes paired and painted square, round or octagonal, until 1846. Within a broad definition encompassing mythical, biblical and modern subjects, all were history paintings. As a group they contain some of Turner's most dazzling displays of colour, audacious handling and challenging iconographies, which even at the time demanded a wide frame of reference, detective work and speculation on the part of critics and exhibition-goers. They were among his most controversial late works, misunderstood or mocked even by admirers like Ruskin.

Bacchus and Ariadne shows Turner at first undecided how to use his new format. Paint continues into the corners, especially at the lower edge, but the upper corners are angled as if he were planning an octagon. However, he added the final glazes with the picture already in a rounded frame. Subsequently framed as a square, and afterwards in a plain modern frame with an octagonal window, the picture has recently been given a restored frame with a round window with decorative spandrels. This seems most sympathetic to a composition of graceful, inward-curving motifs revolving around a silhouette of trees. The sunlit landscape is Claudean, while the figures are borrowed – with variations – from Titian's picture of the subject in the National Gallery since 1826, of which Turner owned a copy. Turner has compressed Titian's *poesia* on an intimate scale, but without the finish and refinement expected of cabinet pictures designed for close looking, leading to accusations of burlesque.

The 1840 picture was exhibited without a companion. Afterwards, square pictures were paired or at least shown with works of similar sizes. Since both subjects came from Ovid's *Metamorphoses* and depict flight from unwanted sexual attention, one might expect *Bacchus and Ariadne* to partner *Glaucus and Scylla* (cat.114), which perhaps first appeared in the rounded frame it has today. In fact, the latter was exhibited the following year with *Dawn of Christianity (Flight into Egypt)* (cat.113). The paintings appear more opposed than linked in their contrasting gold and blue palettes and profane and sacred subjects. Both weighted towards the right, their compositions seem to fit less happily together than the two Ovid pictures whose trees incline yearningly inwards from opposite sides. The colouring of the Ovid subjects, however, is closer, without the warm/cool dichotomy actually shown in 1841. *Dawn of Christianity* is painted on a square canvas with pencil lines at the corners marking an octagon; Turner used the remaining corners for colour trials. However, variant monochrome sketches on a single upright canvas (Tate No5508) adopt the circular form of the final composition, which retains its original round-windowed rococo frame. The lowest of the sketches is inverted in relation to the others, as if reflecting them.

Turner's pairing of *Peace – Burial at Sea* (cat.115) and *War. The Exile and the Rock Limpet* (cat.116) has never been in doubt but the pictures are slightly different sizes. The relationship between their subjects was perplexing and, despite dropping heavy hints, Turner failed to get even Ruskin – never backward in finding meanings undreamed of by the artist himself – to see what he meant by depicting the burial of the painter David Wilkie alongside the exiled Napoleon.[1] Had Ruskin been more sympathetic to either painter, he might have realised that Turner was contrasting the peaceful but highly successful Wilkie, mourned in their absence by his colleagues, having died abroad, with the combative B.R. Haydon, whose

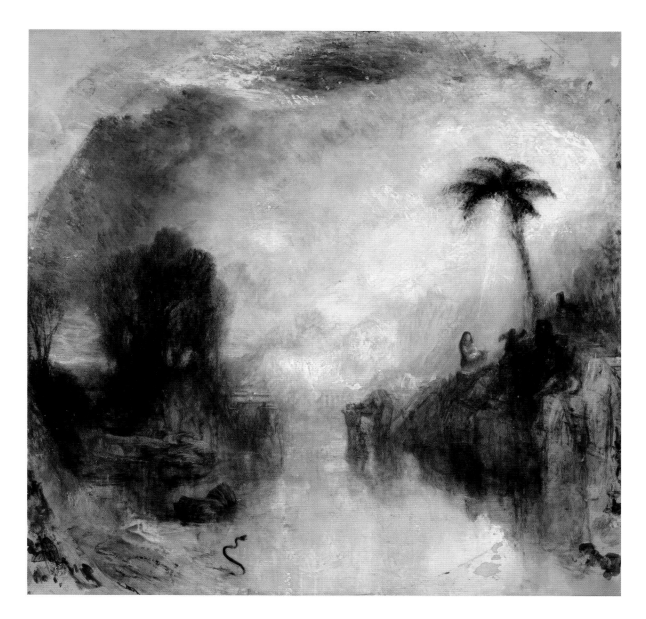

behaviour had alienated him from other artists in London. Having failed as a history painter on a grand scale, Haydon had staved off bankruptcy by painting small potboilers, some of which depicted none other than Napoleon on St Helena. Ruskin seems not to have appreciated that the 'funereal and unnatural blackness' of the ship's sails in *Peace* – which Turner wanted to make even blacker – acted as a foil to the 'scarlet and gold of Napoleon' that he admired so much.[2] Although described by one reviewer as 'round blotches',[3] both pictures were finished as octagons, probably in their frames on the Academy wall.

In the hail of abuse directed at Turner's exhibits in 1842, *Peace* and *War* were slated for their eccentrically juxtaposed subjects and extravagant colour. Unflattering comparisons were made with the music of Hector Berlioz and the bizarre stories of E.T.A. Hoffmann, while it

was suggested (in what would become a cliché of Turner commentary) that they might as well be hung upside down. Undeterred, Turner returned to the Academy in 1843 with *Shade and Darkness – the Evening of the Deluge* (cat.117) and *Light and Colour (Goethe's Theory) – the Morning after the Deluge – Moses Writing the Book of Genesis* (cat.118). Lest their titles suggest a tendency to throw random ideas into a pictorial spin cycle, they strike to the heart of Turner's creative concerns. From a reviewer's description of 'octagon-shaped daubs'[4] we know how they were framed (they have since been presented with and without octagonal windows) but *Light and Colour* assumes circular form and 'Goethe's Theory', in his *Farbenlehre*, is of a colour wheel and its relative emotional values. The spiral motion of Turner's picture mirrors the natural cycle of creation and destruction just as, in verse

he wrote for it, 'humid bubbles' released by the sun's warmth are 'ephemeral as the summer fly'. He may have set aside an earlier version of *Shade and Darkness* (National Gallery of Art, Washington) because its colouring was not a sufficient contrast, lacking what the art historian John Gage has called the 'sublimity of darkness'[5] already given symbolic expression in *Peace*.

Turner exhibited square pictures for the last time in 1846. Ostensibly, *The Angel Standing in the Sun* (cat.119) showed the angel from the Book of Revelation looming over a roiling mass of biblical mayhem, while *Undine Giving the Ring to Massaniello, Fisherman of Naples* (cat.120) conflated German romance and Neapolitan revolutionary history via recent opera and ballet. The pictures can be loosely linked by motifs of love and death but critics were not unanimous in discussing them together and it is not certain that they were really a pair. *Undine* was begun as an octagon, *The Angel* as a circle, but both were finished to the edges of the canvas. While they present another warm/cool contrast and each is centred on a blaze of light, the intense blue background of *Undine* was not planned in relation to *The Angel* but worked up from a pale ground on Varnishing Days to strike a knockout blow to an adjacent picture by David Roberts. A similar blue-grey preparation survives in an unfinished square canvas (cat.121), one of two without explicit narrative and only hinting at figures or buildings. Technically similar and roughly so in size, they seem otherwise unrelated, having different horizon lines. They might be survivals from Turner's reserve of partly prepared canvases, to be developed as imagination, neighbouring pictures or exhibition frames dictated. Perhaps because the exhibited squares originated in such pre-existing lay-ins, imagery, ideas or handling recur. The tent in *Shade and Darkness* recalls the 'bivouac' ascribed to Napoleon or the crab in *War*, while areas of *Peace* and *The Angel* remain in a sketchy, studio state.

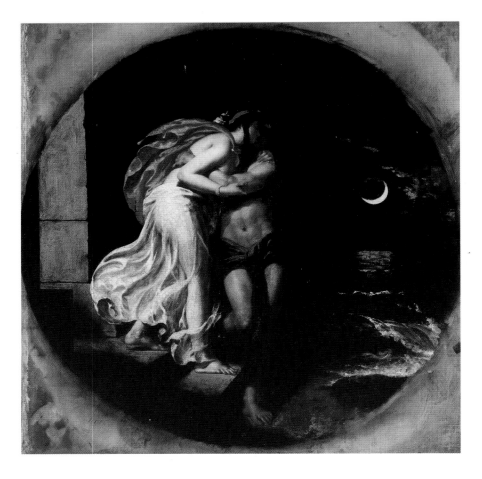

FIG.50
WILLIAM ETTY
The Parting of Hero and Leander exhibited 1827
Oil and metal leaf on canvas 86.4 × 86.4
Tate. Purchased 1945

The unfinished sketches lack the energy released in the exhibited squares as Turner worked within their frames. Arcs of rain, snow or spray had long been hallmarks of his landscapes but compressed into circular motion and rendered with bold sweeps of the brush they reach storm force, sucking in his often mysterious imagery so that these new pictures become almost self-consuming. What prompted such extraordinary works, if not alterations in his later eyesight, 'decline' or 'mental disease'[6] so dubiously suspected by Ruskin in 1846? Illusionistic frescoes in Italian domes; Thomas Lawrence's rounded portraits; historical subjects by William Etty (fig.50); Michelangelo's marble tondo at the Royal Academy since 1830; octagons and roundels by or attributed to Claude (one of which Turner owned); a recent acquisition for the British Museum; or daguerreotypes of the moon and sun (fig.51) – any of these might have been motivations. But Turner needed to look no further than his own work.

In 1840, arguing (under a pseudonym) that 'our pictures should all be circular', Ruskin cited Turner's vignettes composed as circles or ellipses because they reflected optical perception

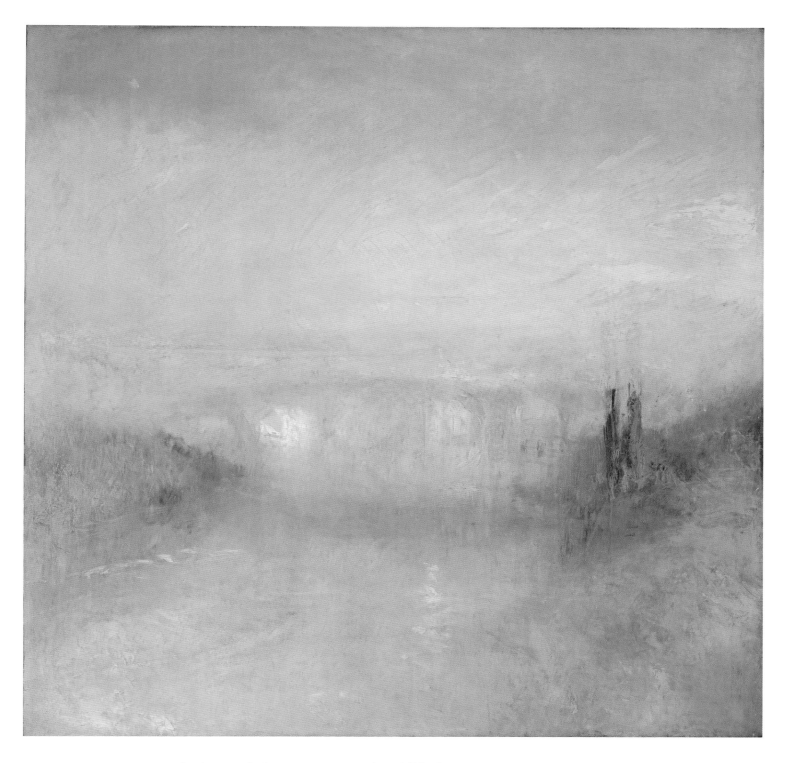

spinning, vortical movements seen in exhibited squares. As a river landscape with a bridge, classical or even Italian in feeling, it has more in common with the oils Turner based on subjects in his *Liber Studiorum* (cats.143–8), although none of these is square; perhaps this was an experiment falling somewhere between these two groups of works. Like the *Liber* oils, the bands of quite pale, contrasting colour harmonised by light are similar to effects in Turner's watercolour 'beginnings'. DBB

Horizons: Sea and Sky

Amy Concannon

By October 1846 Turner had moved to a new address in London: 6 Davis Place, Chelsea, a house directly facing the River Thames (cat.3). There he became known to his neighbours as 'Admiral Booth' on the presumption that he was the husband of the named leaseholder, Mrs Sophia Caroline Booth, whose first marriage (before Mr Booth) had been to a naval officer.[1] It was a misnomer in which Turner no doubt delighted. Not only did parading as 'Admiral Booth' offer a decoy from this most private artist's true celebrity but, as Christine Riding has suggested, it may have borne some attraction as an alternative rank of merit to 'Sir', the title bestowed upon Turner's rival painter of the sea, Augustus Callcott.[2] Accounts of Turner's 'merchantman'[3] appearance legitimised the charade, with one commentator seeing in Turner 'the indescribable charm of a sailor both in appearance and manners; his large grey eyes were those of a man long accustomed to looking straight at the face of nature through fair and foul weather alike'.[4] 'Admiral Booth' was therefore an irresistible – and most fitting – identity for one whose lifelong fascination for the shipping, fishing and marine mythologies was now more intense than ever.

The first oil painting Turner ever exhibited was of the sea – *Fishermen at Sea* (exhibited RA 1796; Tate) – and from the 1830s his focus on the sea gathered pace. By the 1840s, along with Venetian subjects (cats.50–68), seascapes accounted for three-quarters of Turner's output.[5] Pervading his interpretation of a range of subjects, the sea was a stage on which classical or contemporary drama might be played out, as in *Whalers* (cat.107) or *Departure of the Fleet* (cat.173), and was an active emotive agent in *Peace – Burial at Sea* (cat.115). Turner displayed the extremes of his imaginative conception and stylistic realisation of the sea in exhibited works: so while *Fishing Boats Bringing a Disabled Ship into Port Ruysdael* (cat.99) observes the traditions of marine painting in its reference to the genre's Dutch roots, cool palette and crisp detail, works like *Snow Storm – Steam-Boat off a Harbour's Mouth* (cat.95) shattered the boundaries of that tradition. Boldly conceived, vigorously painted and not a little mysterious, this work brings us closer to the responses to the sea that abounded in the very private world of Turner's studio. Immediate, raw and impassioned, these drawings, sketches, unfinished and unexhibited works divulge the intensity of his preoccupation with the sea in these late years.

The prevalence of coastal subjects in Turner's work of the 1830s and 1840s is a direct reflection of his movements. With increasing regularity from the early 1830s Turner was to be found in towns dotted along the Kent coast: Deal, Folkestone and, most frequently of all, Margate. These were places where the artist could be anonymous, free to absorb himself in coastal life. A particular enchantment of Margate was the proprietor of his boarding house, Mrs Booth, who, after the death of her husband in 1833, became Turner's companion, eventually moving with him to London in 1846. Her lodging house occupied high ground overlooking Margate's Cold Harbour, affording Turner round-the-clock proximity to the changing moods of this bustling bay.

The sense of liberation from the structure, pace and pressure of everyday life in London that Turner found in the coast – or its memory – is manifest in his visual response to it. A renewed zeal for experimentation is seen in his embracing of millboard, for example (a thick board originally developed for making boxes and used in bookbinding), a support he had used only infrequently until now, as well as his continued interest in a variety of papers (cats.125, 126). The capricious sea became a vehicle for an emboldening technique, reflective of a master at ease with his materials, be it in watercolours of arresting simplicity or in vigorously worked canvases that teeter between

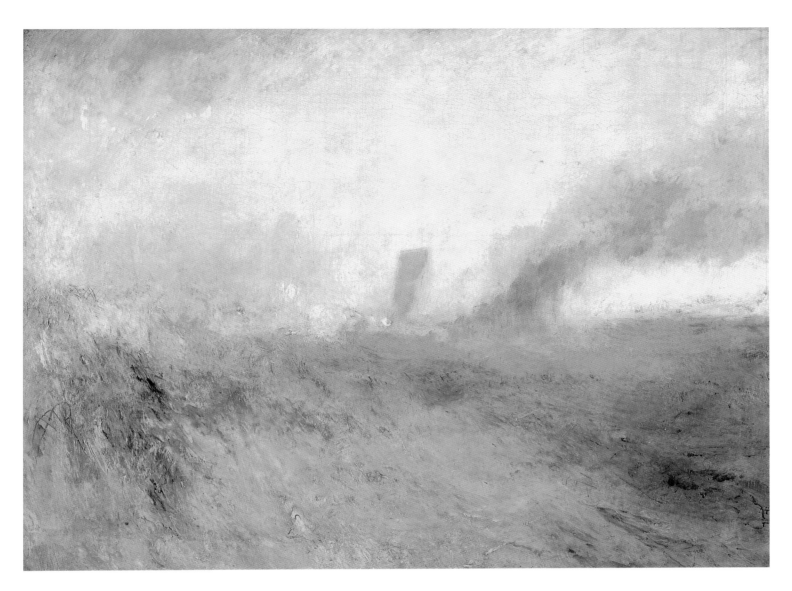

FIG.54
Seascape, Folkestone
c.1845
Oil paint on canvas
83.3 × 117.5
Private collection

finished and unfinished, like *Seascape, Folkestone* (fig.54). The suggestion that this painting was sold directly from Turner's studio in his lifetime raises questions about work we perceive as 'unfinished': was there a taste for these works in Turner's time?[6]

On a visit to Turner's Queen Anne Street gallery, the American sea captain Elisha Ely Morgan saw 'through all the fog and mystery of Turner, how much real sea feeling there was in him and his work'.[7] Turner displayed a particular reverence for Captain Morgan, dubbed by Charles Dickens 'one of the most honest and skilful mariners in the World',[8] and the two became good friends. At Queen Anne Street, the artist apparently followed the Captain 'about the gallery, bent upon hearing all he said'.[9] Other marine-oriented men came into Turner's orbit in the late 1830s: from 1838 an investor in the whaling industry, Elhanan Bicknell, began to

collect his work (Turner is also thought to have painted works on speculation of his purchase) while another acquaintance was Captain George William Manby, an inventor of life-saving devices for ships who had also published an account of his whaling voyage to Greenland.[10] Turner's ability to generate 'real sea feeling' was therefore attributable, at least in part, to the knowledge and anecdotes he gleaned from these men whose experience of the sea stretched far beyond the bounds of his own.

At the same time as extending his realm of knowledge, Turner was also extending his visual focus further and further out to sea. Increasingly and repeatedly in his studies from the mid-1830s, he alights on the horizon, the boundary demarcating sea from sky. In works like *Sea and Sky* from the *Channel* sketchbook (fig.55), watercolour is driven and dragged across the page in limpid formations that interrogate the

interrelationship of water and air, blurring the boundary between the two. Time and time again, as if for the first time, Turner declares anew the thrill of changing conditions along the horizon line; his musings on the physical dynamics of water, light and air reveal him continually striving for an ever-greater understanding and connectedness with the elements on which his career – and the fabric of the natural world – were built.

As both a finite edge to the plane of vision and a gateway to the world beyond, the horizon offered Turner much more than endless combinations of elemental dynamism: it offered restorative solace from a catalogue of responsibilities in the city. In 1845 he exhibited six paintings at the Royal Academy and served on its hanging committee; duties as acting President, for the ailing Sir Martin Archer Shee, imposed such pressure that by May Turner felt induced to seek watery, open horizons. 'I have been so unwell that I was obliged to go away from Town to seek revival by a little change of fresh air', he wrote on 15 May.[11] On this occasion the artist escaped across the Channel to Boulogne, via a few days' rest in Margate, savouring the Kent and

north French coasts in the *Channel* sketchbook (fig.55)and *Ambleteuse and Wimereaux* sketchbook (cat.106). The relief that this 'fresh' environment provided is patent in the meditative watercolours which, in their vast quantities, indicate that for Turner practice was a cure: convalescence did not equate to inactivity.

If Turner felt revived by the sea, he also mused on its morbid potential in shipwrecks, storms and sea monsters. A certain machismo runs through these motifs, reflecting the sea-hardy image he proffered of himself in *Snow Storm – Steam-Boat off a Harbour's Mouth* (cat.95) and in the turbulent surface of *Rough Sea with Wreckage* (cat.140). Indeed, we see Turner as storm-chaser again in Dieppe in 1845, apparently 'looking out for storms and shipwrecks' on what would be his last excursion from England.[12] But storms, sea monsters and shipwrecks also emphasise the vulnerability of man at sea. 'Lost to all hope she lies', began the verse he pencilled into the foreground of one eerie shipwreck scene (fig.56), redolent, like much of Turner's poetry (usually collectively known as 'Fallacies of Hope'), of the futility of man's endeavour in the face of all-powerful nature. His reworking of one painting

FIG.55
from the *Channel* sketchbook c.1845
Watercolour on paper
9.5 × 15.9
Yale Center for British Art, Paul Mellon Collection

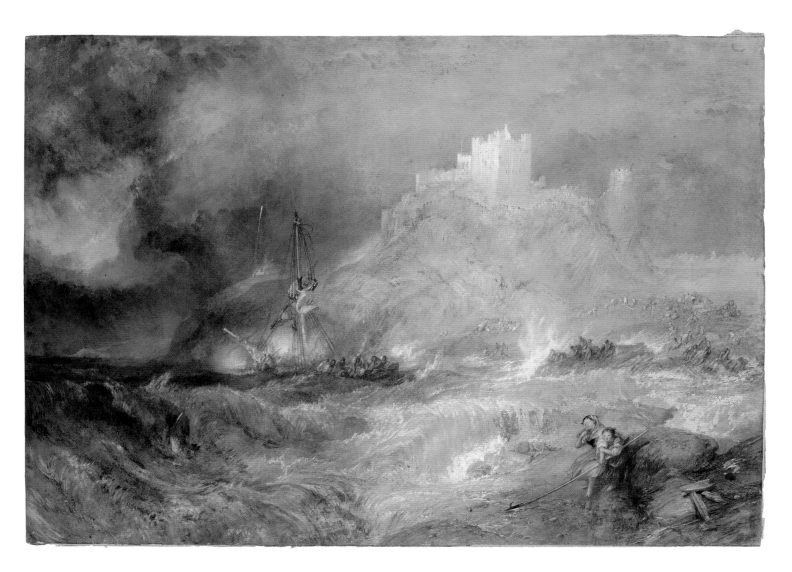

younger artists Daniel Maclise (cat.9) and George Jones (cats.14–15). Engravers of Turner's work in the Society included George Cooke, Thomas Lupton and Edward and William Finden, while its Honorary Secretary was the antiquary John Britton, whose books were regularly furnished with engravings after Turner. Visitors to the Society in 1837 included Turner's agent Thomas Griffith and B.G. Windus, who owned the largest collection of Turner watercolours.[6] Members and their guests were encouraged to bring works of art for discussion. It is likely that *Bamborough Castle* was introduced at the Graphic Society by its first documented owner and invited Society member, Revd Edward Coleridge (nephew of the poet Samuel Taylor Coleridge). Revealed at the meeting, it was apparently hailed as 'one of the finest water-colour drawings in the world'.[7] The excitement around this watercolour is understandable. It had been some seven years since a new watercolour by Turner (Tate, D25467) had been seen in public and this

large-scale, virtuoso rendering of a sublime, emotive subject would not have disappointed the privileged gathering, though few of them could know – or would even approve of – the heights to which Turner would take the watercolour medium over the next decade. AC

1 The closest of these to the finished watercolour is on paper from the same stock. See Matthew Imms, 'Bamburgh Castle, Northumberland c.1837 by Joseph Mallord William Turner', catalogue entry, November 2012, in *J.M.W. Turner: Sketchbooks, Drawings and Watercolours*, ed. David Blayney Brown, December 2012, http://www.tate.org.uk/art/research-publications/jmw-turner/joseph-mallord-william-turner-bamburgh-castle-northumberland-r1141243, accessed 17 March 2014.

2 Christine Riding, 'Shipwreck, Self-preservation and the Sublime', in *The Art of the Sublime*, ed. N. Llewellyn and C. Riding, January 2013, http://www.tate.org.uk/art/research-publications/the-sublime/christine-riding-shipwreck-self-preservation-and-the-sublime-r1133015, accessed 17 March 2014.

3 Thomas Pennant, 1771, quoted in Hill 1998, p.78.

4 *Morning Chronicle*, 17 January 1816.

5 Minutes of the Graphic Society, Royal Academy Archives (GS/1).

6 Ibid.

7 Account given in the catalogue for the sale of John Heugh's collection, Christie's, 28 April 1860, quoted in David Hill, 'An Appreciation', in *Joseph Mallord Turner: Bamborough Castle*, Sotheby's, London 2007, p.10. I am very grateful to David Hill for his kind help in the preparation of this catalogue entry.

Margate Pier c.1835–40

Watercolour and gouache on paper 22.4 × 29.2
The Samuel Courtauld Trust, The Courtauld Gallery,
London
Exhibited London only

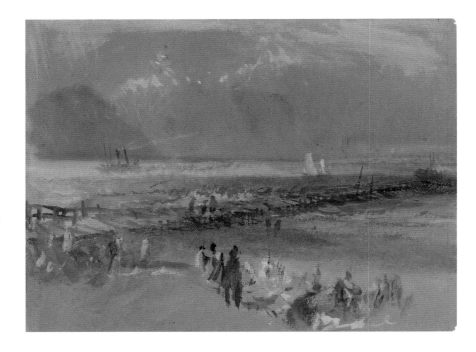

Margate Pier IS A BRAVURA display: on a small scale and using only the most economic mark-making – slashes and daubs – Turner evokes a lively bustle of activity under a typically British blustery sky. Without outlining his composition in pencil, he applies colour directly, alternating between patches of smooth wash, as seen in the distant sea and the patch of blue sky, and staccato flicks and quivers that make for a choppy sea and a windblown group of figures on the sand. Much of the buff paper's surface is left exposed, unifying sand, sea and sky to effectively convey the airy expansiveness of the coast. Turner has also exploited the landscape format of the sheet to suggest depth of field, as the jetty spans its entire width in a dramatic application of perspective. At once splicing the image and leading the eye through it, the vanishing jetty succeeds in suggesting a further dimension of the watery deep.

Mrs Booth's lodgings up on Margate's harbour front offered the perfect vantage point from which Turner could observe happenings on the shore and out at sea. The jetty in *Margate Pier* appears to be the 1,100-ft-long wooden structure built in 1824, Jarvis's Landing Place, where passengers on the regular steam packet from London Bridge Wharf would disembark at low tide. The figures, whose activity is difficult to discern, might then be awaiting the next packet or congregating by a fish stand. Alternatively, *Margate Pier* might be a recollection and a colouristic development of scenes previously observed by Turner. The *Fire at Sea* sketchbook of c.1834 (Tate, TB CCLXXII) contains several quick chalk sketches of a similar jetty flanked by different groups of figures: in one, fishermen mend their nets, while in another, *The Promenade by the Sea* (Tate, TB CCLXXXII 41), we see men in dark clothes and top hats, not

dissimilar to the figure in the central foreground of *Margate Pier*.

This drawing was once a page in a sketchbook that after Turner's death found its way into the possession of Mrs Booth. Ruskin purchased the book from her and subsequently broke it up to sell on again. He expressed a particular admiration for this work, however, writing to the New York collector who purchased it in 1869 that 'This – of all the sketches I sold, I most regretted parting with … very few are equal to this in consummate result with hardly any work.'[1] This New York collector was William T. Blodgett, whose daughter Eleanor presented the work to her godson and future President Franklin Delano Roosevelt as a birthday gift in 1911.[2] AC

1 Ruskin to William T. Blodgett, 10 September 1869, quoted by Joanna Selborne in *Paths to Fame: Turner Watercolours from The Courtauld Gallery*, exh. cat, The Courtauld Gallery and The Wordsworth Trust, Grasmere, 2008, p.137.

2 Selborne 2008, p.137.

125

Riders on a Beach c.1835

Oil paint on board 23 × 30.5
Tate D36675
Exhibited London only

126

Shore Scene with Waves and Breakwater
c.1835

Oil paint on board 22.7 × 30.4
Tate D36680
Exhibited London only

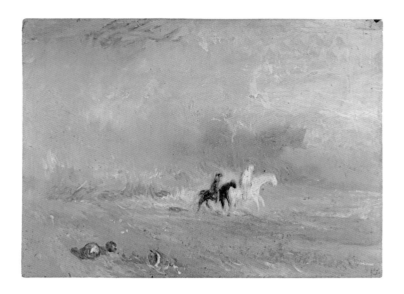

EXPERIMENTATION is a common thread amongst the body of work associated with Turner's frequent trips to Margate from the 1830s. *Riders on a Beach* and *Shore Scene with Waves and Breakwater* are amongst some sixteen coastal sketches on millboard, a thick board originally developed for making boxes and used in bookbinding, dating from this time. This combination of materials – oil on board – is, as Peter Bower notes, an apparently unique feature of Turner's later work, perhaps first being employed for sketches made in Italy in 1828.[1] Turner perhaps found the method and its portable format a satisfying alternative to watercolour when working away from his London studio during long periods in Margate. Yet although *Riders on a Beach* and *Shore Scene with Waves and Breakwater* have a vigour and immediacy that suggests a basis in direct observation, it is unlikely that Turner painted these sketches on the beach itself. In earlier years he had expressed frustrations with the process of painting outdoors and at Margate he had the good fortune to be able to observe the shore directly from the comfort of Mrs Booth's harbourside lodging house. James Hamilton suggests that, with his health declining after a serious bout of cholera in the late 1840s, he turned to millboard and watercolour in place of 'large and heavy-to-work' oils.[2]

The parity between the colour schemes in these sketches suggests that Turner worked on them simultaneously, or that he moved quickly from one to the other while his palette was still wet. Unlike his hundreds of watercolour studies of sea and sky (see cats.129–34), they do not present airy, expansive views but rather much-compacted and almost disorientating perspectives. In *Riders on a Beach* the mysterious grey bulk behind the riders could suggest clouds, a distant land mass or a vessel just going out to sea, but the curtain of white paint obscures certainty, ominously rearing up behind the

riders. The oblique viewpoint in *Scene with Waves and Breakwater* lends a tangible sense of marine tumult, as the sea surges to the left and pounds the sand. Turner has worked thick, viscous paint that has dried into a textured impasto for the foaming waves, giving them a three-dimensional solidity that emphasises their power; conversely, the thinner, more fluidly applied strokes of paint that form the breakwater do much to convey its vulnerability and dilapidated state. AC

1 Bower 1999, p.116. A possible date of 1819 for the Italian sketches has been posited in Butlin and Joll 1984, nos.318–27, pp.179–81.

2 Hamilton 2003, p.131.

127

Storm Approaching from the *Boulogne* sketchbook 1845

Gouache, graphite and watercolour on paper 23 × 32.6
Tate D35408; TB CCCLVIII 6
Exhibited London only

SEEKING 'REVIVAL by a little change of fresh air', Turner left London on 5 May 1845 for the Kent coast.[1] From here he made the cross-Channel journey to Boulogne a few days later. The expanses of bare paper and minimalistic mark-making in these sketches give a sense of Turner's delight in the airy and 'fresh' expanses of scenery he observed along the shores of Kent and northern France. He would most likely have made the journey to Boulogne from Folkestone on a steamboat after the New Commercial Steam Packet Company was established in 1843 to serve this route. *Folkestone*, seen here from an elevated viewpoint on the cliffs above the shore, is typical of the sketches within the *Ideas of Folkestone* sketchbook, which is thought to have been given its name by Turner himself. The ideas are pared-back colouristic transcriptions of an observed landscape: here, the curvature of the cliff is hastily blocked out in crimson and ochre over a slight pencil outline.

Both *Storm Approaching* and *Folkestone* feature in 'roll' sketchbooks with soft covers that Turner could easily store rolled up in his pocket. Their size facilitated the exploration of imagery, enabling Turner to work out compositional and colour relationships on a more expansive scale than he could in the diminutive pocket sketchbooks that at this time typically contained his initial jottings in pencil.

Storm Approaching is a page from the sketchbook associated with his excursion to Boulogne, containing drawings of a similar aesthetic to those in the *Ideas of Folkestone* sketchbook. Ruskin described the Boulogne sketchbook as 'coloured indications or ideas'.[2] This page exemplifies the speed with which

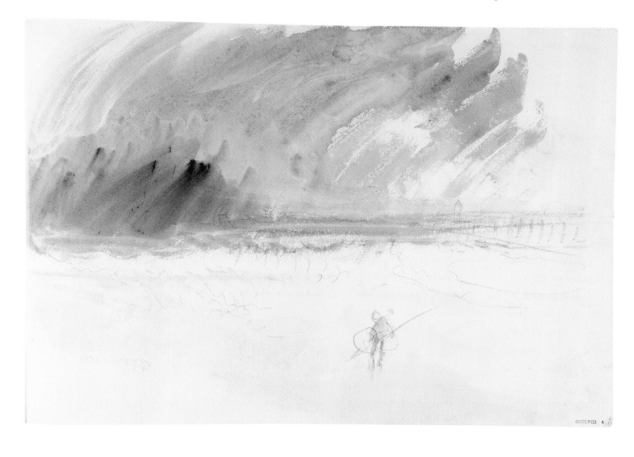

128
Folkestone from the *Ideas of Folkestone*
sketchbook 1845
Gouache, graphite and watercolour on paper 23 × 32.8
Tate D35383; TB CCCLVI 22
Exhibited London only

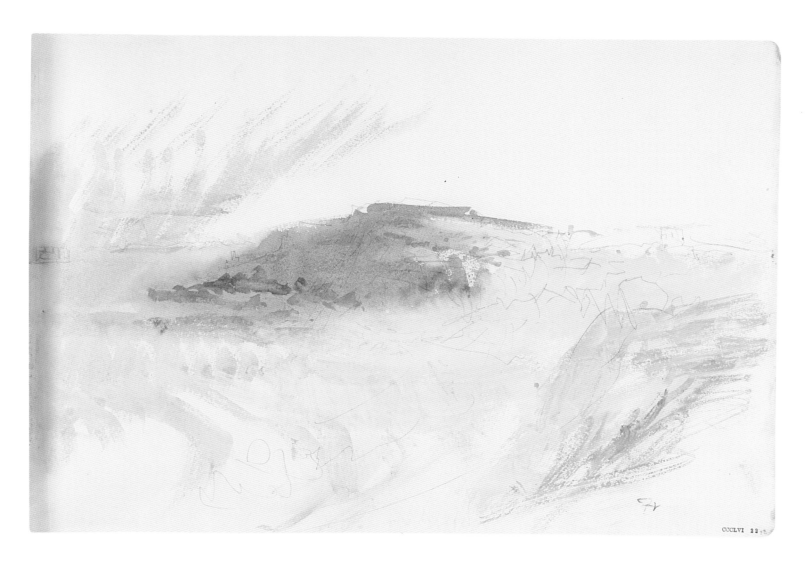

Turner could articulate an idea, dragging pigment over the page in only a few flicks before working a deeper purple wet-in-wet to create the most limpid evocation of a sky about to unleash a storm. Below the pregnant sky stands a single figure with a fishing line, outlined in pencil and embodied by a single dab of Turner's brush. Though not extensively developed, the idea in *Storm Approaching* chimes with the recurrent melancholic theme in Turner's late seascapes; perhaps the figure represents something of his own sense of solitude both at Boulogne, as a lone traveller, and back in the art world of London, where he was swiftly becoming the lone representative of his generation after the deaths of colleagues like Thomas Lawrence and David Wilkie. AC

1 Turner to John James Ruskin, 15 May 1845, in Gage 1980, p.206.
2 Ruskin quoted in Blayney Brown 1987, p.12.

129

Blue Sea and Distant Ship c.1843–5

Watercolour on paper 28.2 × 44.4
Tate D36311; TB CCCLXV 21
Exhibited London only

130

Rain Clouds c.1845

Watercolour on paper 29.1 × 44
Tate D36309; TB CCCLXV 19

131

A Stormy Sky c.1843–5

Watercolour on paper 29.1 × 43.9
Tate D36310; TB CCCLXV 20
Exhibited London only

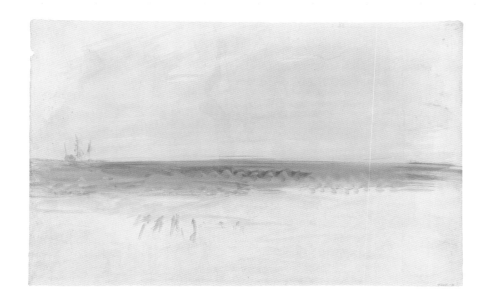

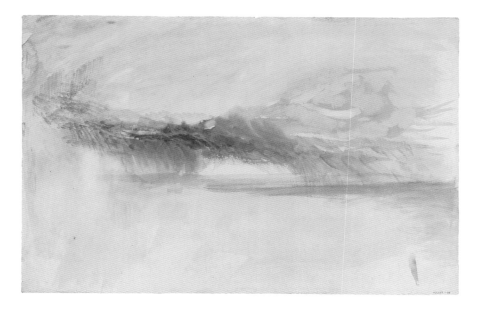

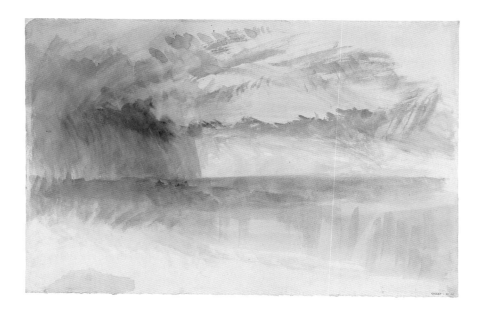

As FLUID AS THE ELEMENTS they depict, these watercolours number amongst hundreds of meditations by Turner on the horizon, the point at which sea meets sky. They reveal the power and speed of his creative process as he conjures magnificent effects, both threatening and uplifting in tone, through the most economic means. Though they resemble the so-called 'colour beginnings' that formed a stage in his devising of finished watercolours, the sheets in this group have no distinct onward purpose but are rather beginnings and ends in themselves.

A consistent formula unites them. In each one the horizon divides the page so that a narrow strip of sea yields to a dominant sky. The foreground, barely worked, is sometimes recognisable as sand and at other times an indistinct extension of the sea. In *Rain Clouds*, *A Stormy Sky* and *Rainbow among Purple and Blue Clouds* (cats.130, 131, 132) this formula is writ in the same palette of purple, blue, yellow and crimson – Turner most likely worked on these in one session, perhaps tracking the development of a weather front at different points across the bay at Margate from the window of Mrs Booth's lodging house. As much as their brisk production is apparent in the dynamic sweeping and scrubbing brushmarks, *Rainbow among Purple and Blue Clouds* belies some careful planning. The arc of the rainbow plunges down into the horizon, its pale tone preserved perhaps by the use of masking fluid or else by scrubbing out the darker mauve wash. Turner then cuts across it with shadowy beams to evoke the colouristic

132

Rainbow among Purple and Blue Clouds
c.1840–5
Watercolour on paper 27.8 × 44
Tate D36302; TB CCCLXV 12

133

Storm Clouds, Looking Out to Sea 1845
Watercolour on paper 23.8 × 33.6
Tate D35397; TB CCCLVII 11
Exhibited London only

134

Storm at Sea c.1845
Watercolour and crayon on paper 21.9 × 29
Tate D35855; TB CCCLXIV 18
Exhibited London only

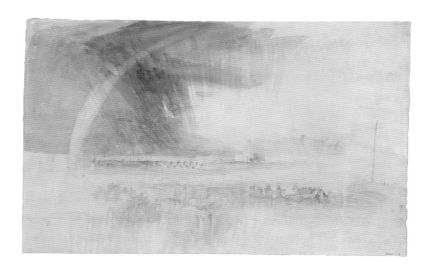

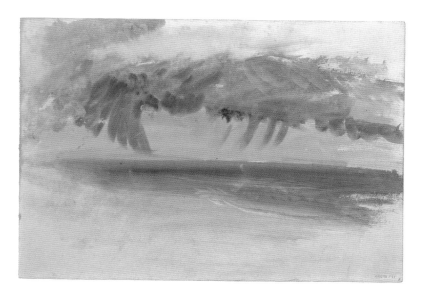

chiaroscuro of the moment at which storm clouds retreat and light returns, transmitting a rainbow through the ether.

To facilitate the speedy evocation of a fleeting moment, Turner used paper prepared by the manufacturer with an animal glue that was less absorbent and thus more conducive to working swiftly wet-in-wet. This is most evident in *Storm Clouds, Looking out to Sea*, where Turner's deployment of fluid washes that bleed and mingle on the page is expertly and almost effortlessly mimetic of nature's watery display. Similar effects are seen in *Storm at Sea*, a more sinister evocation of a violent storm. This can be related in mood and technique to Turner's whaling drawings (see cats.102–5), through the muddy palette dominated by black, the suggestion of boats about to be engulfed in the storm and the use of crayon to define forms on the shore.

Countering the furious crescendo of *Storm at Sea* is the silent calm of *Blue Sea and Distant Ship* (cat.129), amongst the most strikingly economic of Turner's late watercolours. Ripping through the spare, pale washes for sky and sand, a resounding strip of cobalt blue sea is animated by one single zigzag wave and the delicate suggestion of a lone sailing ship on the horizon; indeterminate flicks on the sand might be people or a breakwater. Although the clear sky and cool blue of the flat sea signal calm, there is loaded poignancy in this silence. The lone ship recurs throughout Turner's late seascapes, and it sails here on an incomprehensibly vast expanse of emptiness, through a scene devoid of the

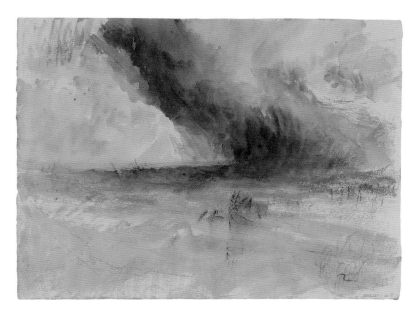

meteorological drama of the other watercolours in this group, and as such offers little distraction from introspection. AC

205

136
Waves Breaking on a Lee Shore at Margate (Study for 'Rockets and Blue Lights') c.1840

Oil paint on canvas 59.7 × 95.2
Tate N02882

Mrs Booth's lodging house, close to the beach, provided an excellent base from which to explore the sea in all its moods, translated into numerous studies of the sea such as this one. In the background can be seen the harbour wall and lighthouse at Margate. There are large swells moving towards it and a fiercely agitated sea is breaking on the shore. The drifting cloud is moving to the left, bringing darkening skies with it. Some marine gear has been cursorily indicated on the sand.

This sketch is considered to be a study for Turner's painting *Rockets and Blue Lights (Close at Hand) to Warn Steam Boats of Shoal Water* (fig.46, p.146), which was exhibited at the Royal Academy in 1840 and the British Institution in 1841. That picture is one of a sequence examining the use of rockets in contributing to safety at sea, including *Life-Boat and Manby Apparatus Going Off to a Stranded Vessel Making Signal (Blue Lights) of Distress* (1831; Victoria and Albert Museum, London) and *Snow Storm – Steam-Boat off a Harbour's Mouth making Signals in Shallow Water, and going by the Lead*, 1842 (cat.95).

The close comparison between this painting and *Rockets and Blue Lights* raises the question of whether Turner had the composition of the finished painting in mind when painting this study or whether he had originally painted it as a self-sufficient study of the sea and later selected it from a group of similar oil sketches when seeking to develop the composition that would become *Rockets and Blue Lights*. SS

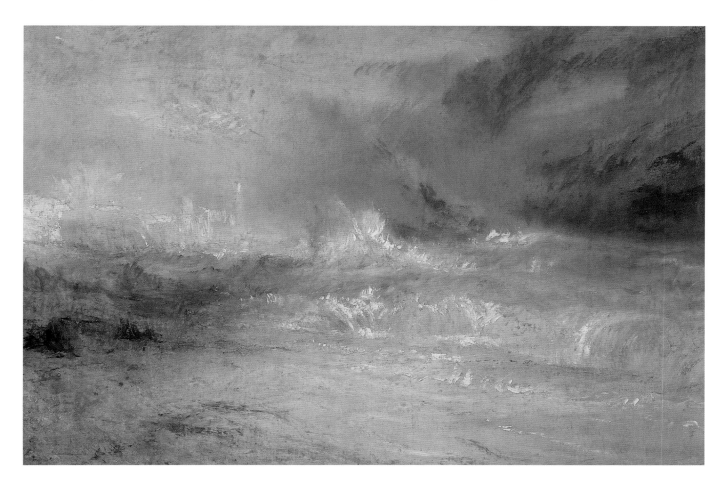

137

Margate(?) from the Sea 1835–40
Oil paint on canvas 91.2 × 122.2
The National Gallery, London. Turner Bequest, 1856
Exhibited London only

138

Seascape with Storm Coming On c.1840
Oil paint on canvas 91.4 × 121.6
Tate NO4445
Exhibited London only

UNFINISHED AND RAW, these paintings embody both the intensity and the process by which Turner's obsession with the sea materialised on canvas. Four of the paintings here – *Margate (?) from the Sea*, *Seascape with Storm Coming On*, *Rough Sea* and *Rough Sea with Wreckage* (cats.137–40) – are on what became Turner's standard-size canvas, roughly 90 × 120 cm. The same rich brown, pastel green and blues, vivid yellow and luminous white run through them, suggesting that they were worked up simultaneously, with their colour applied in sequence, allowing for drying time between layers; *Seascape, Folkestone* (fig.54, p.193) may also be part of this group. For all the economy and formula about this process, their surfaces channel the passion and energy by

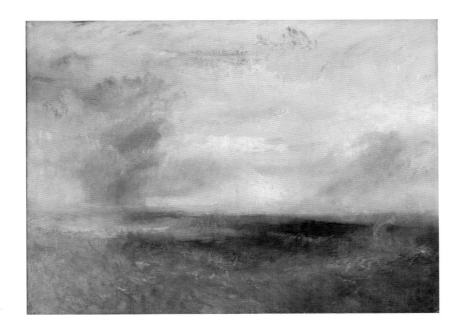

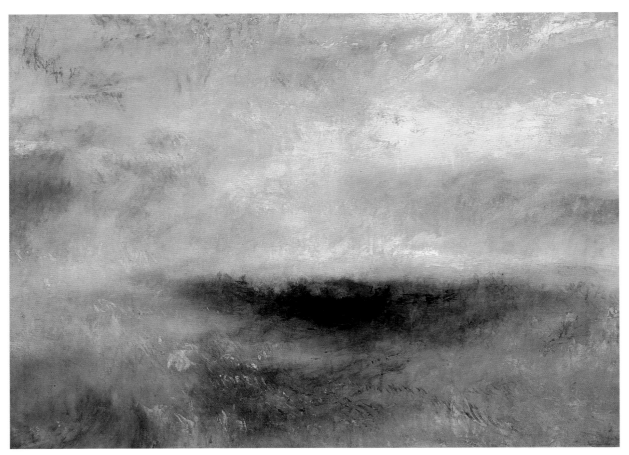

139
Rough Sea c.1840–5
Oil paint on canvas 914 × 1219
Tate N05479
Exhibited London only

which Turner made paint obey his vision: thin layers are furiously driven across the canvas with brushes and rags, while thicker paint is sculpted with a palette knife or even perhaps Turner's hands.

Mostly cool in tone, a vivid show of colour appears in the scumbled red clouds at the top of *Seascape with Storm Coming On*, while *Waves Breaking against the Wind* has suffered some fading of its pigments, for analysis has revealed that the right-hand side originally bore a much rosier sunset, of which only a sliver – long

protected by a frame – remains.[1] Intrinsic to each composition is the interplay between light and dark. Although Turner depicts a diffuse sunlight, reflections of that light from the sea and refraction through clouds colours skies pink and yellow, making for a precarious balance between optimism and threat. This is particularly pronounced in *Rough Sea with Wreckage*, in which splintered remnants of a ship in the foreground are juxtaposed with the dazzling white of a distant ship's sail on the horizon, lit by a dramatic diagonal shaft of light.

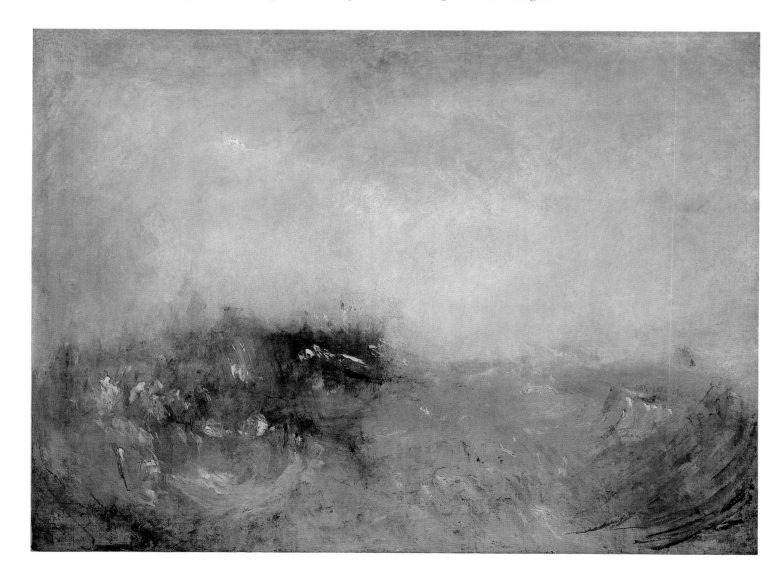

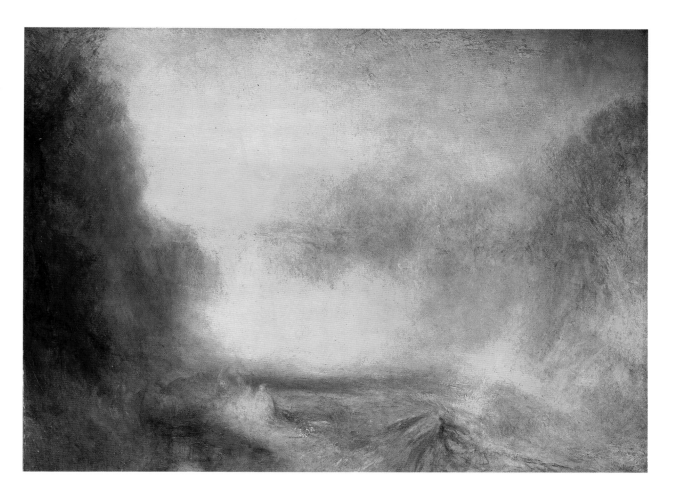

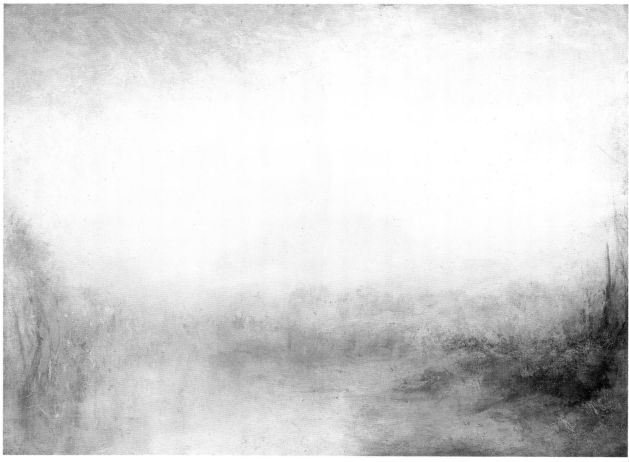

146
Sunrise, a Castle on a Bay: 'Solitude' ?c.1845
Oil paint on canvas 90.8 × 121.9
Tate N01985
Exhibited London only

147
Bridge and Goats: 'The Ponte Delle Torri, Spoleto' ?c.1845
Oil paint on canvas 91.4 × 121.9
Tate N02424

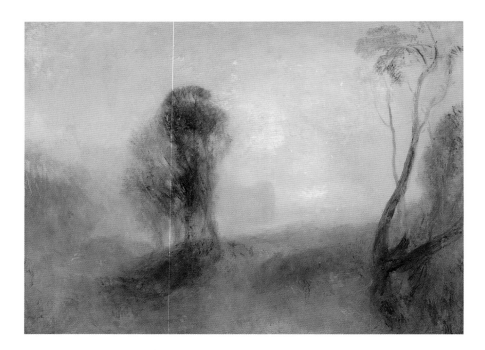

Sunrise IS BASED ON plate 53 of the *Liber*, in which the castle in the background appears similar to the 'Enchanted Castle' in the background of Claude's *Landscape with Psyche outside Cupid's Palace* (National Gallery, London), which Turner could have known from a print by William Woollett. Consequently this is one of the most lyrical and idyllic of the *Liber* transcriptions, with a pronounced classical feeling. But rather than depicted with Claude's picturesque architectural detail, the castle is a ghostly silhouette of greyish white, immersed in the hazy light that fills the middle distance.

Technically and in its use of architecture and employment of a graceful tree to frame the composition, *Sunrise* is comparable to 'The Ponte Delle Torri', based on plate 43 of the *Liber*, as Eric Shanes was the first to observe.[1] The *Liber* plate, 'Bridge and Goats', was long thought to be the first to be made for the series – a view which has received more recent support from the *Liber* scholar Gillian Forrester.[2] If so, this would account for Turner's special affection for the subject, which explores that staple of classical landscape, a bridge in the middle distance, in a suitably Arcadian atmosphere. The *Liber* plate was published in 1812 and its design can be dated as early as c.1806 but Turner did not visit Spoleto until 1819, suggesting that the resemblance may be coincidental and the composition largely imaginary. DBB

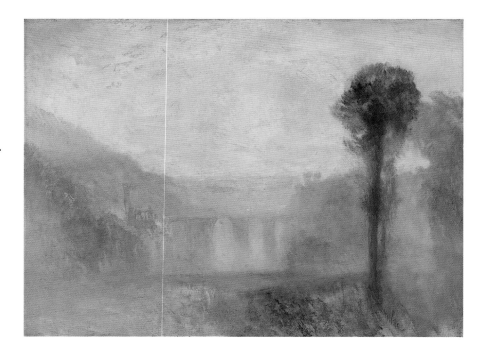

1 Shanes 1981, p.46.
2 Forrester 1996, pp.10–11, 104.

148

Norham Castle, Sunrise ?c.1845
Oil paint on canvas 90.8 × 121.9
Tate N01981

149

Sunrise, with a Boat between Headlands ?c.1845
Oil paint on canvas 91.4 × 121.9
Tate N02002

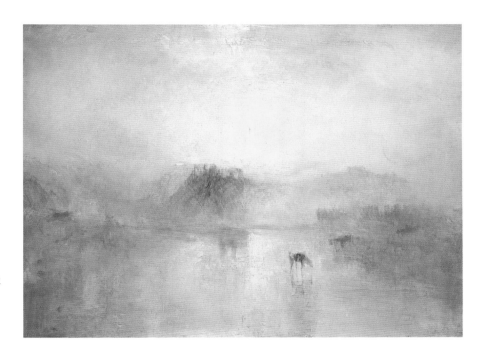

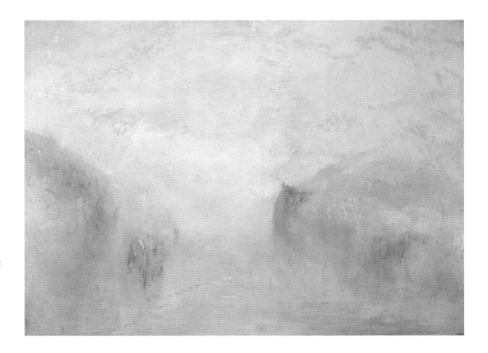

IN COLOUR AND HANDLING these two oils seem so closely related that it is tempting to imagine them being painted at the same time or as a potential pair. They deploy a similar palette of pale yellow and blue with touches of warmer umber and depict the same effect of sunrise. However, only *Norham Castle* derives from the *Liber* – from plate 57. Turner first saw the castle, south of Berwick, on a tour of the North in 1797 and it became a favourite subject to which he bowed and doffed his hat on a later visit in 1831. In a sequence of works from 1798 onwards, he explored its relationship to effects of light, first as a dark silhouette backlit by the rising sun and now enveloped in sunshine almost to the point of dissolution.

Norham Castle has been a touchstone for modern understandings of Turner's later work as abstract or Impressionist, as if he could knowingly 'anticipate' later artistic trends. These are bold claims to make when we cannot know if Turner finished working on it or expected an audience for it at all. The same processes are at work and the same questions arise in the second picture, to the extent that its subject and setting have never been identified with any certainty. The stretch of water between two headlands might be a lake in Switzerland, a river like the Rhine or even the setting of a Claudean seaport. Suggested locations have ranged from the Lake of Lucerne at Brunnen to Turner's imaginary Carthage. In the latter case this might be a possible fifth subject in Turner's final Dido and Aeneas series (cats.171–3), in its preliminary state before completion for exhibition, when it would have been given a warmer tonality as well as figures and architecture. Of these alternatives a Swiss location seems preferable; if not Brunnen, perhaps the castle of Ringgenburg beside Lake Brienz, which Turner had seen for the first time, lost in hazy light, in 1802. But none of these resemblances is exact and if not imaginary, the subject seems to be passing into memory. DBB

150

The Pass of the Splügen:
Sample Study c.1841–2

Graphite and watercolour on paper 24.3 × 30.4
Tate D36125; TB CCCLXIV 277

151

Bellinzona from the Road to Locarno:
Sample Study c.1842–3

Gouache, graphite and watercolour on paper 22.9 × 28.9
Tate D33495; TB CCCXXXII 25

O N THE BACK OF A TOUR made in 1836, Turner rediscovered the enthusiasm for Switzerland that he had felt as a young man thirty years earlier. Returning in 1841, he toured its valleys and lakes, amassing material in his customary way, filling small sketchbooks with hurried pencil jottings and making compositional sketches in watercolour in a larger sketchbook with soft covers that could be rolled up in his coat pocket. Yet this Swiss tour inspired a new venture that hinged upon a select number of watercolour sketches, now known as 'sample studies', that formed a coherent group celebrating the most breathtaking vistas and well-known tourist stations he had encountered that year. It was a model he would repeat again

on subsequent tours of the country in 1842, 1843 and 1844. As the term suggests, the function of a sample study was speculative, to give prospective patrons a hint as to how a fully worked version of the composition might look. The sample studies, of which Turner always retained possession, thus exhibit varying levels of finish. Some, like *The Pass of the Splügen*, comprise little more than a light pencil sketch beneath layers of broad washes that map out colour structure. Others, amongst them *Bellinzona from the Road to Locarno*, display a different tack, paying greater attention to variations in tone and texture and offering more detail in the human element that Turner would often introduce in the foreground.

Turner's deftness at conjuring expansive

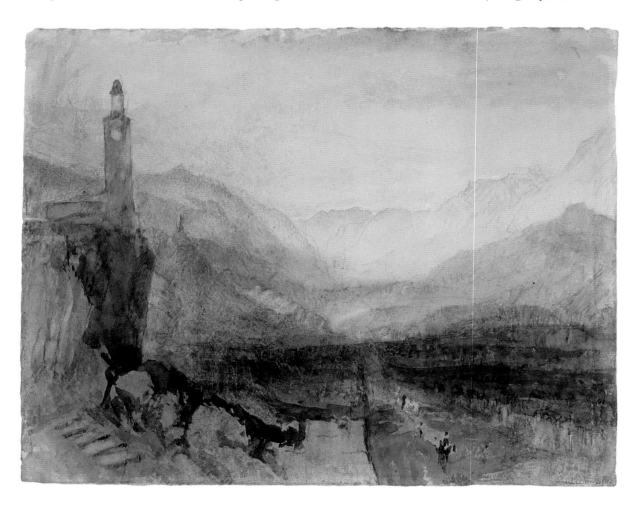

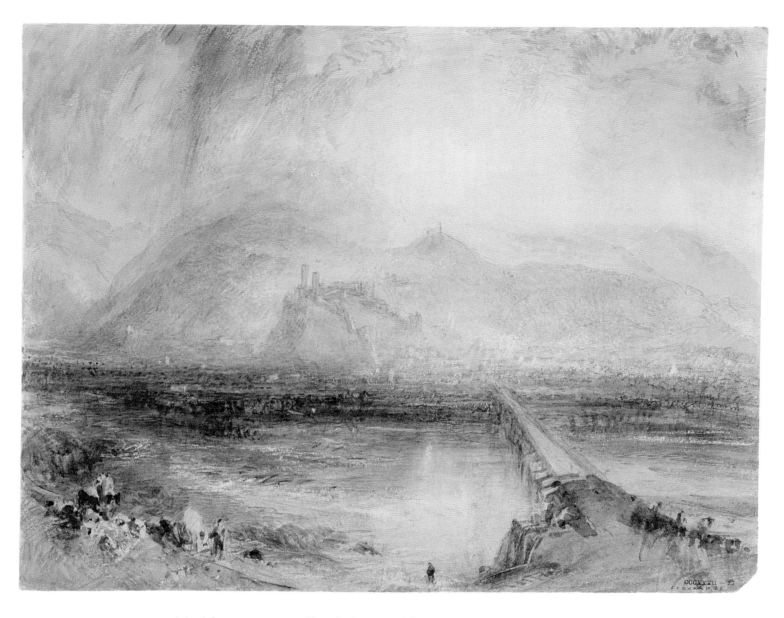

pictorial space on a small scale is exemplified by these sample studies. Sheer breadth characterises the bravura, almost geometric design of *Bellinzona*. Pale against the river, the dramatically foreshortened bridge leads us to the misty heart of the composition, to the horizontal axis of the Ticino river, which is rendered in threads of colour and scratched out to reveal glistening white highlights; vertically, glaring sunlight opposes a sweep of dark purple rain clouds. Turner's emphasis on these colours – cool blues and purple – unifies the composition, as do warm earth tones in *The Pass of the Splügen*, in which an immense depth is achieved as the shadowy valley recedes from view.

Ruskin appreciated the restraint of Turner's sample studies, perceiving them to be free from 'attempts at idealism' and thus, on the whole, 'more valuable than his finished drawings'.[1]

He had a particular reverence for that of *The Pass of the Splügen*, 'the noblest Alpine drawing Turner had ever till then made'.[2] It was amongst the first group of sample compositions he worked up speculatively to demonstrate the transition between sample and finished drawing.[3] Ruskin smarted from losing out in its acquisition to Munro of Novar, who, alongside one of the most important collections of Old Master and contemporary British paintings, already owned over one hundred Turner drawings and would continue collecting.[4] AC

1 Cook and Wedderburn, XIII, pp.189–90.

2 Ibid., p.480.

3 For dating of works, see Appendix II in Warrell 1995, pp.149–55.

4 Cook and Wedderburn, XXXV, p.309.

152

Evening: Cloud on Mount Rigi c.1841

Watercolour on wove paper 21.8 × 26.7
The Ashmolean Museum, University of Oxford. Presented
by John Ruskin to the Ruskin Drawing School (University
of Oxford), 1875. Transferred to the Ashmolean Museum,
1949
Exhibited London only

153

The Red Rigi: Sample Study
c.1841–2

Watercolour on paper 22.8 × 30.2
Tate D36123; TB CCCLXIV 275

Travelling through Switzerland in Turner's footsteps inspired John Ruskin to define the purpose of landscape art as being less concerned with the 'image of the place itself, as the spirit of the place'.[1] A powerful sense of this spirit is conveyed in Turner's drawings of the Rigi. Lying to the east of Lucerne, its slopes descending into the lake, Turner first pictured the mountain in 1802 but in later life it became a touchstone, inspiring his most celebrated work in watercolour.

The Rigi had been a popular tourist destination since at least the beginning of the nineteenth century. Guidebooks promised 'a panorama hardly to be equalled in extent and grandeur among the Alps' at the summit, which Turner painted without ever making the ascent (see entry for cat.167).[2] Far more captivating for

154
The Blue Rigi: Sample Study
c.1841–2
Watercolour on paper 23 × 32.6
Tate D36188; TB CCCLXIV 330

him was the distinctive, isolated bulk of the Rigi itself, viewed in all lights across a plane of water.

In *Evening: Cloud on Mount Rigi* (cat.152) we see it from the north across the lake of Zug, a reversal of Turner's usual perspective on the mountain from across Lake Lucerne. In common with others, however, this seemingly effortless but atmospheric drawing portrays the mountain as a silhouette, boldly defined in a single colour, emerging from a hazy sky. This colouring is taken forward in *The Blue Rigi: Sample Study*, though here the cool tones represent morning; evening, in *The Red Rigi: Sample Study*, is now a brilliant red.

By design, the sample studies show a restraint in handling and effect when set against the more spontaneous *Evening: Cloud on Mount Rigi* and the drama of the finished watercolour, *The Blue Rigi, Sunrise*. This is an intricate tapestry of transparent washes and textured brushwork, structured around pulsating bands of warm and cool tones – a favoured Turner juxtaposition also seen in *Norham Castle, Sunrise* (cat.148) – that frame the majestic mountain, robed in mist. Venus, the morning star, is a speck of white paper revealed by scratching away the colour-washed surface; its glow is extended by a faint

155

The Blue Rigi, Sunrise 1842

Watercolour on paper 29.7 × 45

Tate T12336. Purchased with assistance from the National Heritage Memorial
Fund, the Art Fund (with a contribution from the Wolfson Foundation and
including generous support from David and Susan Gradel, and from other
members of the public through the Save the Blue Rigi appeal), Tate Members
and other donors 2007

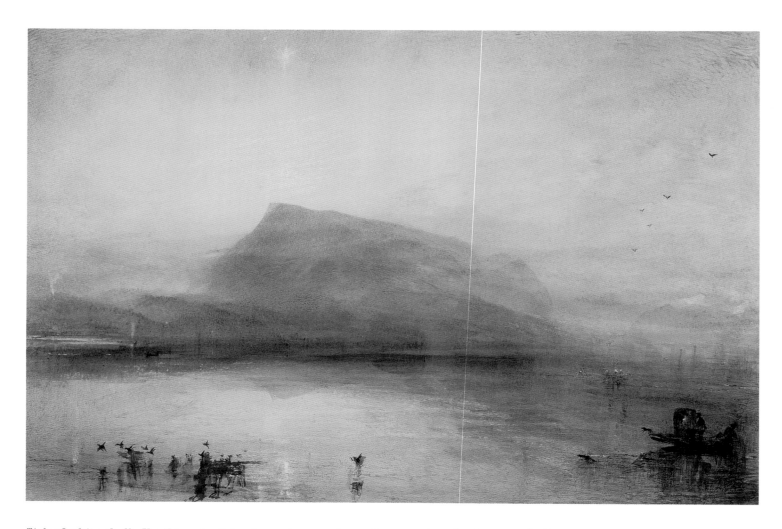

flick of white chalk. Yet this celestial calm and
the still of the water are offset by earthly noise,
for in the foreground appears a commotion of
dogs chasing waterfowl, a typical display of
Turner's wit.

Though *The Blue Rigi* may rank amongst
Turner's most masterful and celebrated
depictions of the mountain, *The Rigi* indicates
the endurance of his fascination with this scene.
He is likely to have captured this sunset in his
sketchbook from a room on the upper floor of his
regular lakeside inn, 'La Cygne', on his last-ever
visit to Switzerland. This higher vantage point

draws the town into the frame and allows Turner
to once again pitch the towers of man against
those of nature, as Lucerne Cathedral's twin
spires pierce the sky far below the Rigi's clouded
summit. A rush of energy is conveyed in this
drawing's limpid layers of bold colour, worked
swiftly and with the confidence of one who might
be familiar with the structure of a scene but is
constantly excited by its variance. AC

1 Cook and Wedderburn, VI, p.36.
2 Murray 1838, p.46.

156
The Rigi from the *Lucerne*
sketchbook 1844
Watercolour on paper 22.8 × 32.5
Tate D34975; TB CCCXLV 12
Exhibited London only

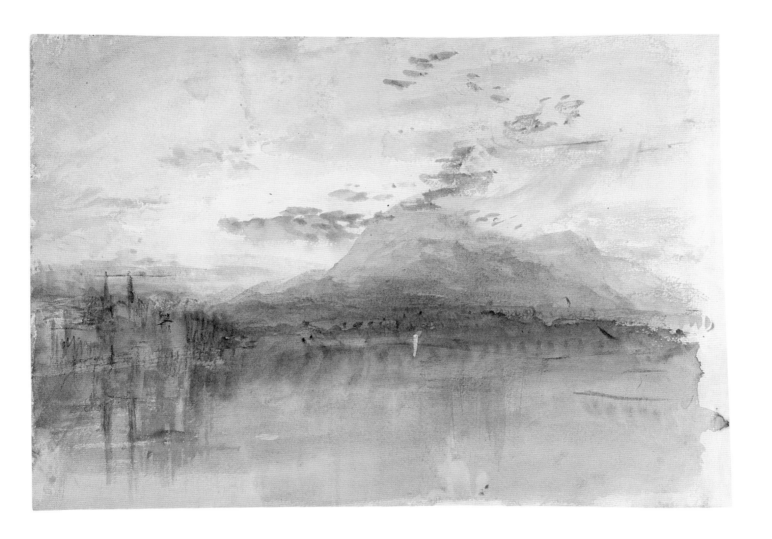

157

Goldau, with the Lake of Zug in the Distance: Sample Study c.1842–3
Graphite, watercolour and pen on paper 22.8 × 29
Tate D36131; TB CCCLXIV 281

158

Lucerne by Moonlight: Sample Study c.1842–3
Watercolour on paper 23.5 × 32.5
Tate D36182; TB CCCLXIV 324
Exhibited London only

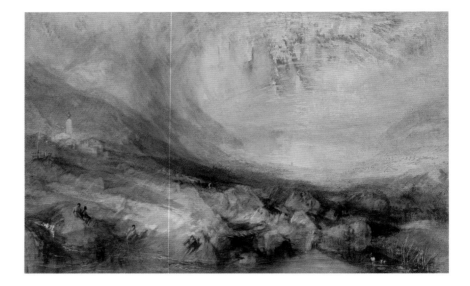

THESE DRAWINGS belong to the group of sample studies Turner prepared in 1842–3. His approach continued to centre upon the colouristic effects of the fall of light at different times of the day, as seen in his evocations of Mount Rigi (cats.152–6). In *Goldau, with the Lake of Zug in the Distance: Sample Study* a wash of brilliant chrome yellow floods the sky with a vibrant sunset. Its warmth permeates the entire sheet and is enhanced, as in so many of these late watercolours, by juxtaposition with the cool tones of the land mass. This effect, however, only hints at the extremity to which Turner would take his colouring in the finished drawing (fig.60).

Turner regularly compounded the emotive force of his works through atmospheric effects. *Goldau*'s violent sunset, with its flashes of scarlet and orange, was read by Ruskin as a direct allusion to the devastating landslide of 1806 that obliterated the village of Goldau, killing over 450 people.[1] Turner's drawing reflects the ongoing fascination with this tragic event, commemorated in Byron's *Manfred* (1817) and well known to Swiss tourists. Figures, possibly tourists, explore the site of the destroyed village, picking their way over boulders so turbulently handled by Turner's brush. And yet, as their jagged, irregular outline traces up the hillside, it comes to define that of the newly built village, indexing the vitality and order that prevails in this afflicted mountain community. The village appears protected by the church at its apex. This beacon of serenity performs an important technical function, too, by balancing the brilliant sunset and leading the eye, via a circular path over the mountains, back to it.

The white of the church comes from the brilliance of the paper, untouched by Turner.

In *Lucerne by Moonlight: Sample Study*, the tower of Lucerne's most distinctive bridge, the Kapellbrücke, derives its definition from the opposite tactic, for here is Turner's most concentrated application of dark pigment. Similarly, while *Goldau* represents the preparatory work for one of Turner's most boldly colouristic performances on paper, *Lucerne by Moonlight* is the most monochromatic of the 1842–3 Swiss drawings; as Andrew Wilton has suggested, the artist may have been remembering a print from his youth, *Lucerne: Moonlight*, which featured in the *Liber Studiorum*.[2] The watercolour's tranquillity is achieved through economic means of thinly laid washes which gently gradate tone; the glassy surface of the lake is much in contrast to the raw handling and rough texture of the Goldau boulders. AC

1 *Modern Painters*, in Cook and Wedderburn, VII, p.438.
2 Wilton 1982, p.69.

FIG.60
Goldau 1843
Watercolour and scratching out on paper
30.5 × 47
Private collection

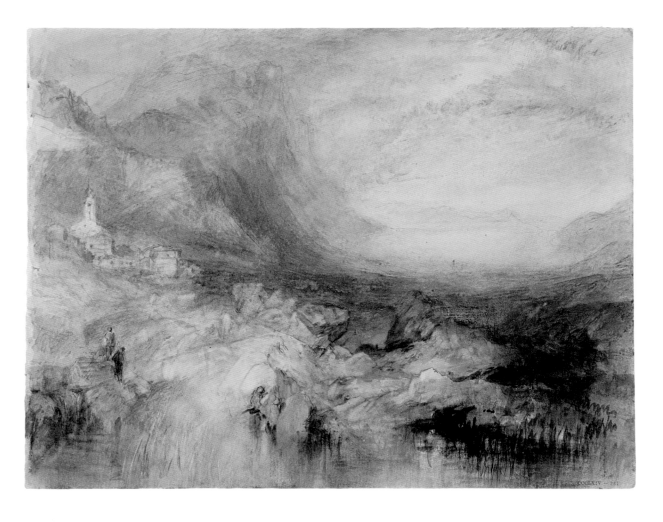

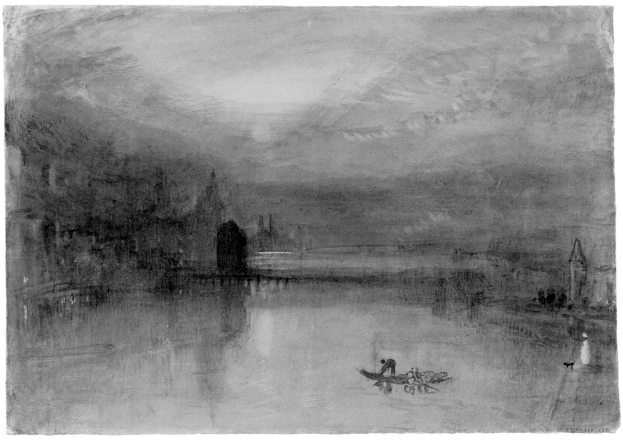

159

Arth, on the Lake of Zug.
Early Morning: Sample Study c.1842–3

Graphite, watercolour and pen on paper 22.8 × 29
Tate D36129; TB CCCLXIV 280
Exhibited London only

160

The Lake of Zug 1843

Watercolour 29.8 × 46.6
The Metropolitan Museum of Art, Marquand Fund, 1959.
Inv.59.120
Exhibited London only

T URNER VISITED ARTH, which lies less
than two miles from Goldau in the cleft
between the Rigi and Rossnau mountains,
in the summers of 1841 and 1842. Working
across a pocket sketchbook and larger sheets
of paper, he might have even stopped to sketch
the pencil outline *Arth, on the Lake of Zug* on
the spot, as Ian Warrell has suggested.[1] Later
on came the elaborate watercolour effects:
feathery shading to suggest the bulk of the
mountain, layers of vertical strokes for the
landscape's watery reflection, and flourishes of
pen delineating detail of the town and its wooded
surroundings.

Ruskin plausibly suggested that this scene of
the sun rising was conceived as a pendant to the

sun setting over nearby Goldau (see cat.157 and
fig.60, p.228).[2] There is indeed a parity between
the two compositions, notably in Turner's
treatment of the mountain peaks, which in both
works appear to dissolve into a vaporous vortex
around the sun.

Lake of Zug is a particularly striking
amplification of its sample study, in colour, depth
and scope. Turner widens the prospect – as he
had when working up *The Blue Rigi* (cat.155) –
and the human element in the landscape is much
emphasised. The church of Sts George and Zeno,
given such a prominent focus in the sample
study, has recessed into a shady band of heavily
gummed watercolour while the foreground
emerges into focus. The inclusion of women

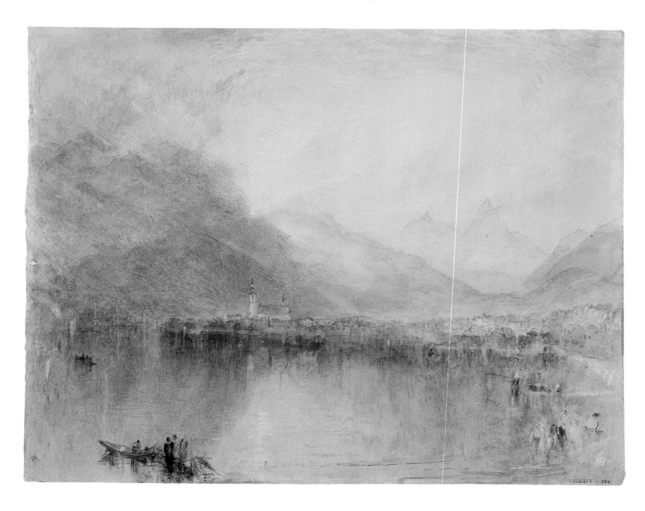

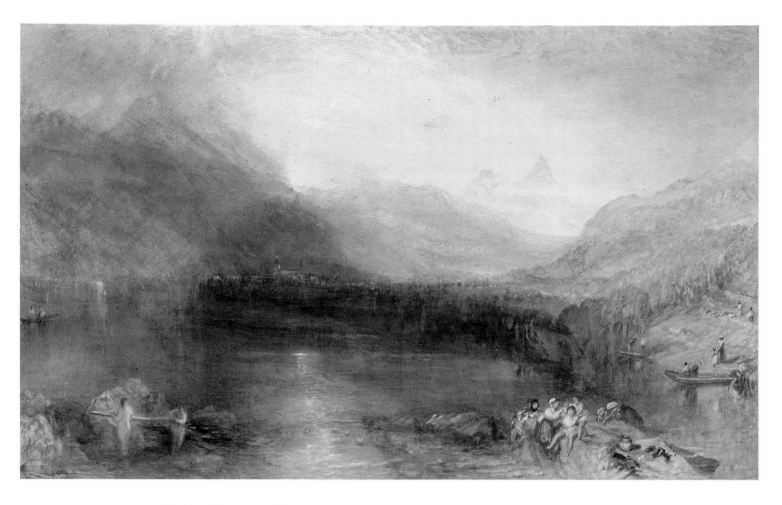

bathing here consolidates this as a vision of the beauty and fertility of the natural world.

The finished drawing was commissioned by Munro of Novar but, as was also the case with *The Pass of the Splügen* (see cat.150), Ruskin yearned to add it to his own collection. His chance came when Munro yielded *Lake of Zug* on account of it being 'too blue'.[3] This long-coveted work soon fell from Ruskin's favour, however. Most typical of his tendency to revise his opinion, Ruskin came to complain of this drawing's focus on the 'facts' of the scene.

That he found the figures 'coarse' reflects less on Turner's delineation of them and more on Ruskin's personal discomfort with female nudity.[4] His discovery of Turner's relationship with Mrs Booth and of erotic drawings by the artist inspired similar repulsion.[5] AC

1 Warrell 2007, p.219.

2 Warrell 1995, p.67.

3 Cook and Wedderburn, XIII, p.484.

4 Ibid., p.455.

5 See Warrell 2012.

161

*Küssnacht, Lake of Lucerne:
Sample Study* c.1842–3

Graphite, watercolour and pen on paper 22.8 × 29.2
Tate D36053; TB CCCLXIV 208
Exhibited London only

162

*Küssnacht, Lake of Lucerne,
Switzerland* 1843

Watercolour and gouache on paper 30.5 × 47.3
Manchester City Galleries
Exhibited London only

T HE SAMPLE STUDY for the finished drawing of the little lakeside village of Küssnacht is, by comparison with other such studies, relatively highly resolved. Its colouring is largely mirrored in the finished drawing, as are the spatial relationships of the boats on the water. The vivid green swathe of gouache representing the forest on the right-hand shore is particularly striking, its reflection punctuated by a horizontal ripple cast by Turner dragging the end of his brush through the paint whilst still wet.

Bathed in golden sunlight, this is a glorious setting for the day-to-day activities of industrious locals and leisured tourists. Details of boats and facial features come into focus in the finished drawing (cat.162), presenting a lake so clear that a submerged oar is visible as it slices the water's

surface in the lower right foreground. Such carefully delineated human activity, detailed and precise, displays a direct continuity with Turner's earlier drawings, particularly his work for the engraved series *Picturesque Views in England and Wales* (1825–38). So, too, does the presence of lettering, in the phonetic spelling of Küssnacht on the boat at the left and in the appearance of Turner's signature 'I M W T' on the boat in the lower right corner. Although Turner signed works less regularly after the mid-1830s, this Latinate signature was a reprise of that he had applied to the sombre drawing he showed in 1830 at the Royal Academy, *The Funeral of Thomas Lawrence: A Sketch from Memory* (Tate, D25467: see detail, fig.61), the last watercolour he exhibited there. In the context of *Küssnacht, Lake*

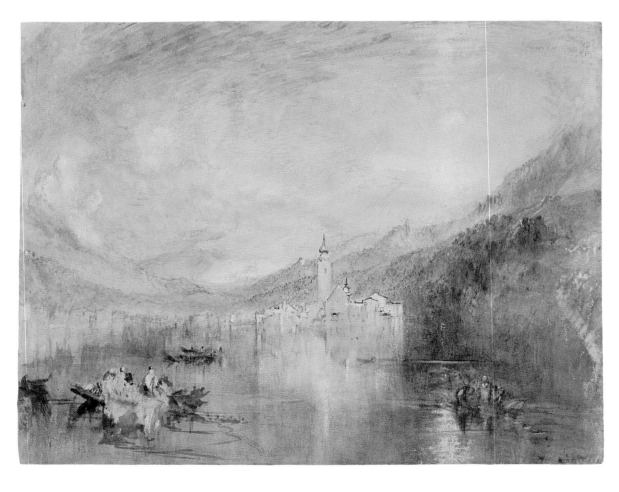

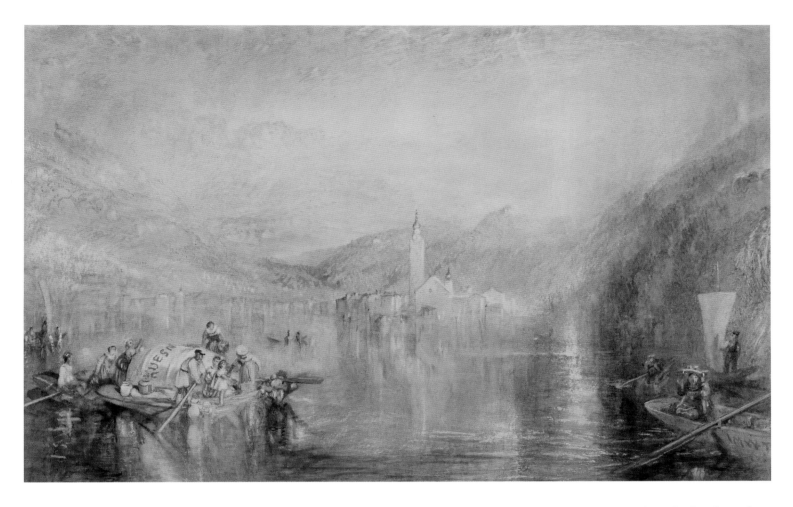

of Lucerne, however, this signature performs a more playful function: though its classicised format is redolent of grandeur, intellect and timelessness, attention is drawn to it by the smiling, outward gaze of the boat's female passenger, who seemingly calls upon the viewer to participate in the enjoyment of the scene courtesy of its creator, Turner.

An inscription by Turner on the reverse of the sample study names Munro of Novar as the patron destined to own the finished drawing. As well as 'Kussnacht', Turner's inscription also references 'Tells Church' and 'Gesler Castle', sites associated with the folk hero William Tell

and his enemy, the tyrant Albrecht Gessler, who threatened to throw Tell to the lake's reptiles at Küssnacht. Though neither building is apparent from Turner's chosen viewpoint (the church in the centre is that of Sts Peter and Paul), the artist would have been keen to emphasise the wider cultural resonances of his subject; in 1804 Schiller wrote the legend of William Tell as a play, which was first performed under Goethe's direction, while the opera by Rossini was first performed in London in 1830.[1] AC

1 Croal and Nugent 1997, p.114; Warrell 1995, p.66.

FIG.61
Funeral of Sir Thomas Lawrence: A Sketch from Memory (detail)
exhibited 1830
Watercolour and gouache on paper 56.1 × 76.9
Tate D25467; TB CCLXIII 344

163

Brunnen, from the Lake of Lucerne: Sample Study ?1843–5

Graphite, watercolour and gouache on paper 24.2 × 29.6
Tate D36237; TB CCCLXIV 375
Exhibited London only

164

Lake Lucerne: Sample Study 1844

Graphite and watercolour on paper 24.4 × 30.3
Tate D36197; TB CCCLXIV 338
Exhibited London only

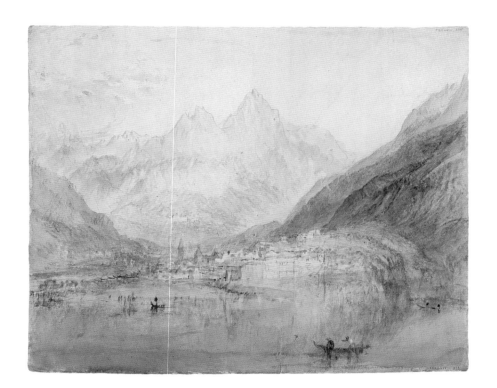

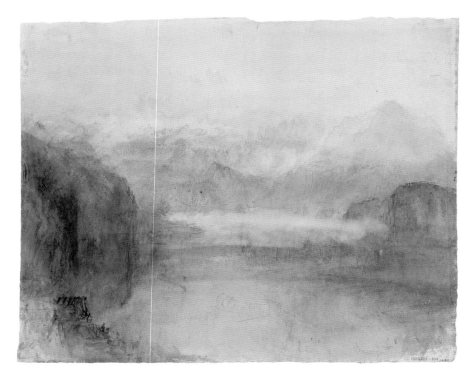

L AKE L UCERNE features in some fourteen of the twenty-five finished watercolours Turner made in the 1840s, and in many more studies beside (see also cats.43–4, for example).[1] Reaching along four different valleys, its size and complex shape offered him endless spectacular mountainous vistas over bright turquoise waters, while its history – featuring in the heroic myth of William Tell, and being the site for the foundation of modern Switzerland – made for rich associations beyond visualisation of the landscape itself.

Turner was repeatedly drawn to the lakeside town of Brunnen, using it as a base from which to explore the southernmost stretch of the lake. In *Brunnen, from the Lake of Lucerne*, the looming twin peak of the Mythen is echoed in the pointed towers of the town below. Ruskin particularly admired this sample study, finding the area on the right-hand slope 'very elaborate and beautiful', where bold, overlapping washes of colour combine to give a sense of depth, texture and shading.[2] Turner appears to revel in this combination of dramatic rock formation and the glassy surface of the lake: in *Lake Lucerne*, a view down the lake from Brunnen, the drama of the vertical cliff face is emphasised by the horizontal bloom of rising mist, created by rubbing away at the colour to reveal the white of the paper. In the foreground he has pencilled in a boat; in the finished version of this drawing (private collection) this boat would become a paddle steamer, heralding the advent of a new age of speed in lake transport.

Sailing south from Brunnen one reaches the small town seen in *Fluelen: Morning (Looking Towards the Lake of Lucerne)*. As in the view of Brunnen, Turner effects a powerful juxtaposition of scale between the human-built environment and the natural world, emphasised here by the tonal modelling of the cliffs, their apparent bulk dwarfing the town below. The thread of revisitation that runs through these late Swiss

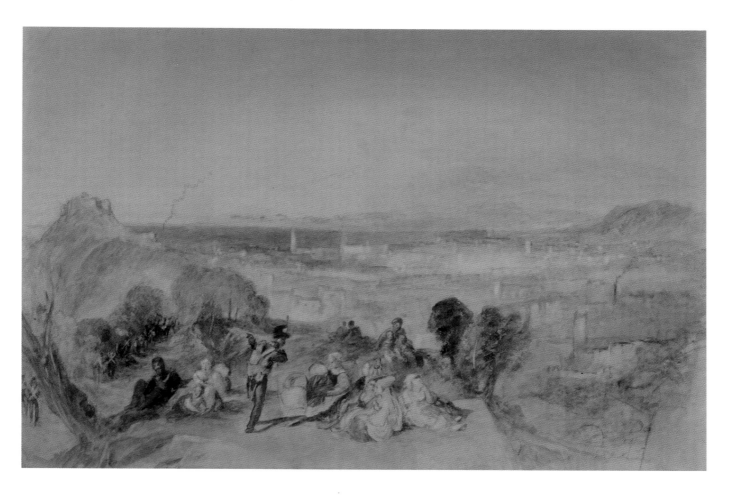

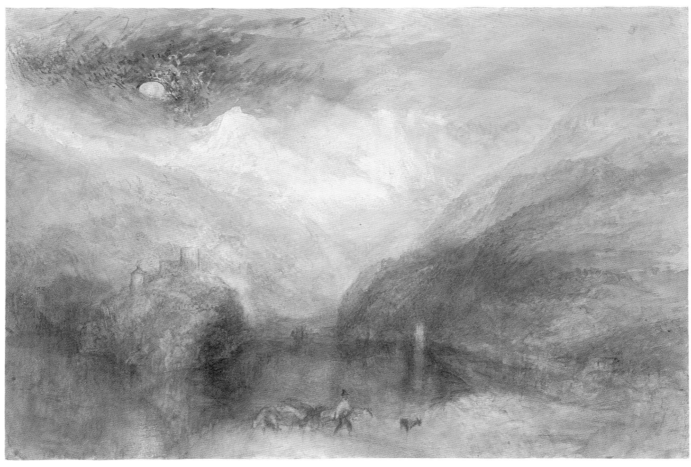

171
Mercury Sent to Admonish Aeneas exhibited 1850
Oil paint on canvas 90.2 × 120.6
Tate N00553

172
The Visit to the Tomb exhibited 1850
Oil paint on canvas 91.4 × 121.9
Tate N00555

173
The Departure of the Fleet exhibited 1850
Oil paint on canvas 89.9 × 120.3
Tate N00554

TURNER SHOWED at the Royal Academy for the last time in 1850, sending these three canvases and another that has been lost since the early twentieth century. They revisited Book 4 of Virgil's *Aeneid* and its story of the love of Aeneas for Dido, Queen of Carthage, where he lingers for a time, delaying his destiny as founder of Rome. Carthage, like Venice, had been rich in symbolism for Turner's generation. A great trading power brought low by pride and luxury and eclipsed by a greater empire, Rome, it was an awful warning to modern Britain. In pictures of its rise, fall and wars with Rome such as *Regulus* (cat.78) it was one of Turner's main points of contact with the art of Claude. The 1850 pictures reprised this and carried Turner's final epigraphs from his 'Fallacies of Hope'.

In the first picture Mercury is hard to locate and may have melted into air, as Virgil describes him doing after delivering his message to Aeneas to remind him that he is neglecting his fleet and future. If so, his fate mirrors the picture, which dissolves in morning mist and Turner's gauzy, quivering brushwork. Aeneas probably stands on the left in his richly coloured cloak, with Cupid, interposed by Venus in place of his son Ascanius to cast his amorous spell. The second, lost picture showed Aeneas recounting his exploits at Troy to Dido as they drift in a barge in Carthage harbour. In the third, the lovers try in vain to cool their ardour by visiting the tomb of the queen's late husband, Sychaeus. Finally, Aeneas tears himself away and sets sail again with his fleet. Turner evokes the splendour of Carthage through grand architecture and hints of vast crowds painted in jewel colours; but as night falls, the city and its queen are abandoned.

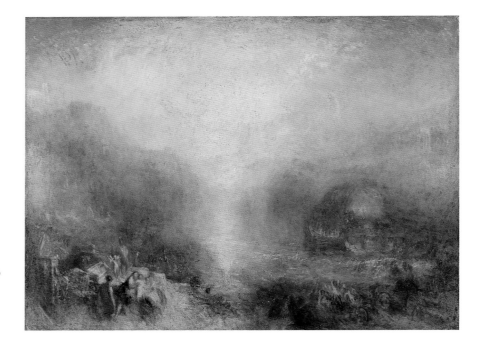

At least three of the four pictures were painted in sequence in Turner's last home at Davis Place; a visitor recalled that they were 'set in a row and he went from one to the other, first painting upon one, touching on the next, and so on, in rotation'.[1] This conformed with Turner's longstanding practice, in watercolour as well as oil, of working on a production line of 'beginnings' and lay-ins. By now he was too frail to work publicly on Varnishing Days and the pictures were finished before delivery to the exhibition rooms. Reviewers, both bedazzled and bemused, were on the whole kinder than in recent years, evidently realising that they would not see Turner again in the Academy. DBB

1 For the execution and condition of these pictures, see pp.49–55 in the present volume.

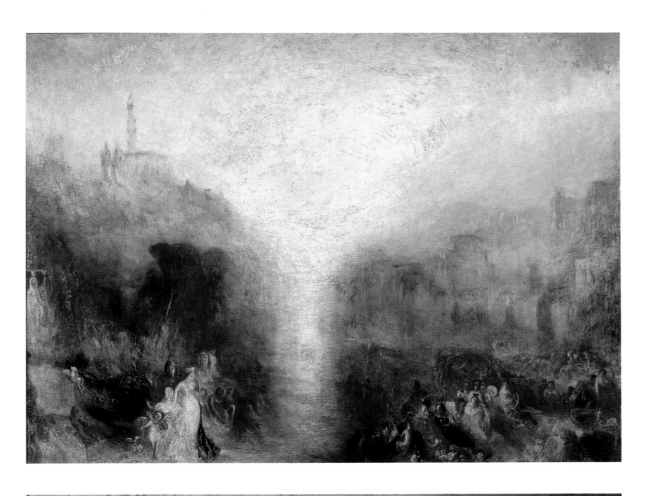

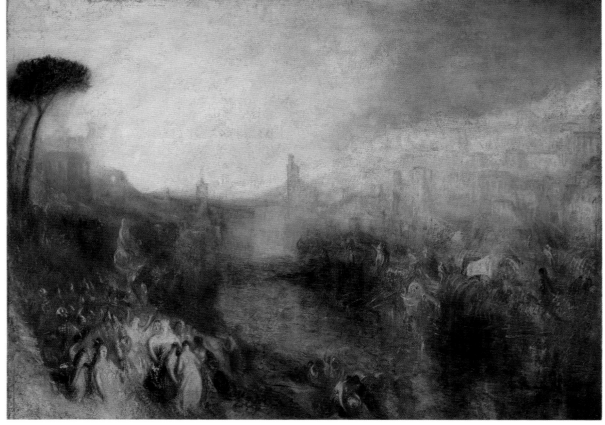

241

Bibliography

Robert Adam and Anthony Walker, *The Ruins of the Palace of the Emperor Diocletian at Spalatro*, London 1764

Nicholas Alfrey, 'Turner and the Cult of Heroes', *Turner Studies*, vol.8, no.2, Winter 1988, pp.33–44

J. Wykeham Archer, *Vestiges of Old London*, London 1851

J. Wykeham Archer, 'Joseph William Mallord Turner, R.A.' [*sic*], *Once a Week*, 1 Feb. 1862, pp.162–6

A.G.H. Bachrach, *Turner's Holland*, exh. cat., Tate Gallery, London 1994

Anthony Bailey, *Standing in the Sun: A Life of J.M.W. Turner*, London 1997

David Beevers (ed.), *Brighton Revealed: Through Artists' Eyes, c.1760–1960*, exh. cat., The Royal Pavilion, Art Gallery & Museums, Brighton 1995

Peter Bicknell, 'Turner's *The Whale Ship*: A Missing Link?', *Turner Studies*, vol.5, no.2, Winter 1985, pp.20–3

Peter Bicknell and Helen Guiterman, 'The Turner Collector: Elhanan Bicknell', *Turner Studies*, vol.1, no.7, Summer 1987, pp.34–44

Dinah Birch (ed.), *Ruskin on Turner*, London 1990

M. Bishop, S. Gelbier and J. King, 'J.M.W. Turner's Painting: The Unpaid Bill, or the Dentist Reproving his Son's Prodigality', *British Dental Journal*, vol.197, 2004, pp.757–62

David Blayney Brown, *Turner and the Channel: Themes and Variations c.1845*, exh. cat., Tate Gallery, London 1987

David Blayney Brown, *From Turner's Studio: Paintings and Oil Sketches from the Turner Bequest*, exh. cat., Bristol Museum and Art Gallery and national tour, London 1991

David Blayney Brown, *Turner and Byron*, exh. cat., Tate Gallery, London 1992

David Blayney Brown, *Romanticism*, London 2001

David Blayney Brown, *Turner in the Tate Collection*, London 2002

David Blayney Brown, *Turner Watercolours*, London 2007

Peter Bower, 'The Fugitive Mr. Turner', *Turner Society News*, no.53, Oct. 1989

Peter Bower, *Turner's Later Papers: A Study of the Manufacture, Selection and Use of*

Turner's Drawing Papers 1820–1851, exh. cat., Tate Gallery, London 1999

John Lewis Bradley and Ian Gushy (eds.), *The Correspondence of John Ruskin and Charles Eliot Norton*, Cambridge 1987

W.H. Brock, 'The Royal Society's Glass Workers' Cataract Committee: Sir William Crookes and the development of sunglasses', *Notes and Records of the Royal Society*, 2007, pp.61, 301–12

Martin Butlin and Evelyn Joll, *The Paintings of J.M.W. Turner*, rev. edn New Haven and London 1984

Martin Butlin, Andrew Wilton and John Gage, *Turner 1775–1851*, exh. cat., Royal Academy of Arts, London 1974

Anthony Carlisle, *An Essay on the Disorders of Old Age and on the Means for Prolonging Human Life*, London 1817

Anthony Carlisle, *Practical Observations on the Preservation of Health, and the Prevention of Diseases; comparing the author's experience on the disorders of childhood and old age, on scrofula, and on the efficacy of cathartic medicines*, London 1838

G.A. Cate (ed.), *The Correspondence of Thomas Carlyle and John Ruskin*, Stanford, CA 1982

Jeannie Chapel, 'The Turner Collector: Joseph Gillott, 1799–1872', *Turner Studies*, vol.6, no.2, Winter 1968, pp.43–50

Robert Chignell, *J.M.W. Turner R.A.*, London 1902

Timothy Clifford, *Turner at Manchester*, Manchester 1982

Edward Tyas Cook and Alexander Wedderburn (eds.), *The Works of John Ruskin*, I–XXXIX, London 1903–12

Melva Croal and Charles Nugent, *Turner Watercolours from Manchester*, exh. cat., Manchester 1997

Allan Cunningham, *The Lives of the Most Eminent British Painters, Sculptors, and Architects*, London 1829

Allan Cunningham, *The Cabinet Gallery of Pictures, Selected from the Splendid Collections of Art, Public and Private, which adorn Great Britain, with Biographical and Critical Descriptions*, London 1833–4

Lionel Cust, 'The Portraits of J.M.W. Turner', *Magazine of Art*, 1895, pp.248–9

Helen Dorey, *John Soane & J.M.W. Turner: Illuminating a Friendship*, exh. cat., Sir

John Soane's Museum, London 2007

Richard Dorment, *British Painting in the Philadelphia Museum: From the Seventeenth through the Nineteenth Century*, Philadelphia 1986

Charles Eastlake Smith (ed.), *Journals and Correspondence of Lady Eastlake*, London 1895

Helmut von Erffa and Allen Staley, *The Paintings of Benjamin West*, New Haven and London 1986

Joan Evans and John Howard Whitehouse (eds.), *The Diaries of John Ruskin*, 3 vols., Oxford 1956–9

George Field, *Chromatography, or A Treatise on Colours and Pigments, and of their Powers in Painting*, London 1835

Alexander J. Finberg, *The National Gallery: A Complete Inventory of the Drawings of the Turner Bequest*, London 1909

Alexander J. Finberg, *The Life of J.M.W. Turner, R.A.*, London, rev. edn 1961

Gerald Finley, 'The Deluge Pictures: Reflections on Goethe, J.M.W. Turner and Early Nineteenth-Century Science', *Zeitschrift für Kunstgeschichte*, vol.60, 1991, pp.538–48

Gerald Finley, *Angel in the Sun: Turner's Vision of History*, Montreal 1999

Gillian Forrester, *Turner's 'Drawing Book': The Liber Studiorum*, exh. cat., Tate Gallery, London 1996

William Powell Frith, *My Autobiography and Reminiscences*, London 1887, rev. edn 1888

John Gage, *Colour in Turner: Poetry and Truth*, London 1969

John Gage, *Turner: Rain, Steam and Speed*, London 1972

John Gage (ed.), *The Collected Correspondence of J.M.W. Turner*, Oxford 1980

John Gage, 'Turner's Annotated Books: "Goethe's Theory of Colours"', *Turner Studies*, vol.4, no.2, Winter 1984, pp.34–52

John Gage, 'Further Correspondence of J.M.W. Turner', *Turner Studies*, vol.6, no.1, Summer 1986, pp.2–9

John Gage, *J.M.W. Turner: 'A Wonderful Range of Mind'*, London 1987

John Gage, *George Field and his Circle: From Romanticism to the Pre-Raphaelite Brotherhood*, exh. cat., Fitzwilliam Museum, Cambridge 1989

H. Garland, 'Diabetic amyotrophy', *British Medical Journal*, vol.2, 1955, pp.1278–90

Lawrence Gowing, *Turner: Imagination and Reality*, exh. cat., Museum of Modern Art, New York 1966

Simon Grant, 'Monsters and Myths: the Manifestations of Man's Deepest Fears', in *Aquatopia: the Imaginary of the Ocean Deep*, exh. cat., Tate St Ives, London 2013

Darcy Grimaldo Grigsby, 'Patina, Painting, and Portentous Somethings', *Representations*, 2002, pp.78, 140–4

Helen Guiterman, '"The Great Painter": Roberts on Turner', *Turner Studies*, vol.9, no.1, Summer 1989, pp.2–9

James Hamilton, *Turner: A Life*, London 1997

James Hamilton, *Turner and the Scientists*, exh. cat., Tate Gallery, London 1998

James Hamilton, *Turner: The Late Seascapes*, exh. cat., Sterling and Francine Clark Art Instute, Williamstown; Manchester Art Gallery, Manchester; Burrell Collection, Glasgow, New Haven and London 2003

James Hamilton (ed.), *Turner and Italy*, exh. cat., National Gallery of Scotland, Edinburgh 2009

Martin Hardie, *Watercolour Painting in Britain*, II, London 1967

Robert Hewison, Ian Warrell and Stephen Wildman, *Ruskin, Turner and the Pre-Raphaelites*, exh. cat., Tate Gallery, London 2000

D. Hill, *Turner in the North*, New Haven and London 1998

D. Hill, *J.M.W. Turner: Le Mont Blanc et la Vallée d'Aoste*, exh. cat., Museo Archeologico Regionale, Aosta 2000

Madeline House et al. (eds.), *Letters of Charles Dickens*, 12 vols., Oxford 1965–2002

Derek Hudson and Kenneth W. Luckhurst, *The Royal Society of Arts, 1754–1954*, London 1954

Lawrence Hutton, *Portraits in Plaster from the Collection of Laurence Hutton*, New York 1894

Evelyn Joll, Martin Butlin and Luke Herrmann (eds.), *The Oxford Companion to J.M.W. Turner*, Oxford 2001

P.A. Kempster and J.E. Alty, 'John Ruskin's relapsing encephalopathy', *Brain*, no.131, 2008, pp.2520–5

Charles Knight (ed.), *London*, I, London 1841

D. Leon, *Ruskin, the Great Victorian*, London 1949

G.D. Leslie, *The Inner Life of the Royal Academy*, London 1914

Jeremy Lewison, *Turner, Monet, Twombly: Late Paintings*, exh. cat., Tate Liverpool, London 2012

R. Liebreich, 'Turner and Mulready – On the Effect of certain Faults of Vision on Painting, with especial Reference to their Works', *Proceedings of the Royal Institution*, vol.6, 1872, pp.450–63

Raymond Lister (ed.), *The Letters of Samuel Palmer*, Oxford 1974

Brian Livesley, 'The Climacteric Disease', *Journal of the American Geriatric. Society*, vol.25, no.4, 1977, pp.162–6

Brian Livesley, 'The Ageing and Ills of Turner: A Physician's View', *Turner Society News*, no.120, 2013, pp.16–20

B. Livesley and C.E. Sissons, 'Chronic Lead Intoxication mimicking Motor Neurone Disease', *British Medical Journal*, vol.4, 1968, pp.387–8

M.L. Lloyd, 'Sunny memories: containing personal recollections of some celebrated characters', *Women's Printing Society*, rev. edn, 1880

Katharine Lochnan (ed.), *Turner Whistler Monet*, exh. cat., Art Gallery of Ontario, Toronto; Galeries nationales du Grand Palais, Paris; Tate Britain, London 2004

E.D. Louis et al., 'Association between Essential Tremor and Blood Lead Concentration', *Environmental Health Perspectives*, vol.11, 2003, pp.1707–11

Brian Lukacher, 'Turner's Ghost in the Machine: Technology, Textuality, and the 1842 *Snow Storm*', *Word and Image*, vol.6, issue 2, 1990, pp.119–37

Brian Lukacher, 'Britton's Conquest: Creating an antiquarian nation, 1790–1860', in *Landscapes of Retrospection: The Magoon Collection of British Drawings and Prints, 1739–1860*, ed. F. Consagra, Poughkeepsie: The Frances Lehman Loeb Art Center, Vassar College 1999

Brian Lukacher, *Joseph Gandy: An Architectural Visionary in Georgian England*, London 2006

Anne Lyles, *Turner: The Fifth Decade. Watercolours 1830–1840*, exh. cat., Tate Gallery, London 1992

John McCoubrey, 'War and Peace…: Turner, Haydon and Wilkie', *Turner Studies*, vol.4, no.2, Winter 1984, pp.2–7

John McCoubrey, 'Time's Railway: Turner and the Great Western', *Turner Studies*, vol.6, no.1, Summer 1986, pp.33–9

John McCoubrey, '*The Hero of a Hundred Fights*: Turner, Schiller and Wellington', *Turner Studies*, vol.10, no.2, Winter 1990, pp.7–11

G.W. Manby, *Journal of a Voyage to Greenland in the Year 1821*, London 1822

Nicola Moorby and Ian Warrell, *How to Paint Like Turner*, London 2010

Peter F. Morgan (ed.), *The Letters of Thomas Hood*, Toronto 1973

John Murray (firm), *A Handbook for Travellers in Switzerland*, London 1838

Kathleen Nicholson, *Turner's Classical Landscapes: Myth and Meaning*, Princeton 1990

M. Nishda et al., 'Dietary Vitamin C and the Risk for Periodontal Disease', *Journal of Periodontology*, vol.71, 2000, pp.1215–23

Leslie Parris (ed.), *Exploring Late Turner*, exh. cat., Salander O'Reilly Galleries, New York 1999

K.D. Patterson, 'Pandemic and Epidemic Influenza 1830–1848', *Society of Scientific Medicine*, vol.21, 1985, pp.1–80

J.R. Piggott, *Turner's Vignettes*, exh. cat., Tate Gallery, London 1993

J.R. Piggott, 'Turner's Chelsea Cottage: The Controversy of 1895', *Turner Society News*, no.116, Autumn 2011, pp.7–12

J.R. Piggott, 'Matthew Cotes Wyatt's "Colossal Statue" of Wellington (1846) and Turner's *The Hero of a Hundred Fights* (1847)', *Turner Society News*, no.117, Spring 2012, pp.12–19

Willard Bissell Pope (ed.), *The Diary of Benjamin Robert Haydon*, Cambridge, MA 1960

Cecilia Powell, *Turner in the South: Rome, Naples, Florence*, New Haven and London 1987

Cecilia Powell, *Turner's Rivers of Europe: The Rhine, Meuse and Mosel*, exh. cat., Tate Gallery, London 1991

Cecilia Powell, 'Turner's Women: The Painted Veil', *Turner Society News*, no.63, March 1993, pp.12–15

Cecilia Powell, *Turner in Germany*, exh. cat., Tate Gallery, London 1995

Richard and Samuel Redgrave, *A Century of British Painters*, London 1866

Cyrus Redding, 'The late Joseph Mallord William Turner', *Fraser's Magazine*, no.45, Feb. 1852

Christopher Ricks (ed.), *Samuel Rogers: Table-Talk and Recollections*, London 2011

Christine Riding and Richard Johns, *Turner and the Sea*, exh. cat., National Maritime Museum, London 2013

E.V. Rippingille (ed.), *The Artist and Amateur's Magazine*, London 1843

William S. Rodner, *J.M.W. Turner: Romantic Painter of the Industrial Revolution*, Berkeley 1997

Christopher Rowell, Ian Warrell and David Blayney Brown, *Turner at Petworth*, exh. cat., Tate Gallery, London 2002

John Ruskin, *Modern Painters*, London 1898

Joanna Selborne, *Paths to Fame: Turner Watercolours from The Courtauld Gallery*, exh. cat., Courtauld Gallery, London; Wordsworth Trust, Grasmere, London 2008

Eric Shanes, *Turner Studies*, vol.1, no.1, 1981

Eric Shanes, *Turner's Human Landscape*, London 1990

Eric Shanes, *Turner's Watercolour Explorations, 1810–1842*, exh. cat., Tate Gallery, London 1997

Eric Shanes (ed.), *Turner: The Great Watercolours*, exh. cat., Royal Academy of Arts, London 2000

Eric Shanes, *The Life and Masterworks of J.M.W. Turner*, London 2008

Harold I. Shapiro, *Ruskin in Italy: Letters to his Parents, 1845*, Oxford 1972

Sam Smiles, *The Turner Book*, London 2006

Sam Smiles, *J.M.W. Turner: The Making of a Modern Artist*, Manchester 2007

Sam Smiles, 'Turner: Space, persona, authority', in *Biographies and Space: Placing the subject in art and architecture*, eds. D. Arnold and J. Sofaer, London and New York 2008, pp.99–114

Thomas Smith, *Recollections Of The British Institution For Promoting The Fine Arts in The United Kingdom*, London 1860

Sheila M. Smith, 'Contemporary Politics and "The External World" in Turner's *Undine*

and *The Angel Standing in the Sun*', *Turner Studies*, vol.6, no.1, Summer 1986, pp.40–50

Katharine Solender, *Dreadful Fire!* exh. cat., Cleveland Museum of Art, Cleveland 1984

David Solkin (ed.), *Turner and the Masters*, exh. cat., Tate Britain, London 2009

Robert Southey, *Journal of a Tour in the Netherlands, in the Autumn of 1815*, Boston 1902

Lindsay Stainton, *Turner's Venice*, London 1985

Tom Taylor (ed.), *Autobiographical Recollections by the Late Charles Robert Leslie, R.A.*, London 1860

Walter Thornbury, *The Life of J.M.W. Turner*, 2 vols., London 1862, rev. edn 1877

John Thornes, *John Constable's Skies: A Fusion of Art and Science*, Birmingham 1999

Joyce H. Townsend, *Turner's Painting Techniques*, exh. cat., Tate Gallery, London 1993a

Joyce H. Townsend, 'The materials of J.M.W. Turner: pigments', in *Studies in Conservation*, vol.38, 1993b, pp.231–54

Joyce H. Townsend, 'The materials of J.M.W. Turner: primings and supports, in *Studies in Conservation*, vol.39, 1994, pp.145–53

Joyce H. Townsend et al., 'Nineteenth-century paint media, part I: The formulation and properties of megilps', in Ashok Roy and Perry Smith, *Painting Techniques: History, Materials and Studio Practice*, London 1998, pp.205–10

Charles Chenevix Trench, *The Royal Malady*, London 1964

Robert Upstone, *Turner: The Final Years; Watercolours 1840–1851*, exh. cat., Tate Gallery, London 1993

Barry Venning, 'Turner's Whaling Subjects', *Burlington Magazine*, vol.127. no.983, Feb. 1985, p.76

Gustav Waagen, *Works of Art and Artists in England*, 1838

Gustav Waagen, *Treasures of Art in Great Britain*, London 1854

Marcia Briggs Wallace, 'J.M.W. Turner's Circular, Octagonal and Square Paintings 1840–1846', *Arts Magazine*, no.55, April 1979, pp.107–17

Robert K. Wallace, 'The Two Antarctic Sources for Turner's 1846 Whaling Oils',

Turner Studies, vol.8, no.1, Summer 1988, pp.20–31

Robert K. Wallace, 'The Antarctic Sources Vignettes', *Turner Studies*, vol.9, no.1, Summer 1989, pp.48–55

William C. Ward, *John Ruskin's Letters to William Ward; with a Short Biography of William Ward*, Boston, MA 1922

Ian Warrell, *Through Switzerland with Turner: Ruskin's First Selection from the Turner Bequest*, exh. cat., Tate Gallery, London 1995

Ian Warrell, *Turner and Venice*, exh. cat., Tate Britain, London 2003

Ian Warrell (ed.), *J.M.W. Turner*, exh. cat., National Gallery of Art, Washington 2007

Ian Warrell, *Turner's Secret Sketches*, London 2012

Ian Warrell (ed.), *Turner from the Tate: the Making of a Master*, London 2013a

Ian Warrell, '"I saw Louis Philippe land at Portsmouth": Fixing Turner's Presence at the Arrival of the King of the French, 8 October 1844', in *Turner Society News*, no.120, Autumn 2013b, pp.8–15

David Watkin (ed.), *Sir John Soane: Enlightenment Thought and the Royal Academy Lectures*, Cambridge 1996

Ortrud Westheider and Michael Philipp (eds.), *Turner and the Elements*, exh. cat., Bucerius Kunst Forum, Hamburg 2011

Selby Whittingham, 'The Turner Collector: B.G. Windus', *Turner Studies*, vol.7, no.2, Winter 1987, pp.29–35

Selby Whittingham, *An Historical Account of the Will of J.M.W. Turner, R.A.*, London 1993

Andrew Wilton, *The Life and Work of J.M.W. Turner*, Fribourg 1979

Andrew Wilton, *Turner Abroad*, London 1982

Andrew Wilton, *Turner in his Time*, London 1987

Emma L. Winter, 'German Fresco Painting and the New Houses of Parliament at Westminster, 1834–1851,' *The Historical Journal*, vol.47, no.2, 2004, pp.291–329

Amy Woolner, *Thomas Woolner, R.A. Sculptor and Poet – His Life in Letters*, London, 1917

Warwick Wroth, *Cremorne and the Later London Gardens*, London 1907

Chronology
J.M.W. Turner 1835–51

David Blayney Brown

1835

Turner turns sixty on 23 April (his supposed birthday).

Exhibits at the Royal Academy [RA] (*The Bright Stone of Honour (Ehrenbreitstein…*), and British Institution [BI] (*The Burning of the Houses of Lords and Commons…*).

Visits Denmark, Germany, Bohemia and Holland.

Turner's gallery opens, with earlier pictures.

Prints and illustrations after Turner appearing this year include: vignettes in the first monthly parts of Samuel Rogers's *Poetical Works*; *Finden's Landscape Illustrations of the Bible*; Macrone's edition of Milton's *Poetical Works*; further *Picturesque Views in England and Wales*.

1836

Exhibits at RA (*Juliet and her Nurse*; *Mercury and Argus*) for the last time at Somerset House, and at BI.

Exchanges (?April) gifts of prints (?proofs of *The Rivers of France* previously published in *Turner's Annual Tour*, 1833–5) and a medal with Louis-Philippe of France.

Tours France, Switzerland and the Val d'Aosta with H.A.J. Munro of Novar; gives Munro a sketchbook previously used in 1824.

'The Sketcher' (Revd John Eagles) attacks *Juliet and her Nurse* in *Blackwood's Magazine*. John Ruskin writes a response, which Turner advises him not to publish.

A government enquiry into the running of the RA investigates complaints that

Turner no longer lectures as Professor of Perspective. Martin Archer Shee, RA President, defends Turner, who is elected to the Academy Council and appointed Visitor to the Life School. Turner arranges (December) a farewell RA dinner at Somerset House.

1837

Exhibits at RA's new premises in Trafalgar Square, adjacent to the National Gallery [NG] (*Story of Apollo and Daphne*; *The Parting of Hero and Leander*) and serves on the Hanging Committee; presents a group portrait of earlier members by J.F. Rigaud.

Exhibits at BI (*Regulus*, originally painted in Rome; largely repainted on Varnishing Days) and shown at Graphic Society (*Bamborough Castle*).

Early works are shown in a loan exhibition of Old Masters at BI.

Moxon's edition of Thomas Campbell's *Poetical Works* appears, with Turner's vignettes.

Visits Paris and Versailles, and Petworth.

Resigns as RA Professor of Perspective.

Deaths of William IV, John Constable, Sir John Soane, and Lord Egremont, whose funeral Turner attends at Petworth.

1838

Exhibits at RA (*Modern Italy – the Pifferari*; *Ancient Italy – Ovid Banished from Rome*) and BI.

Last engravings of *England and Wales* published; the series is abandoned due to financial difficulties.

1839

Exhibits at RA (*Ancient Rome; Agrippina Landing with the Ashes of Germanicus…*; *Modern Rome – Campo Vaccino*) and BI.

Visits Belgium, Luxembourg and Germany.

Forty-two watercolours from the late Walter Fawkes's collection at Farnley Hall, Yorkshire are lent by his son to the Music Hall, Leeds.

In a codicil to his will, revokes annuities to Sarah Danby and her daughters.

Macrone's edition of Thomas Moore's *Epicurean* appears with Turner vignettes.

1840

Exhibits at RA (*Bacchus and Ariadne*; *Venice, the Bridge of Sighs*; *?Neapolitan Fisher-Girls Surprised Bathing by Moonlight*) and BI (*Mercury and Argus* previously RA, 1836).

Meets Ruskin for the first time at Thomas Griffith's house; later, with other artists, presents Griffith a 'superb piece of plate' for his help in selling their work.

Visits Venice via Rotterdam, the Rhine and Coburg; visits Schloss Rosenau, birthplace of Prince Albert of Saxe-Coburg-Gotha who marries Queen Victoria this year.

Charles Eastlake publishes English translation of Goethe's *Farbenlehre*; Turner owns and annotates a copy.

1841

Exhibits at RA (*Dawn of Christianity (Flight into Egypt)*; *Glaucus and Scylla*) and BI.

Visits Switzerland – Schaffhausen, Constance, Zurich, the Splügen Pass and Lucerne.

Witnesses and draws (October/November) a fire at the Tower of London; is refused access to the still-burning buildings by the commanding officer and the Duke of Wellington.

J.T. Willmore engraves *Mercury and Argus* (RA 1836, BI 1840).

Ruskin becomes a regular visitor to Turner's Gallery, Queen Anne Street.

Deaths of David Wilkie and Francis Chantrey, the latter a close friend.

1842

Exhibits at RA (*The Dogano, San Giorgio, Citella, from the Steps of the Europa*; *Snow Storm – Steam-Boat off a Harbour's Mouth…*; *Peace – Burial at Sea*; *War. The Exile and the Rock Limpet*).

Paints ten sample studies and four watercolours, mostly Swiss subjects, to be marketed through Griffith; nine sold, to Ruskin, Munro and Elhanan Bicknell.

In the *Art Union*, advertises five large-plate prints after earlier pictures; apart from *St Mark's Place, Venice – Juliet and her Nurse* (RA 1836), these are mainly classical or Italian subjects. They are published through Griffith.

Buys back his drawings for Campbell's poems, which the poet has failed to sell; the Findens, who have recently engraved Turner watercolours for a proposed *Royal Gallery of British Art*, go bankrupt.

Visits Switzerland via the St Gotthard Pass.

1843

Exhibits at RA (*The Opening of the Wallhalla*; *The Sun of Venice Going to Sea*; *Shade and Darkness – The Evening of the Deluge*; *Light and Colour (Goethe's Theory – the Morning after the Deluge …*; *St Benedetto, Looking towards Fusina*).

Proposes ten more Swiss watercolours for sale via Griffith; six are commissioned, by Munro and Ruskin.

William Miller engraves *Modern Italy* (RA 1838).

The first volume of Ruskin's *Modern Painters* published (as by a 'Graduate of Oxford') by Smith, Elder & Co.

1844

Exhibits at RA (*Rain, Steam, and Speed – the Great Western Railway*; *Van Tromp Going about to Please his Masters*; *Approach to Venice*).

Visits Switzerland for the last time.

At Portsmouth (October) sees Louis-Philippe arrive for a state visit.

Modern Painters having prompted new interest in Turner, Bicknell, Joseph Gillott and others buy unsold pictures. At dinner with Griffith, Turner thanks Ruskin 'for the first time' for writing the book.

This year or next, Francis McCracken commissions Swiss and Venetian pictures.

Deaths of Augustus Callcott, a close friend, and William Beckford, a former patron.

Assigns land at Twickenham for almhouses for poor artists, to be administered by Trustees – Rogers, Munro, Shee and Charles Turner; the document is not implemented.

1845

Appointed Acting President and then Deputy President of RA during the illness of Shee (until December 1846).

Exhibits at RA (*Whalers*; *Venice, Evening, Going to the Ball*; *Morning, Returning from the Ball, St Martino*) and Royal Scottish Academy, Edinburgh [RSA] (*Neapolitan Fisher-girls… previously RA 1840*).

By invitation, sends *The Opening of the Wallhalla* (RA 1843) to the Congress of European Art, Munich, where it is badly received.

Earlier pictures (lent by Gillott) are shown at the Royal Manchester Institution.

Makes ten more Swiss watercolours, for Ruskin, Munro, Windus, et al.

Attends Ruskin's birthday dinner, Denmark Hill, and afterwards regularly joins family events.

Health breaks down this year, preventing an intended trip to Switzerland. Instead goes twice to the Channel coast of France; in autumn, dines with Louis-Philippe at Château d'Eu.

1846

Exhibits at RA (*Hurrah! For the Whaler Erebus! Another Fish!*; *Whalers (Boiling Blubber) Entangled in Flaw Ice, Endeavouring to Extricate Themselves*; *Undine Giving the Ring to Massaniello, Fisherman of Naples*; *The Angel Standing in the Sun*) and BI.

Munro lends *Mercury and Argus* (RA 1836) to RSA; an earlier work is lent by James Miller to the Royal Hibernian Academy, Dublin [RHA].

Moves his base from Queen Anne Street to 6 Davis Place, Cremorne New Road, Chelsea (Cheyne Walk), where he lives with his companion and former Margate landlady Mrs Booth.

In poor health, declines to stand as RA Auditor (10 December) and attends (30 December) his last Council Meeting as Deputy President.

1847
Exhibits at RA (*The Hero of a Hundred Fights*), repainted over an earlier work; adds a rainbow to Daniel Maclise's *Noah's Sacrifice* on Varnishing Day.

Earlier works are shown at RHA.

Paints several more Swiss watercolours for Ruskin.

Robert Vernon bequeaths British pictures to NG, including *The Dogano, San Giorgio, Citella, from the Steps of the Europa* (RA 1842), the first by Turner to hang there.

The photographer J.J.E. Mayall opens a London studio, to which Turner becomes a regular visitor.

1848
Has no exhibits at the RA for the first time since 1824.

Cicero's Villa (RA 1839) is shown at RHA, lent by James Miller.

Hires Francis Sherrell as a studio assistant.

In a new codicil to his will, refers to his 'Bequest' and displays of 'finished pictures' to be changed every two years, and instructs that a 'Turner's Gallery' be built at NG. Griffith and Ruskin join his Executors and Trustees.

1849
Exhibits at RA (*The Wreck Buoy*, repainted over an earlier picture, to the alarm of its lender and owner, Munro).

Earlier works are lent by their owners to BI and RSA.

Declines an offer from the Society of Arts to hold a retrospective on the grounds of 'a peculiar inconvenience this year'; admits (December) his health is 'much on the wane'.

Makes a final codicil to his will, requiring NG to comply with the terms of his Bequest within ten years of his death, failing which his finished pictures are to be shown free at Queen Anne Street until two years before the lease expires, then sold to benefit RA and the Artists' General Benevolent Fund.

1850
Last exhibits at RA (*Mercury Sent to Admonish Aeneas*; *The Visit to the Tomb*; *The Departure of the Fleet*).

Earlier work is lent to the Society of Painters in Water-Colours and Liverpool Academy.

Hawksworth Fawkes writes a catalogue of his father, Walter's, collection of Turner watercolours; Turner thanks him for a copy in his Christmas letter.

1851
Does not exhibit but attends RA Varnishing Days (admiring Solomon Hart's *Caxton's Printing Press*), private view and dinners.

Visits the Crystal Palace, under construction in Hyde Park for the Great Exhibition (May–October).

From October, is bedridden at Davis Place.

Dies, 19 December; is buried in St Paul's Cathedral, 30 December.

Credits

Index

Bold catalogue numbers refer to main entries.

Supporting Tate

Tate relies on a large number of supporters – individuals, foundations, companies and public sector sources – to enable it to deliver its programme of activities, both on and off its gallery sites. This support is essential in order for Tate to acquire works of art for the Collection, run education, outreach and exhibition programmes, care for the Collection in storage and enable art to be displayed, both digitally and physically, inside and outside Tate. Your donation will make a real difference and enable others to enjoy Tate and its Collection both now and in the future. There are a variety of ways in which you can help support Tate and also benefit as a UK or US taxpayer. Please contact us at:

Development Office
Tate
Millbank
London SWIP 4RG

Tel: +44 (0)20 7887 4900
Fax: +44 (0)20 7887 8098

Tate Americas Foundation
520 West 27 Street Unit 404
New York, NY 10001
USA

Tel: 001 212 643 2818
Fax: 001 212 643 1001

Donations, no matter the size, are gratefully received, either to support particular areas of interest, or to contribute to general activity costs.

GIFTS OF SHARES
We can accept gifts of quoted shares and securities. All gifts of shares to Tate are exempt from capital gains tax, and higher rate taxpayers enjoy additional tax efficiencies. For further information please contact the Development Office.

GIFT AID
Through Gift Aid you can increase the value of your donation to Tate as we are able to reclaim the tax on your gift. Gift Aid applies to gifts of any size, whether regular or a one-off gift. Higher rate taxpayers are also able to claim additional personal tax relief. Contact us for further information and to make a Gift Aid Declaration.

LEGACIES
A legacy to Tate may take the form of a residual share of an estate, a specific cash sum or item of property such as a work of art. Legacies to Tate are free of inheritance tax, and help to secure a strong future for the Collection and galleries. For further information please contact the Development Office.

OFFERS IN LIEU OF TAX
Inheritance Tax can be satisfied by transferring to the Government a work of art of outstanding importance. In this case the amount of tax is reduced, and it can be made a condition of the offer that the work of art is allocated to Tate. Please contact us for details.

TATE MEMBERS
Tate Members enjoy unlimited free admission throughout the year to all exhibitions at Tate, as well as a number of other benefits such as exclusive use of our Members' Rooms and a free annual subscription to *Tate Etc*. Whilst enjoying the exclusive privileges of membership, you are also helping secure Tate's position at the very heart of British and modern art. Your support actively contributes to new purchases of important art, ensuring that Tate's collection continues to be relevant and comprehensive, as well as funding projects in London, Liverpool and St Ives that increase access and understanding for everyone.

TATE PATRONS
Tate Patrons share a passion for art and are committed to supporting Tate on an annual basis. The Patrons help enable the acquisition of works across Tate's broad collecting remit and also give their support to vital conservation, learning and research projects. The scheme provides a forum for Patrons to share their interest in art and meet curators, artists and one another in an enjoyable environment through a regular programme of events. These events take place both at Tate and beyond and encompass curator-led exhibition tours, visits to artists' studios and private collections, art trips both in the UK and abroad, and access to art fairs. The scheme welcomes supporters from outside the UK, giving the programme a truly international scope. For more information, please contact the Patrons Office on +44(0)20 7887 8740 or at patrons.office@tate.org.uk.

CORPORATE MEMBERSHIP
Corporate Membership at Tate Modern, Tate Britain and Tate Liverpool offers companies opportunities for corporate entertaining and the chance for a wide variety of employee benefits. These include special private views, special access to paying exhibitions, out-of-hours visits and tours, invitations to VIP events and talks at members' offices.

CORPORATE INVESTMENT
Tate has developed a range of imaginative partnerships with the corporate sector, ranging from international interpretation and exhibition programmes to local outreach and staff development programmes. We are particularly known for high-profile business to business marketing initiatives and employee benefit packages. Please contact the Corporate Fundraising team for further details.

CHARITY DETAILS
The Tate Gallery is an exempt charity; the Museums & Galleries Act 1992 added the Tate Gallery to the list of exempt charities defined in the 1960 Charities Act. Tate Members is a registered charity (number 313021). Tate Foundation is a registered charity (number 1085314).

TATE AMERICAS FOUNDATION
Tate Americas Foundation is an independent charity based in New York that supports the work of Tate in the United Kingdom. It receives full tax exempt status from the IRS under section 501(c)(3) allowing United States taxpayers to receive tax deductions on gifts towards annual membership programmes, exhibitions, scholarship and capital projects. For more information contact the Tate Americas Foundation office.

TATE TRUSTEES
Tomma Abts
Lionel Barber
Tom Bloxham, MBE
The Lord Browne of Madingley, FRS, FREng (Chairman)
Mala Gaonkar
Maja Hoffmann
Lisa Milroy
Elisabeth Murdoch
Franck Petitgas
Dame Seona Reid, DBE
Hannah Rothschild
Monisha Shah
Gareth Thomas
Wolfgang Tillmans

The Trusthouse Charitable
Foundation
David and Emma Verey
Dinah Verey
Clodagh and Leslie Waddington
Gordon D Watson
Mr and Mrs Anthony Weldon
The Duke of Westminster, OBE
TD DL
Sam Whitbread
Mr and Mrs Stephen Wilberding
Michael S Wilson
The Wolfson Foundation
*and those who wish to remain
anonymous*

DONORS TO THE TATE BRITAIN MILLBANK PROJECT
The Deborah Loeb Brice
Foundation
Clore Duffield Foundation
Alan Cristea Gallery
Sir Harry and Lady Djanogly
The Gatsby Charitable
Foundation
J Paul Getty Jr Charitable Trust
Paul Green, Halcyon Gallery
The Heritage Lottery Fund
The Hiscox Foundation
James and Clare Kirkman
The Linbury Trust and The
Monument Trust
The Manton Foundation
The Mayor Gallery
Ronald and Rita McAulay
Midge and Simon Palley
PF Charitable Trust
The Porter Foundation
The Dr Mortimer and Theresa
Sackler Foundation
Mrs Coral Samuel, CBE
Tate Members
The Taylor Family Foundation
David and Emma Verey
Sir Siegmund Warburg's
Voluntary Settlement
Garfield Weston Foundation
The Wolfson Foundation
*and those who wish to remain
anonymous*

TATE BRITAIN BENEFACTORS AND MAJOR DONORS
We would like to acknowledge
and thank the following
benefactors who have supported
Tate Britain prior to February
2014.

The Ahmanson Foundation
The Ampersand Foundation
Gregory Annenberg Weingarten
and the Annenberg Foundation
The Art Fund
Arts Council England
Arts & Humanities Research Council
Artworkers Retirement Society
Charles Asprey
averda
Gillian Ayres
John Baldessari
The Estate of Peter and Caroline
Barker-Mill
The Barns-Graham Charitable Trust
Rosamond Bernier
Anne Best
Big Lottery Fund
Billstone Foundation
Maria Rus Bojan
The Charlotte Bonham-Carter
Charitable Trust
Charles Booth-Clibborn
Frank Bowling, Rachel Scott,
Benjamin and Sacha Bowling,
Marcia and Iona Scott
Sir Alan and Sarah Bowness
Bowness, Hepworth Estate

Pierre Brahm
The Estate of Dr Marcella Louis
Brenner
British Council
Elizabeth and Rory Brooks
The Estate of Mrs Kathleen Bush
Lucy Carter
The Trustees of the Chantrey
Bequest
The Clore Duffield Foundation
The Clothworkers' Foundation
Contemporary Art Society
Giles and Sonia Coode-Adams
Isabelle and John Corbani
Douglas S Cramer
Alan Cristea Gallery
The Estate of William Crozier
Bilge Ogut-Cumbusyan and Haro
Cumbusyan
Thomas Dane
Alex Davids
Tiqui Atencio Demirdjian and Ago
Demirdjian
Department for Business,
Innovation and Skills
Department for Culture, Media
and Sport
James Diner
Jonathan Djanogly
Anthony and Anne d'Offay
Peter Doig
Jytte Dresing, The Merla Art
Foundation, Dresing Collection
EDP - Energias de Portugal, S.A.
The John Ellerman Foundation
Ibrahim El-Salahi
European Commission
European Union
Esmée Fairbairn Collections Fund
The Estate of Maurice
Farquharson
HRH Princess Firyal of Jordan
Wendy Fisher
Eric and Louise Franck
The Getty Foundation
Ida Gianelli
Liam Gillick
Milly and Arne Glimcher
Nicholas and Judith Goodison
Douglas Gordon and Artangel
Richard Green
Konstantin Grigorishin
Guaranty Trust Bank Plc
Calouste Gulbenkian Foundation
The Haberdashers' Company
Paul Hamlyn Foundation
Viscount and Viscountess
Hampden and Family
Noriyuki Haraguchi
Hauser & Wirth
Heritage Lottery Fund
Friends of Heritage Preservation
Damien Hirst
Robert Hiscox
David Hockney
The Estate of Mrs Mimi Hodgkin
Maja Hoffmann/LUMA
Foundation
Vicky Hughes and John A Smith
Fady Jameel
Amrita Jhaveri
Karpidas Family
J. Patrick Kennedy and Patricia A.
Kennedy
Bharti Kher
Jack Kirkland
James and Clare Kirkman
Leon Kossoff
The Kreitman Foundation
Samuel H. Kress Foundation,
administered by the Foundation
of the American Institute for
Conservation
Andreas and Ulrike Kurtz
Kirby Laing Foundation
David and Amanda Leathers
The Leathersellers' Company

Charitable Fund
Legacy Trust UK
The Leverhulme Trust
Gemma Levine
Lisson Gallery
John Lyon's Charity
The Estate of Sir Edwin Manton
The Manton Foundation
Lord McAlpine of West Green
Fergus McCaffrey
The Paul Mellon Centre for
Studies in British Art
The Andrew W Mellon
Foundation
Sir Geoffroy Millais
The Modern Institute
The Henry Moore Foundation
Daido Moriyama
The Estate of Mrs Jenifer Ann Murray
National Heritage Memorial Fund
The Netherlands Organisation for
Scientific Research (NWO)
Averill Ogden and Winston
Ginsberg
Tony Oursler and Artangel
Outset Contemporary Art Fund
The Paolozzi Foundation
Mrs Véronique Parke
The Estate of Mr Brian and Mrs
Nancy Pattenden
Stephen and Yana Peel
Stanley Picker Trust
The Porter Foundation
Gilberto Pozzi
Oliver Prenn
Laura Rapp and Jay Smith
Sir John Richardson
Nick and Alma Robson Foundation
Barrie and Emmanuel Roman
Mr and Mrs Richard Rose
Helen and Ken Rowe
Edward Ruscha
The Estate of Simon Sainsbury
Sir Anthony and Lady Salz
James Scott
Robert Scott
Edward Siskind
Candida and Rebecca Smith
Clive K Smith OBE
The Estate of Mrs Freda Mary
Snadow
Nicholas and Elodie Stanley
Mercedes and Ian Stoutzker
The Estate of Jiro Takamatsu
Tate 1897 Circle
Tate Africa Acquisitions
Committee
Tate Americas Foundation
Tate Asia-Pacific Acquisitions
Committee
Tate International Council
Tate Latin American Acquisitions
Committee
Tate Members
Tate Middle East and North Africa
Acquisitions Committee
Tate North American Acquisitions
Committee
Tate Patrons
Tate Photography Acquisitions
Committee
Tate Russia and Eastern Europe
Acquisitions Committee
Tate South Asia Acquisitions
Committee
Taylor Family Foundation
Terra Foundation for American Art
The Estate of Mr Nicholas Themans
Luis Tomasello
Russell Tovey
The Tretyakov Family Collection
Petri and Jolana Vainio
The Vandervell Foundation
Waddington Custot Galleries Ltd
Offer Waterman & Co.
Wellcome Trust
The Estate of Fred Williams

Jane and Michael Wilson
Samuel and Nina Wisnia
The Lord Leonard and Lady
Estelle Wolfson Foundation
Poju and Anita Zabludowicz
Ms Silke Ziehl
*and those who wish to remain
anonymous*

PLATINUM PATRONS
Mr Alireza Abrishamchi
Ghazwa Mayassi Abu-Suud
Mr Shane Akeroyd
Basil Alkazzi
Ryan Allen and Caleb Kramer
Mr and Mrs Edward Atkin CBE
Rhona Beck
Beecroft Charitable Trust
Mr Harry Blain
Rory and Elizabeth Brooks (Chair)
The Lord Browne of Madingley,
FRS, FREng
Karen Cawthorn Argenio
Mr Stephane Custot
Ms Miel de Botton
Ms Sophie Diedrichs-Cox
Elizabeth Esteve
Mr David Fitzsimons
The Flow Foundation
Mr Michael Foster
Edwin Fox Foundation
Mrs Lisa Garrison
Hugh Gibson
The Goss-Michael Foundation
Ms Nathalie Guiot
Mr and Mrs Yan Huo
Mr Phillip Hylander
Mrs Gabrielle Jungels-Winkler
Maria and Peter Kellner
Esperanza Koren
Mr and Mrs Eskandar Maleki
Scott and Suling Mead
Gabriela Mendoza and Rodrigo
Marquez
Pierre Tollis and Alexandra Mollof
Mr Donald Moore
Mary Moore
Jacqueline Orsatelli
Mr and Mrs Paul Phillips
Mariela Pissioti
Maya and Ramzy Rasamny
Frances Reynolds
Simon and Virginia Robertson
Mr and Mrs Richard Rose
Claudia Ruimy
Vipin Sareen and Rebecca Mitchell
Mr and Mrs J Shafran
Mrs Andrée Shore
Maria and Malek Sukkar
Mr Vladimir Tsarenkov and Ms
Irina Kargina
Mr and Mrs Petri Vainio
Michael and Jane Wilson
Lady Estelle Wolfson of
Marylebone
Poju and Anita Zabludowicz
*and those who wish to remain
anonymous*

GOLD PATRONS
Eric Abraham
The Anson Charitable Trust
Elena Bowes
Broeksmit Family Foundation
Ben and Louisa Brown
Nicolò Cardi
Melanie Clore
Beth and Michele Colocci
Mr Dónall Curtin
Mrs Robin D'Alessandro
Harry G. David
Mr Frank Destribats
Mrs Maryam Eisler
Mala Gaonkar
Kate Groes
Ms Natascha Jakobs
Tiina Lee

Paul and Alison Myners
Reem Nassar
Mr Francis Outred
Simon and Midge Palley
Mathew Prichard
Valerie Rademacher
Carol Sellars
Mr and Mrs Stanley S. Tollman
Emily Tsingou and Henry Bond
Rebecca Wang
Manuela and Iwan Wirth
Barbara Yerolemou
*and those who wish to remain
anonymous*

SILVER PATRONS
Allahyar Afshar
Agnew's
Sharis Alexandrian
Ms Maria Allen
Mrs Malgosia Alterman
Toby and Kate Anstruther
Mr and Mrs Zeev Aram
Mrs Charlotte Artus
Tim Attias
Miss Silvia Badiali
Trevor Barden
Mrs Jane Barker
Mr Edward Barlow
Victoria Barnsley, OBE
Jim Bartos
Alex Beard
Mr Harold Berg
Lady Angela Bernstein
Madeleine Bessborough
Ms Karen Bizon
Janice Blackburn
Shoshana Bloch
David Blood and Beth Bisso
Mrs Sofia Bogolyubov
Nathalie and Daniel Boulakia
Helen Boyan
Mr Brian Boylan
Ivor Braka
Alex Branczik
Viscountess Bridgeman
The Broere Charitable Foundation
Mr Dan Brooke
Michael Burrell
Mrs Marlene Burston
Scott Button
Mrs Aisha Caan
Timothy and Elizabeth Capon
Mr Francis Carnwath and Ms
Caroline Wiseman
Lord and Lady Charles Cecil
Dr Peter Chocian
Frances Clarke
Frank Cohen
Nicola Collard
Mrs Jane Collins
Dr Judith Collins
Terrence Collis
Mr and Mrs Oliver Colman
Carole and Neville Conrad
Giles and Sonia Coode-Adams
Alastair Cookson
Cynthia Corbett
Mark and Cathy Corbett
Tommaso Corvi-Mora
Mr and Mrs Bertrand Coste
Kathleen Crook and James Penturn
James Curtis
Michael Cutting
Loraine da Costa
Sir Howard Davies
Mr and Mrs Roger de Haan
Giles de la Mare
Maria de Madariaga
Mr Jean-Evrard Dominicé and Mrs
Stephanie de Preux Dominicé
Anne Chantal Defay Sheridan
Marco di Cesaria
Simon C Dickinson Ltd
Liz and Simon Dingemans
Ms Charlotte Ransom and Mr
Tim Dye

Rafe Eddington
Joan Edlis
Lord and Lady Egremont
John Erle-Drax
Dr Nigel Evans
Stuart and Margaret Evans
Eykyn Maclean LLC
Gerard Faggionato
Ms Rose Fajardo
Richard Farleigh
Mrs Heather Farrar
David Fawkes
Mrs Margy Fenwick
Mr Bryan Ferry, CBE
The Sylvie Fleming Collection
Mrs Jean Fletcher
Lt Commander Paul Fletcher
Steve Fletcher
Katherine Francey Stables
Stephen Friedman
Mr Mark Glatman
Ms Emily Goldner and Mr
 Michael Humphries
Kate Gordon
Mr and Mrs Paul Goswell
Penelope Govett
Martyn Gregory
Sir Ronald Grierson
Mrs Kate Grimond
Richard and Odile Grogan
Mrs Helene Guerin-Llamas
Arthur Hanna
Michael and Morven Heller
Richard and Sophia Herman
Mrs Patsy Hickman
Robert Holden
James Holland-Hibbert
Lady Hollick, OBE
Holtermann Fine Art
John Huntingford
Mr Alex Ionides
Maxine Isaacs
Helen Janecek
Sarah Jennings
Mr Haydn John
Mr Michael Johnson
Jay Jopling
Mrs Marcelle Joseph and Mr
 Paolo Cicchiné
Mrs Brenda Josephs
Tracey Josephs
Mr Joseph Kaempfer
Andrew Kalman
Ghislaine Kane
Jag-Preet Kaur
Dr Martin Kenig
Mr David Ker
Nicola Kerr
Mr and Mrs Simon Keswick
Richard and Helen Keys
Mrs Mae Khouri
David Killick
Mr and Mrs James Kirkman
Brian and Lesley Knox
The Kotick Family
Kowitz Trust
Mr and Mrs Herbert Kretzmer
Linda Lakhdhir
Mrs Julie Lee
Simon Lee
Mr Gerald Levin
Leonard Lewis
Sophia and Mark Lewisohn
Mr Gilbert Lloyd
George Loudon
Mrs Elizabeth Louis
Mark and Liza Loveday
Catherine Lovell
Jeff Lowe
Kate MacGarry
Anthony Mackintosh
Fiona Mactaggart
The Mactaggart Third Fund
Mrs Jane Maitland Hudson
Lord and Lady Marks
Marsh Christian Trust
David McCleave

Mrs Anne-Sophie McGrath
Ms Fiona Mellish
Mrs R W P Mellish
Professor Rob Melville
Mr Alfred Mignano
Victoria Miro
Ms Milica Mitrovich
Jan Mol
Lulette Monbiot
Mrs Bona Montagu
Mrs William Morrison
Richard Nagy
Julian Opie
Pilar Ordovás
Isabelle Paagman
Desmond Page
Maureen Paley
Dominic Palfreyman
Michael Palin
Mrs Adelaida Palm
Stephen and Clare Pardy
Mrs Véronique Parke
Frans Pettinga
Trevor Pickett
Mr Oliver Prenn
Susan Prevezer QC
Mr Adam Prideaux
Mr and Mrs Ryan Prince
James Pyner
Ivetta Rabinovich
Patricia Ranken
Mrs Phyllis Rapp
Ms Victoria Reanney
Dr Laurence Reed
The Reuben Foundation
Lady Ritblat
Ms Chao Roberts
David Rocklin
Frankie Rossi
Mr David V Rouch
Mr James Roundell
Mr Charles Roxburgh
Hakon Runer and Ulrike Schwarz-
 Runer
Naomi Russell
Mr Alex Sainsbury and Ms Elinor
 Jansz
Mr Richard Saltoun
Mrs Cecilia Scarpa
Cherrill and Ian Scheer
Sylvia Scheuer
Mrs Cara Schulze
Deborah Scott
The Hon Richard Sharp
Neville Shulman, CBE
The Schneer Foundation
Ms Julia Simmonds
Paul and Marcia Soldatos
Louise Spence
Nicholas Stanley
Mr Nicos Steratzias
Stacie Styles and Ken McCracken
Mrs Patricia Swannell
Mr James Swartz
The Lady Juliet Tadgell
Tot Taylor
Anthony Thornton
Britt Tidelius
Mr Henry Tinsley
Karen Townshend
Andrew Tseng
Melissa Ulfane
Mrs Cecilia Versteegh
Gisela von Sanden
Audrey Wallrock
Sam Walsh AO
Stephen and Linda Waterhouse
Offer Waterman
Lisa West
Miss Cheyenne Westphal
Walter H. White, Jnr.
Sue Whiteley
Mr David Wood
Mr Douglas Woolf
Anthony Zboralski
*and those who wish to remain
 anonymous*

YOUNG PATRONS
HH Princess Nauf AlBendar
 Al-Saud
Miss Noor Al-Rahim
HRH Princess Alia Al-Senussi
 (Chair, Young Patrons
 Ambassador Group)
Miss Sharifa Alsudairi
Sigurdur Arngrimsson
Miss Katharine Arnold
Maria and Errikos Arones
Miss Joy Asfar
Ms Mila Askarova
Miss Olivia Aubry
Flavie Audi
Sarah Bejerano
Josh Bell and Jsen Wintle
Miss Marisa Bellani
Mr Erik Belz
Mr Edouard Benveniste-Schuler
William Bertagna
Roberto Boghossian
Alina Boyko
Johan Bryssinck
Miss Verena Butt
Miss May Calil
Miss Sarah Calodney
Matt Carey-Williams and Donnie
 Roark
Georgina Casals
Alexandra and Kabir Chhatwani
Miss Katya Chitova
Arthur Chow
Bianca Chu
Mrs Mona Collins
Alicia Corbin
Thamara Corm
Daphné Cramer
Florencia Curto
Mr Theo Danjuma
Mr Joshua Davis
Ms Lora de Felice
Countess Charlotte de la
 Rochefoucauld
Emilie De Pauw
Agnes de Royere
Federico Martin Castro
 Debernardi
Carine Decroi
Mira Dimitrova
Ms Michelle D'Souza
Indira Dyussebayeva
Alexandra Economou
Miss Roxanna Farboud
Emilie Faure
Jane and Richard Found
Mr Andreas Gegner
Mrs Benedetta Ghione-Webb
Miss Dori Gilinski
Nicolas Gitton
Antonella Grevers
Georgia Griffiths
Jessica Grosman
Olga Grotova and Oleksiy Osnach
Mr Nick Hackworth
Alex Haidas
Ms Michelle Harari
Sara Harrison
Kira Allegra Heller
Christoph Hett
Mrs Samantha Heyworth
Andrew Honan
Katherine Ireland
Kamel Jaber
Scott Jacobson
Mr Christopher Jones
Aurore and Charles-Edouard
 Joseph
Ms Melek Huma Kabakci
Sophie Kainradl
Miss Meruyert Kaliyeva
Efe and Aysun Kapanci
Nicole Karlisch
Philipp Keller
Miss Tamila Kerimova
Ms Chloe Kinsman
Berrak Kocaoglu
Anastasia Koreleva
Zeynep Korutürk

Alkistis Koukouliou
Mr Jimmy Lahoud
Ms Anna Lapshina
Isabella Lauder-Frost
Mrs Julie Lawson
Karen Levy
Miss MC Llamas
Alex Logsdail
Mr John Madden
Ms Sonia Mak
Mr Jean-David Malat
Kamiar Maleki
Zoe Marden
Rebecca Marques
Dr F. Mattison Thompson
Ms Clémence Mauchamp
Miss Nina Moaddel
Mr Fernando Moncho Lobo
Erin Morris
Ali Munir
Katia Nounou
Mrs Annette Nygren
Miruna Onofrei
Katharina Ottmann
Christine Chungwon Park
Alexander V. Petalas
The Piper Gallery
Ana Plecas
Mr Eugenio Re Rebaudengo
Mr Simon Sakhai
Miss Tatiana Sapegina
Natasha Maria Sareen
Elena Scarpa
Franz Schwarz
Alex Seddon
Count Indoo Sella Di Monteluce
James Sevier
Robert Sheffield
Henrietta Shields
Ms Marie-Anya Shriro
Jag Singh
Tammy Smulders
Miss Jelena Spasojevic
Beatrice Spengos
Thomas Stauffer and Katya
 Garcia-Anton
Gemma Stewart-Richardson
Gerald Tan
Mr Edward Tang
Nayrouz Tatanaki
Miss Inge Theron
Soren S K Tholstrup
Hannah Tjaden
Mr Giancarlo Trinca
Mr Philippos Tsangrides
Ms Navann Ty
Angus Walker
Mr Neil Wenman
Ms Hailey Widrig Ritcheson
Lars N. Wogen
Ms Seda Yalcinkaya
Arani Yogadeva
Daniel Zarchan
Alma Zevi
*and those who wish to remain
 anonymous*

**INTERNATIONAL COUNCIL
MEMBERS**
Mr Segun Agbaje
Staffan Ahrenberg, Editions
 Cahiers d'Art
Doris Ammann
Mr Plácido Arango
Gabrielle Bacon
Anne H Bass
Cristina Bechtler
Nicolas Berggruen
Olivier and Desiree Berggruen
Baron Berghmans
Mr Pontus Bonnier
Frances Bowes
Ivor Braka
The Deborah Loeb Brice
 Foundation
The Broad Art Foundation
Bettina and Donald L Bryant Jr
Melva Bucksbaum and Raymond
 Learsy

Andrew Cameron AM
Fondation Cartier pour l'art
 contemporain
Nicolas and Celia Cattelain
Mrs Christina Chandris
Richard Chang
Pierre TM Chen, Yageo
 Foundation, Taiwan
Lord Cholmondeley
Mr Kemal Has Cingillioglu
Mr and Mrs Attilio Codognato
Sir Ronald Cohen and Lady
 Sharon Harel-Cohen
Mr Douglas S Cramer and Mr
 Hubert S Bush III
Mr Dimitris Daskalopoulos
Mr and Mrs Michel David-Weill
Julia W Dayton
Ms Miel de Botton
Tiqui Atencio Demirdjian and Ago
 Demirdjian
Joseph and Marie Donnelly
Mrs Olga Dreesmann
Barney A Ebsworth
Füsun and Faruk Eczacibaşi
Stefan Edlis and Gael Neeson
Mr and Mrs Edward Eisler
Carla Emil and Rich Silverstein
Alan Faena
Harald Falckenberg
Fares and Tania Fares
HRH Princess Firyal of Jordan
Mrs Doris Fisher
Mrs Wendy Fisher
Dr Corinne M Flick
Amanda and Glenn Fuhrman
Candida and Zak Gertler
Alan Gibbs
Lydia and Manfred Gorvy
Kenny Goss
Mr Laurence Graff
Ms Esther Grether
Konstantin Grigorishin
Mr Xavier Guerrand-Hermès
Mimi and Peter Haas Fund
Margrit and Paul Hahnloser
Andy and Christine Hall
Mr Toshio Hara
Paul Harris
Mrs Susan Hayden
Ms Ydessa Hendeles
Marlene Hess and James D. Zirin
André and Rosalie Hoffmann
Ms Maja Hoffmann (Chair)
Vicky Hughes
ITYS, Athens
Dakis and Lietta Joannou
Sir Elton John and Mr David
 Furnish
Pamela J. Joyner
Mr Chang-Il Kim
Jack Kirkland
C Richard and Pamela Kramlich
Bert Kreuk
Andreas and Ulrike Kurtz
Catherine Lagrange
Mr Pierre Lagrange and Mr Roubi
 L'Roubi
Baroness Lambert
Bernard Lambilliotte
Agnès and Edward Lee
Mme RaHee Hong Lee
Jacqueline and Marc Leland
Mr and Mrs Sylvain Levy
Mr Eugenio Lopez
Mrs Fatima Maleki
Panos and Sandra Marinopoulos
Mr and Mrs Donald B Marron
Andreas and Marina Martinos
Mr Ronald and The Hon Mrs
 McAulay
Angela Westwater and David
 Meitus
Mr Leonid Mikhelson
Aditya and Megha Mittal
Simon and Catriona Mordant
Mrs Yoshiko Mori
Mr Guy and The Hon Mrs Naggar

Mr and Mrs Takeo Obayashi
Hideyuki Osawa
Irene Panagopoulos
Young-Ju Park
Yana and Stephen Peel
Daniel and Elizabeth Peltz
Andrea and José Olympio Pereira
Catherine and Franck Petitgas
Sydney Picasso
Mr and Mrs Jürgen Pierburg
Jean Pigozzi
Lekha Poddar
Miss Dee Poon
Ms Miuccia Prada and Mr Patrizio Bertelli
Laura Rapp and Jay Smith
Maya and Ramzy Rasamny
Patrizia Sandretto Re Rebaudengo and Agostino Re Rebaudengo
Robert Rennie and Carey Fouks
Sir John Richardson
Michael Ringier
Lady Ritblat
Ms Güler Sabanci
Dame Theresa Sackler
Mrs Lily Safra
Muriel and Freddy Salem
Dasha Shenkman
Uli and Rita Sigg
Michael S Smith
Norah and Norman Stone
Julia Stoschek
John J Studzinski, CBE
Maria and Malek Sukkar
Mrs Marjorie Susman
David Teiger
Mr Budi Tek, The Yuz Foundation
Mr Robert Tomei
The Hon Robert H Tuttle and Mrs Maria Hummer-Tuttle
Mr and Mrs Guy Ullens
Mrs Ninetta Vafeia
Corinne and Alexandre Van Damme
Paulo A W Vieira
Robert and Felicity Waley-Cohen
Diana Widmaier Picasso
Christen and Derek Wilson
Michael G Wilson
Mrs Sylvie Winckler
The Hon Dame Janet Wolfson de Botton, DBE
Anita and Poju Zabludowicz
Michael Zilkha
and those who wish to remain anonymous

AFRICA ACQUISITIONS COMMITTEE
Tutu Agyare (Co-Chair)
Mrs Nwakaego Boyo
Lavinia Calza
Priti Chandaria Shah
Mrs Kavita Chellaram
Salim Currimjee
Harry G. David
Mr and Mrs Michel David-Weill
Robert Devereux (Co-Chair)
Hamish Dewar
Robert and Renee Drake
Mrs Wendy Fisher
Kari Gahiga
Andrea Kerzner
Samallie Kiyingi
Matthias and Gervanne Leridon
Nicholas Logsdail
Caro Macdonald
Dr Kenneth Montague
Miles Morland Foundation
Alain F. Nkontchou
Professor Oba Nsugbe QC
Helen Ogunbiyi
Pascale Revert Wheeler
Kathryn Jane Robins
Emile Stipp
Roelof Petrus van Wyk
Varnavas A. Varnava
Mercedes Vilardell
Tony Wainaina

and those who wish to remain anonymous

ASIA-PACIFIC ACQUISITIONS COMMITTEE
Matthias Arndt
Bonnie and R Derek Bandeen
Andrew Cameron AM
Mr and Mrs John Carrafiell
Mrs Christina Chandris
Richard Chang
Pierre TM Chen, Yageo Foundation, Taiwan
Adrian Cheng
Mr and Mrs Yan d'Auriol
Katie de Tilly
Mr Hyung-Teh Do
Ms Mareva Grabowski
Reade and Elizabeth Griffith
Cees Hendrikse
Mr Yongsoo Huh
Tessa Keswick
Shareen Khattar Harrison
Mr Chang-Il Kim
Ms Yung Hee Kim
Alan Lau
Woong Yeul Lee
Mr William Lim
Ms Dina Liu
Ms Kai-Yin Lo
Anne Louis-Dreyfus
Elisabetta Marzetti Mallinson
Mrs Geraldine Elaine Marden
The Red Mansion Foundation
Mr Paul Serfaty
Dr Gene Sherman AM
Leo Shih
Mr Robert Shum
Sir David Tang (Chair)
Mr Budi Tek, The Yuz Foundation
Rudy Tseng (Taiwan)
and those who wish to remain anonymous

LATIN AMERICAN ACQUISITIONS COMMITTEE
Monica and Robert Aguirre
Karen and Leon Amitai
Luis Benshimol
Estrellita and Daniel Brodsky
Carmen Busquets
Trudy and Paul Cejas
Patricia Phelps de Cisneros
Gerard Cohen
David Cohen Sitton
HSH the Prince Pierre d'Arenberg
Tiqui Atencio Demirdjian (Chair)
Patricia Druck
Angelica Fuentes de Vergara
Rocio and Boris Hirmas Said
Marta Regina and Ernest Fernandez Holman
Anne Marie and Geoffrey Isaac
Nicole Junkermann
Jack Kirkland
Rodrigo Leal
Fatima and Eskander Maleki
Becky and Jimmy Mayer
Catherine Petitgas
Frances Reynolds
Erica Roberts
Judko Rosenstock and Oscar Hernandez
Guillermo Rozenblum
Alin Ryan Lobo
Lilly Scarpetta
Norma Smith
Juan Carlos Verme
Tania and Arnoldo Wald
Juan Yarur Torres
and those who wish to remain anonymous

MIDDLE EAST AND NORTH AFRICA ACQUISITIONS COMMITTEE
HRH Princess Alia Al-Senussi
Abdullah Al Turki
Mehves Ariburnu
Sule Arinc
Marwan T Assaf
Perihan Bassatne
Foundation Boghossian
Ms Isabelle de la Bruyère
Füsun Eczacibaşi
Maryam Eisler (Co-Chair)
Shirley Elghanian
Delfina Entrecanales, CBE
Miss Noor Fares
Taymour Grahne
Maha and Kasim Kutay
Lina Lazaar Jameel and Hassan Jameel
Mrs Fatima Maleki
Fayeeza Naqvi
Dina Nasser-Khadivi
Ebru Özdemir
Mrs Edwina Özyegin
Charlotte Philipps
Ramzy and Maya Rasamny (Co-Chair)
Mrs Karen Ruimy
Dania Debs-Sakka
Sherine Magar-Sawiris
Miss Yassi Sohrabi
Maria and Malek Sukkar
Ana Luiza and Luiz Augusto Teixeira de Freitas
Berna Tuglular
Roxane Zand
and those who wish to remain anonymous

NORTH AMERICAN ACQUISITIONS COMMITTEE
Carol and David Appel
Jacqueline Appel and Alexander Malmaeus
Abigail Baratta
Dorothy Berwin and Dominique Levy
Paul Britton
Dillon Cohen
Matt Cohler
Beth Rudin De Woody
James Diner
Wendy Fisher
Glenn Fuhrman
Victoria Gelfand-Magalhaes
Pamela J Joyner
Monica Kalpakian
Elisabeth and Panos Karpidas
Christian Keese
Anne Simone Kleinman and Thomas Wong
Marjorie and Michael Levine
James Lindon
Massimo Marcucci
Lillian and Billy Mauer
Liza Mauer and Andrew Sheiner
Nancy McCain
Della and Stuart McLaughlin
Marjorie and Marc McMorris
Stavros Merjos
Gregory R. Miller
Aditya and Megha Mittal
Shabin and Nadir Mohamed
Jenny Mullen
Elisa Nuyten and David Dime
Amy and John Phelan
Nathalie Pratte
Melinda B and Paul Pressler
Liz Gerring Radke and Kirk Radke
Laura Rapp and Jay Smith
Robert Rennie (Chair) and Carey Fouks
Kimberly Richter
Amie Rocket and Anthony Munk
Komal Shah
Donald R Sobey
Robert Sobey
Beth Swofford
Dr Diane Vachon
Christen and Derek Wilson
and those who wish to remain anonymous

PHOTOGRAPHY ACQUISITIONS COMMITTEE
Her Highness Sheikha Fatima Bint Hazza' Bin Zayed Al Nahyan
Ryan Allen
Artworkers Retirement Society
Joumana Lati Asseily
Louise Baring Franck
Mr Nicholas Barker
Cynthia Lewis Beck
Marisa Bellani
Veronica and Jeffrey Berman
Pierre Brahm (Chair)
William and Alla Broeksmit
Elizabeth and Rory Brooks
Justina Burnett
Marcel and Gabrielle Cassard
Nicolas and Celia Cattelain
Beth and Michele Colocci
Fares and Tania Fares
David Fitzsimons
Lisa Garrison
Ms Emily Goldner and Mr Michael Humphries
Margot and George Greig
Alexandra Hess
Michael Hoppen
Bernard Huppert
Tim Jefferies, Hamiltons Gallery
Dede Johnston
Jack Kirkland
Mr Scott Mead
Sebastien Montabonel
Mr Donald Moore
Ellen and Dan Shapiro
Saadi Soudavar
Nicholas Stanley
Maria and Malek Sukkar
Mrs Caroline Trausch
Michael and Jane Wilson
and those who wish to remain anonymous

RUSSIA AND EASTERN EUROPE ACQUISITIONS COMMITTEE
Dilyara Allakhverdova
Maria Baibakova
Razvan BANESCU
David Birnbaum
Maria Rus Bojan
Maria Bukhtoyarova
Mark Ćuček
Mr Pavel Erochkine
Elena Evstafieva
Dr Kira Flanzraich (Chair)
Lyuba Galkina
Konstantin Grigorishin
Cees Hendrikse
Øivind Johansen
Carl Kostyál
Arina Kowner
Mrs Grażyna Kulczyk
Peter Kulloi
Ms Nonna Materkova
Teresa Mavica
Victoria Mikhelson
Neil K. Rector
Ovidiu Şandor
Zsolt Somlói
The Tretyakov Family Collection
Igor Tsukanov
Mrs Alina Uspenskaya
and those who wish to remain anonymous

SOUTH ASIA ACQUISITIONS COMMITTEE
Akshay Chudasama
Prajit Dutta, Aicon Gallery
Zahida Habib
Dr Amin Jaffer
Darashaw Mehta
Yamini Mehta
Mr Rohan Mirchandani
Shalini Misra
Amna and Ali Naqvi
Fayeeza Naqvi
Mrs Chandrika Pathak
Puja and Uday Patnaik
Lekha Poddar (Chair)
Mr Raj and Mrs Reshma Ruia
Rajeeb Samdani
Tarana Sawhney
Dinesh and Minal Vazirani, Saffronart
Osman Khalid Waheed
Manuela and Iwan Wirth
and those who wish to remain anonymous

THE 1897 CIRCLE
Marilyn Bild
David and Deborah Botten
Geoff Bradbury
Charles Brett
Mr and Mrs Cronk
Alex Davids
Jonathan Davis
Professor Martyn Davis
Ronnie Duncan
Mr R.N. and Mrs M.C. Fry
L.A. Hynes
Dr Martin Kenig
Isa Levy
Martin Owen
Dr Claudia Rosanowski
Simon Reynolds
Deborah Stern
Estate of Paule Vézelay
Simon Casimir Wilson
Andrew Woodd
Mr and Mrs Zilberberg
and those who wish to remain anonymous

TATE BRITAIN CORPORATE SUPPORTERS
BMW
BP
Christie's
EY
Hildon Ltd
Le Méridien
Markit
Sotheby's
and those who wish to remain anonymous

TATE BRITAIN CORPORATE MEMBERS
AIG
Bank of America Merrill Lynch
Citadel
Clifford Chance LLP
Deloitte LLP
Deutsche Bank
EY
GAM (UK) Limited
HSBC
Hyundai Card
JATO Dynamics
The John Lewis Partnership
Kingfisher plc
Linklaters
Mace
Mazars
Morgan Stanley
Pearson
Quilter Cheviot
The Brooklyn Brothers
Tishman Speyer
Unilever
Vodafone
Wolff Olins
and those who wish to remain anonymous